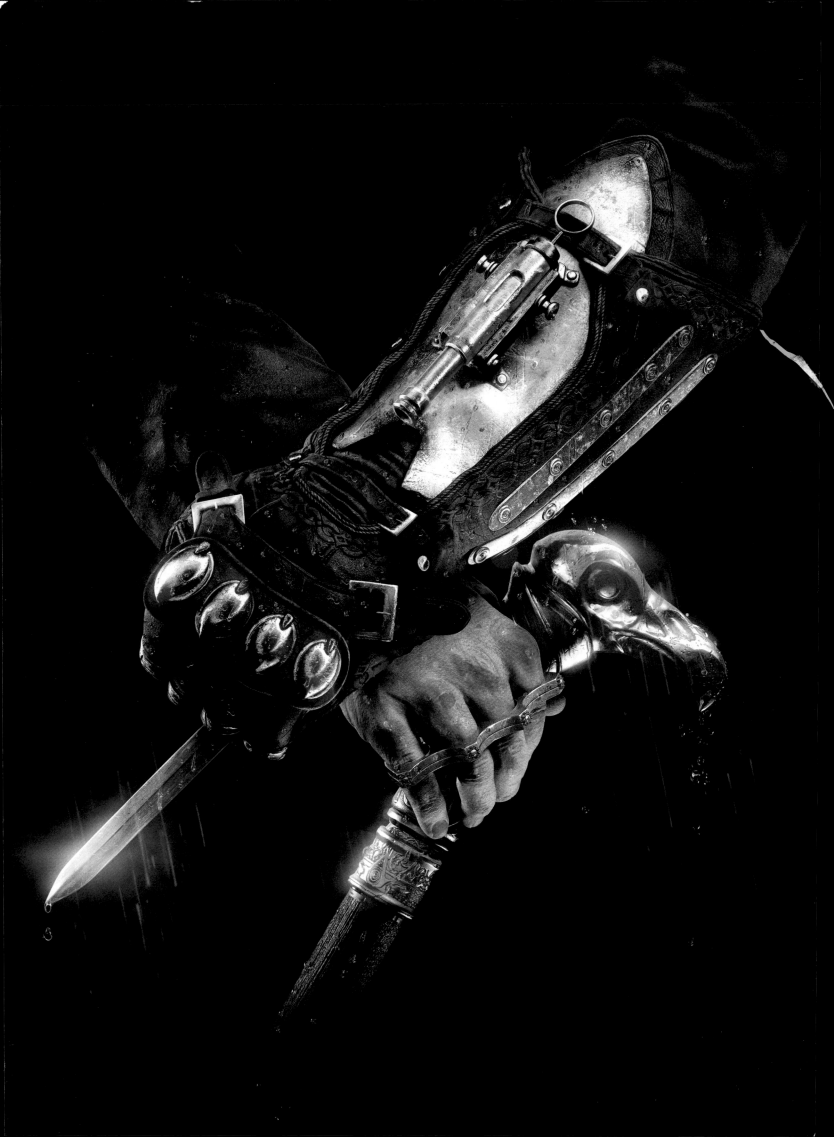

THE ART OF ASSASSIN'S CREED SYNDICATE
ISBN: 9781783295760
ISBN Limited Edition: 9781783295777

Published by Titan Books
A division of Titan Publishing Group Ltd.
144 Southwark St.
London
SE1 0UP

First edition: October 2015
10 9 8 7 6 5 4 3 2 1

Book design by Amazing15.com

To receive advance information, news, competitions, and exclusive
offers online, please sign up for the Titan newsletter on our
website: **www.titanbooks.com**

Did you enjoy this book? We love to hear from our readers.
Please e-mail us at: **readerfeedback@titanemail.com** or write to
Reader Feedback at the above address.

A CIP catalogue record for this title is available from the British Library.

Printed and bound in Spain.

THE ART OF
ASSASSIN'S CREED
SYNDICATE

PAUL DAVIES

FOREWORD BY
THIERRY DANSEREAU

TITAN BOOKS

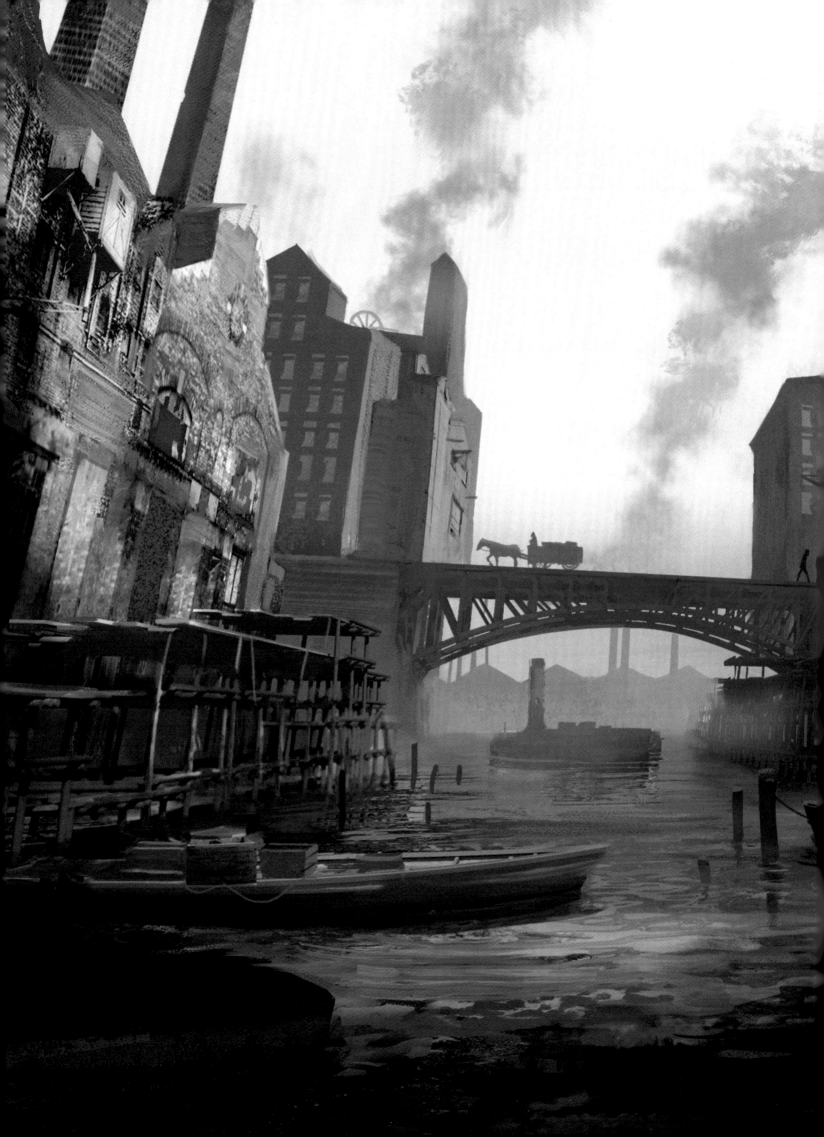

CONTENTS

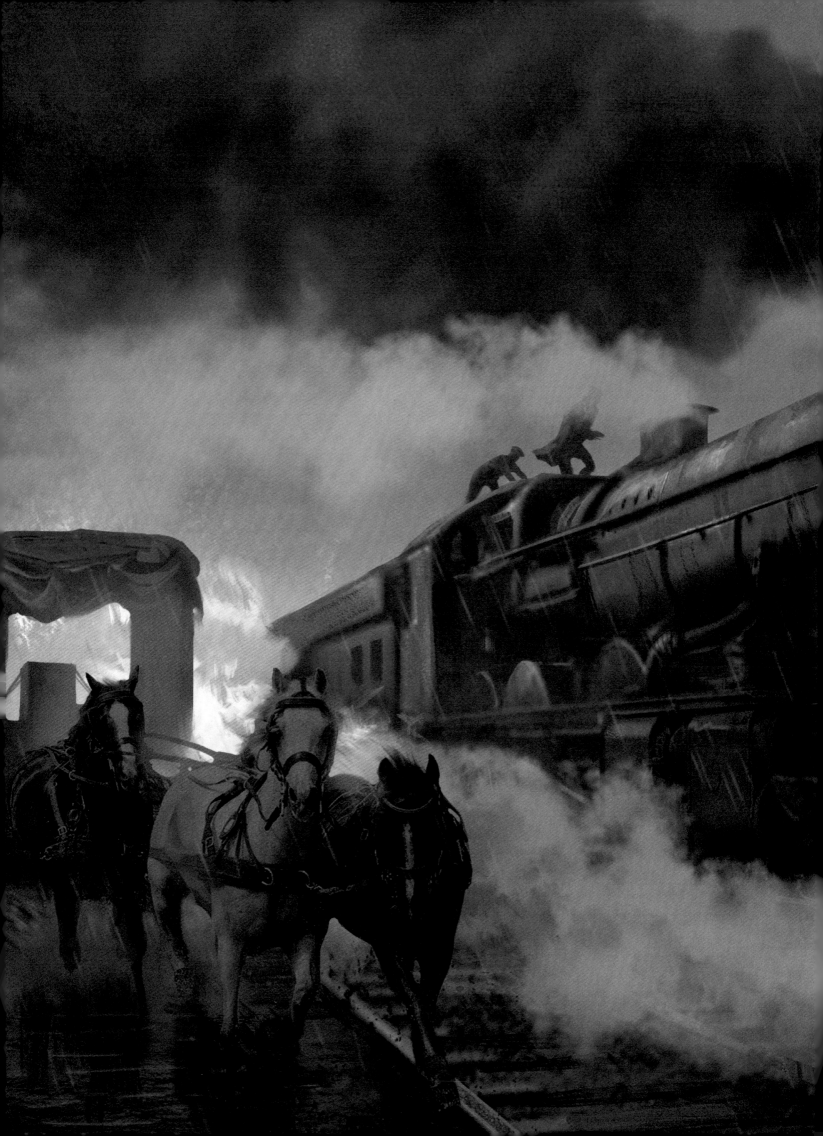

HELLO EVERYONE AND welcome to the visual world of Assassin's Creed Syndicate.

The game takes place in London in 1868, at the end of the era that dramatically changed the way we live today: the Industrial Revolution. For the first time in brand history, Assassin's Creed will take place at the gates of the modern age.

Nineteenth century London is a city of extreme contrasts and contradictions. The splendor and colors of Buckingham's gardens and the majesty of the architecture reveal opulence and pomp, the same way that workhouses and smoke-spewing factories reveal degradation and poverty. It was a time of advanced technological developments and major projects. Mass production brought the emergence of the middle class and of the working class. For the vast majority, it was an era of extreme poverty, unsanitary living conditions, debauchery, crime, disease and intense pollution.

Of course, the incongruity within the city makes for an ideal game setting, filled with opportunities for artistic contrasts. Overall, we'll emphasize the industrial revolution's elements like its factories and warehouses, its trains and railway networks, its slums and working class houses and the intense pollution, creating a unique visual signature for Assassin's Creed Syndicate in comparison with the previous entries in the brand.

Our main visual guideline was to create an immersive, colorful, saturated and contrasted world. It also needed to be dark and harsh in order to be coherent and accurate with the reality of the time period. We identified three pillars that drove the art direction: Contrast, Evolution and Movement. Each word has to find a resonance in everything we produce.

I would like to take this opportunity to acknowledge the tremendous work done by the worldwide Ubisoft production team, with a special thanks to our teams in Quebec, Montreal, Annecy, Montpellier, Singapore, Shanghai, Newcastle and Sofia. I also want to thank all the internal and external partners without whom this game would not be the same.

And finally a very personal thank you to all the concepts artists who produced these magnificent concept arts, all of whom make this book possible. They exceeded their goal to stimulate, support and direct our creativity. They are a source of pride amongst the teams and above all, they make us dream.

Thierry Dansereau, Art Director

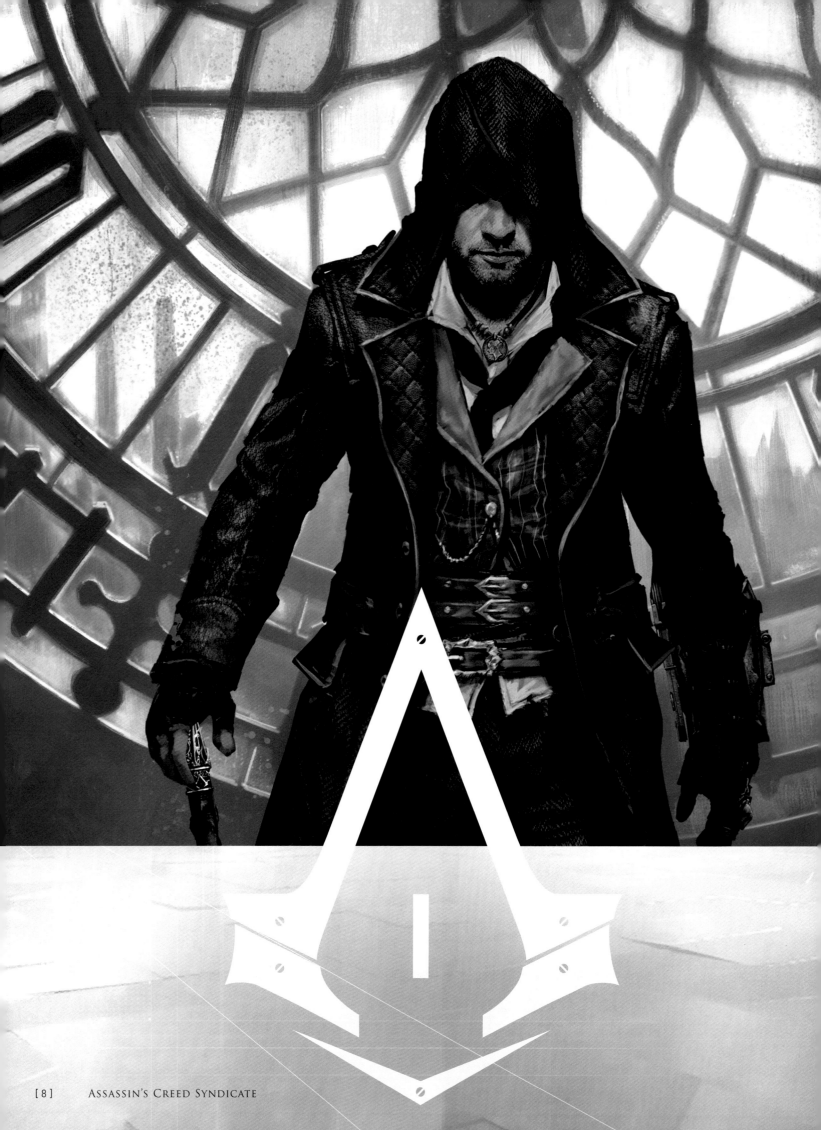

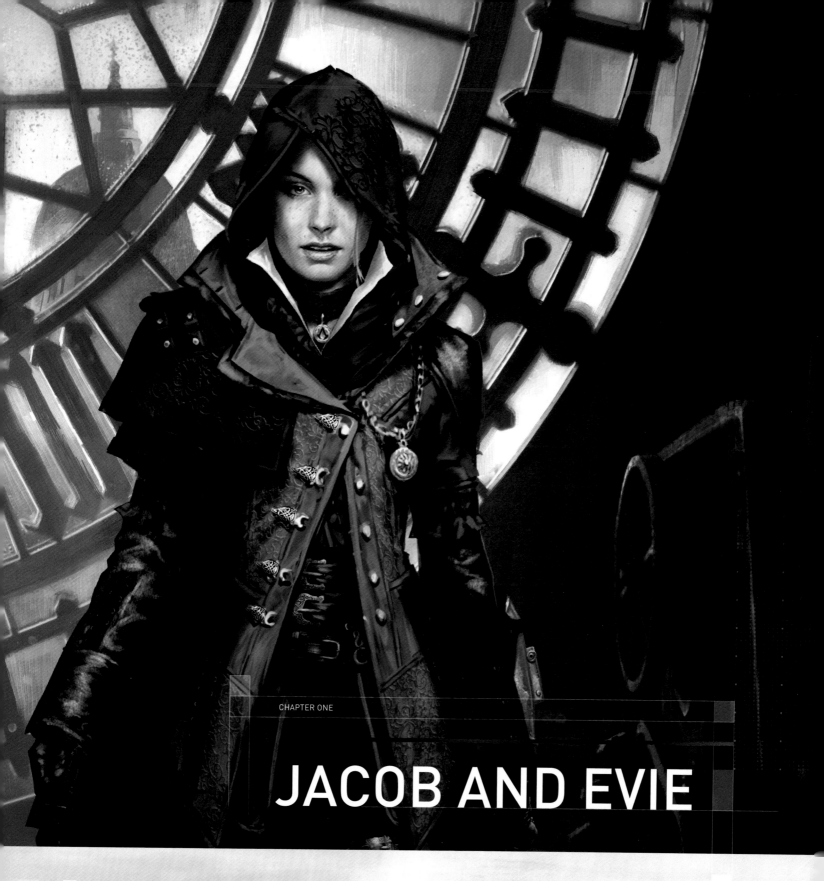

JACOB AND EVIE

THE WORLD OF *ASSASSIN'S CREED SYNDICATE* IS ONE OF MANY CONTRASTS, STARTING WITH THE HEROES WE SHALL MEET AND THROUGHOUT THE FAMOUS STREETS OF THE OLD ENGLISH CAPITAL. INTERWOVEN OPPOSITES DRAMATICALLY SHAPE THIS ADVENTURE, WITH ONE CENTRAL CONFLICT THAT YOU MANY KNOW VERY WELL: ASSASSINS VERSUS TEMPLARS. AT ITS CENTER WE FIND THE FRYE TWINS, JACOB AND EVIE.

Within smoky-grey Victorian London these colorful personalities are brought into play, according to art director Thierry Dansereau: "It was clear to us, right from the very beginning, that our heroes had to embody a charismatic and rebellious spirit. We were inspired by the attitudes and the fashion from Rock and Punk Rock movements born in the UK and mixed that with 19th century clothing."

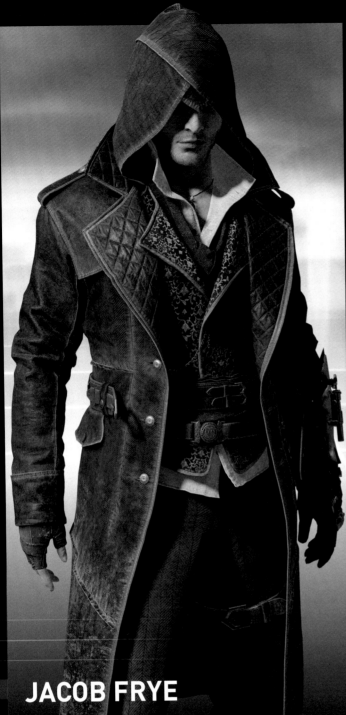

JACOB FRYE

AS AN ASSASSIN BORN of a criminal background, street gangster Jacob Frye brings an element of unpredictability to the role of hero. "Jacob is brash, rebellious, and loud, representing the vitality and vigor of Imperial Britain," explains Thierry Dansereau. "He is the physical manifestation of the country's 'can do' attitude and boundless determination. He lights up every room he enters, and endlessly entertains with compelling tales of past exploits and dreams of a brighter tomorrow." This attitude inspires a look intended to suggest a "direct and often brazen approach" to conflict. When not stirring up trouble to challenge for rival territory, Jacob assumes anonymity by wearing a very dapper top hat. The Victorian accessory is a first for the *Assassin's Creed* series in which heroes usually wear a distinguished hooded cloak.

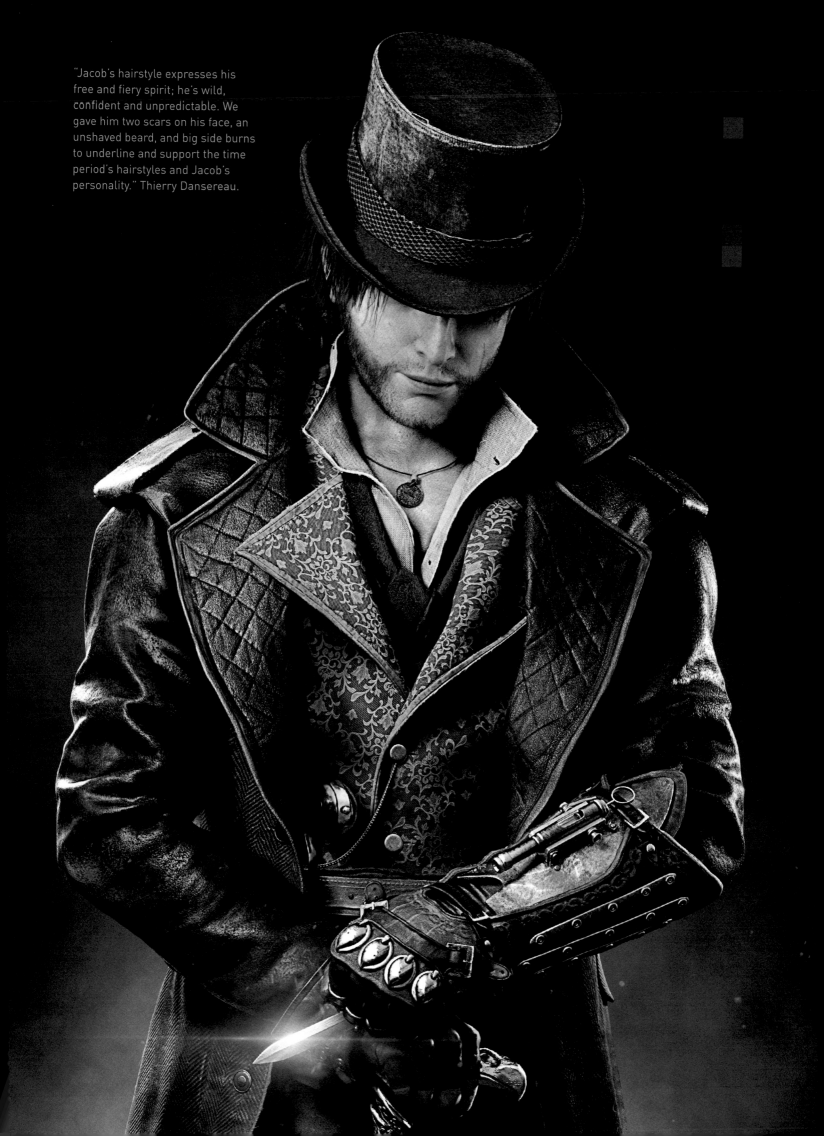

"Jacob's hairstyle expresses his free and fiery spirit; he's wild, confident and unpredictable. We gave him two scars on his face, an unshaved beard, and big side burns to underline and support the time period's hairstyles and Jacob's personality." Thierry Dansereau.

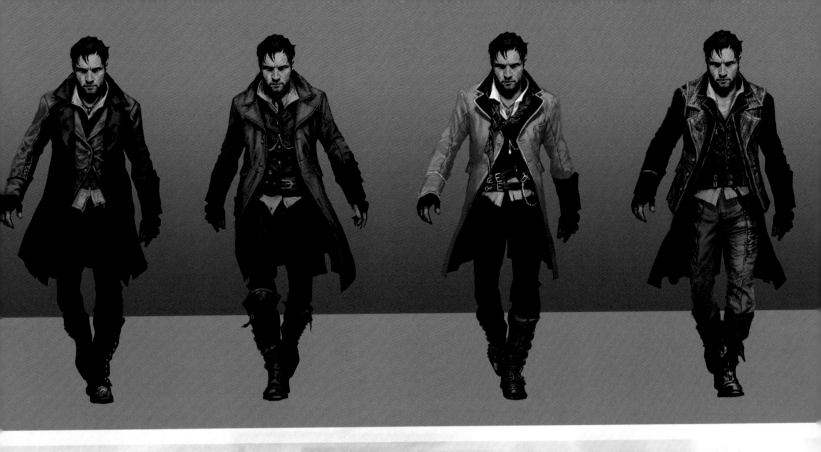

"I think I've lost count how many costume sketches I've done while exploring Jacob's look. But I have to be honest, it was so much fun! But it's also necessary to do many designs so we can edit the designs down to the best ones we want to use in game." Grant Hillier, concept artist.

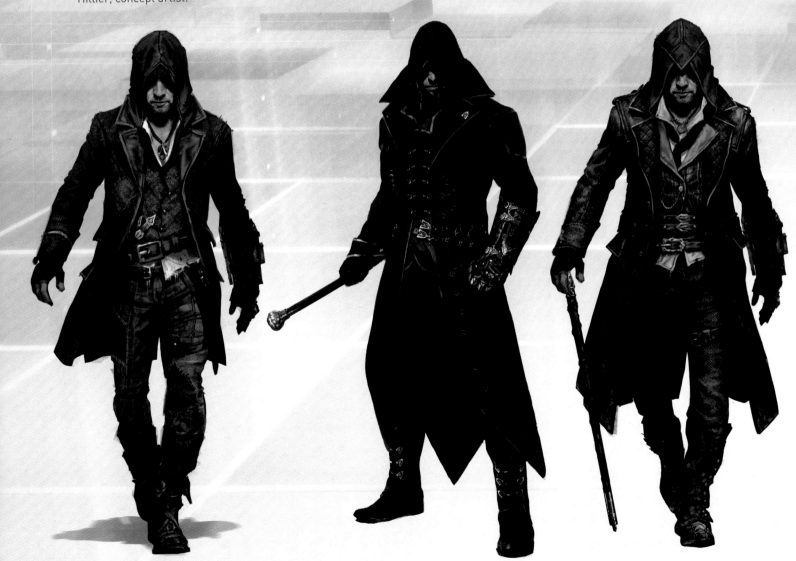

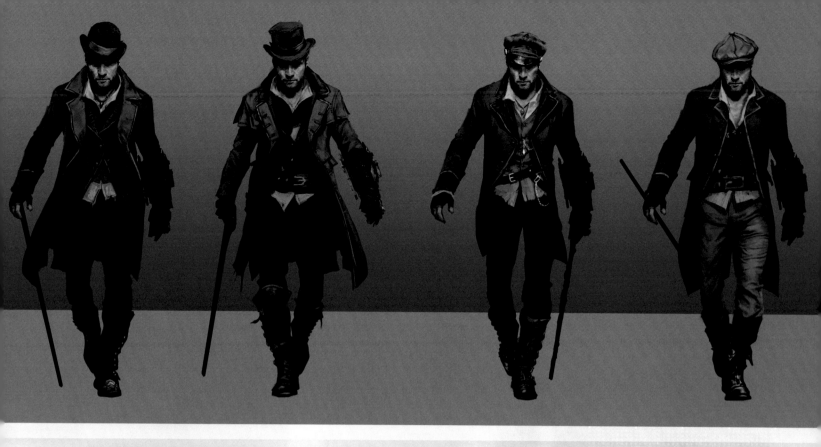

"Pushing the designs to balance the era specific details with the typical Assassin shapes was a great challenge. I really enjoy this type of exploration. It also helps to have other talented artists with a keen eye to give helpful feedback and suggestions to improve the designs. A real group effort." Grant Hillier.

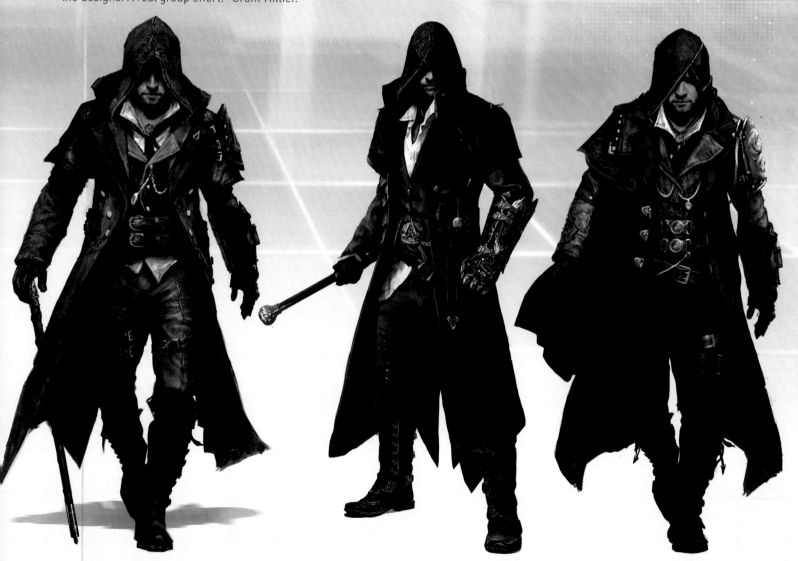

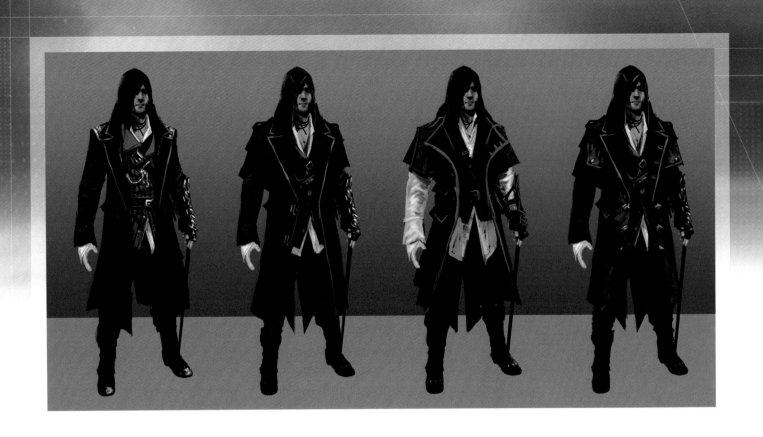

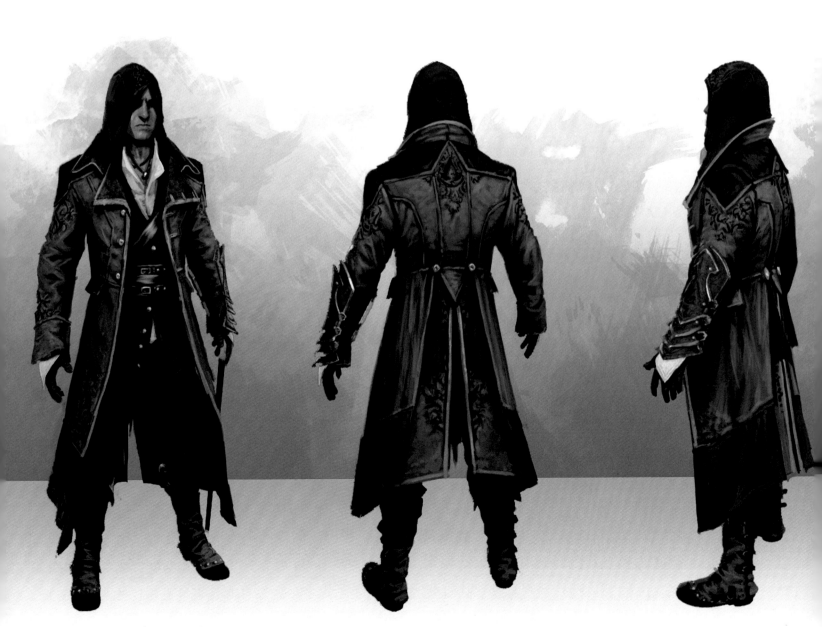

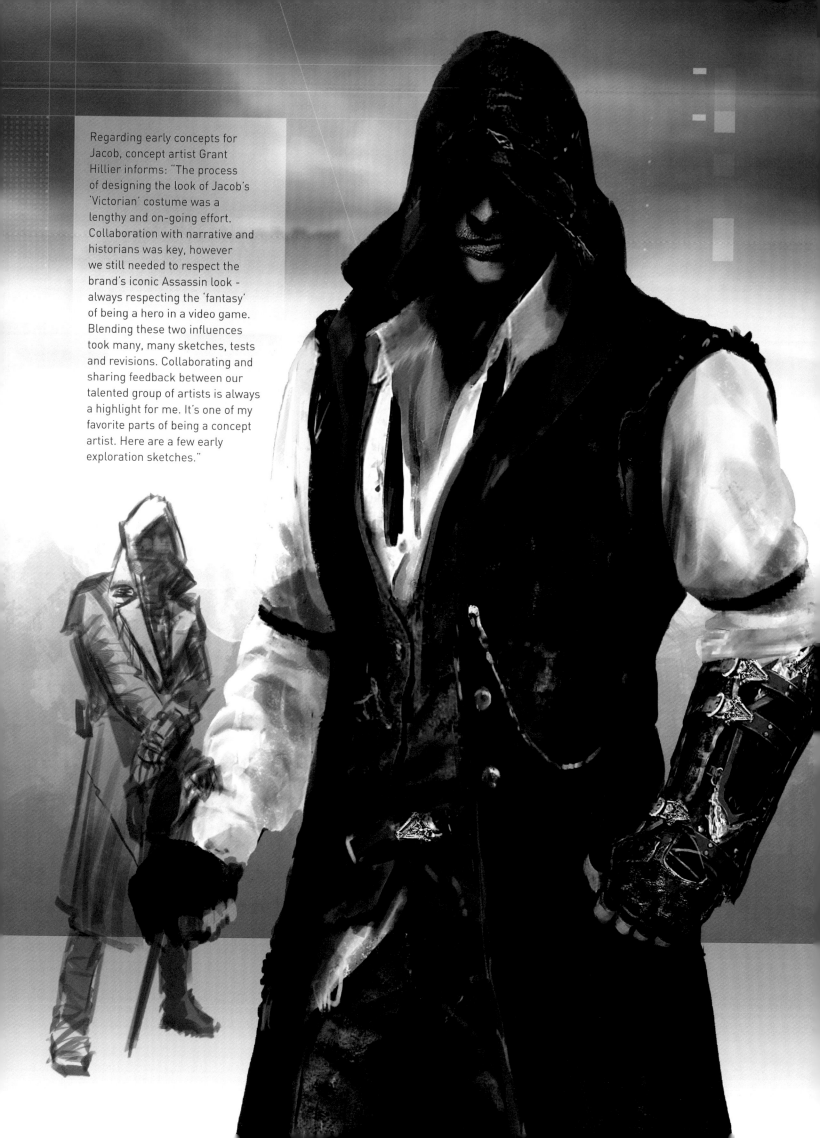

Regarding early concepts for Jacob, concept artist Grant Hillier informs: "The process of designing the look of Jacob's 'Victorian' costume was a lengthy and on-going effort. Collaboration with narrative and historians was key, however we still needed to respect the brand's iconic Assassin look - always respecting the 'fantasy' of being a hero in a video game. Blending these two influences took many, many sketches, tests and revisions. Collaborating and sharing feedback between our talented group of artists is always a highlight for me. It's one of my favorite parts of being a concept artist. Here are a few early exploration sketches."

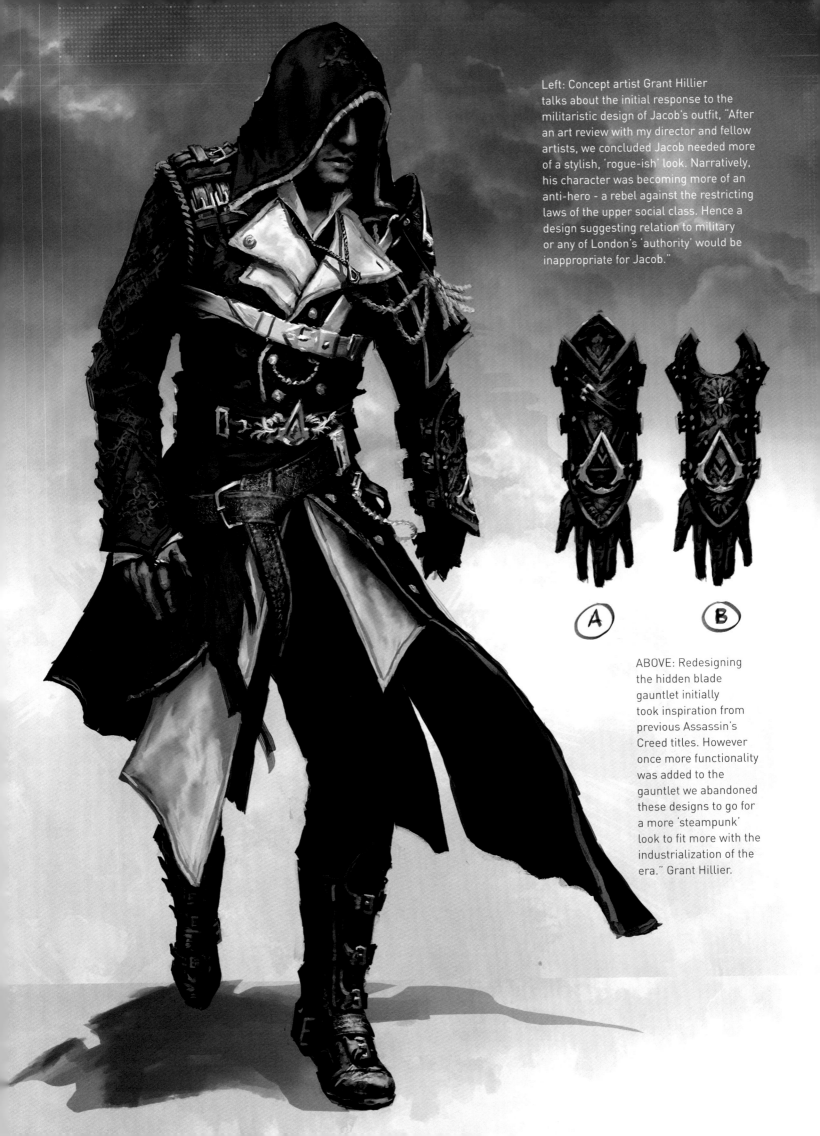

Left: Concept artist Grant Hillier talks about the initial response to the militaristic design of Jacob's outfit, "After an art review with my director and fellow artists, we concluded Jacob needed more of a stylish, 'rogue-ish' look. Narratively, his character was becoming more of an anti-hero - a rebel against the restricting laws of the upper social class. Hence a design suggesting relation to military or any of London's 'authority' would be inappropriate for Jacob."

A

B

ABOVE: Redesigning the hidden blade gauntlet initially took inspiration from previous Assassin's Creed titles. However once more functionality was added to the gauntlet we abandoned these designs to go for a more 'steampunk' look to fit more with the industrialization of the era." Grant Hillier.

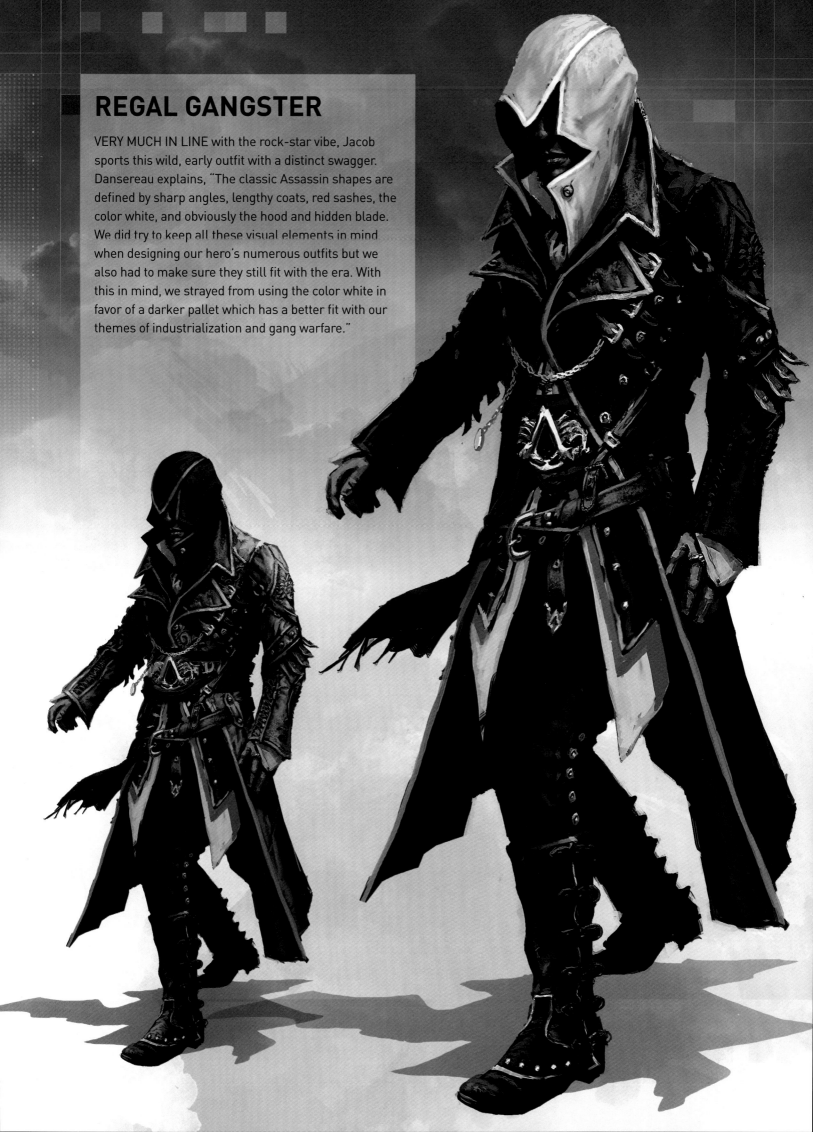

REGAL GANGSTER

VERY MUCH IN LINE with the rock-star vibe, Jacob sports this wild, early outfit with a distinct swagger. Dansereau explains, "The classic Assassin shapes are defined by sharp angles, lengthy coats, red sashes, the color white, and obviously the hood and hidden blade. We did try to keep all these visual elements in mind when designing our hero's numerous outfits but we also had to make sure they still fit with the era. With this in mind, we strayed from using the color white in favor of a darker pallet which has a better fit with our themes of industrialization and gang warfare."

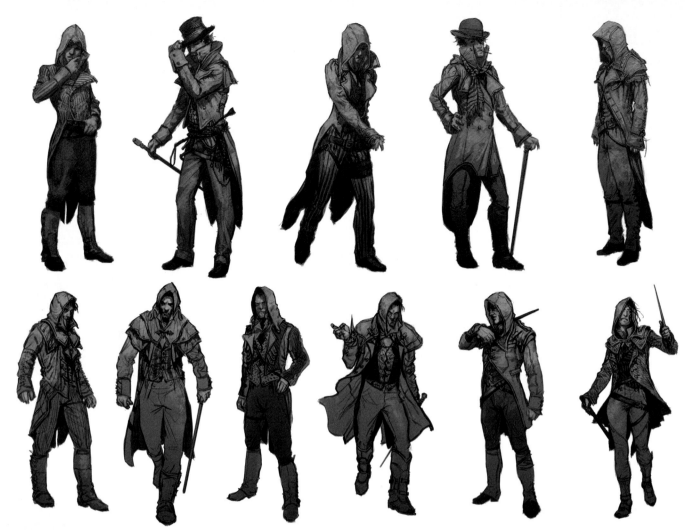

ABOVE AND BELOW: "These are some of the earliest sketches I did when first working on Syndicate. It's interesting to see how the designs for Jacob and Evie evolved to come back to a similar look as we have here in these early drawings." Grant Hillier.

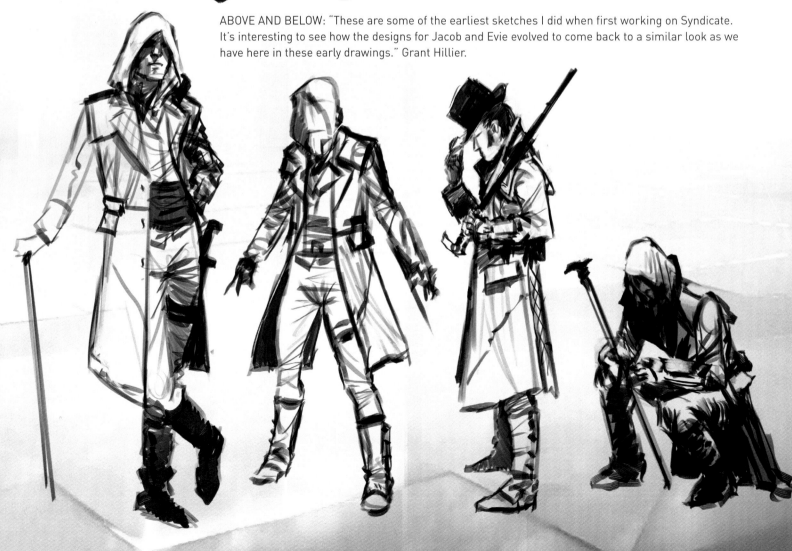

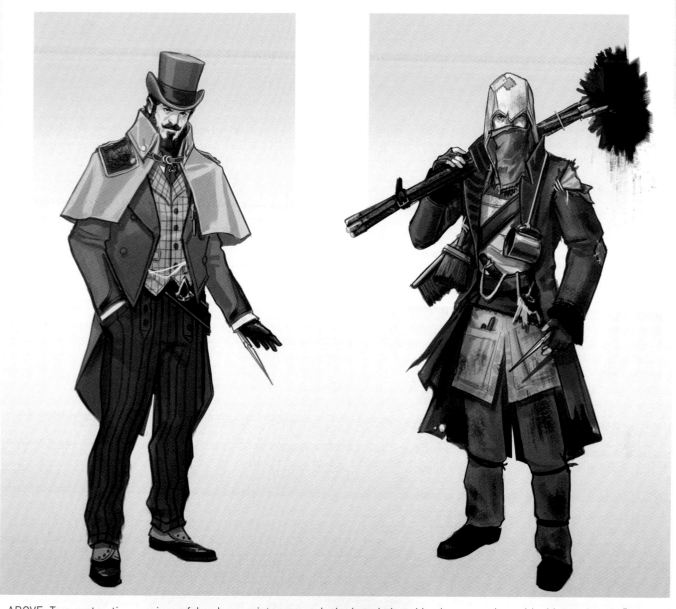

ABOVE: Two contrasting versions of Jacob: a society man and a bedraggled working hero complete with chimney brush. "We explored many directions for the right look Jacob. Below are a few designs exploring the idea that Jacob was more of a heavy set brawler rather than a lean, nimble assassin." Grant Hillier.

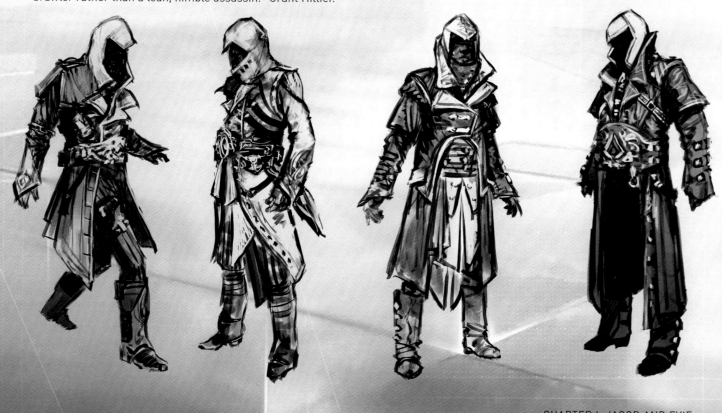

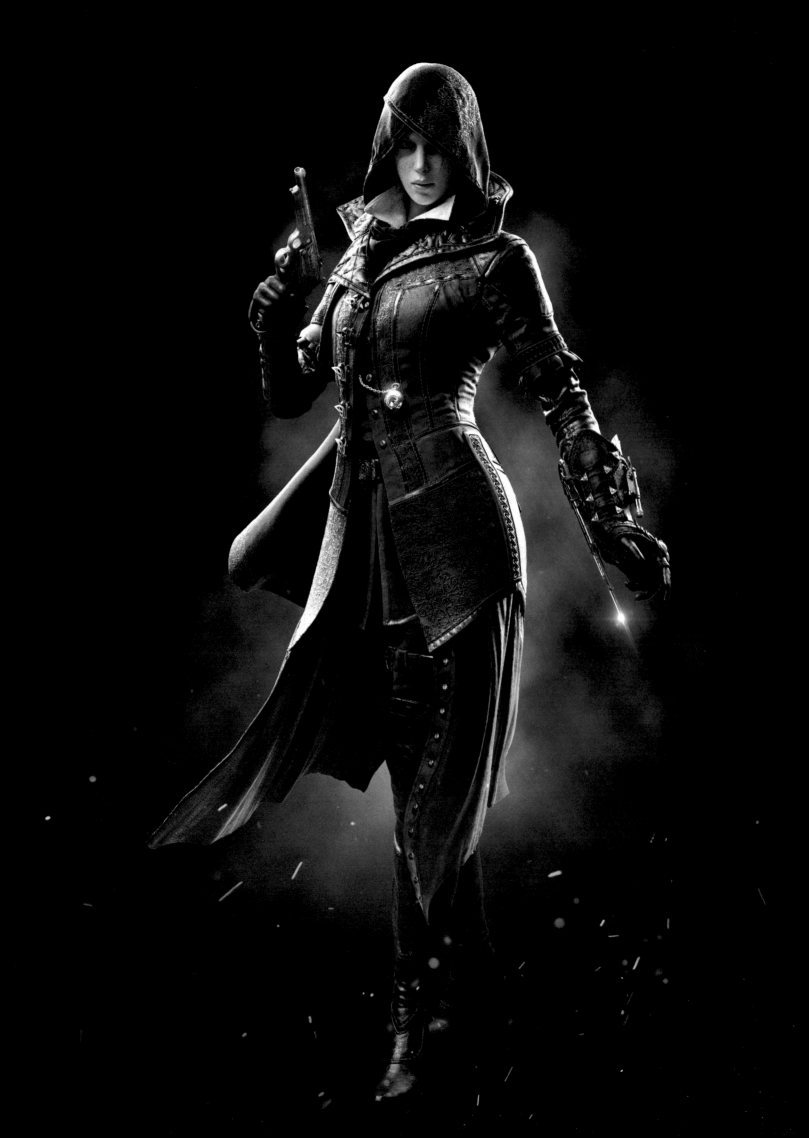

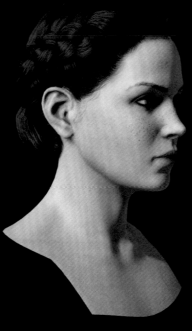
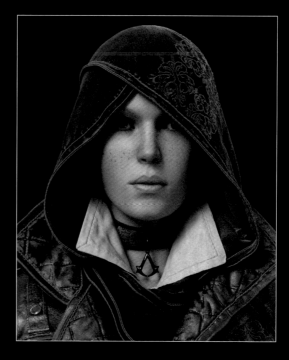
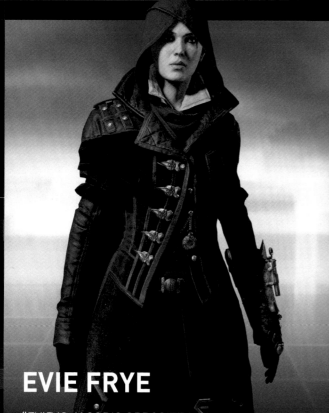
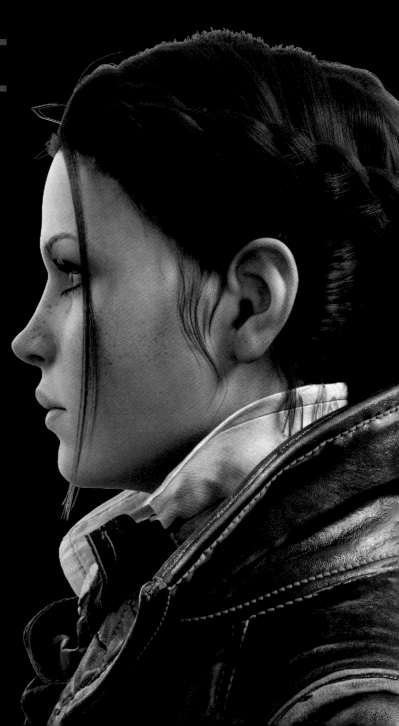

EVIE FRYE

"EVIE IS JACOB'S OPPOSITE in nearly every way," explains Dansereau. "Careful and precise, she considers her actions and endeavors in order to remain ten steps ahead of the enemy. Evie's thoughtfulness makes her Jacob's superior when it comes to the art of assassination. She's more practiced with a blade, treads lighter, and is able to manipulate social situations to her advantage. This would make Evie a true Master Assassin were she not so tightly wound. She's too quick to critique and ignore alternatives. Most find her tenacity inspirational, Jacob finds it annoying."

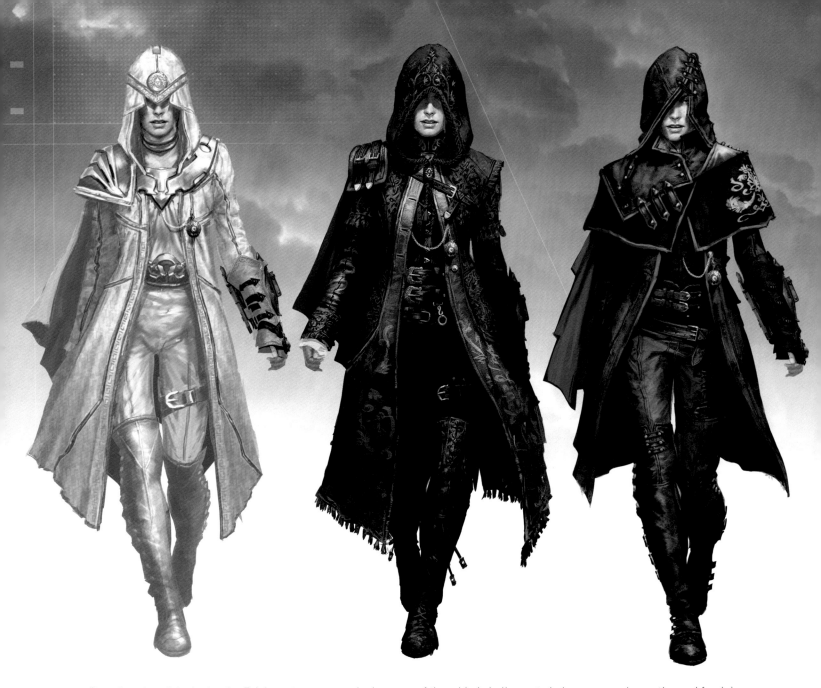

"I really enjoyed designing for Evie's costumes - maybe because of the added challenge to balance more decorative and feminine elements of the era's fashion with the functionality of climbing and fighting as an assassin. Big dresses with tons of volume just would not work with her combat and navigation animations." Grant Hillier.

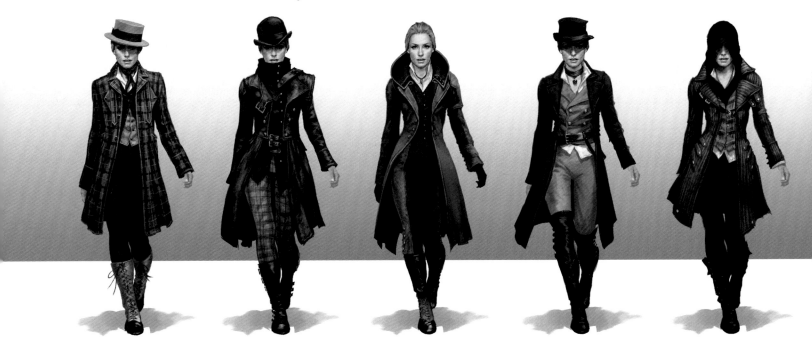

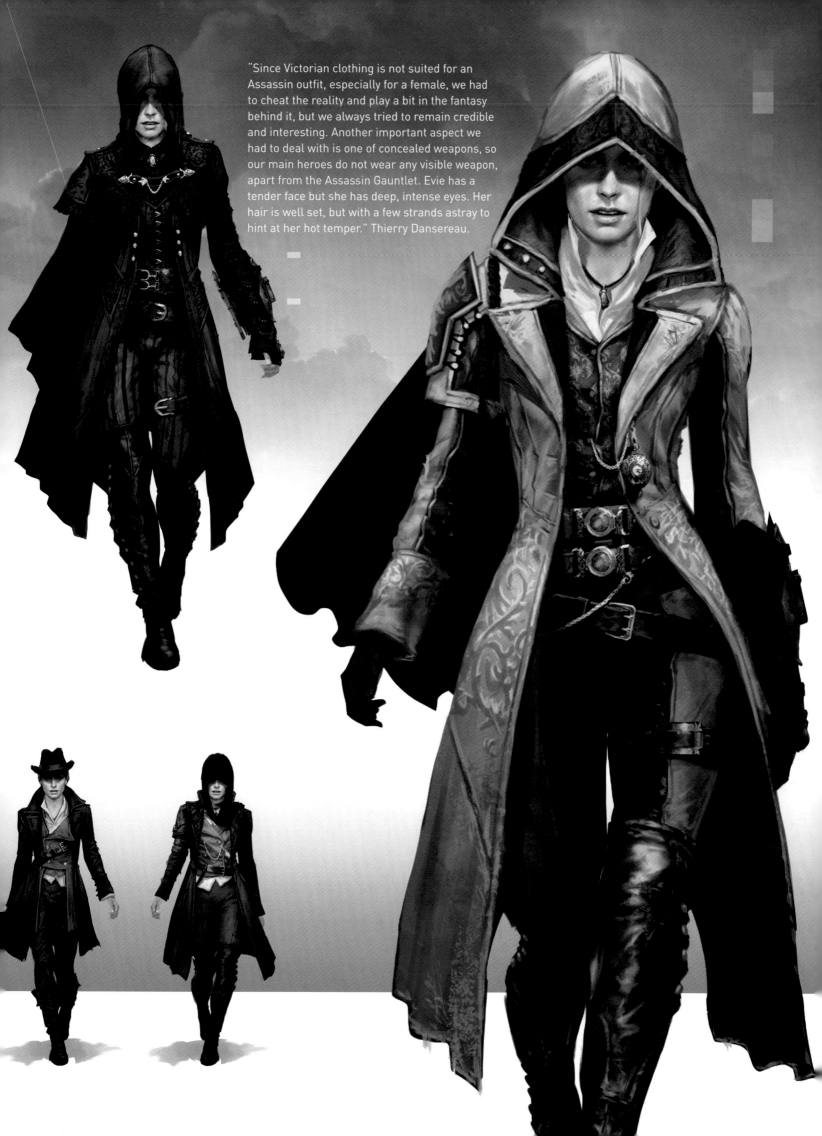

"Since Victorian clothing is not suited for an Assassin outfit, especially for a female, we had to cheat the reality and play a bit in the fantasy behind it, but we always tried to remain credible and interesting. Another important aspect we had to deal with is one of concealed weapons, so our main heroes do not wear any visible weapon, apart from the Assassin Gauntlet. Evie has a tender face but she has deep, intense eyes. Her hair is well set, but with a few strands astray to hint at her hot temper." Thierry Dansereau.

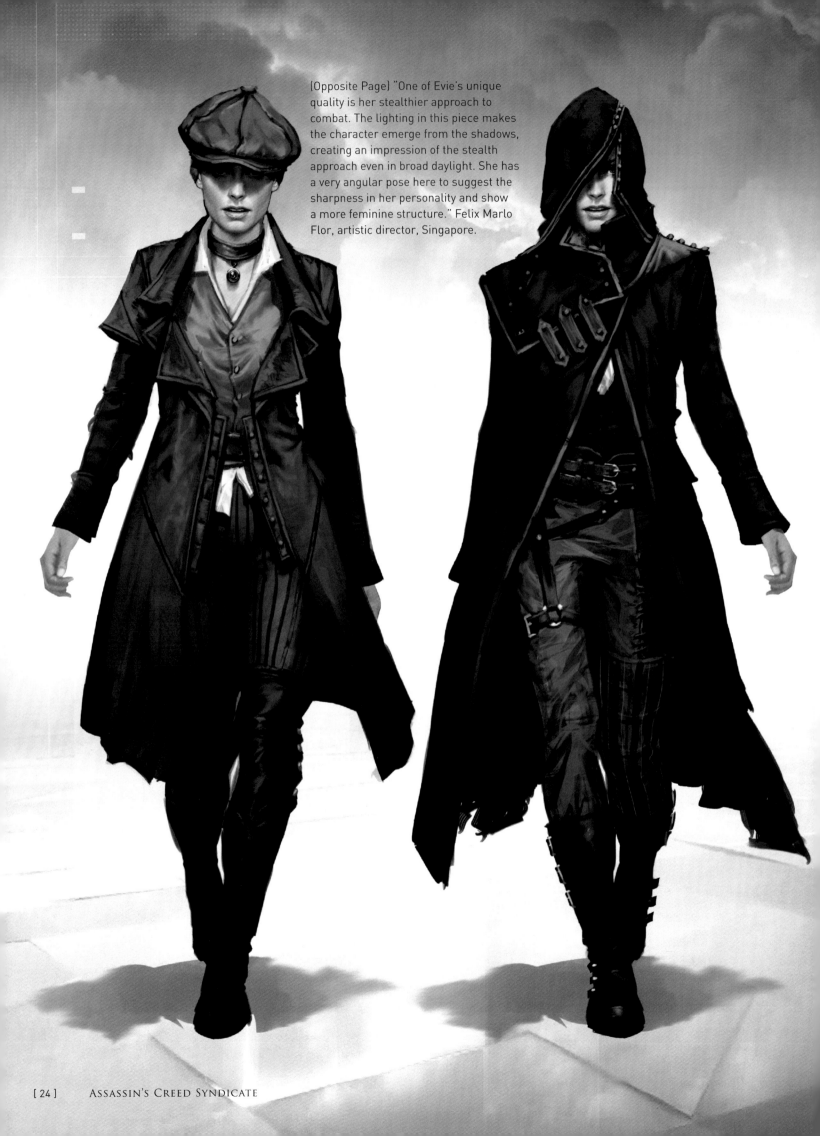

(Opposite Page) "One of Evie's unique quality is her stealthier approach to combat. The lighting in this piece makes the character emerge from the shadows, creating an impression of the stealth approach even in broad daylight. She has a very angular pose here to suggest the sharpness in her personality and show a more feminine structure." Felix Marlo Flor, artistic director, Singapore.

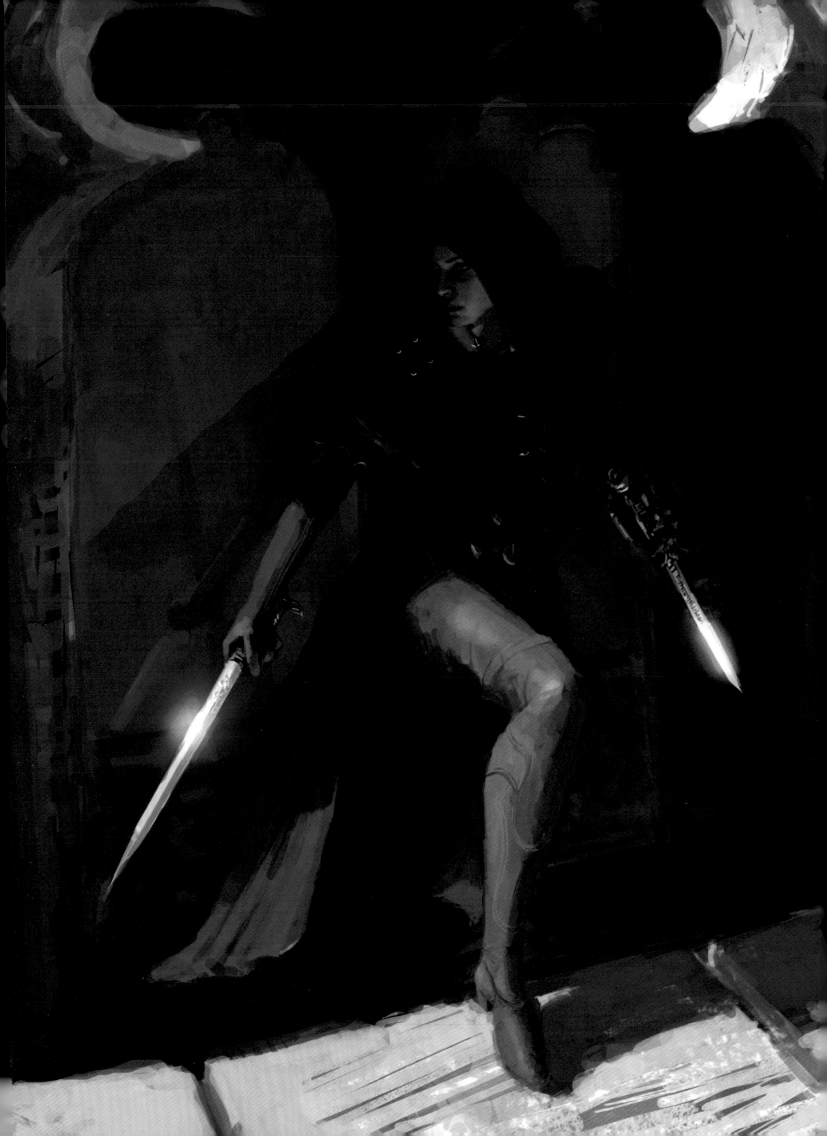

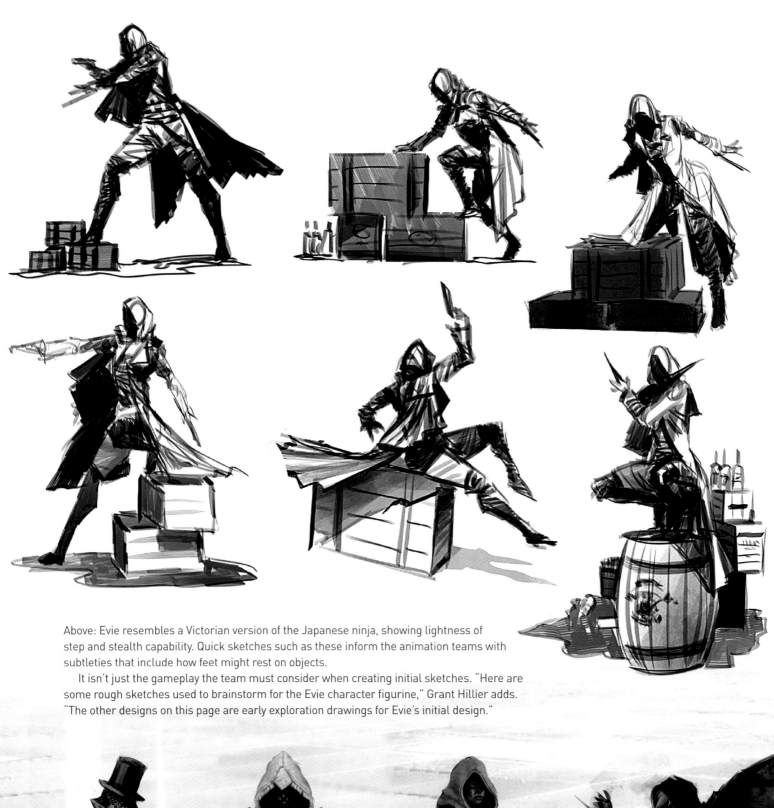

Above: Evie resembles a Victorian version of the Japanese ninja, showing lightness of step and stealth capability. Quick sketches such as these inform the animation teams with subtleties that include how feet might rest on objects.

It isn't just the gameplay the team must consider when creating initial sketches. "Here are some rough sketches used to brainstorm for the Evie character figurine," Grant Hillier adds. "The other designs on this page are early exploration drawings for Evie's initial design."

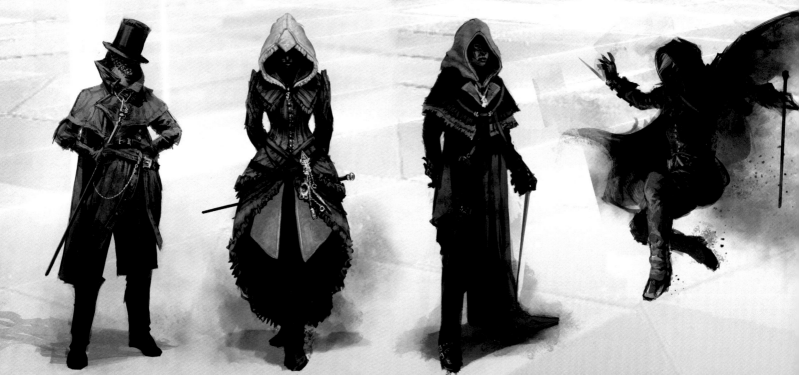

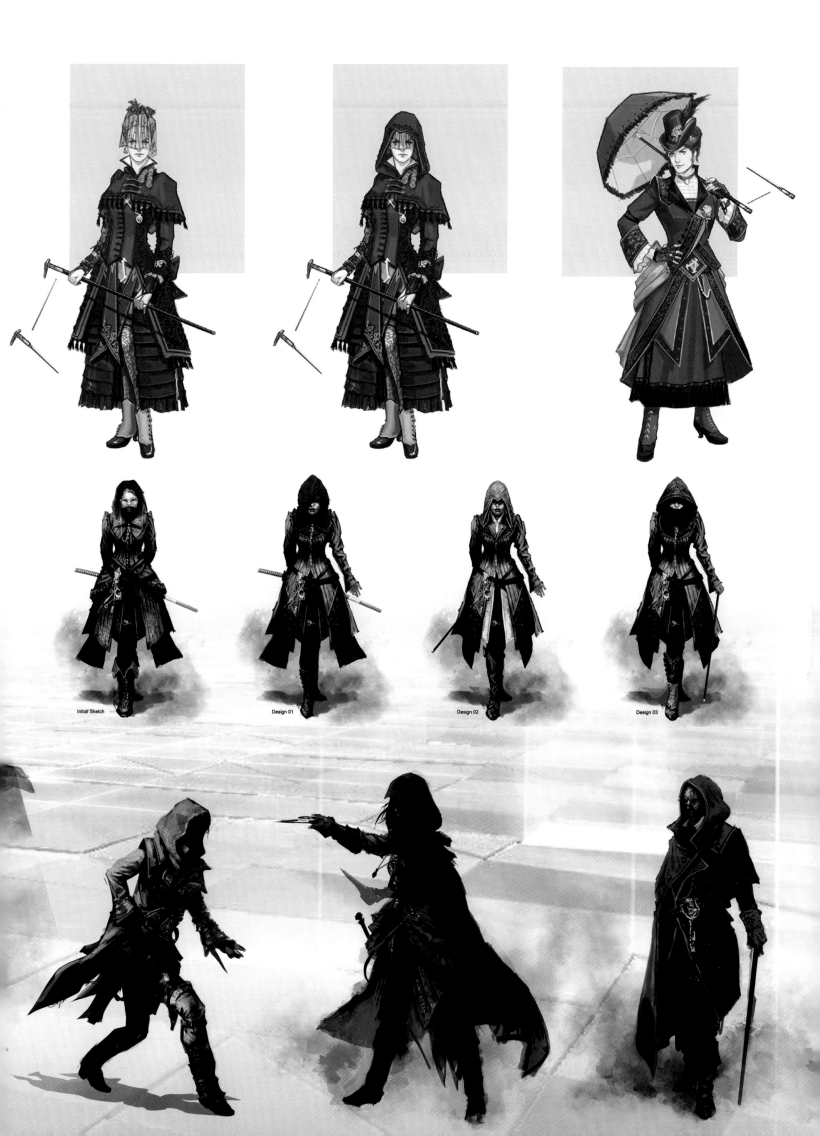

Initial Sketch

Design 01

Design 02

Design 03

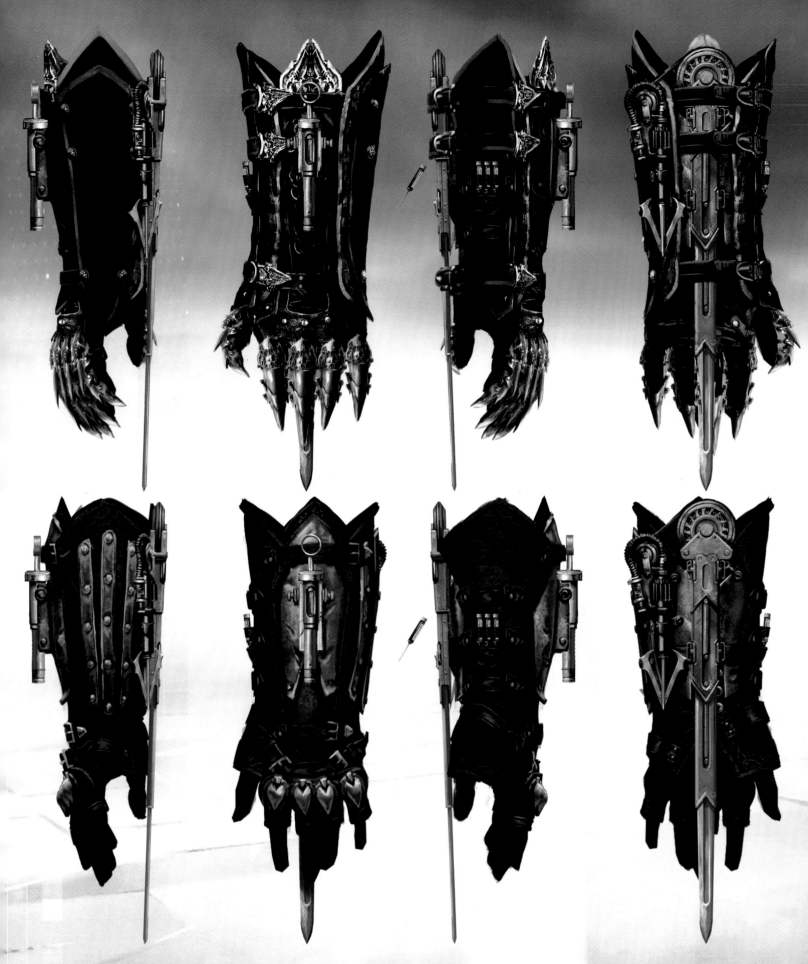

TOP: The gauntlet as it might appear as part of an armored suit, the metal plating hinged to permit the deft use of fingers while serving as knuckle-dusters that also resemble a claw. This ensemble is entirely conspicuous however.

ABOVE AND RIGHT: Grant Hiller - "Many of these designs were created for *Syndicate*. A nice change from doing character design. A concept artist must first be a good designer, versatile and able to concept weapons, props, characters, environments, or whatever the project requires. If you're flexible as an artist and designer, you'll always be a valued asset to the art team."

ASSASSIN'S GAUNTLET

THIS MOST ICONIC OF accessories received a great deal of attention from the concept artists, aiming to convey both the fashions and technological revelations of the day. Mechanized, and with a hint of mass-production possibility to reflect the industrial era, the Assassin's assorted hidden tools comprise the familiar blade alongside the new rope launcher. Grant Hillier details the challenges faced by the team, "It was a great challenge to fit all the gadgets onto the design and make it look 'believable' and somewhat functional. It was important to take inspiration from the era's Industrial Revolution, and so support the narrative, gameplay and world the players will explore."

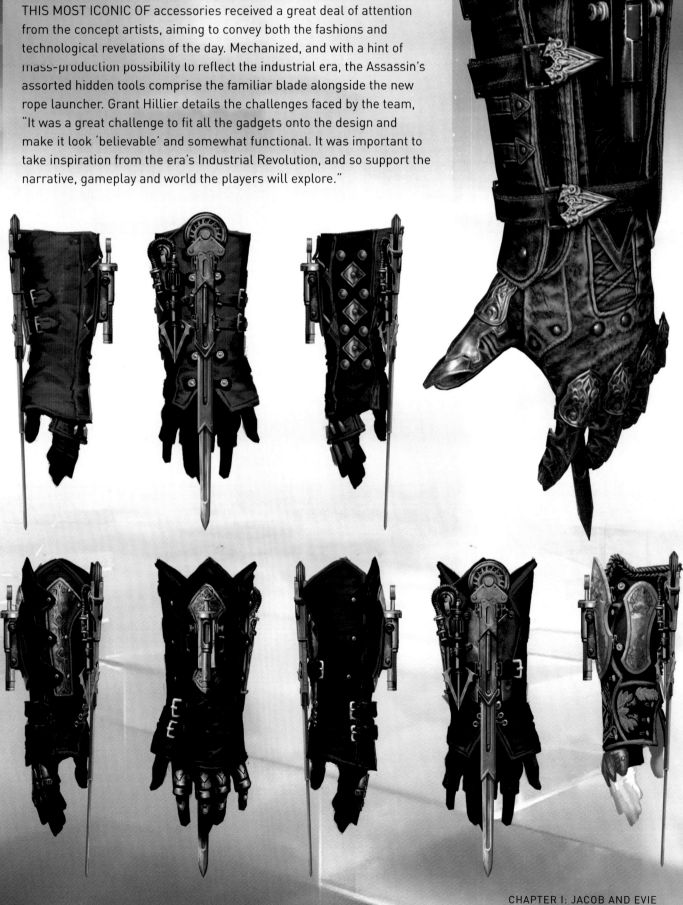

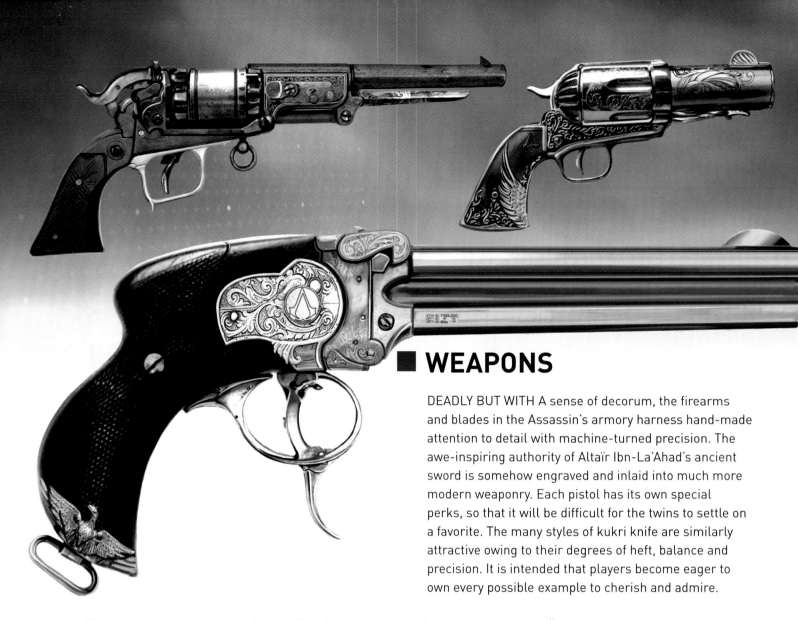

■ WEAPONS

DEADLY BUT WITH A sense of decorum, the firearms and blades in the Assassin's armory harness hand-made attention to detail with machine-turned precision. The awe-inspiring authority of Altaïr Ibn-La'Ahad's ancient sword is somehow engraved and inlaid into much more modern weaponry. Each pistol has its own special perks, so that it will be difficult for the twins to settle on a favorite. The many styles of kukri knife are similarly attractive owing to their degrees of heft, balance and precision. It is intended that players become eager to own every possible example to cherish and admire.

BELOW: Legend says that once a kukri knife is drawn on the battlefield it must taste blood. "Kukri designs suggest the many cultures under the influence of the British Empire during the Victorian Era. Many designs have exotic iconography and materials." Grant Hillier.

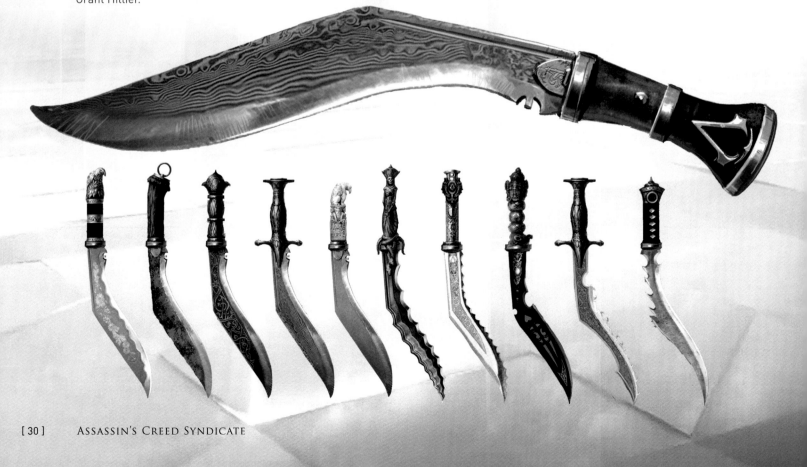

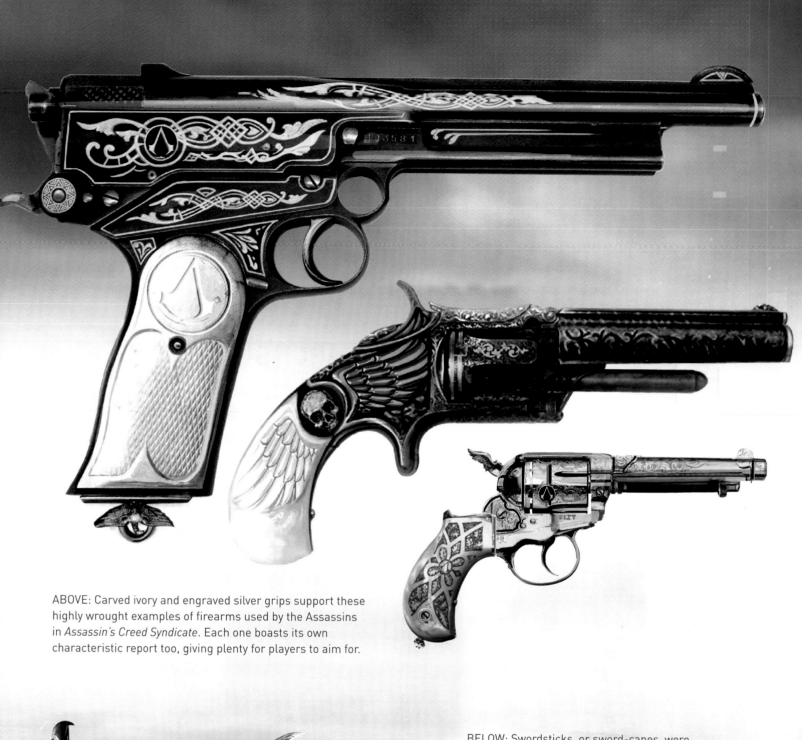

ABOVE: Carved ivory and engraved silver grips support these highly wrought examples of firearms used by the Assassins in *Assassin's Creed Syndicate*. Each one boasts its own characteristic report too, giving plenty for players to aim for.

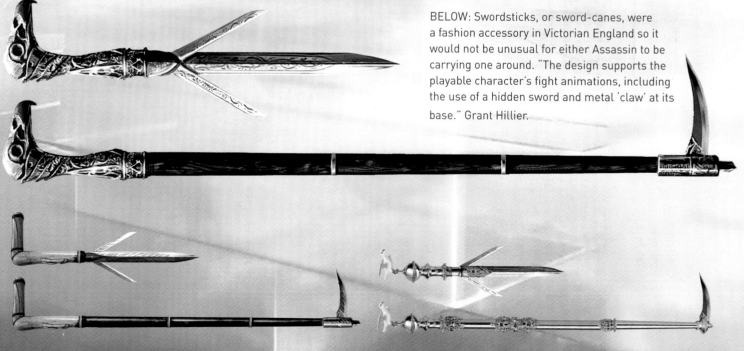

BELOW: Swordsticks, or sword-canes, were a fashion accessory in Victorian England so it would not be unusual for either Assassin to be carrying one around. "The design supports the playable character's fight animations, including the use of a hidden sword and metal 'claw' at its base." Grant Hillier.

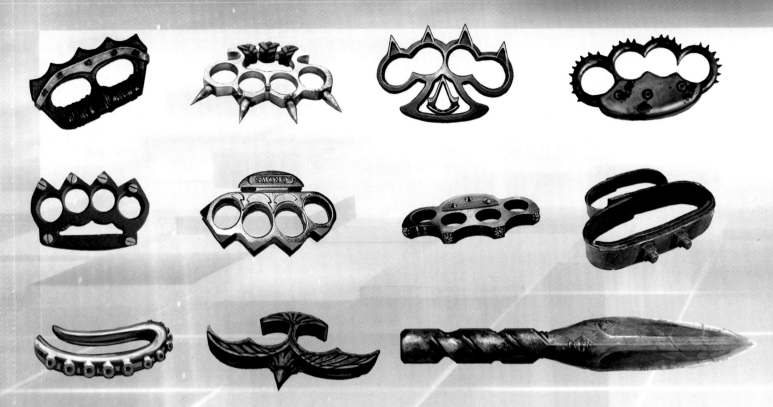

Even this collection of brass knuckles has a collectible quality to entice those players eager to acquire every last item in the game. For something with such a crude purpose they are exquisitely designed, though eye-watering upon using only a little imagination.

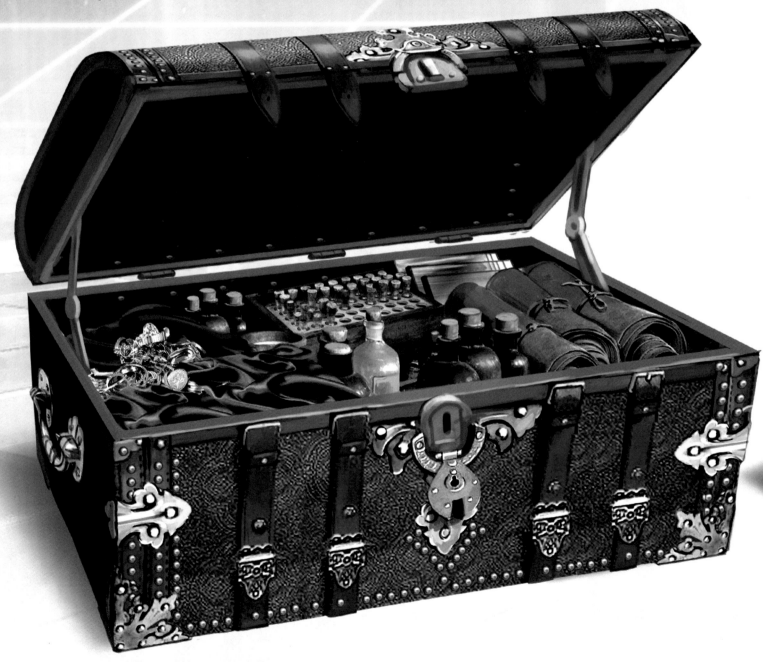

◼ EXPLOSIVES

DYNAMITE WAS PATENTED EXACTLY one year before the events of *Assassin's Creed Syndicate*. An entire crateful would be very hard to gain outside of construction companies, and so gleefully received by the likes of Jacob and Evie Frye for other means. Industrialization enabled the humble hand grenade to improve in design also, from wooden plugged tops to brass and iron housings. These are faithfully reproduced by Ubisoft artists to sit alongside Jacob's improvised efforts and some more mysterious devices.

ABOVE AND RIGHT: Jacob and Evie benefit from an evolution of the explosive strategies first employed by Ezio Auditore in *Assassin's Creed: Revelations*. This cache is considerably more potent however, and its usage more refined including the voltaic bomb (right), which uses electricity to stun and disable targets.

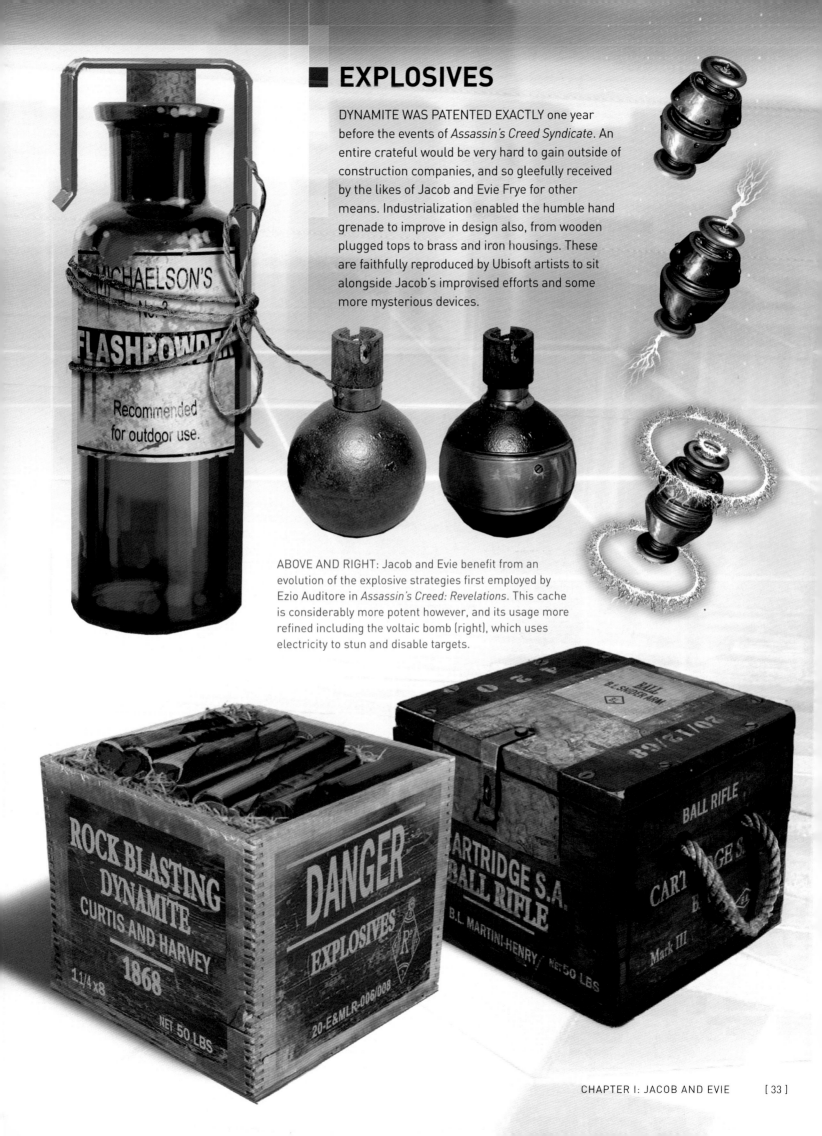

WESTMINSTER

WITH BIG BEN AND THE HOUSES OF PARLIAMENT, WESTMINSTER ABBEY AND BUCKINGHAM PALACE AMONG ITS LANDMARKS, THE CITY OF WESTMINSTER PROVIDED UBISOFT WITH BOTH A HUGE CHALLENGE AND GREAT CREATIVE OPPORTUNITY. WITH AN ASSASSIN'S FREE-RUNNING SKILLS ALLOWING FOR EXTREME DEGREES OF ACCESS, DEPICTIONS ARE REQUIRED TO SERVE MUCH MORE THAN A VIEW FROM AFAR.

It was with fondness for such locations that the Ubisoft team pondered scenarios within which Jacob and Evie could wreak havoc. "This illustration is an idea that came to me at the very start of pre production," begins concept artist Hugo Puzzuoli. "Jacob can shatter, using shoulders or feet, some old chimneys; the idea being to exploit the environment as something derelict to enable some fun interactions."

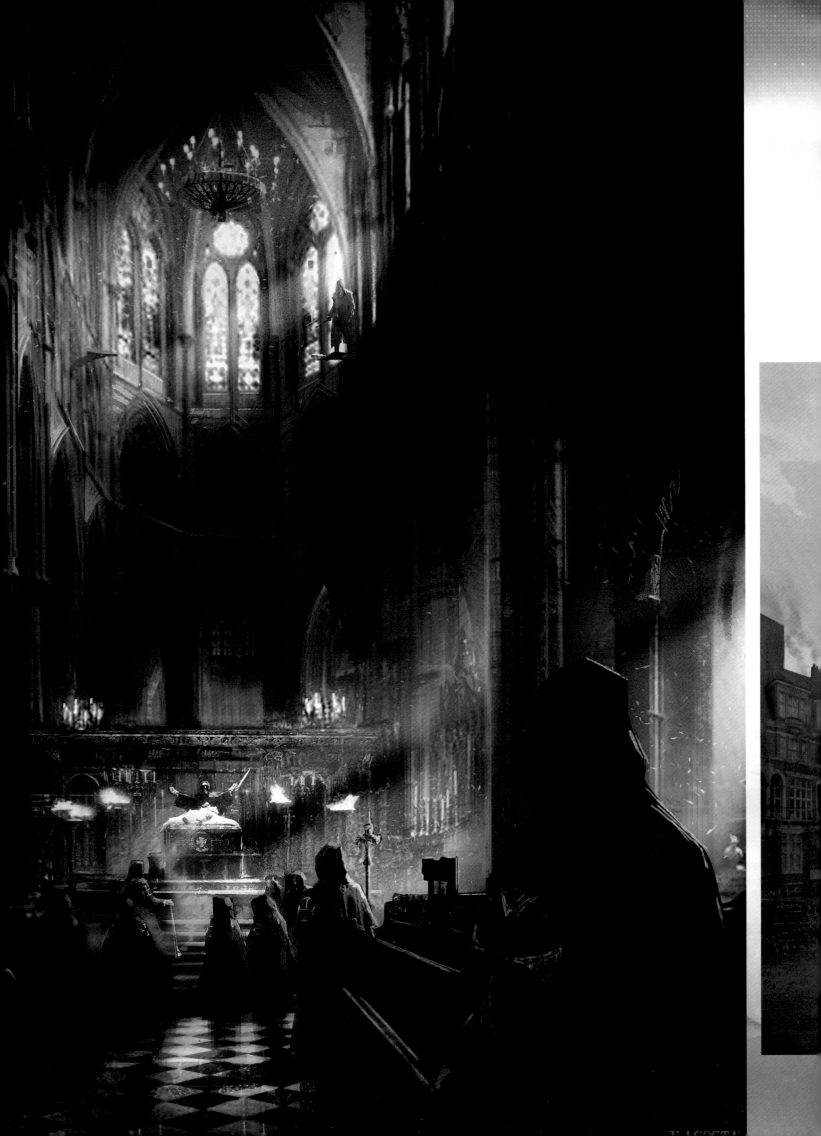

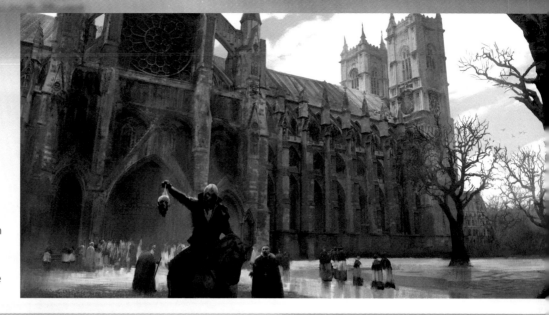

RIGHT: A rider allows his gory trophy one last look at the emerald green lawn beside Westminster Abbey. What a beautiful clear day on which to breathe your last.

"Westminster with its beautiful gothic architecture was a joy to render. I added round shapes like the clouds and trees in the park to add contrast. The saturated colors of sky and grass also serve to contrast with the white/grey colors of the cathedral." Hugo Puzzuoli.

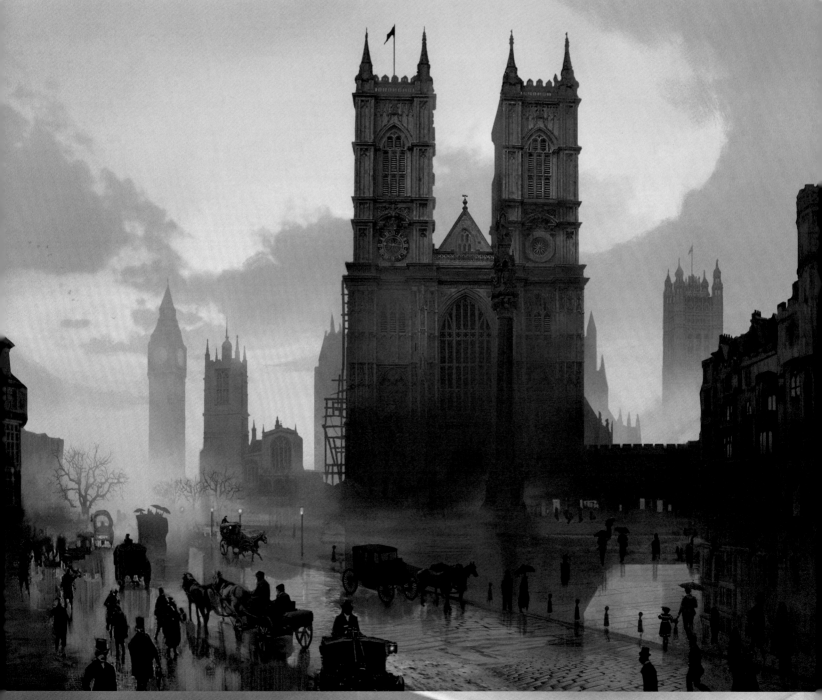

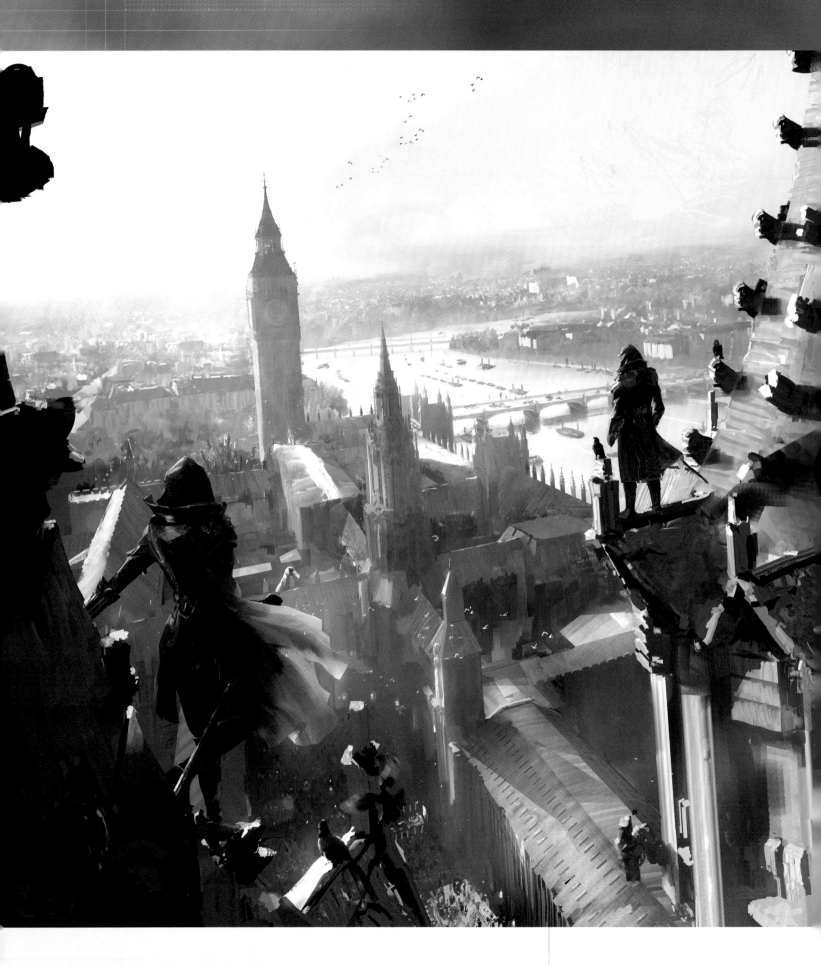

"The city of London is filled with five- to six-storey-high buildings and often very large streets," observes resident historian Jean-Vincent Roy. "This led to the creation of the Assassin's Gauntlet, which will completely change how players parkour across the city."

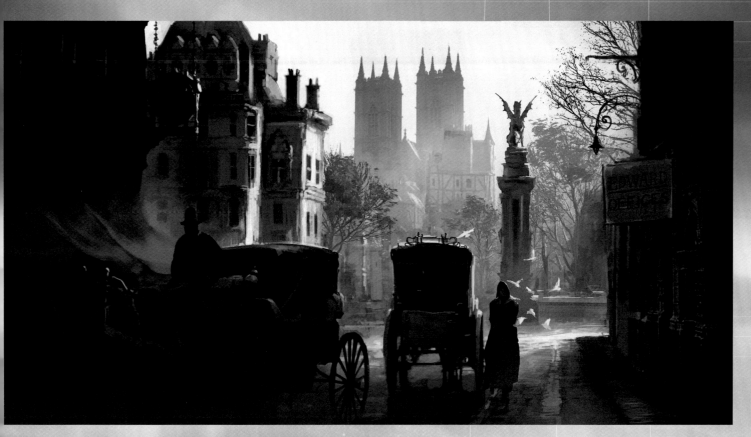

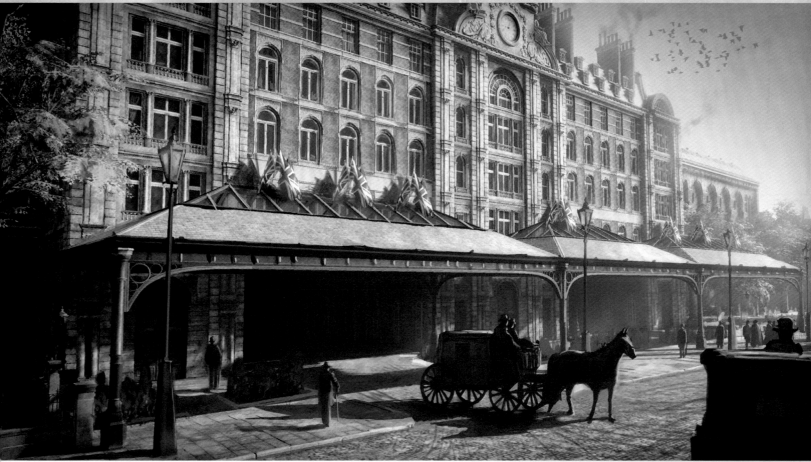

"Our project was in a better position, references-wise, than
any previous title simply because we had access to much more
data of much better quality. Our Art Director went to London,
our World Director went to London, as well as several other
members of the team."

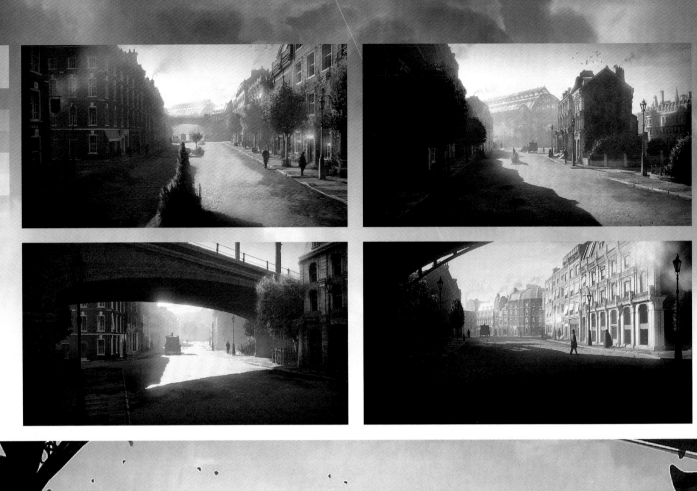

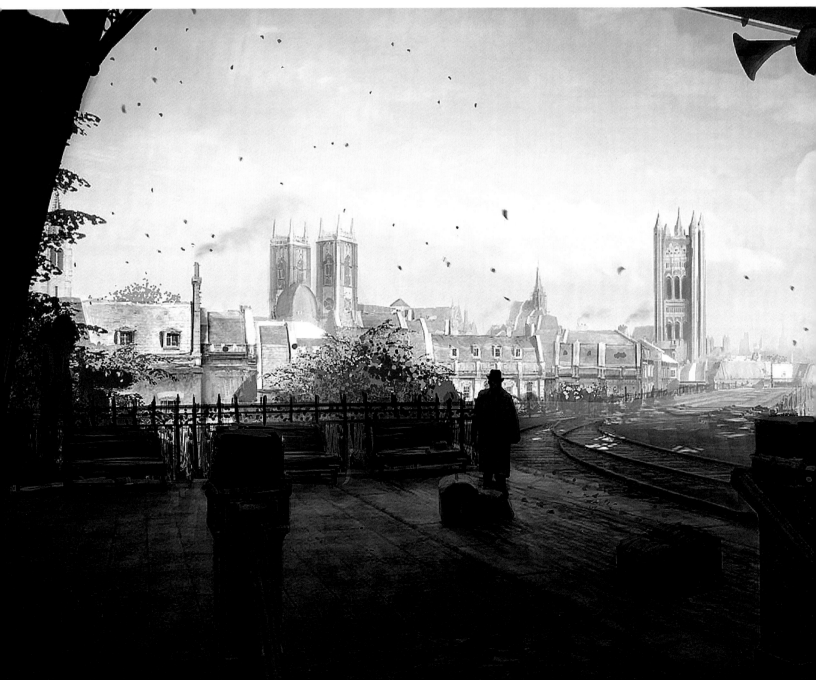

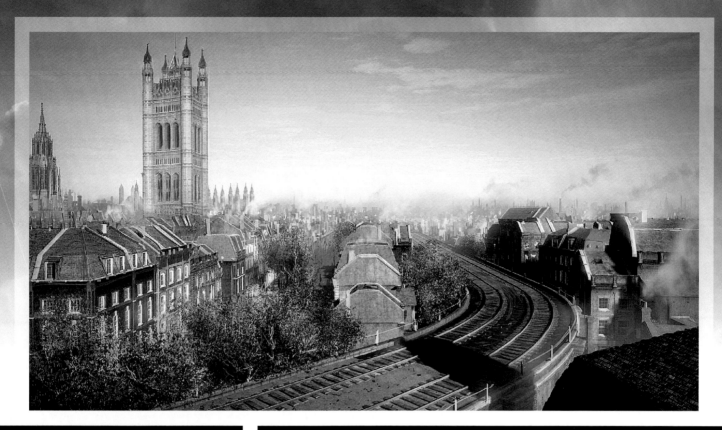

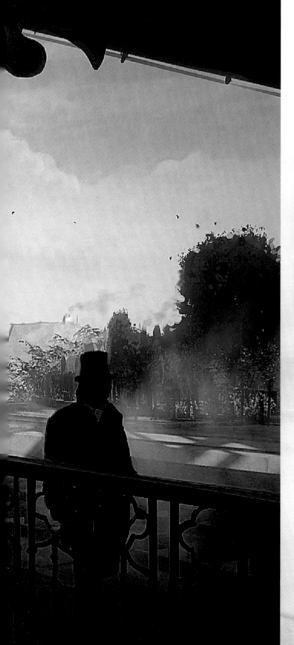

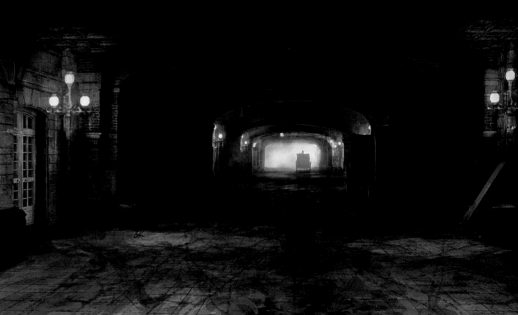

On these pages are views of the fledgling service that connected London and led to the building of Victoria Railway Bridge (aka Grosvenor Bridge) across the River Thames. The artists capture the still of the morning as early-bird commuters gather on the platform. Above right, the line carves through residential areas, and we see Westminster Cathedral as a constant reminder of the capital's history. It is a perfect snapshot of a period in time.

Gilles Beloeil created these images as a canvas for the team. "I've made this series of images to help the team to "dress" the city and make it livelier. A warm evening atmosphere and fall colors to contrast with the cold shadow zones. I've added passers-by, interesting silhouettes in the background, smoke and depth. Adding vegetation also brought life, as well as movement in the leaves, birds and the smoke."

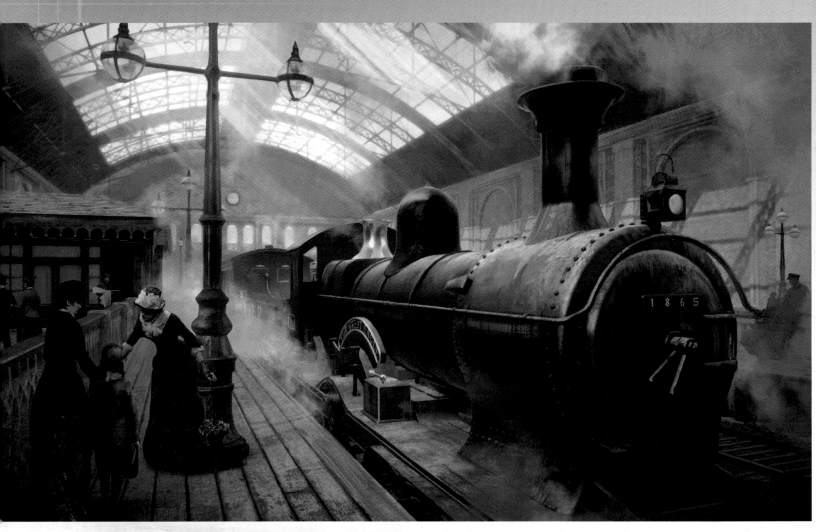

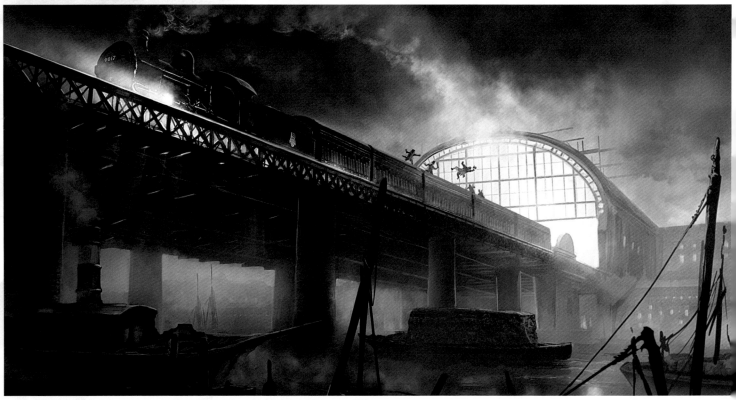

The advent of steam-powered transportation was so thrilling, though Londoners may have played down the excitement if their lot was a daily commute. Ubisoft concept artists experimented with lighting and particles to bring an unprecedented level of atmosphere to the gaming stage. The great engines seem alive with billowing smoke filling the rafters. Above we see Grosvenor Bridge by night, Caroline Soucy presenting a stiff challenge to the technical team to harness this all as an interactive experience.

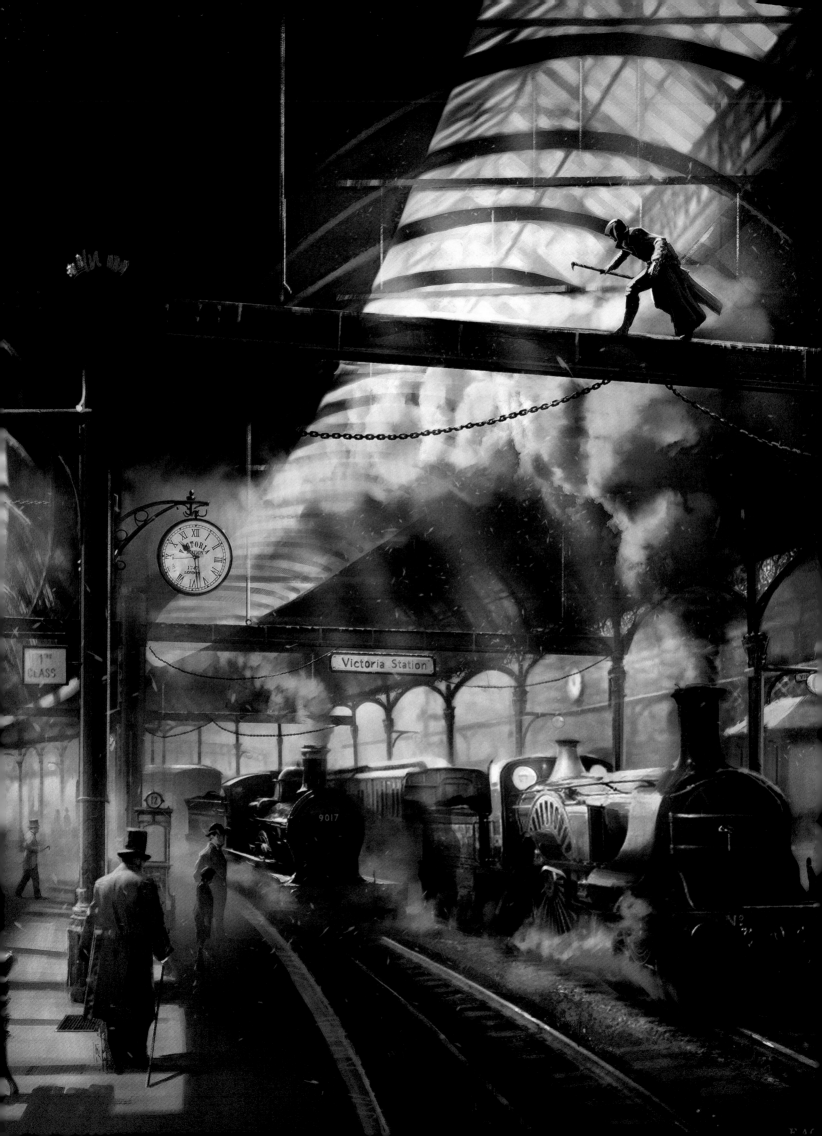

BIG BEN

THE WORKINGS OF THE famously reliable clock are
wonderfully exaggerated to serve as an imposing stage
for one of the Assassin's confrontations. Radiance
filtering through the clock face is entirely true-to-
life, however, casting shadows while highlighting the
combatants – the light playing tricks. Big Ben, the great
bell itself, is faithfully reproduced with little imagination
needed to achieve an enchanting chamber within which
to conduct secret meetings with a close eye on time.

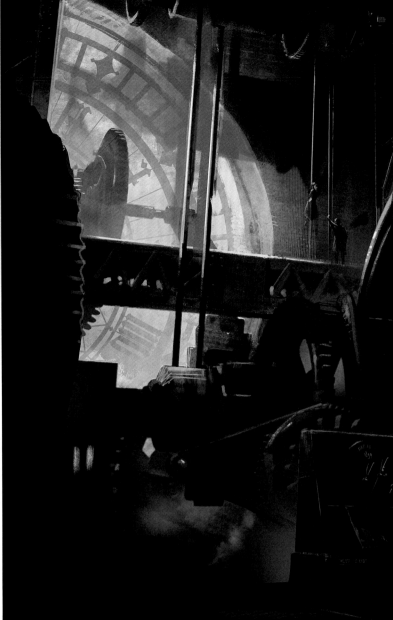

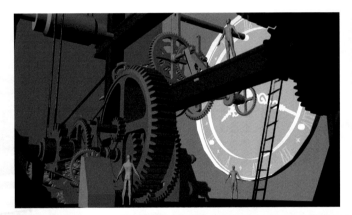

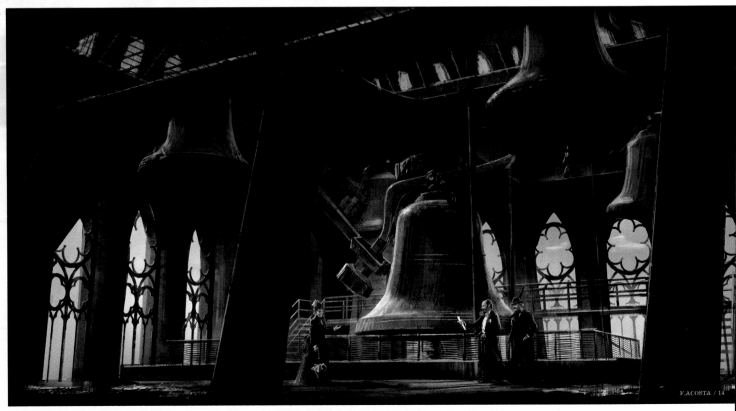

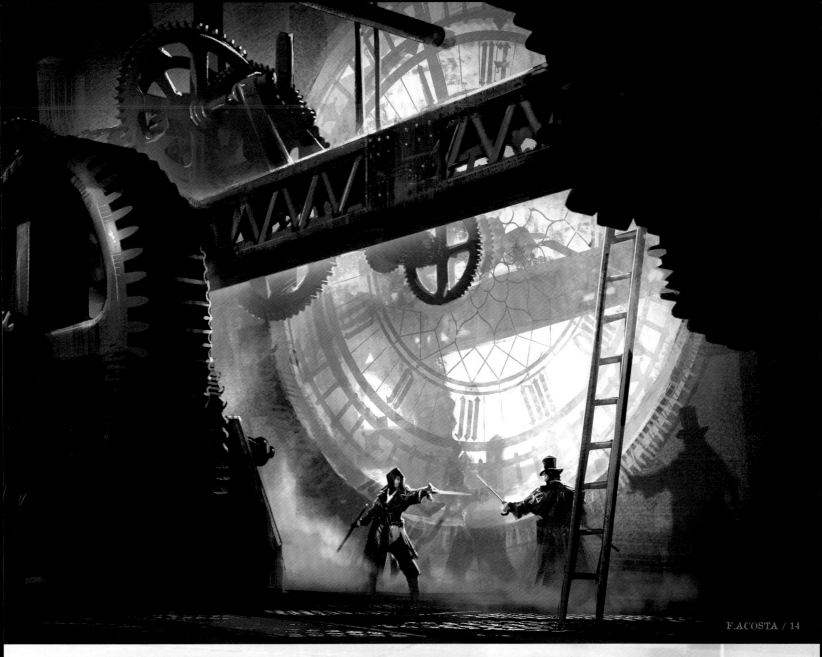

F.ACOSTA / 14

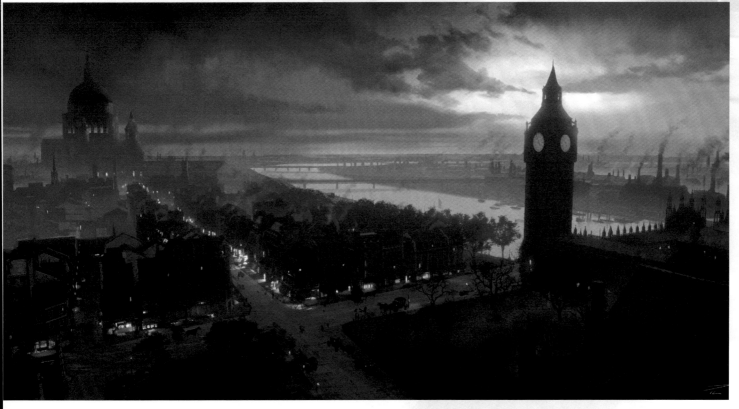

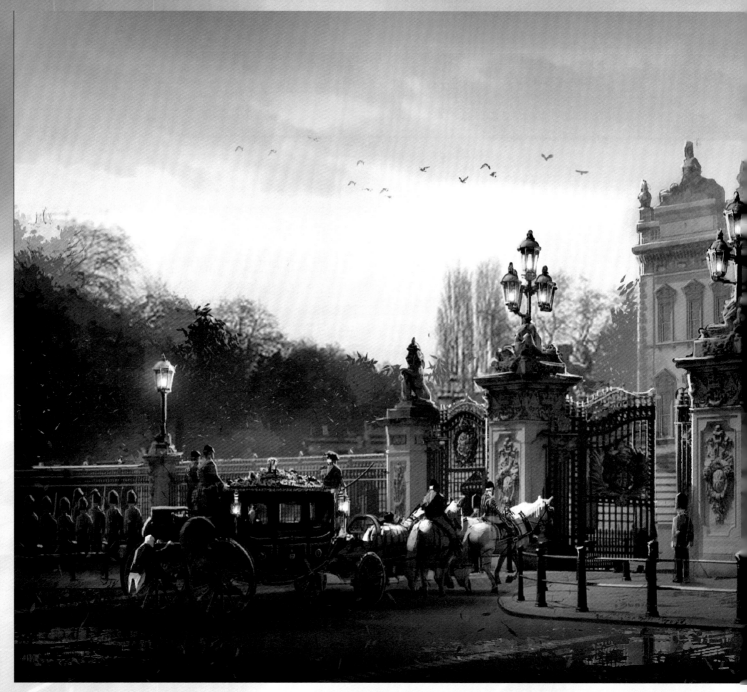

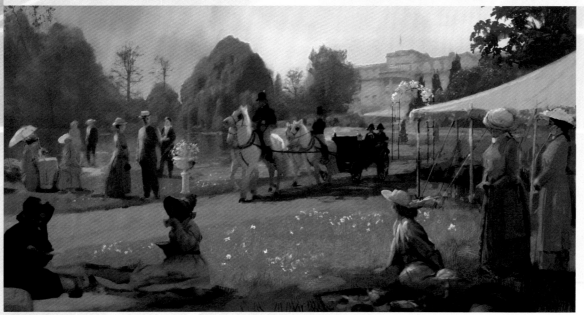

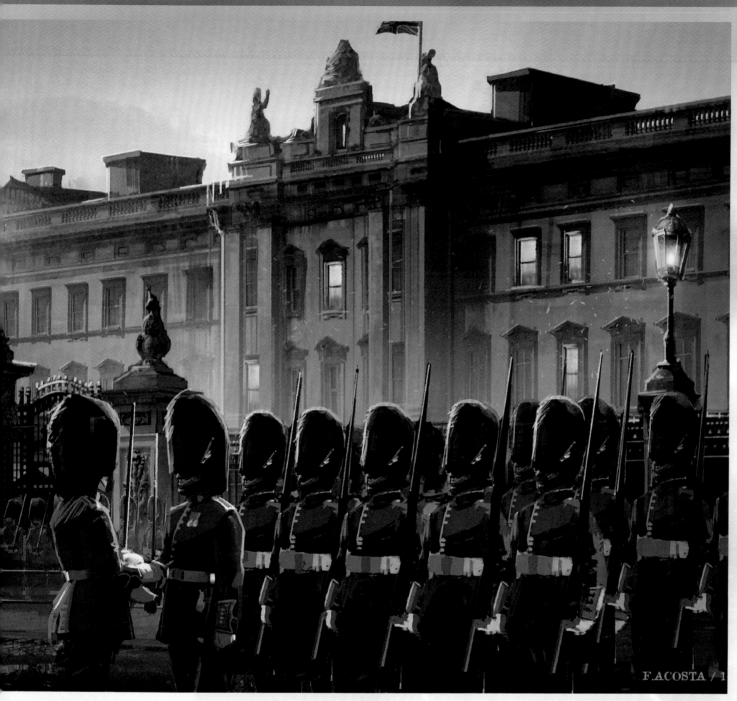

F.ACOSTA / 1

BUCKINGHAM PALACE

"WE WANTED TO GET a feel for the city," says Jean-Vincent Roy of the research necessary to bring Victorian London to life: "How streets roll and unwind, how natural light affects ambience through the day, how the River Thames acts as an artery, pulsing through the city, and how it feels to walk the streets, only to find yourself unknowingly face to face with such famous landmarks. We visited as much as we could; walking with guides across London taking thousands of pictures."

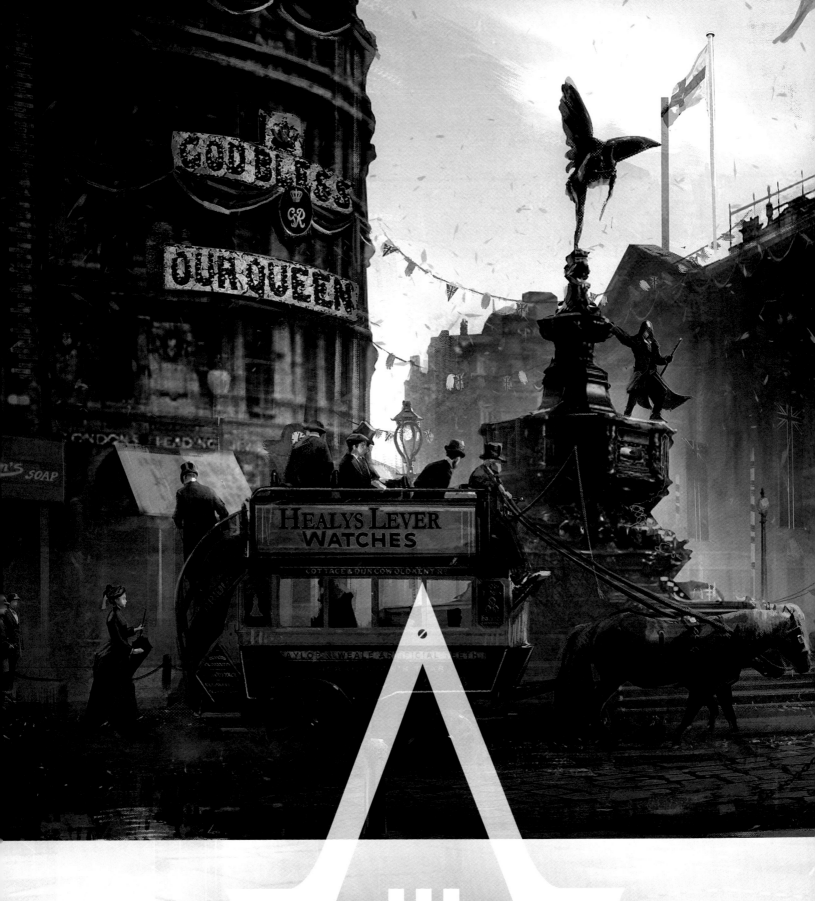

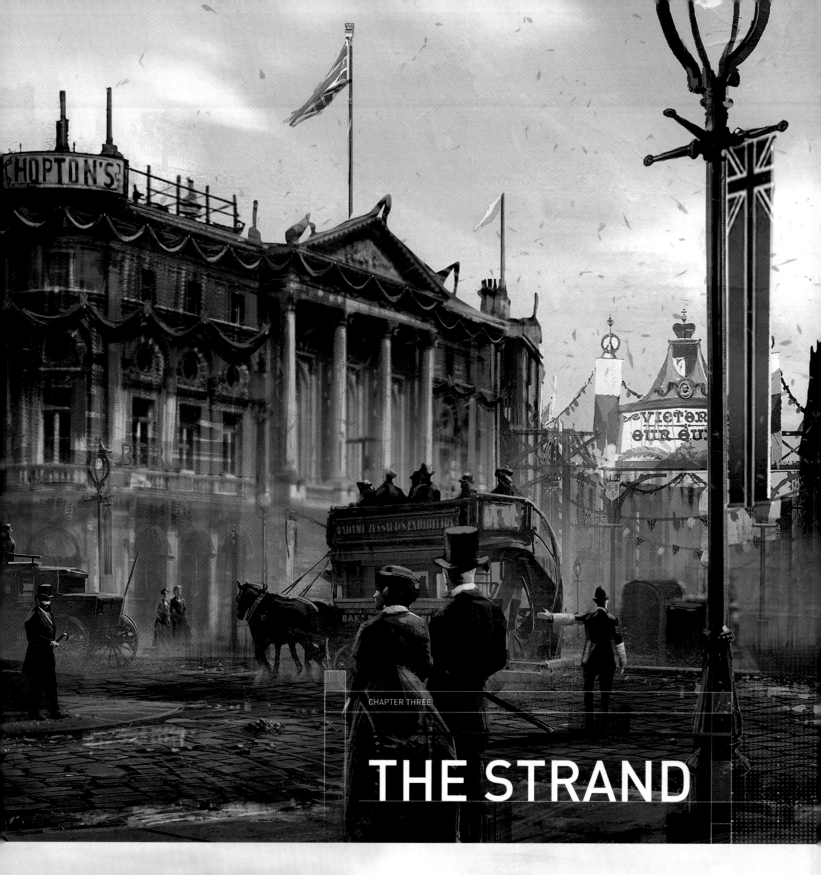

THE STRAND

JACOB ASSUMES A DRAMATIC POSE OVERLOOKING PICCADILLY CIRCUS AND THE APPROACH TO THEATRELAND. THE AREA IS BEDECKED WITH BANNERS, DRAPERY AND FLAGS IN HONOR OF THE POPULAR QUEEN VICTORIA. TWO OF THE FAMOUS MONUMENTS SEEN HERE WERE NOT IN FACT ERECTED UNTIL THE 1890S BUT WHAT WOULD THIS PART OF TOWN BE WITHOUT ITS TROCADERO AND 'EROS' MEMORIAL STATUE?

Well-to-do Victorians descended upon The Strand for their entertainment needs as the men's top hats and tails and ladies' bustles illustrate in this main concept. They are bystanders to Jacob and Evie Frye's exploits, which sometimes include commandeering a passing carriage. Everyday life, though often larger-than-life in the capital, poised for sudden disruption is our Assassin's specialty.

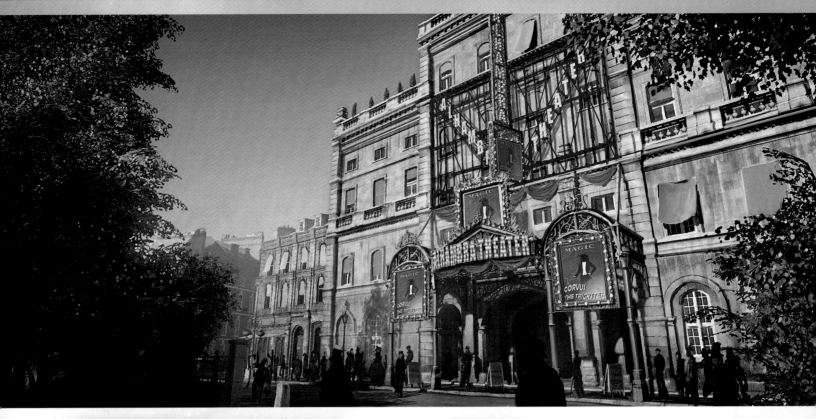

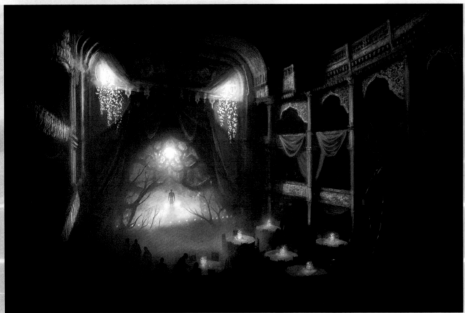

ALHAMBRA THEATRE

AWAY FROM THE STAGE the darkness consumes the audience so that mystery figures can observe unseen from the catwalks and gantries. While performers rehearse, we see the inner workings of the stage apparatus laid bare. Concept artist Gilles Beloeil talks about creating the theater. "We had to give to the Alhambra theater a significant style. We wanted its host's personality to be visible in the décor, the lighting and the accessories. The red amplifies the diabolic nature of the character and the lighting reinforces the disturbing side of the place. The décor on the scene seems straight out of a nightmare, emphasized by the foliage's symmetry. As for the exterior, we needed to keep this savor while adding structure so that the façade was distinctive."

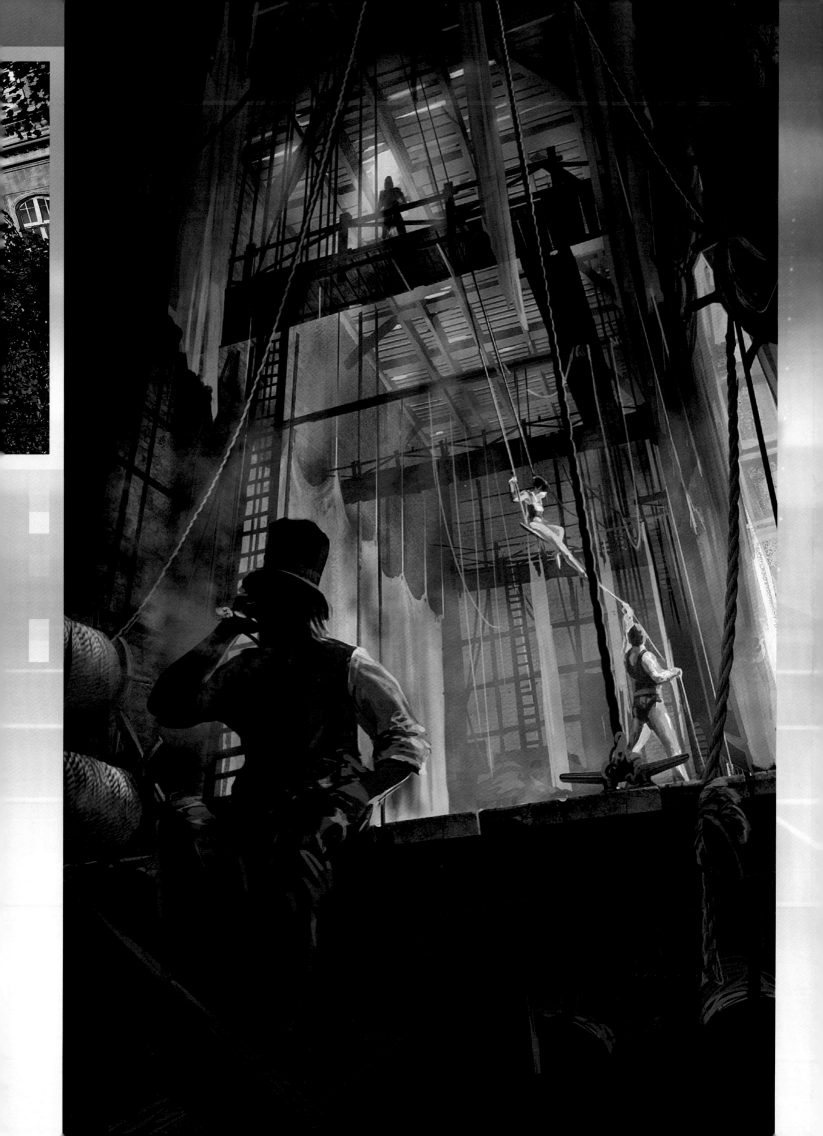

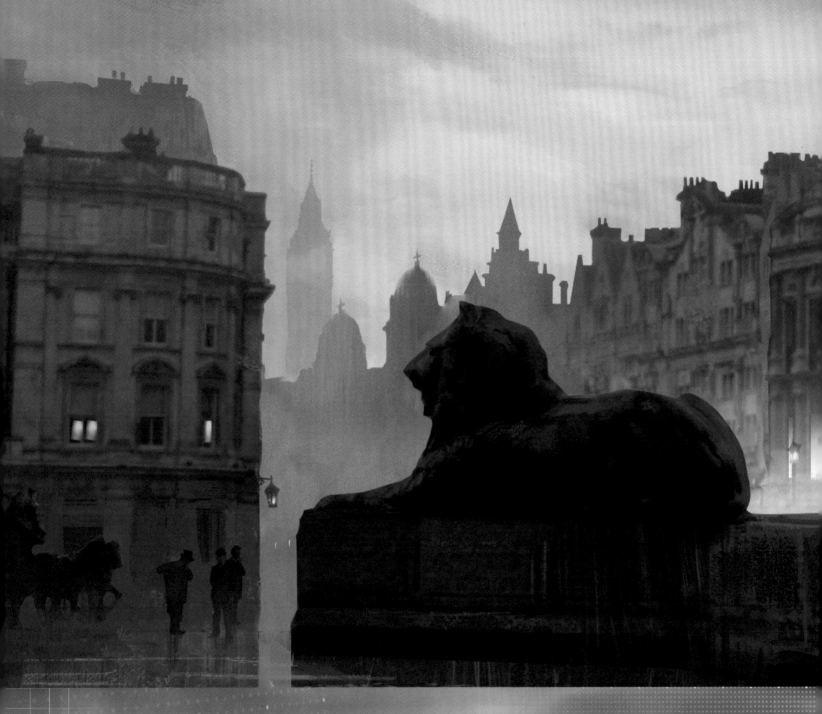

TRAFALGAR SQUARE

HEAVY ON SYMBOLOGY, WE find Jacob here flanked by two of Sir Edward Landseer's iconic lions. They are, all three of them, powerful hunters. The scene is all the more brooding owing to the time of day chosen combined with atmospheric effects, which in all scenes were greatly considered by the Ubisoft designers. There is also the perennial *Assassin's Creed* thrill of stepping into a place in time where old historic monuments were still quite new. The last of the four bronze lions had been set in their positions less than a year before events in *Assassin's Creed: Syndicate*. All around Jacob and Evie, as they pursue their social justice goals, the city itself is evolving to become the capital that we know today.

A fight club adopts this rooftop location, with Jacob assessing the performance. Hugo Puzzuoli: "The thick fog and the grey-blue sky charged with humidity are great tools to create depth easily. This is also, and above all, what everyone is expecting from London!"

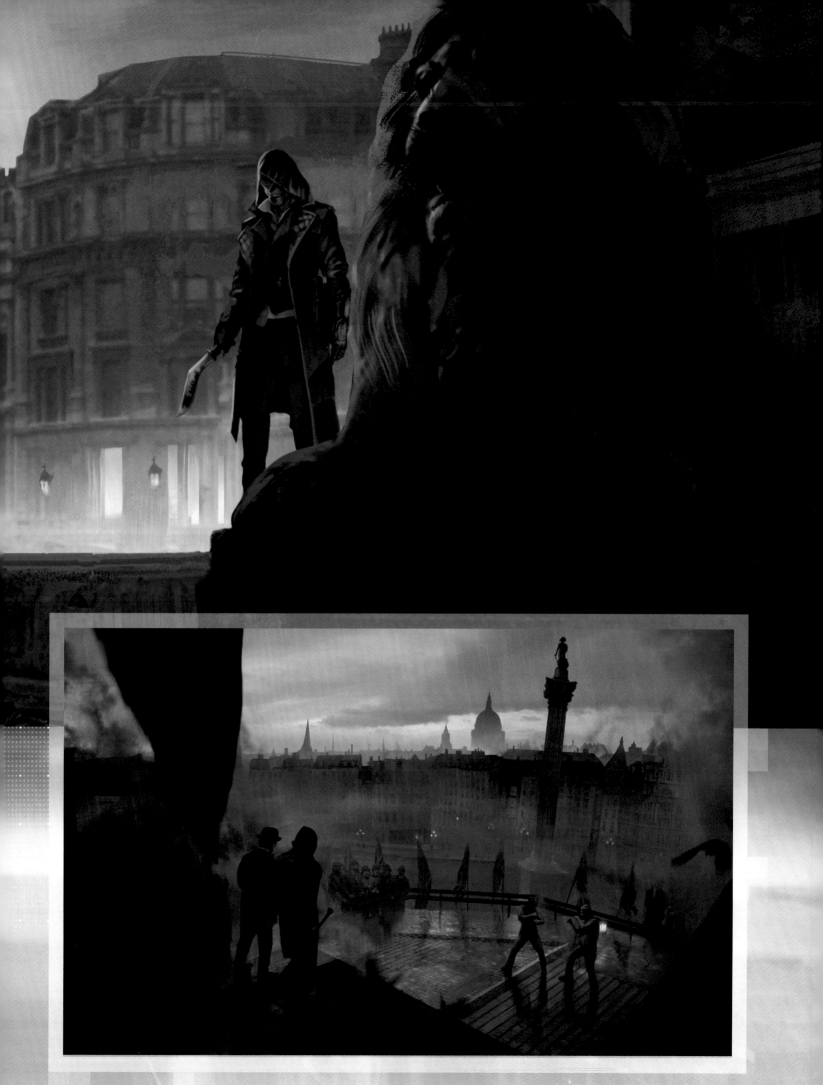

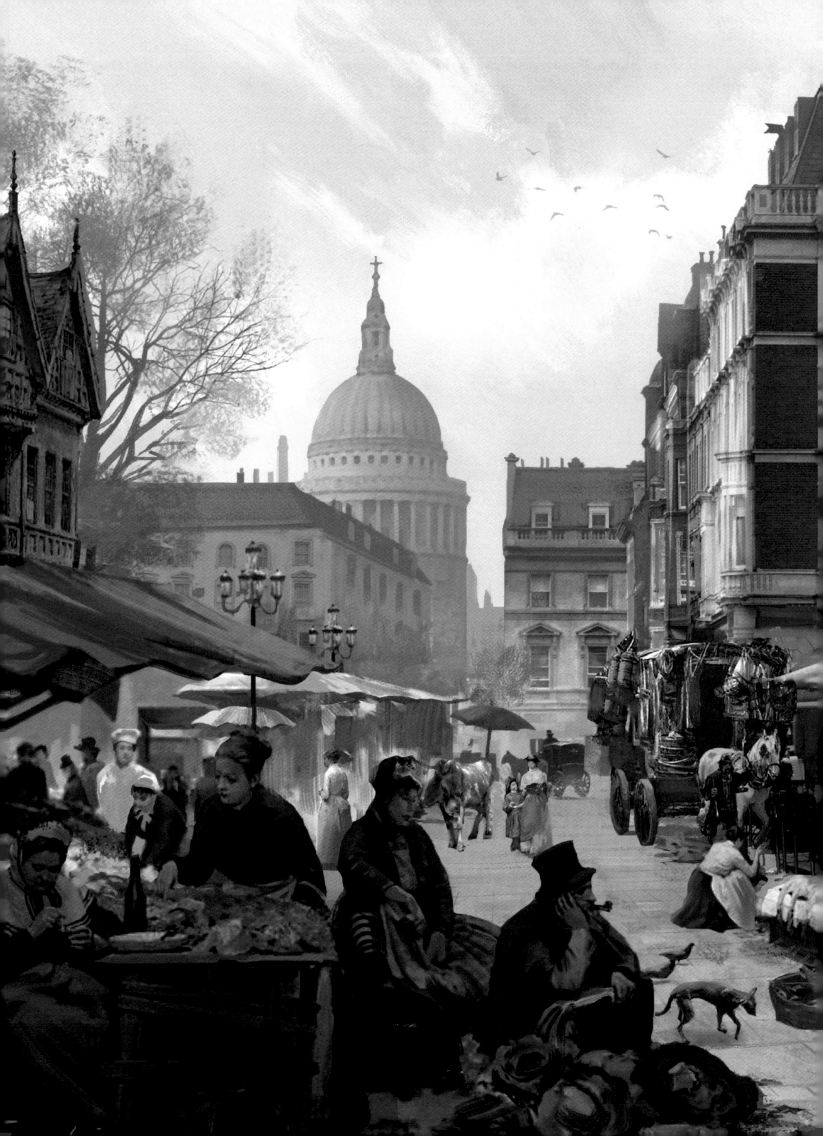

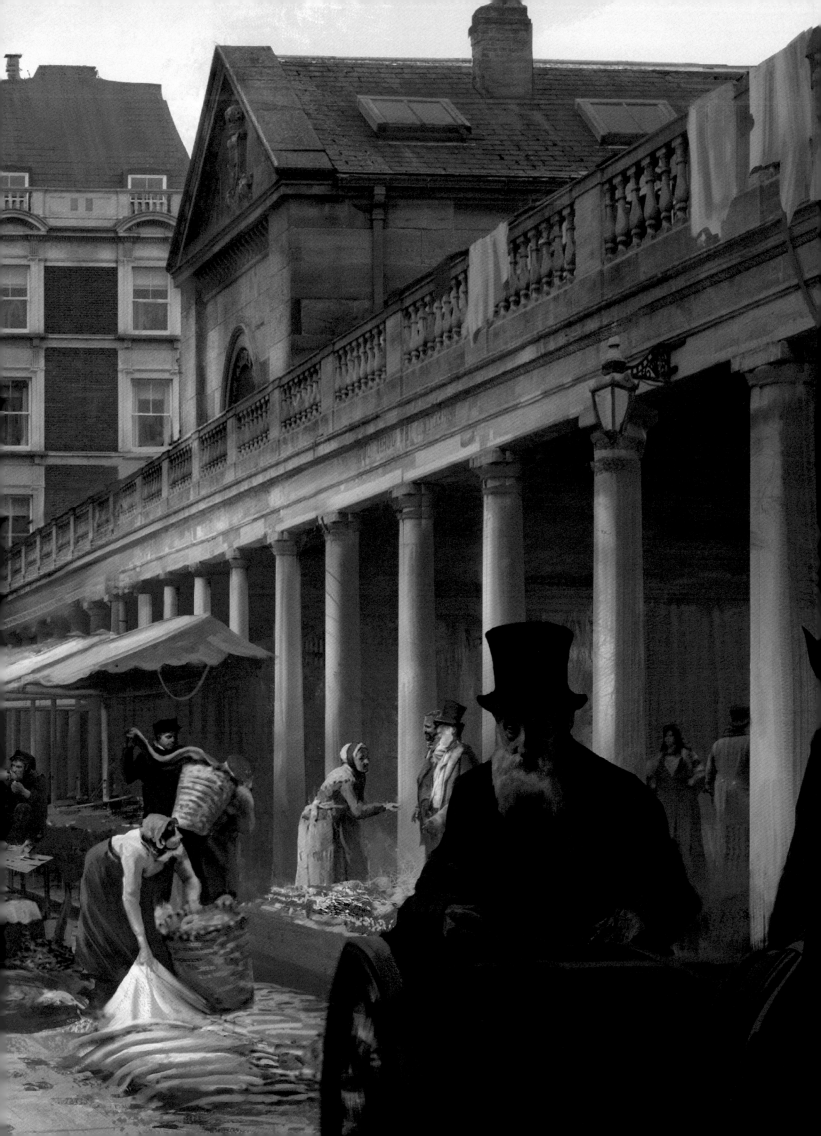

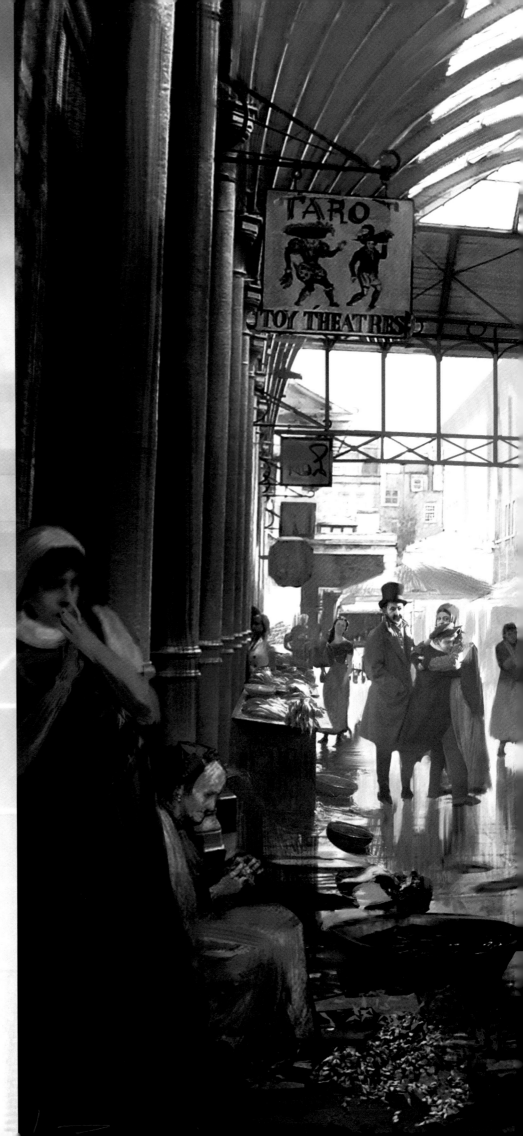

COVENT GARDEN

SHOCKED ONLOOKERS ARE FROZEN to the spot as a smartly-dressed killer wipes gore from his blade. The backdrop of architect Charles Fowler's neo-classical market building and the gentlefolk that frequent its stalls make the occasion all the more ghastly. Contrasting elements are employed by Ubisoft's concept artists to show how the thin veneer of polite society can be so quickly shattered by struggles that have been suppressed. Explosive events such as these form the main beats of Jacob and Evie's story, refreshing their urge – and in turn player determination – to seek justice. It is a thrill ride like no other.

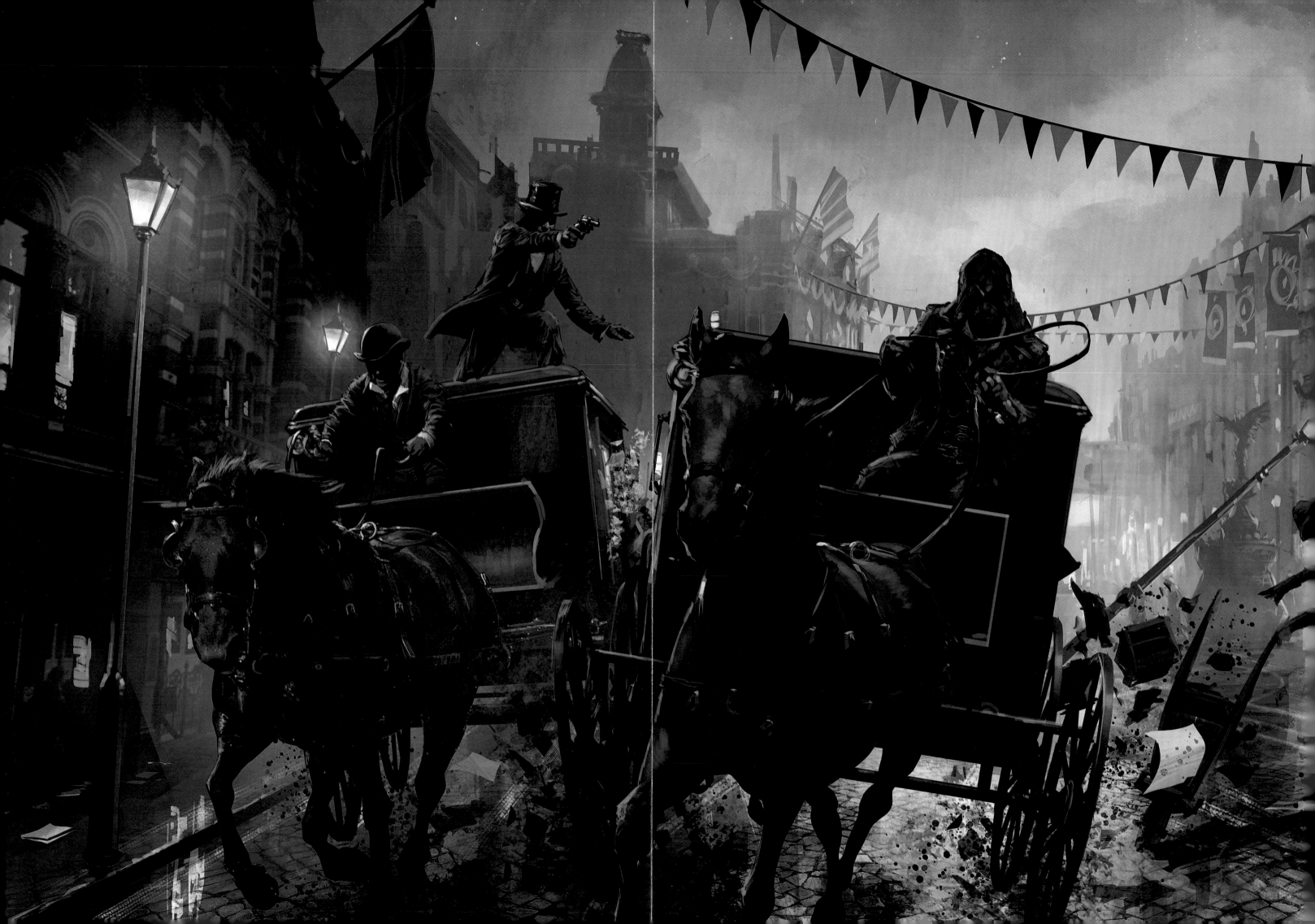

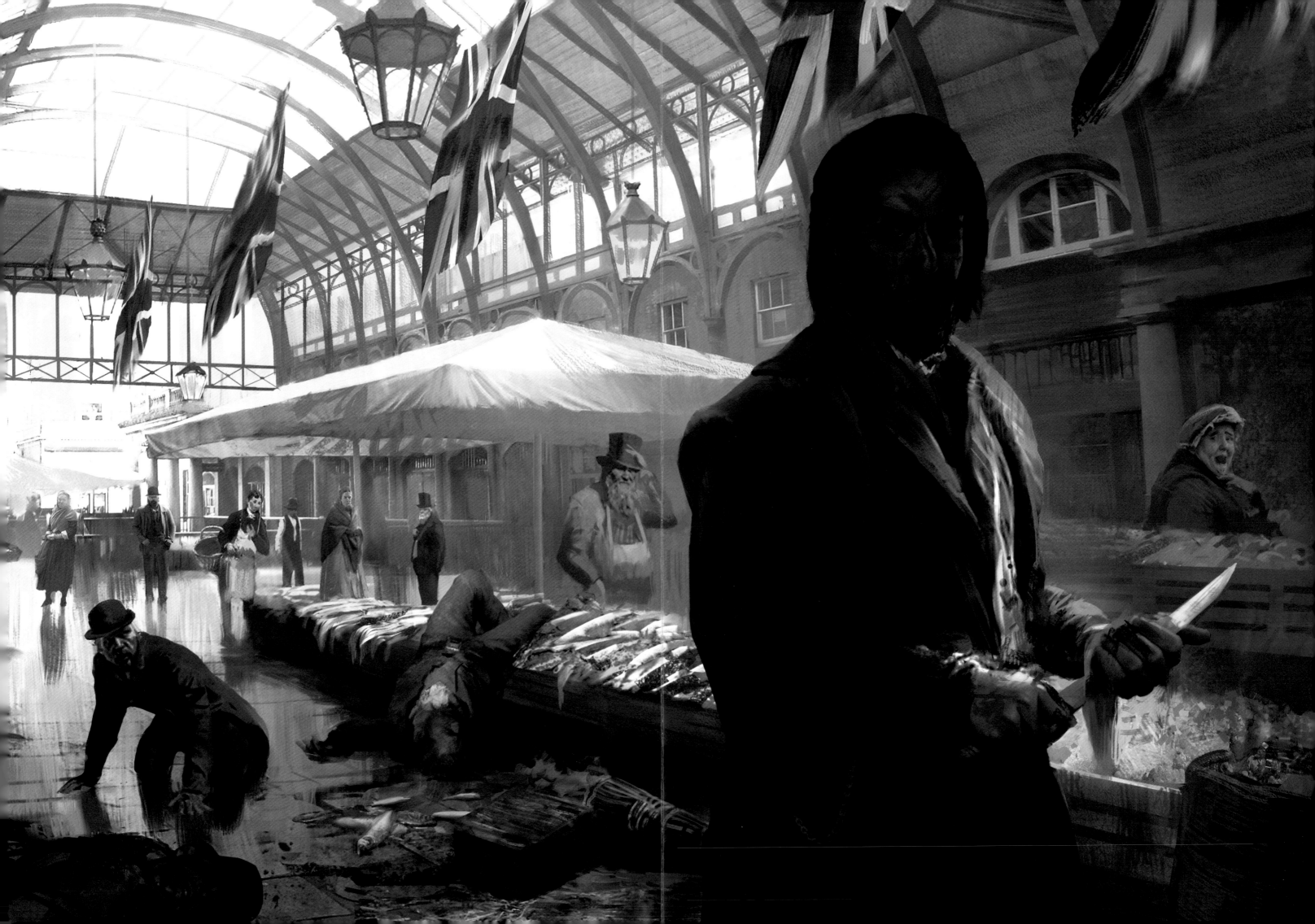

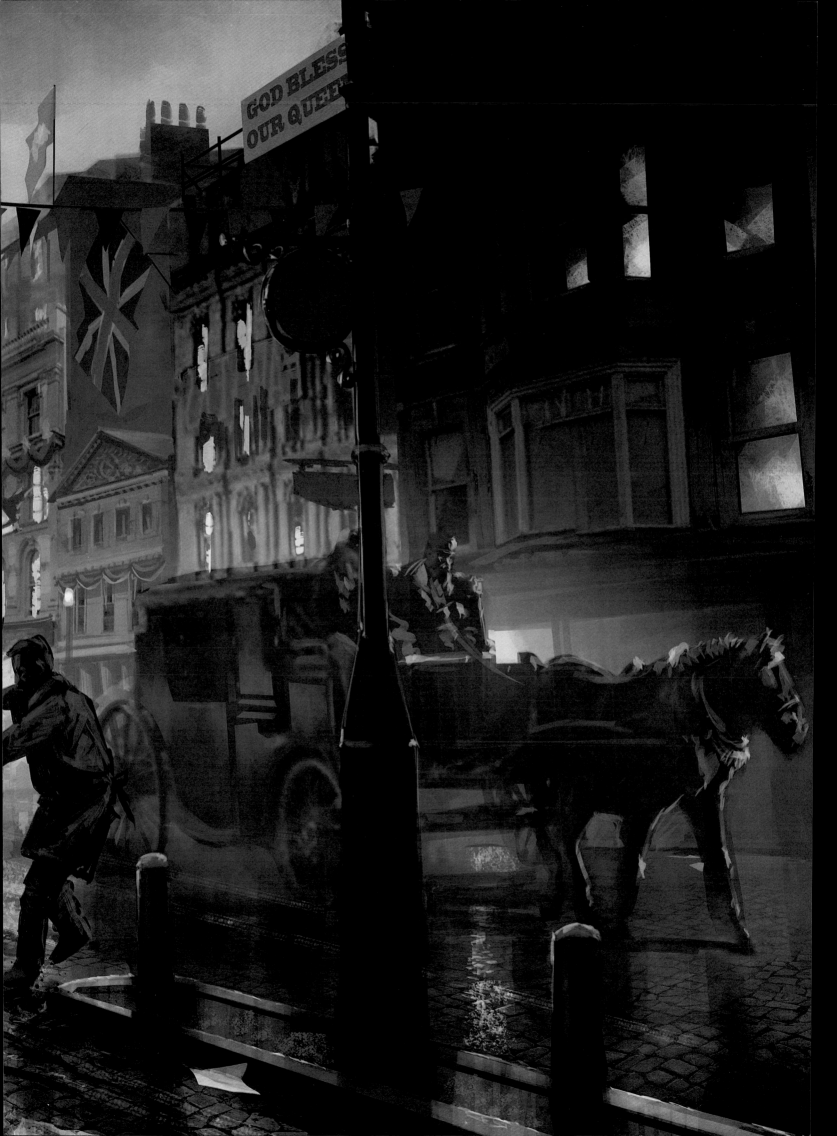

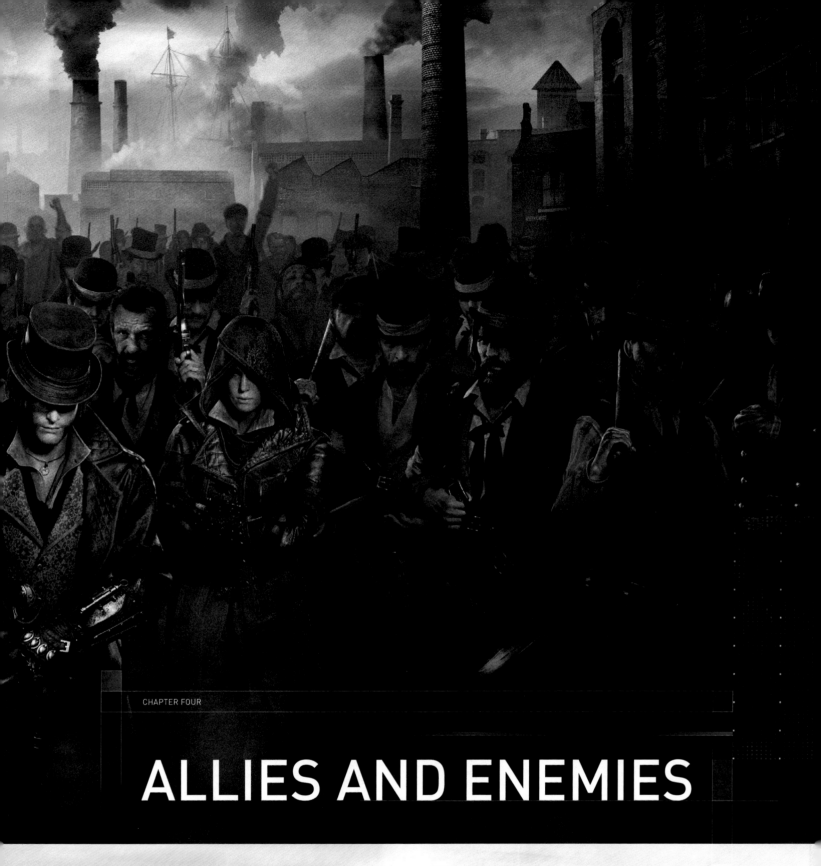

ALLIES AND ENEMIES

ASSASSIN'S CREED SYNDICATE IS THE STORY OF AN UPRISING, IN WHICH THE LOWER CLASS UNITE TO PROTEST THEIR FAIR SHARE OF LONDON'S RAPIDLY INCREASING SPOILS. THEIR CAUSE IS TAKEN UP BY OUR HEROES JACOB AND EVIE FRYE IN THE PURSUIT OF MORE CLANDESTINE GOALS. THIS RAGTAG ARMY PRESENTED UBISOFT WITH THE CHALLENGE OF TRANSFORMING REGULAR FOLK INTO WARRIORS.

"A challenge that we had to work around was that most of our gang members are civilians," says art director Thierry Dansereau. "They are an angry mob that ended up as criminals. For some people, it was their only option, should they want to survive in this harsh social system. So we had to make sure they stood out from the crowd, as the player needs to be able to identify who is a threat and who is an ally."

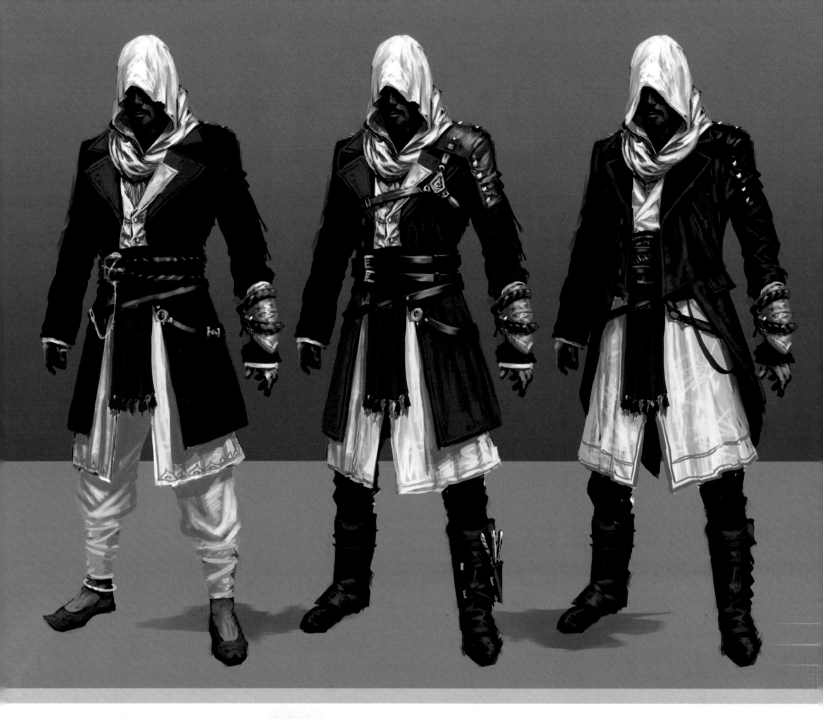

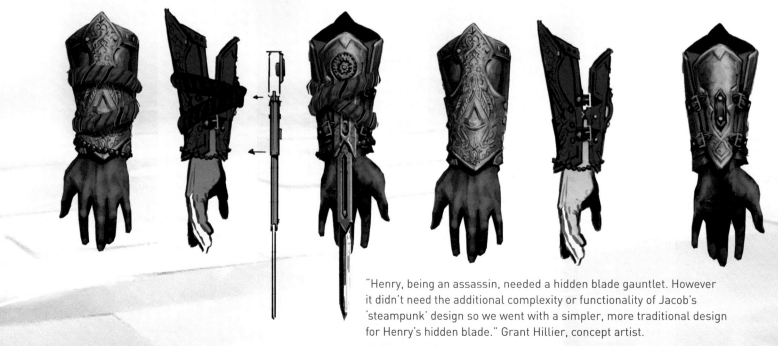

"Henry, being an assassin, needed a hidden blade gauntlet. However it didn't need the additional complexity or functionality of Jacob's 'steampunk' design so we went with a simpler, more traditional design for Henry's hidden blade." Grant Hillier, concept artist.

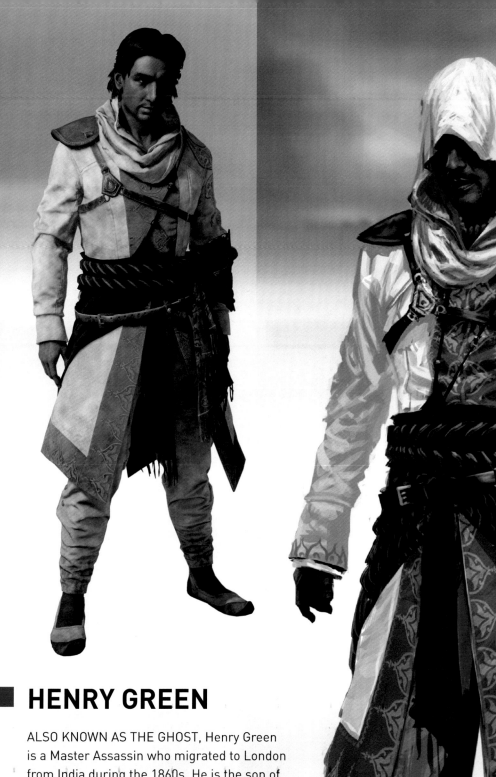

HENRY GREEN

ALSO KNOWN AS THE GHOST, Henry Green is a Master Assassin who migrated to London from India during the 1860s. He is the son of Arbaaz Mir, the Assassin featured in *Brahman* and *Chronicles*. As a member of the British Brotherhood, Green helps newcomers Jacob and Evie to establish their street gang, the Rooks, and from this point onward serves as a patient advisor. Green's character is drawn from the era of the British Raj, when the British Crown ruled over the Indian subcontinent between 1858 and 1947. On Green's appearance, Hillier says, "Initially we explored some designs where Henry wore a Victorian English jacket over his Indian costume to 'blend in' with London's crowd life (top left sketches). Ultimately we decided to use a design that more clearly depicted his cultural origins."

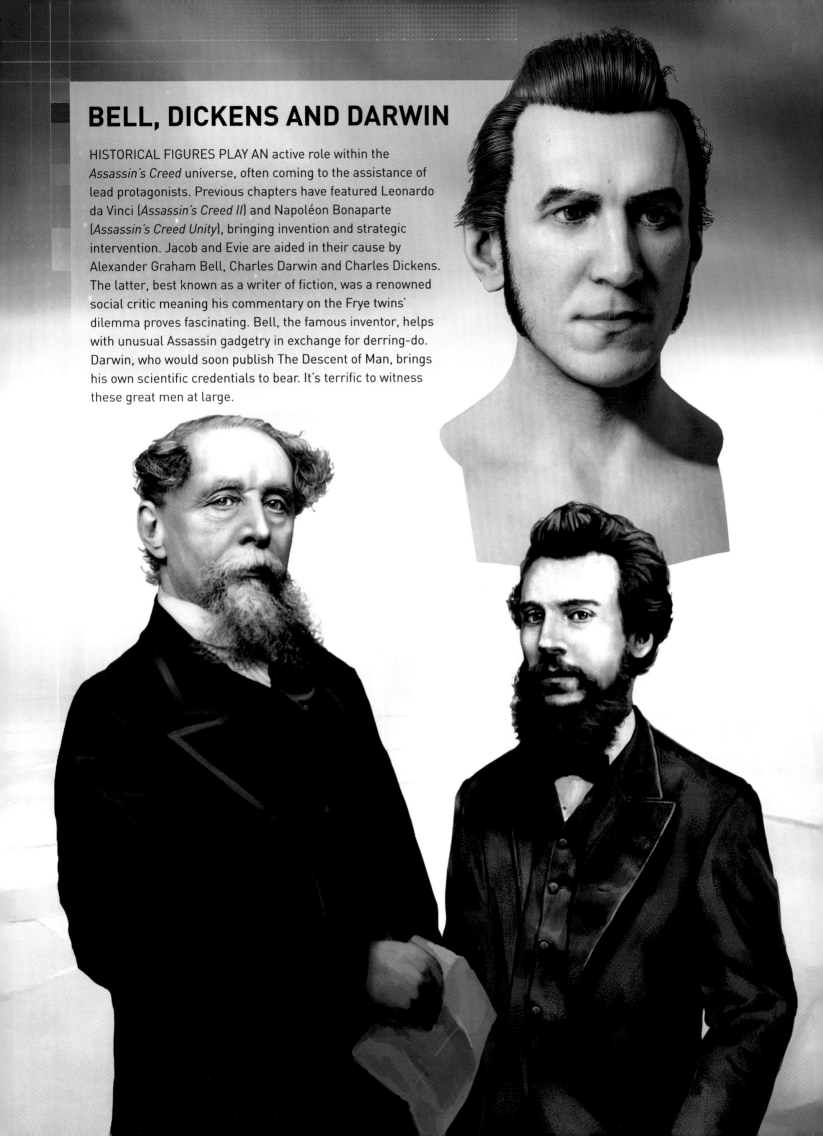

BELL, DICKENS AND DARWIN

HISTORICAL FIGURES PLAY AN active role within the *Assassin's Creed* universe, often coming to the assistance of lead protagonists. Previous chapters have featured Leonardo da Vinci (*Assassin's Creed II*) and Napoléon Bonaparte (*Assassin's Creed Unity*), bringing invention and strategic intervention. Jacob and Evie are aided in their cause by Alexander Graham Bell, Charles Darwin and Charles Dickens. The latter, best known as a writer of fiction, was a renowned social critic meaning his commentary on the Frye twins' dilemma proves fascinating. Bell, the famous inventor, helps with unusual Assassin gadgetry in exchange for derring-do. Darwin, who would soon publish The Descent of Man, brings his own scientific credentials to bear. It's terrific to witness these great men at large.

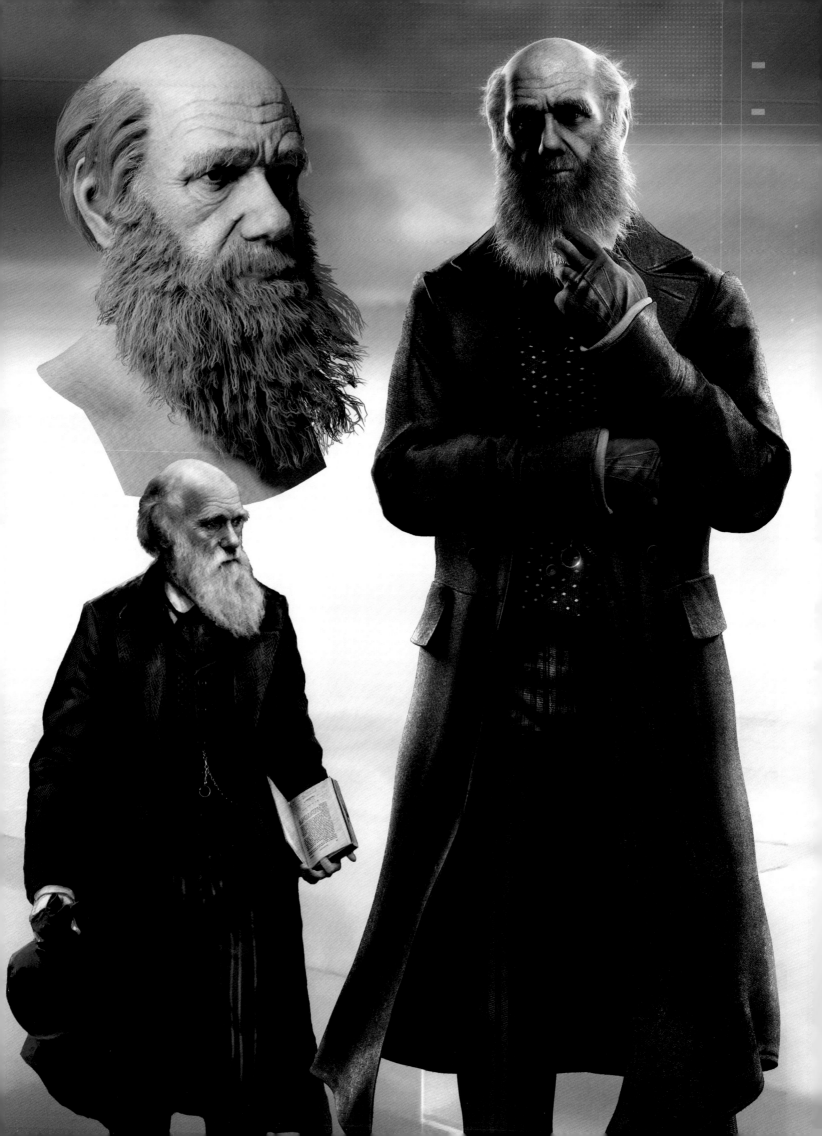

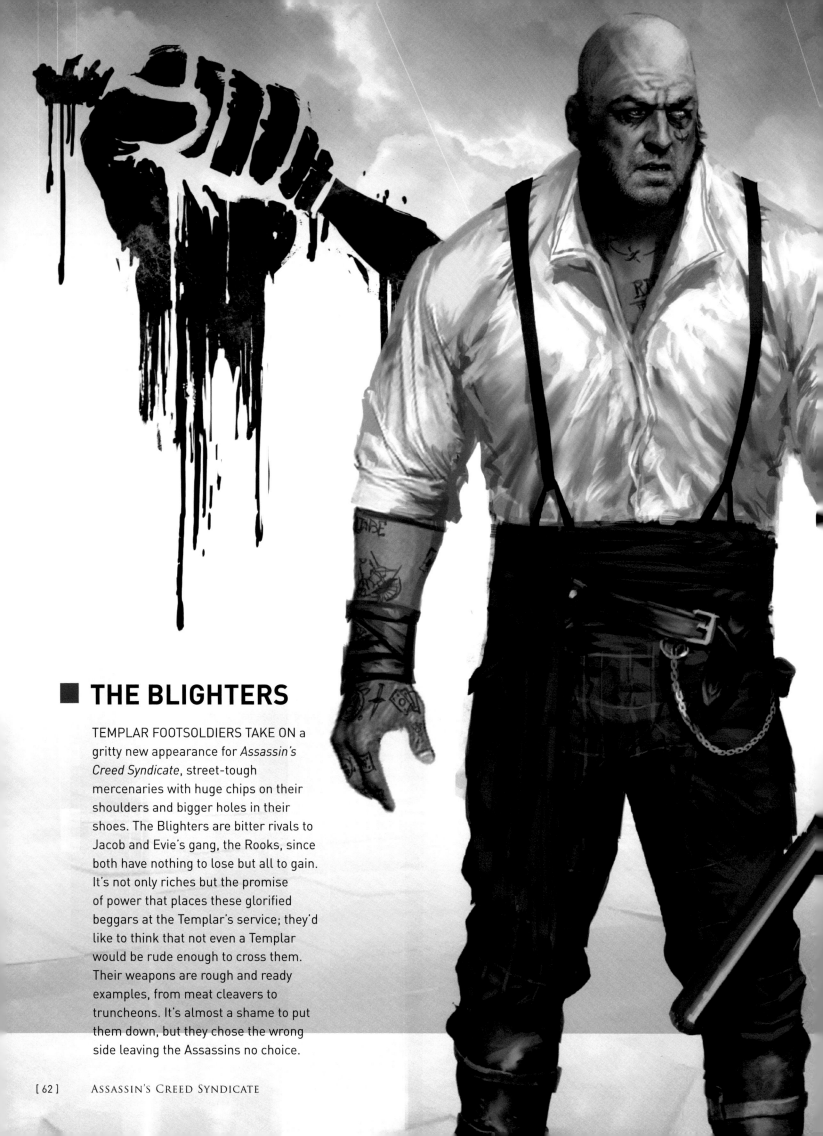

■ THE BLIGHTERS

TEMPLAR FOOTSOLDIERS TAKE ON a
gritty new appearance for *Assassin's
Creed Syndicate*, street-tough
mercenaries with huge chips on their
shoulders and bigger holes in their
shoes. The Blighters are bitter rivals to
Jacob and Evie's gang, the Rooks, since
both have nothing to lose but all to gain.
It's not only riches but the promise
of power that places these glorified
beggars at the Templar's service; they'd
like to think that not even a Templar
would be rude enough to cross them.
Their weapons are rough and ready
examples, from meat cleavers to
truncheons. It's almost a shame to put
them down, but they chose the wrong
side leaving the Assassins no choice.

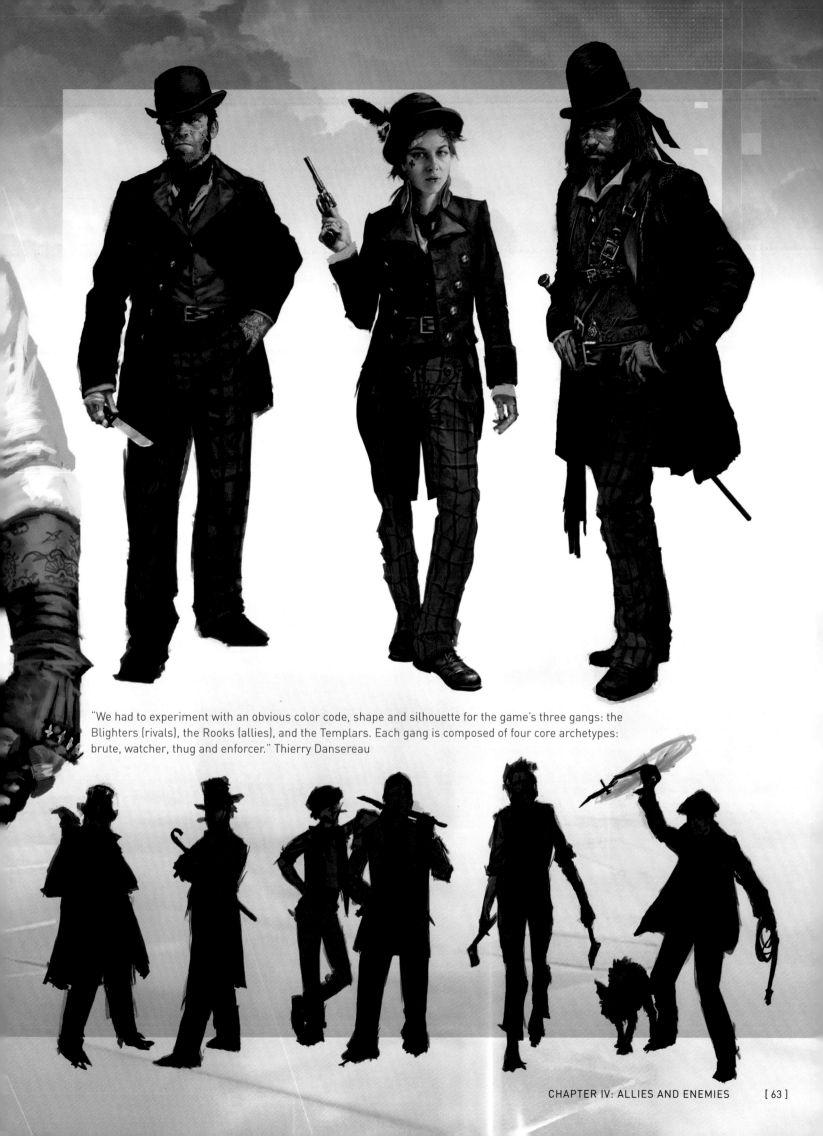

"We had to experiment with an obvious color code, shape and silhouette for the game's three gangs: the Blighters (rivals), the Rooks (allies), and the Templars. Each gang is composed of four core archetypes: brute, watcher, thug and enforcer." Thierry Dansereau

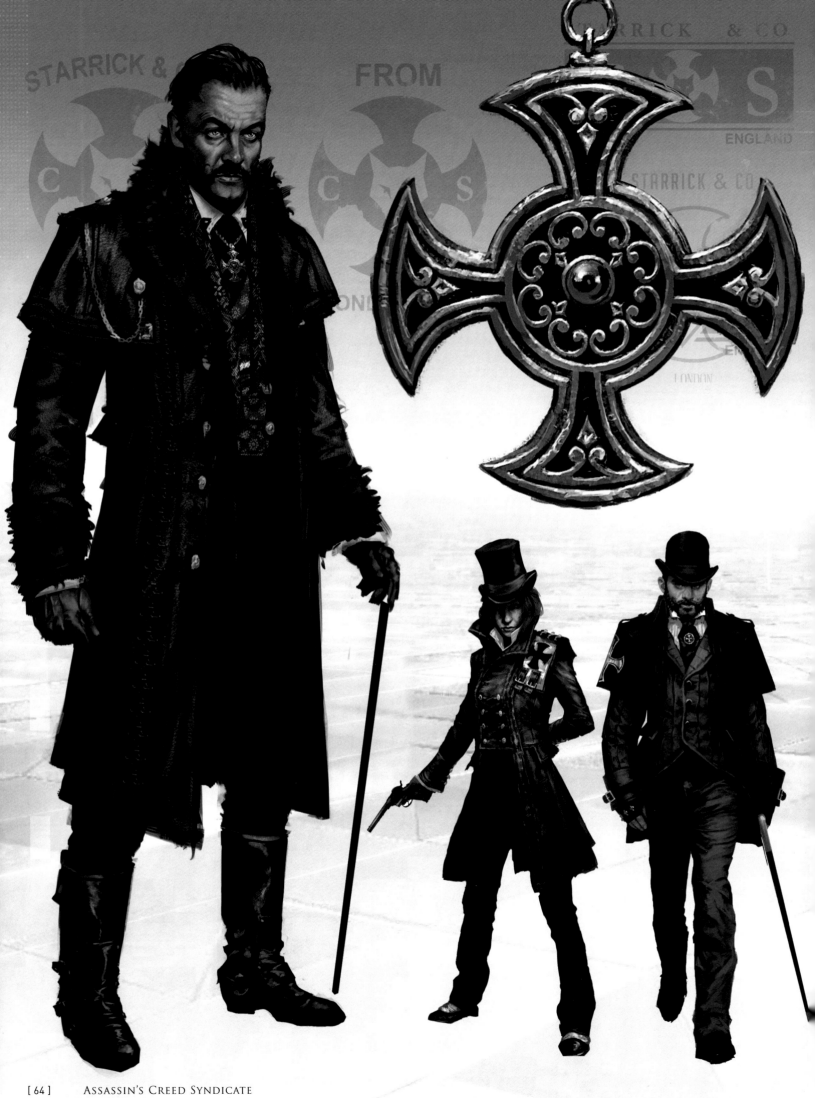

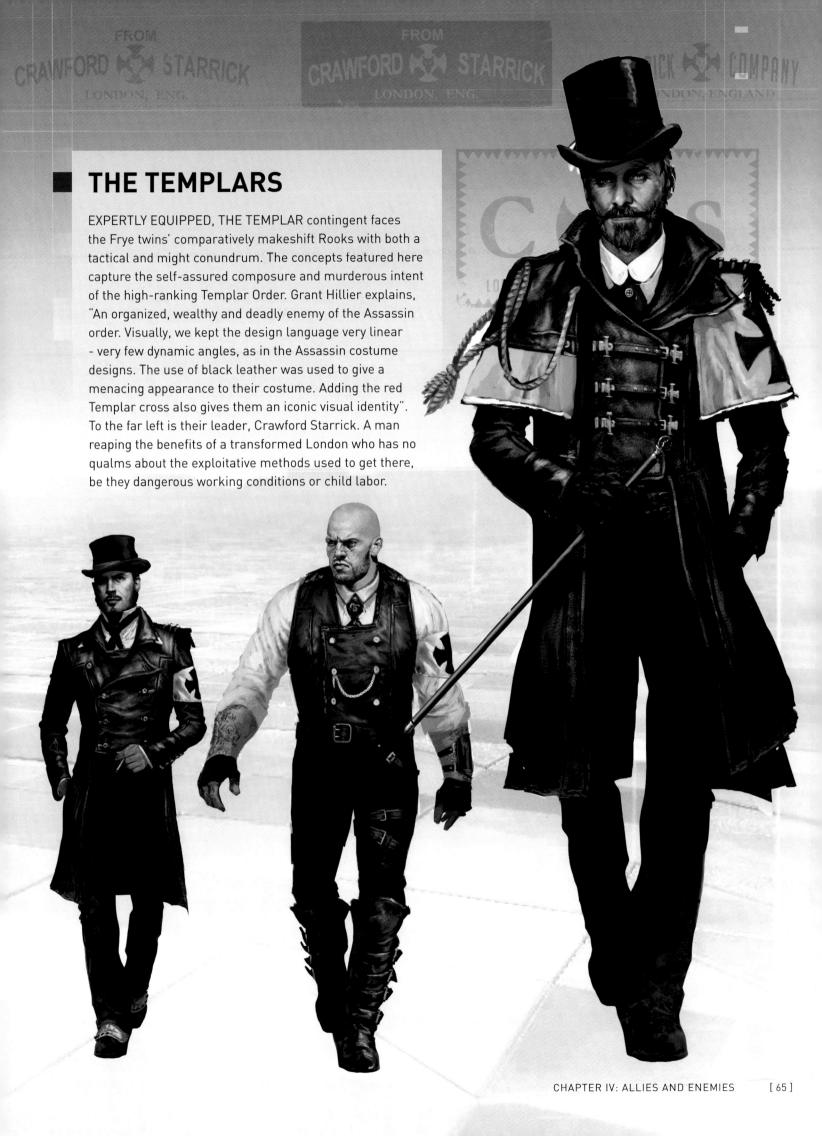

THE TEMPLARS

EXPERTLY EQUIPPED, THE TEMPLAR contingent faces the Frye twins' comparatively makeshift Rooks with both a tactical and might conundrum. The concepts featured here capture the self-assured composure and murderous intent of the high-ranking Templar Order. Grant Hillier explains, "An organized, wealthy and deadly enemy of the Assassin order. Visually, we kept the design language very linear - very few dynamic angles, as in the Assassin costume designs. The use of black leather was used to give a menacing appearance to their costume. Adding the red Templar cross also gives them an iconic visual identity". To the far left is their leader, Crawford Starrick. A man reaping the benefits of a transformed London who has no qualms about the exploitative methods used to get there, be they dangerous working conditions or child labor.

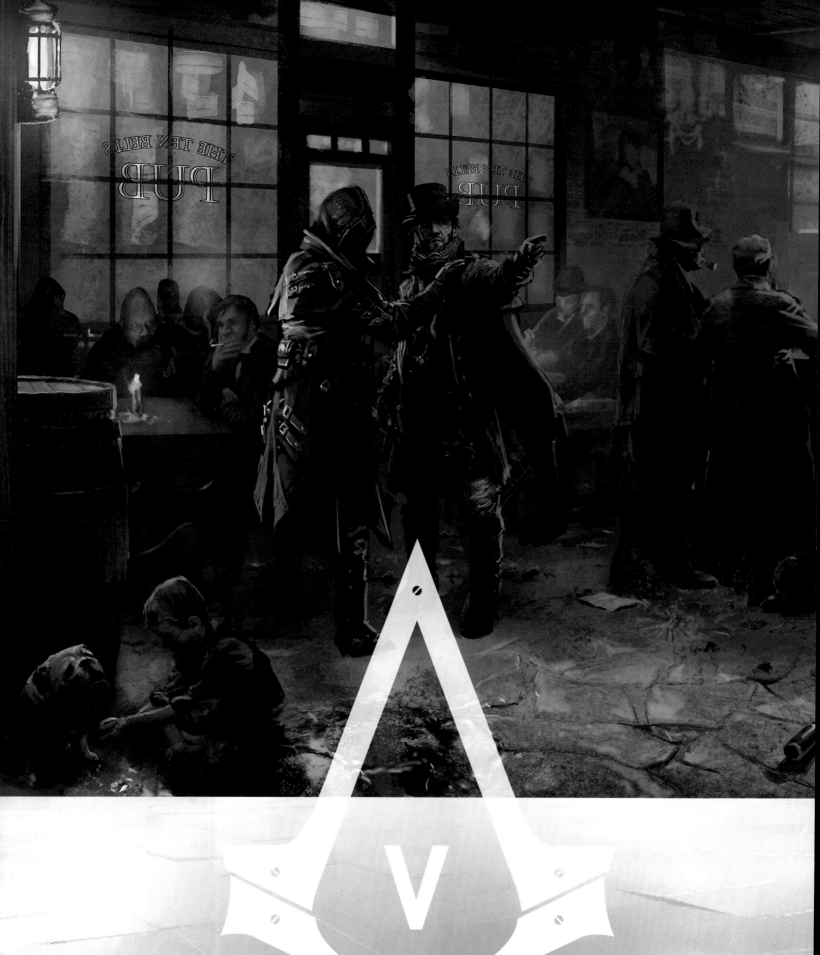

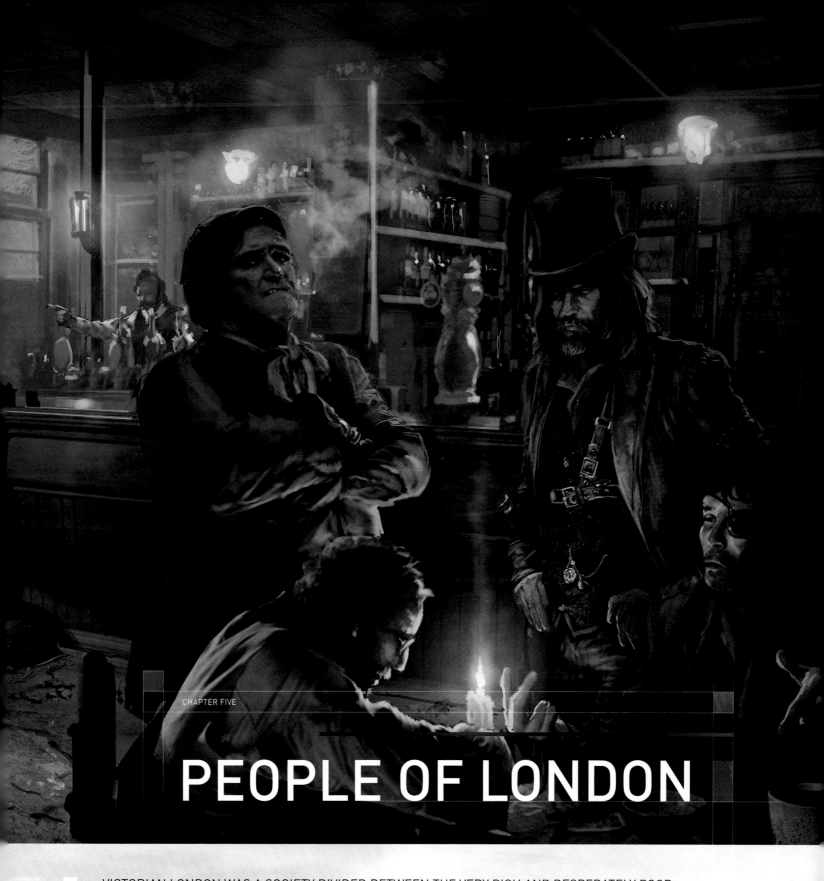

PEOPLE OF LONDON

VICTORIAN LONDON WAS A SOCIETY DIVIDED BETWEEN THE VERY RICH AND DESPERATELY POOR; THE UPPER CLASS AND WORKING CLASS. UNSURPRISINGLY THE LATTER FORMED THE MAJORITY, AND IT IS SAID THAT THREE OUT OF FOUR LONDONERS WERE MANUAL LABORERS. THE RISE OF THE MIDDLE CLASS DISTINGUISHED THE ERA TOO, AS MONEY CAME FROM INDUSTRIAL SUCCESS AND ACADEMIC ACHIEVEMENT.

The representation of Victorian London society for *Assassin's Creed Syndicate* was informed by specialists such as librarians and university professors. They helped the team to understand the evolution of ideologies and better appreciate the influence of Indian and Sikh culture on Victorian fashion. In this chapter we can see how this wealth of information was channeled, bringing the times to life.

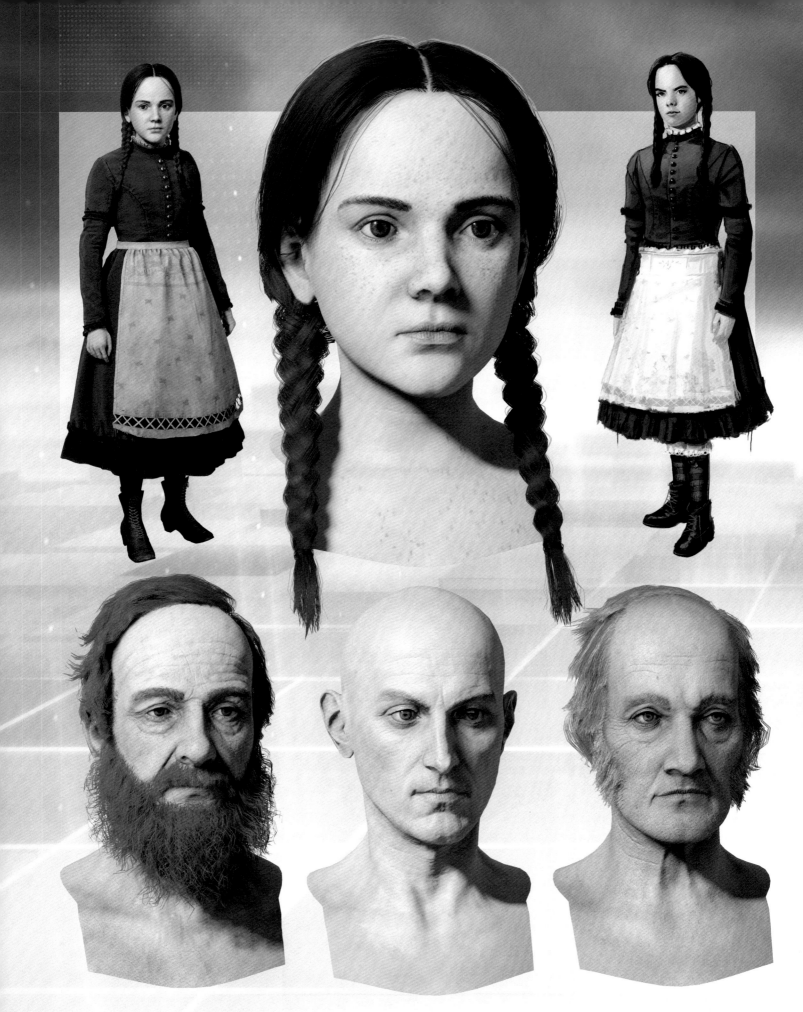

TOP: Clara O'Dea is the young informant for Jacob, Evie and Henry Green. She works at the Seven Bells tavern which serves as home base for The Rooks. Her precocious nature and bright personality are captured in sharp brown eyes and tidy, if a little rumpled, pigtails. An original concept sketch for Clara is shown above right with the final full-body character render above left.

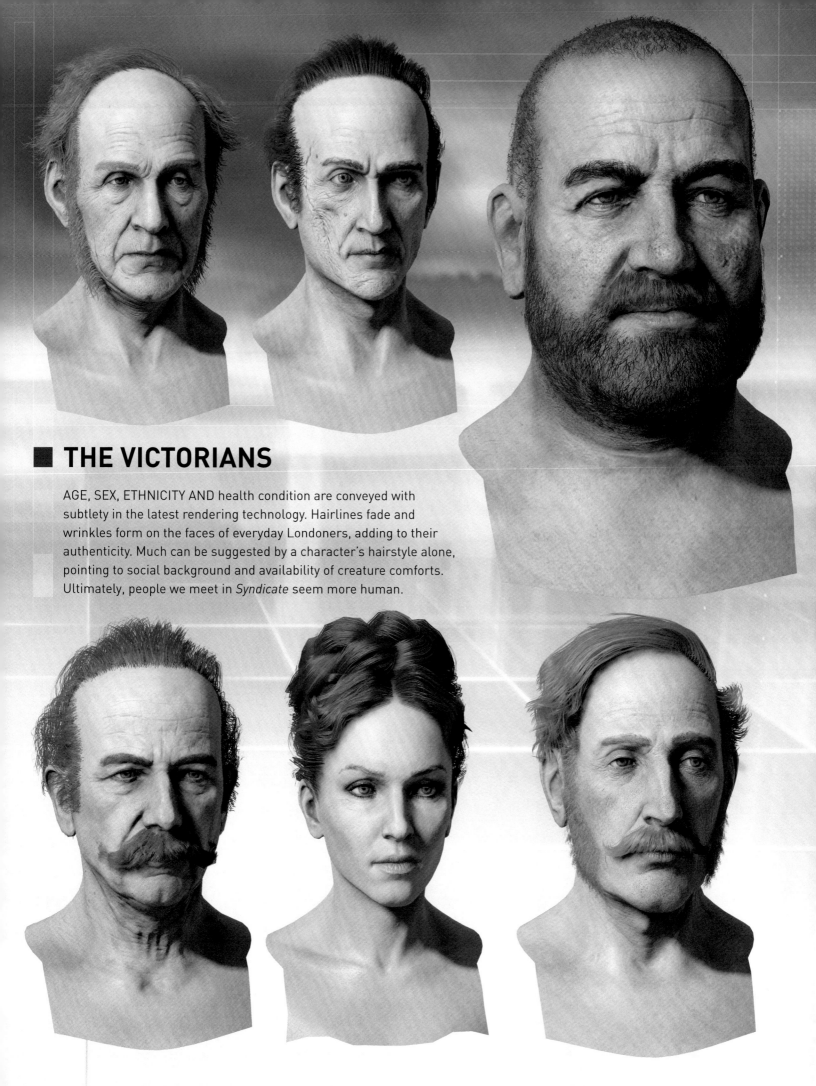

■ THE VICTORIANS

AGE, SEX, ETHNICITY AND health condition are conveyed with subtlety in the latest rendering technology. Hairlines fade and wrinkles form on the faces of everyday Londoners, adding to their authenticity. Much can be suggested by a character's hairstyle alone, pointing to social background and availability of creature comforts. Ultimately, people we meet in *Syndicate* seem more human.

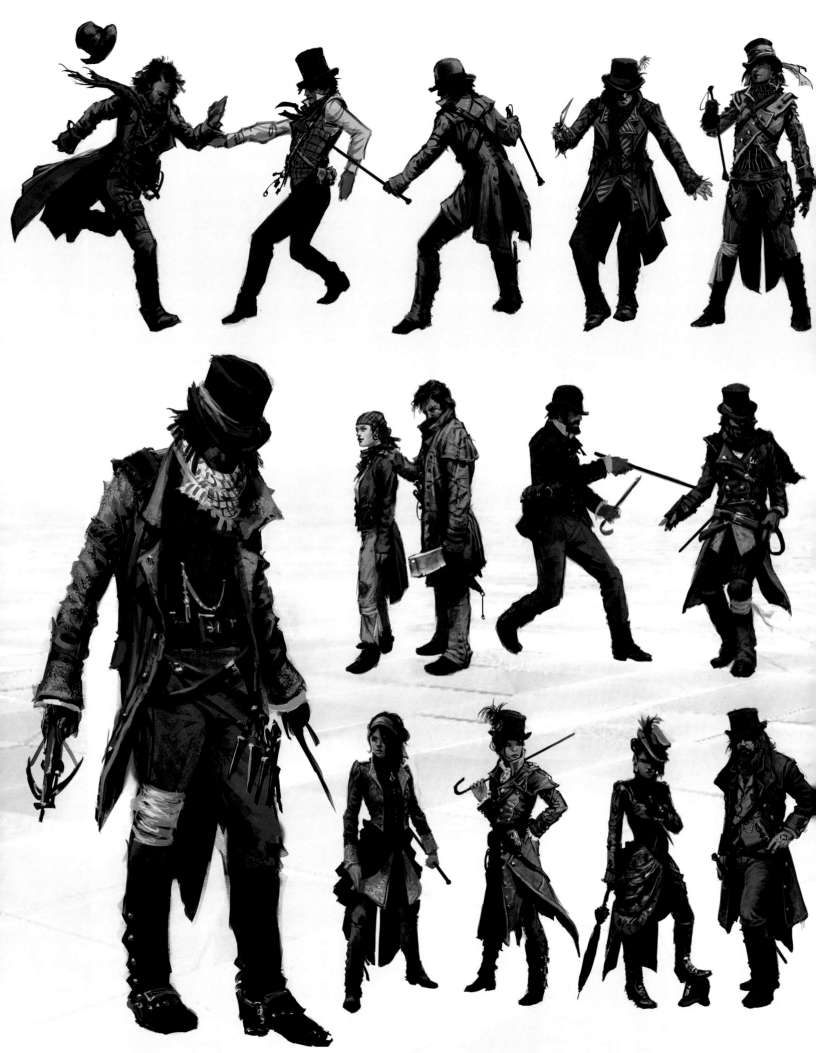

ASSASSIN'S CREED SYNDICATE

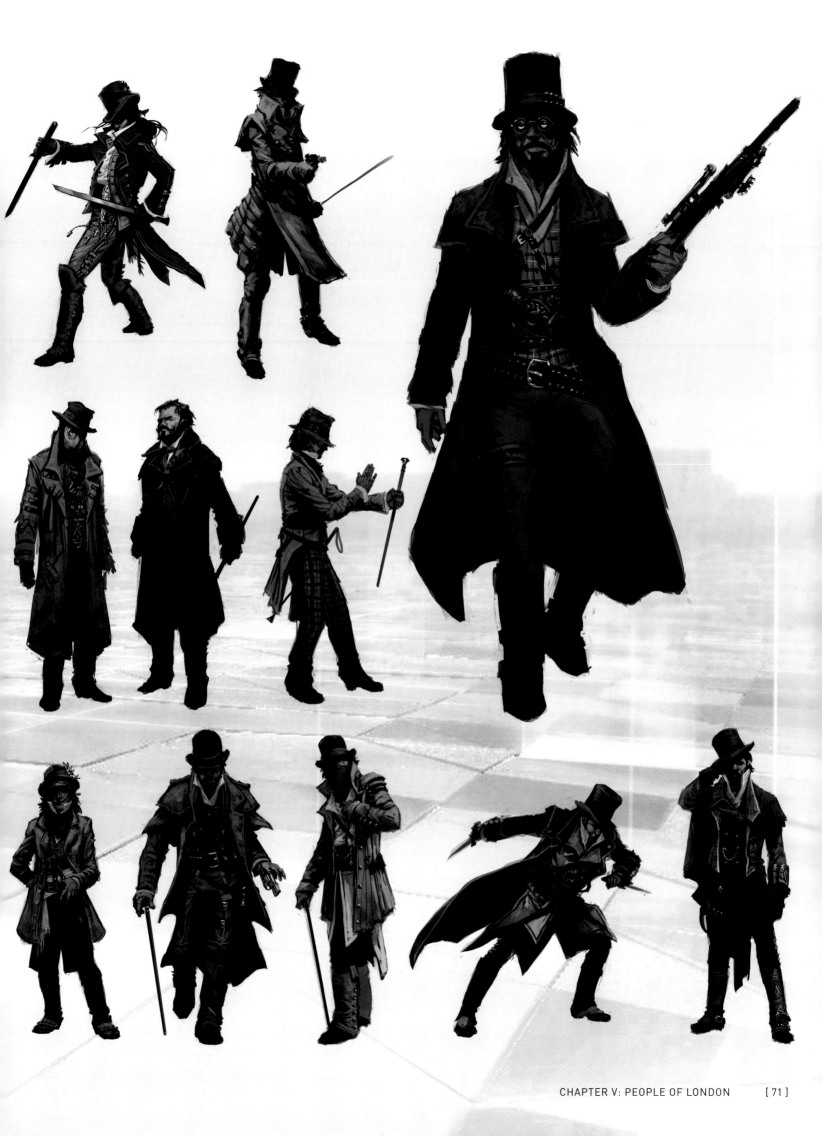

■ LIFE STUDIES

BEFORE FINALIZING THE CROSS-SECTION of London life represented in *Assassin's Creed Syndicate*, London's human and animal inhabitants alike were explored on the concept artist's sketchpad. "Fast and economical, it enables me to explore many ideas," says Hillier. "They are a great way to start discussions and provide inspiration regarding all manner of topics during the early stages of preproduction. We did so many of these that we didn't get enough time to go back and do final color concepts for many of the subjects we wanted to use in *Syndicate* - the Victorian era is just so rich with endless and varied possibility."

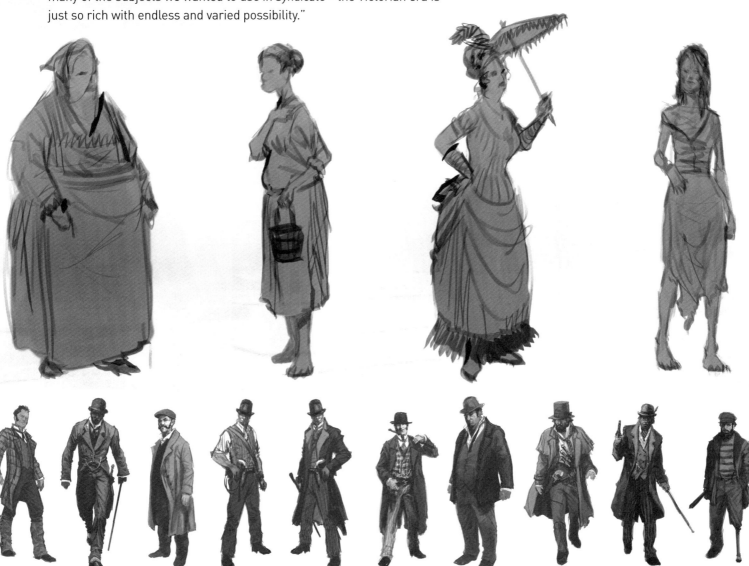

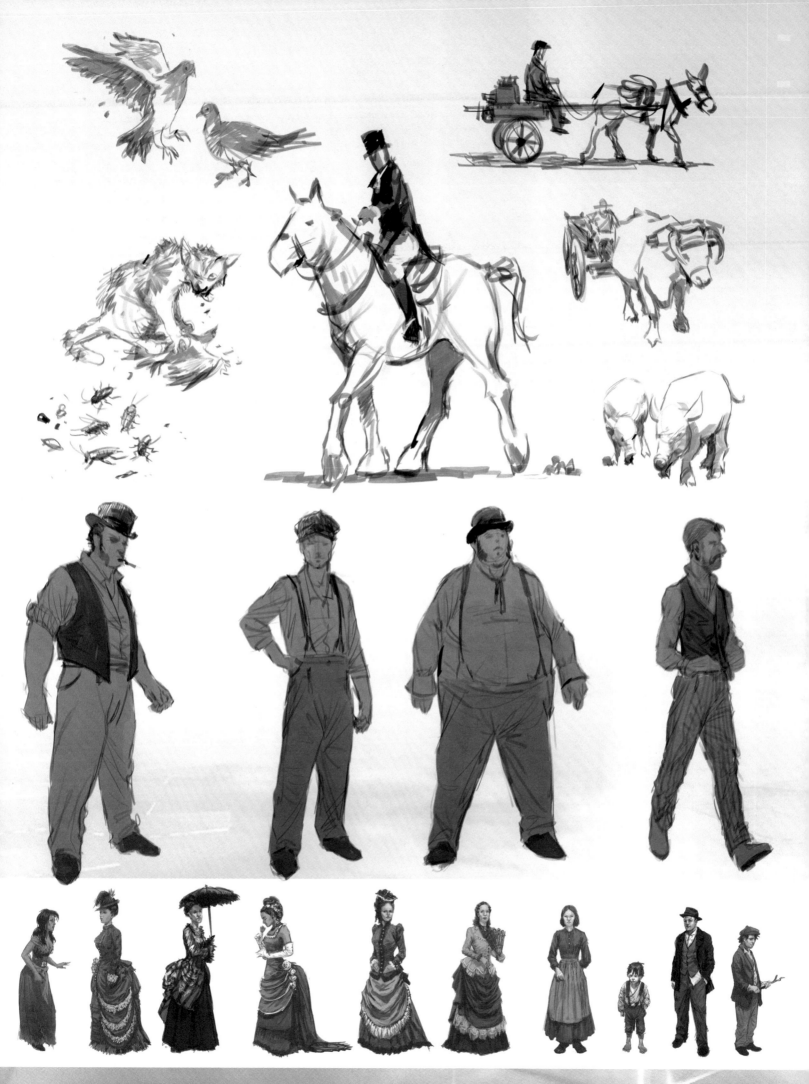

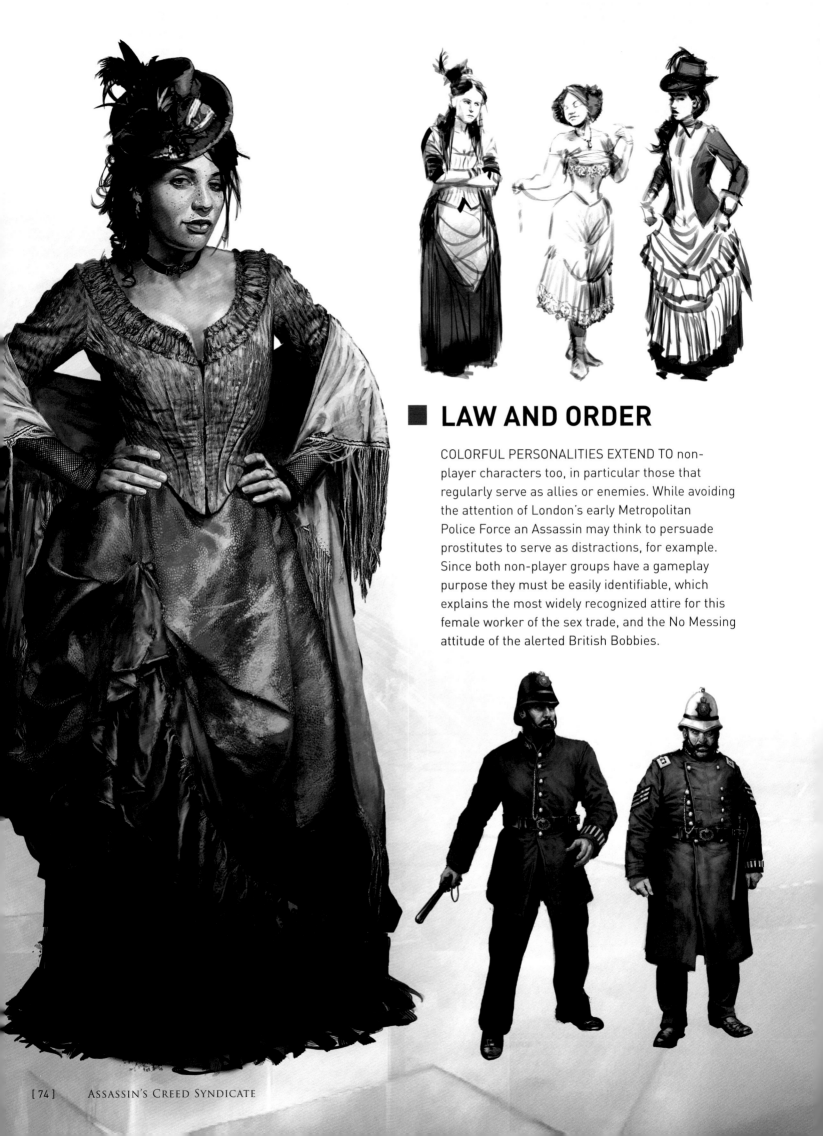

LAW AND ORDER

COLORFUL PERSONALITIES EXTEND TO non-player characters too, in particular those that regularly serve as allies or enemies. While avoiding the attention of London's early Metropolitan Police Force an Assassin may think to persuade prostitutes to serve as distractions, for example. Since both non-player groups have a gameplay purpose they must be easily identifiable, which explains the most widely recognized attire for this female worker of the sex trade, and the No Messing attitude of the alerted British Bobbies.

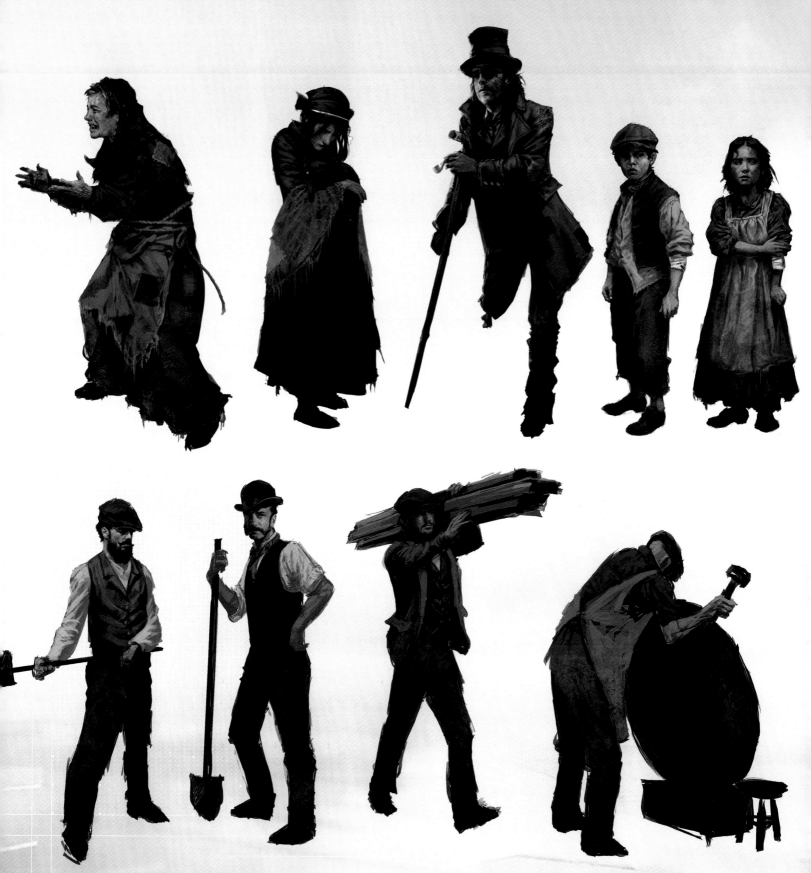

FACES IN THE CROWD

HUMAN EMOTION SPEAKS FROM every enquiring brow, busted nose, and hunched back in this selection of everyday folk that serve as studies for the general public. There is softness and grim determinedness, sorrow and anger playing across both the faces and body language of the populace.

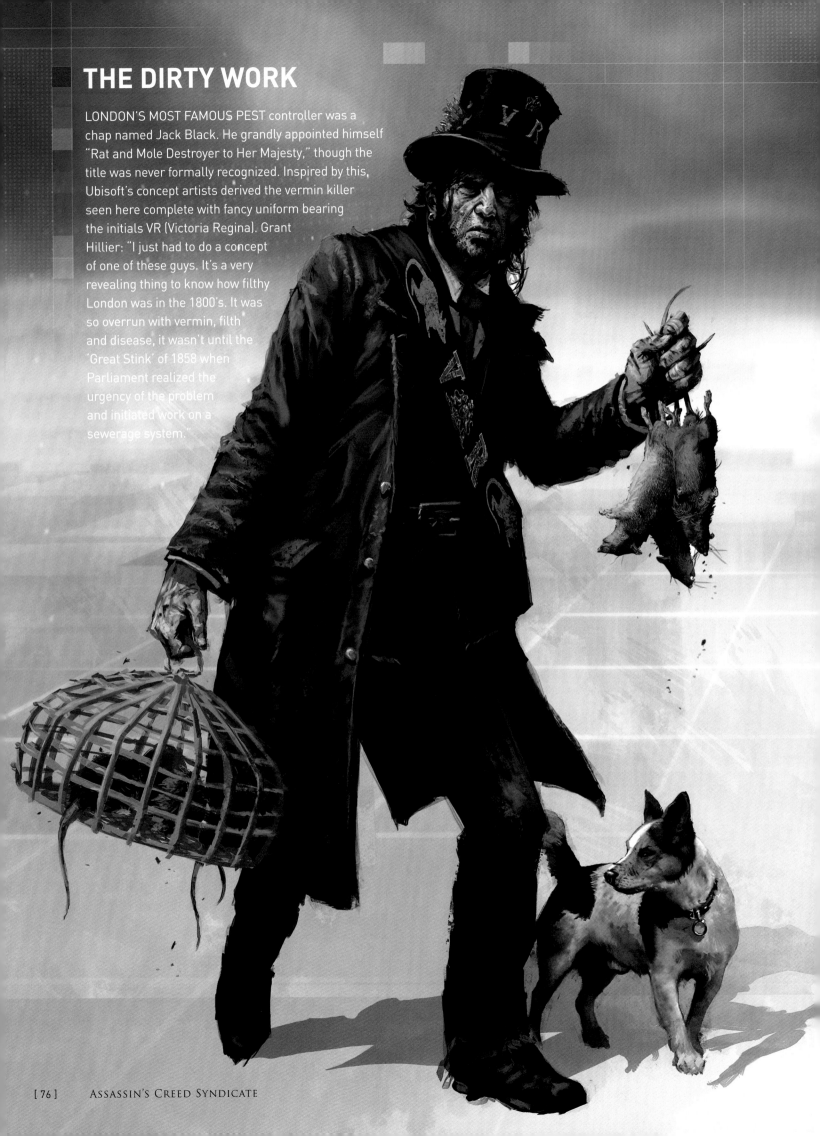

THE DIRTY WORK

LONDON'S MOST FAMOUS PEST controller was a chap named Jack Black. He grandly appointed himself "Rat and Mole Destroyer to Her Majesty," though the title was never formally recognized. Inspired by this, Ubisoft's concept artists derived the vermin killer seen here complete with fancy uniform bearing the initials VR (Victoria Regina). Grant Hillier: "I just had to do a concept of one of these guys. It's a very revealing thing to know how filthy London was in the 1800's. It was so overrun with vermin, filth and disease, it wasn't until the 'Great Stink' of 1858 when Parliament realized the urgency of the problem and initiated work on a sewerage system."

ABOVE AND BELOW: "Concepts for working class and 'thugs' which the player may encounter during their exploration of *Syndicate's* version of Victorian London." Grant Hillier.

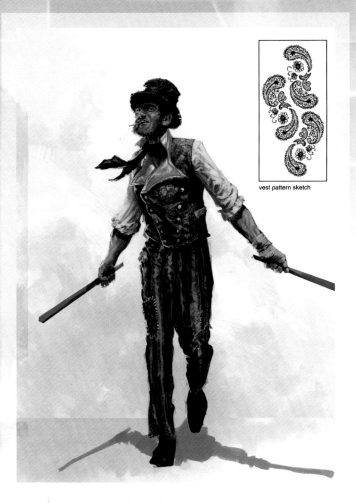

vest pattern sketch

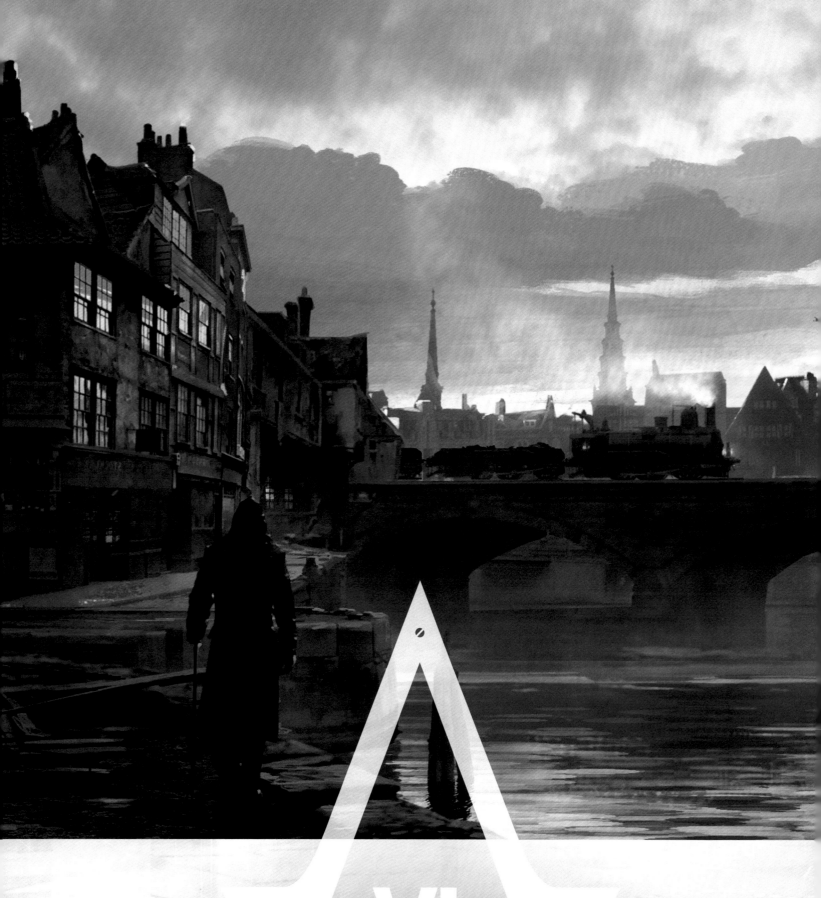

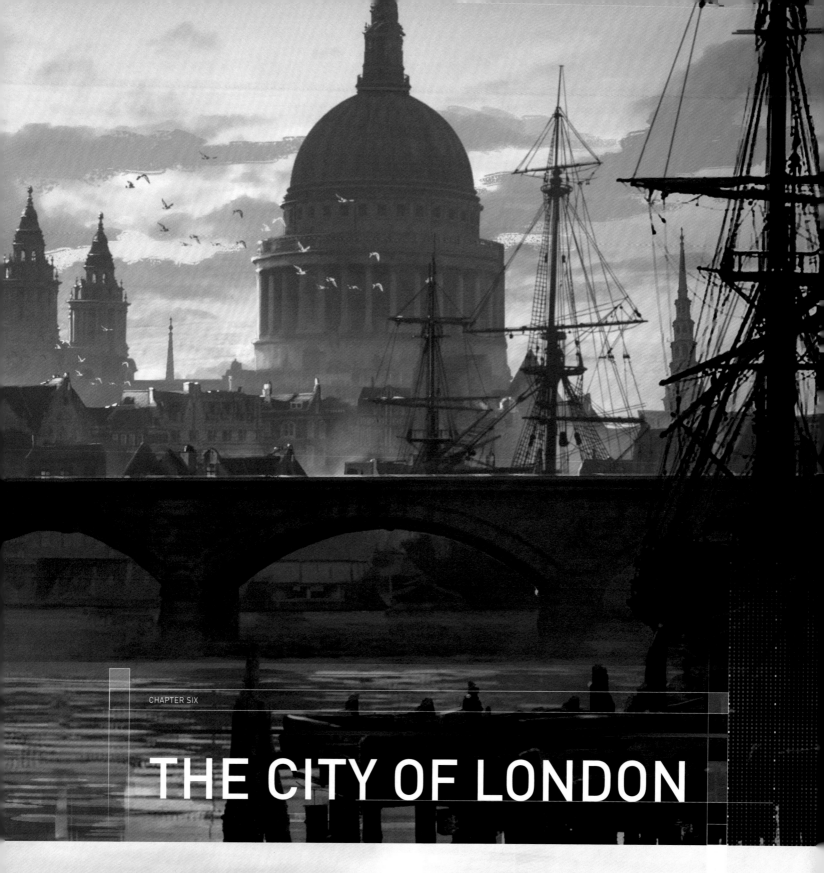

THE CITY OF LONDON

ST. PAUL'S CATHEDRAL AND LONDON BRIDGE AS IMAGINED BY FRANCHISE ART DIRECTOR RAPHAEL LACOSTE. THE ASSASSIN STANDS IN THE FOREGROUND, A SILHOUETTE, PLANNING THE APPROACH TO A TARGET. THE SUN IS SETTING; THE TIME IS NOT YET RIGHT. THIS ONE EVOCATIVE CONCEPT TELLS DESIGNERS MUCH OF WHAT THEY NEED TO KNOW OF THE ART TEAM'S INTENTION FOR A SCENE, INCLUDING MOOD.

Atmosphere is conveyed at the concept stage by a Color Script system established by Thierry Dansereau. This helps to keep the narrative experience varied and compelling. Dansereau explains: "The Color Script is an overview where you get to see the entire mood of the game at a glance. The goal is to make sure we're contrasting the color and mood to enhance the emotion of each sequence and mission."

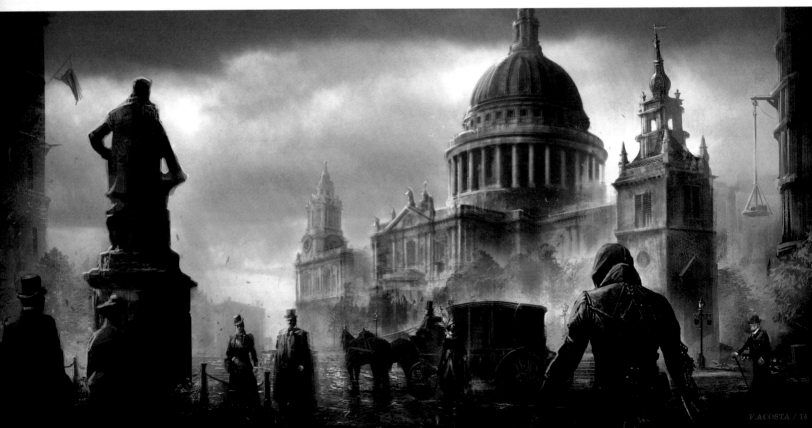

The City and St. Paul's Cathedral in concepts from artists Fernando Acosta and Frederick Rambaud. They are overcast and besieged by heavy rain to convey drama required in each scene. Advances in rendering technology allow in-game interpretation to come impressively close.

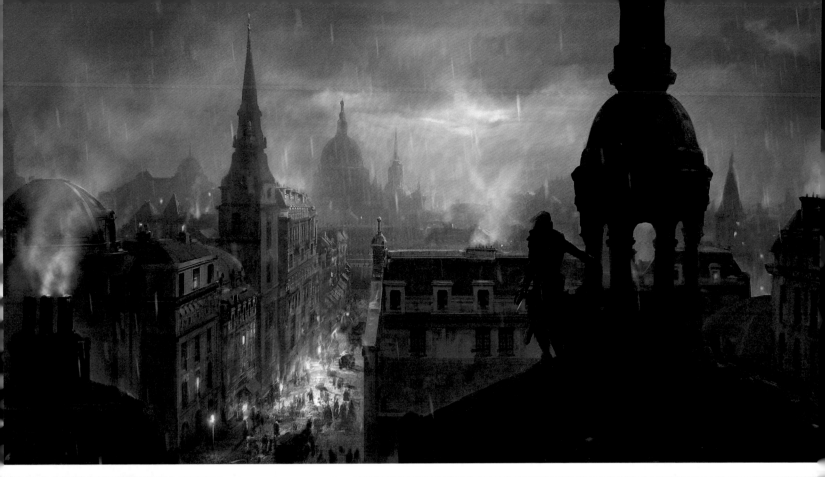

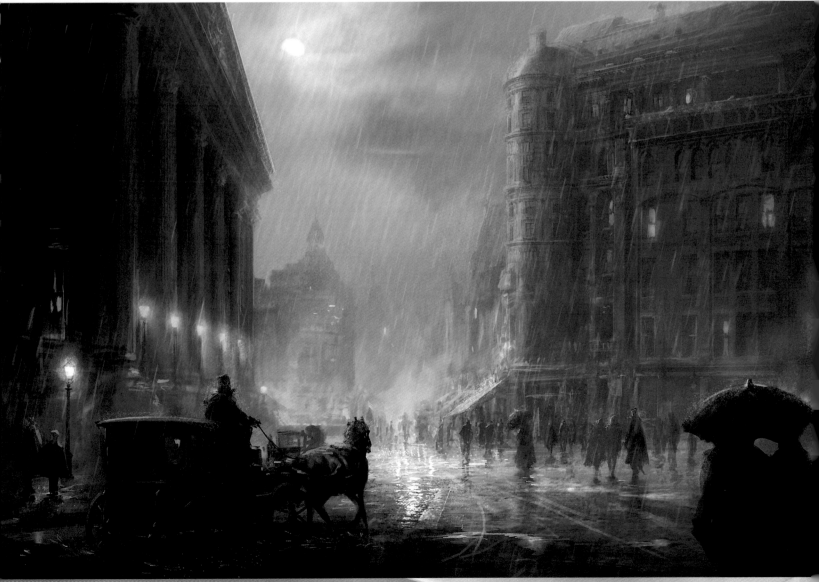

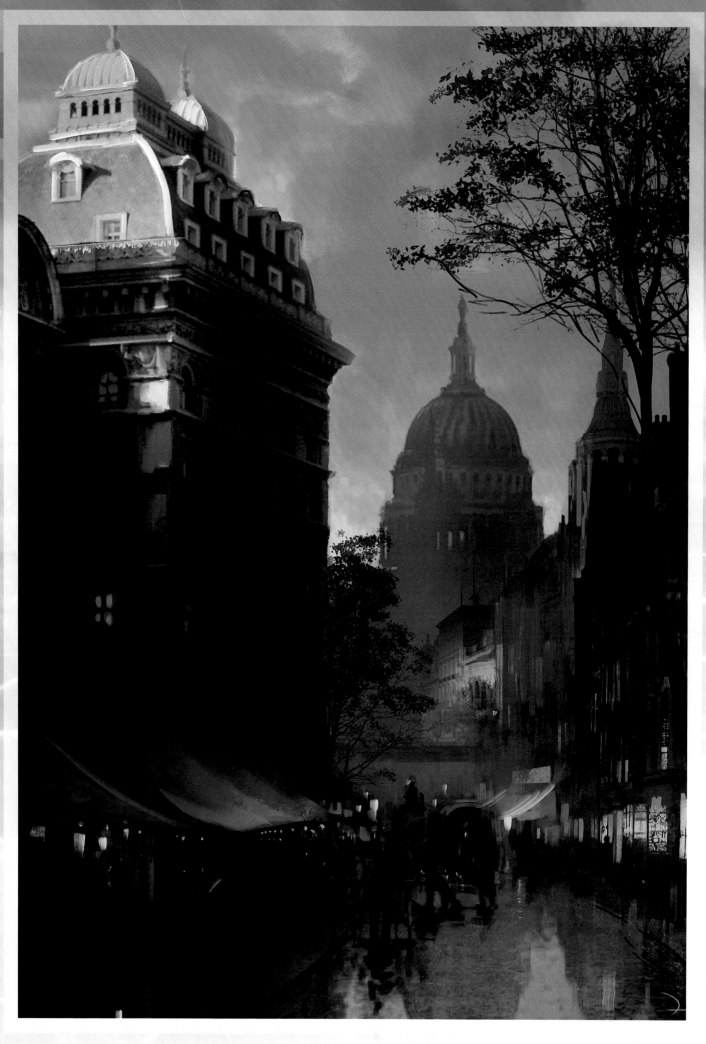

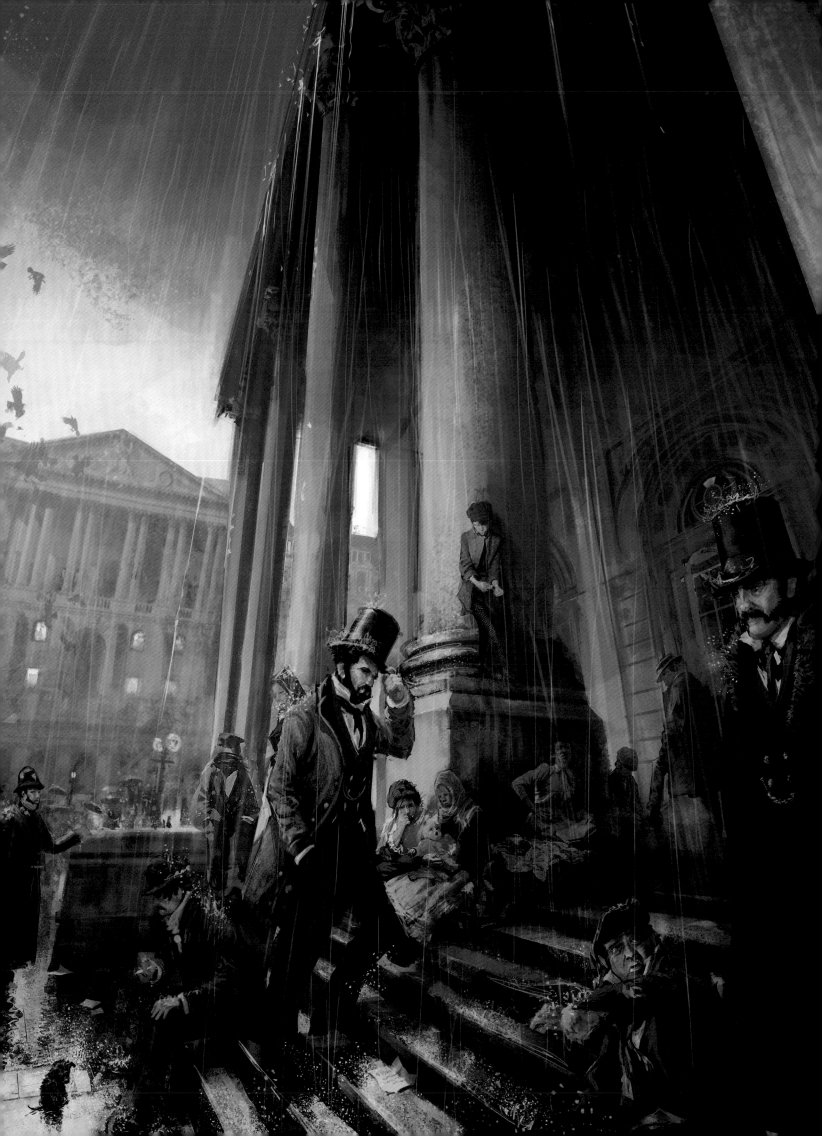

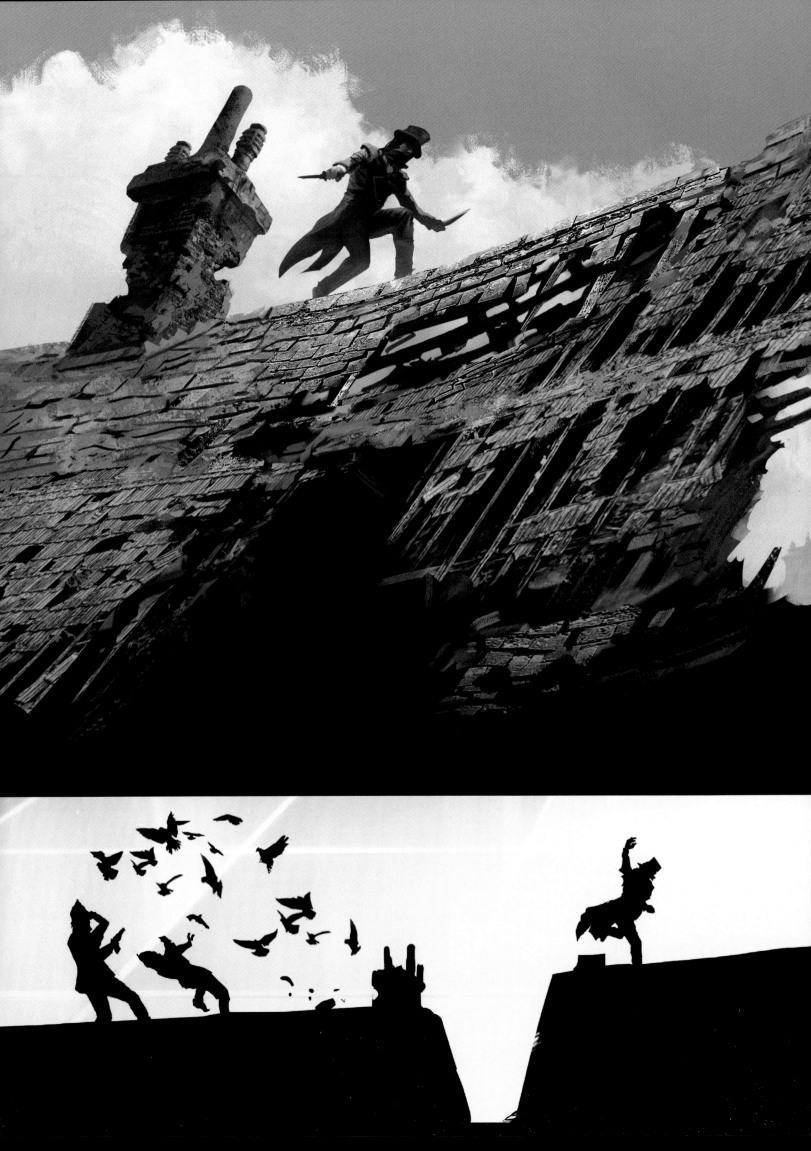

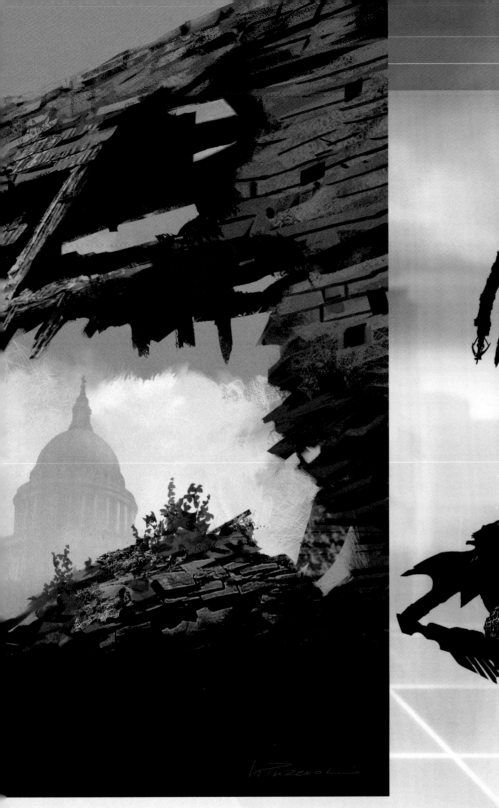

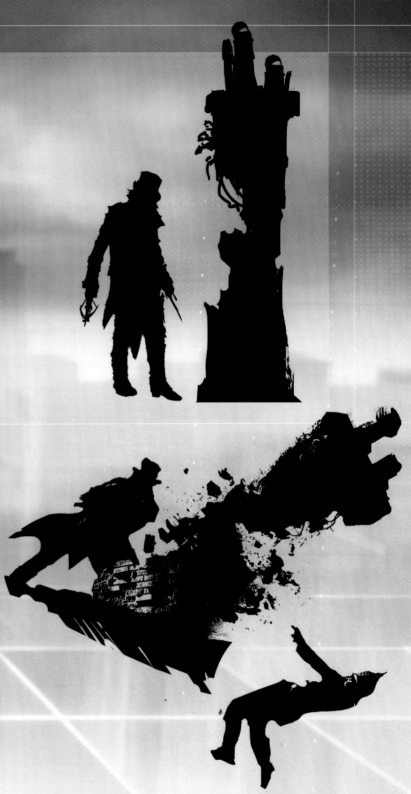

◾ ROOF TOP ACTION

BEFORE THE ANIMATION TEAM is involved, concept artists envisage scenarios described by designers to plan sequences or one-off incidents. It saves time to question the narrative context before many hours are spent producing outtakes for the virtual cutting-room floor. A particular action may not be suited to a certain character, for example, but can be set aside for another occasion. If successful, a popular idea can be interpreted in numerous ways during the course of the game so investigating situations in this way makes the concept team's contribution extremely important.

"Here are some contextual gameplay ideas for animation I had at the very beginning of the pre production. Play with the London rooftops' derelict environment to create danger and destabilize enemies. At that time fires were also much more common."
Hugo Puzzuoli

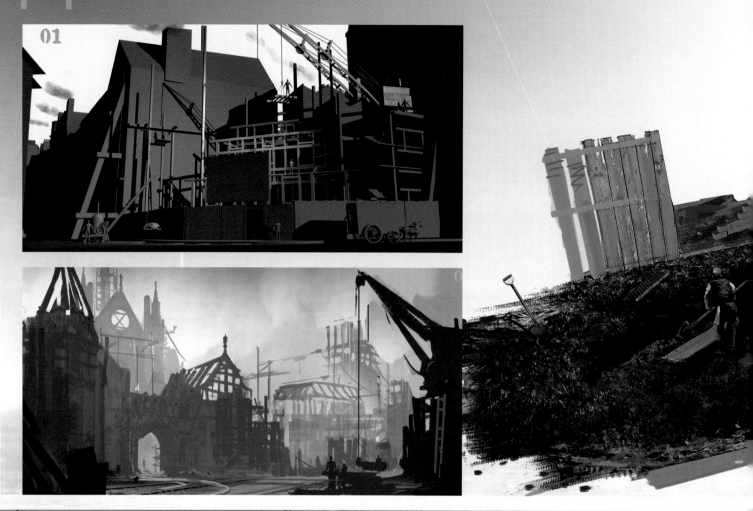

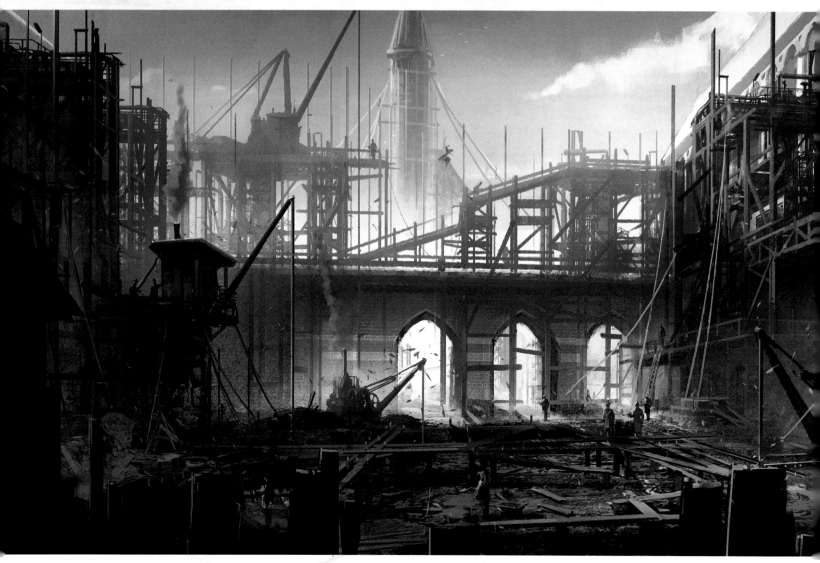

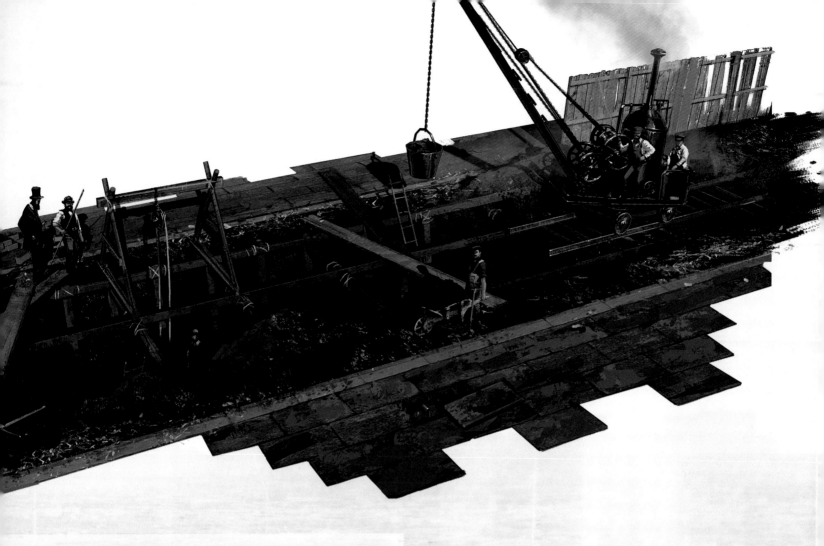

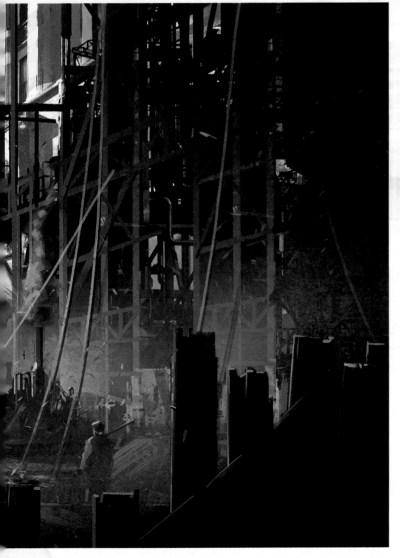

UNDER CONSTRUCTION

MUCH OF WHAT IS now established in London was only recently built or underway throughout the *Assassin's Creed Syndicate* timeline. Construction of the Royal Courts of Justice only began in 1873, which explains the magnificent building's absence from the game. This did not stifle the imaginations of the concept team, however. Instead, an opportunity was grasped to showcase steam-powered construction equipment on the site of the famous Law Courts. The early hydraulic crane was also used to build the railways, contributing greatly to the rapid pace of progress brought about by the Industrial Revolution. And so, as a backdrop to an adventure focused on the unsung heroes behind London's finest architectural achievements, the Royal Courts of Justice became arguably more impressive in skeletal form than boasting a lovely façade.

19th century London was perhaps one big accident waiting to happen, however wonderful. The scene depicting Ludgate (below) shows a near perfect cross-section of rapid commercial growth fuelled by steam; the locomotive seeming an improbable thing before St. Paul's.

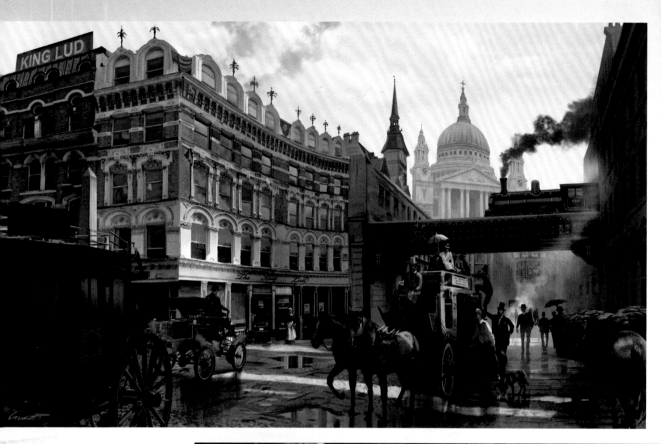

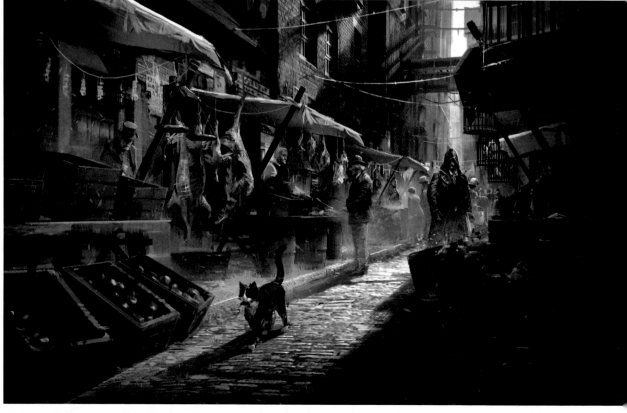

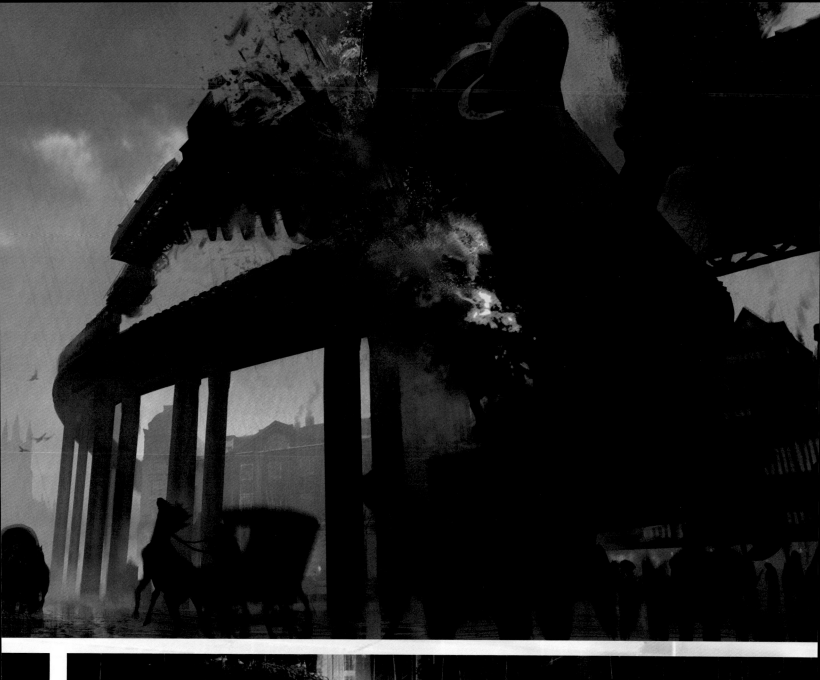

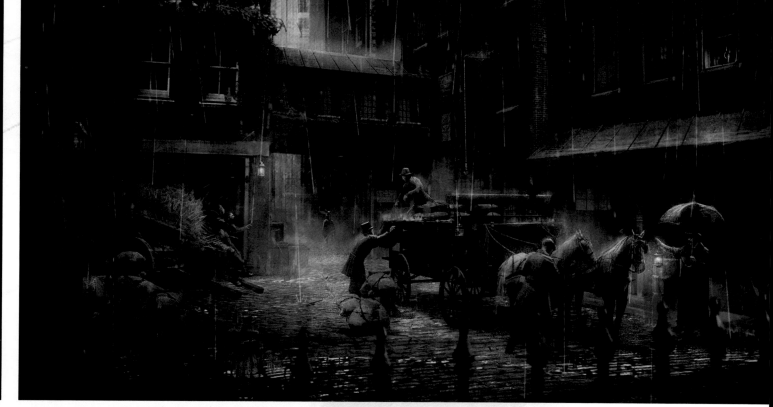

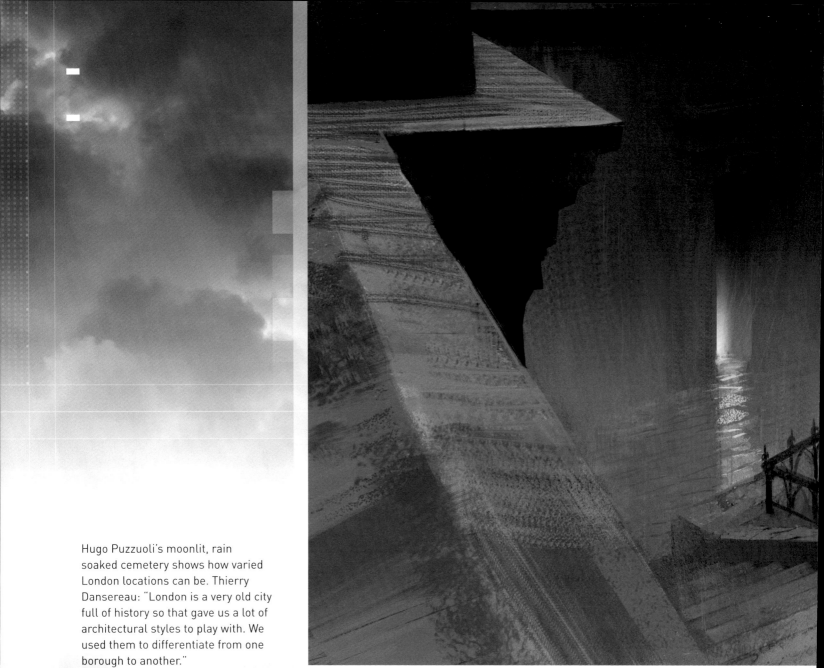

Hugo Puzzuoli's moonlit, rain soaked cemetery shows how varied London locations can be. Thierry Dansereau: "London is a very old city full of history so that gave us a lot of architectural styles to play with. We used them to differentiate from one borough to another."

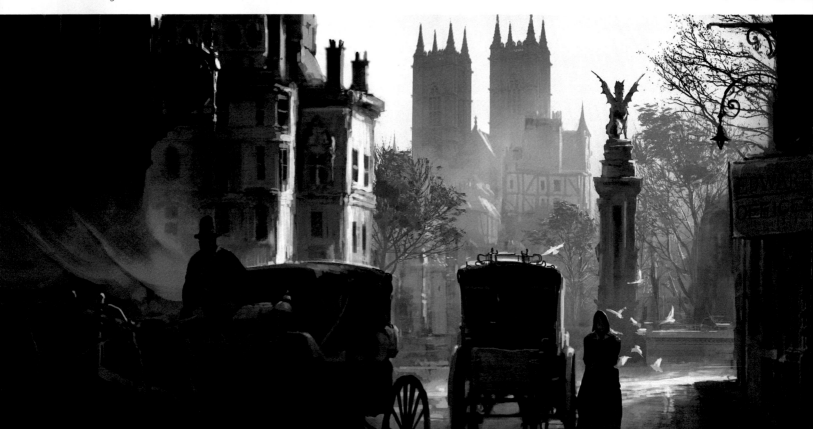

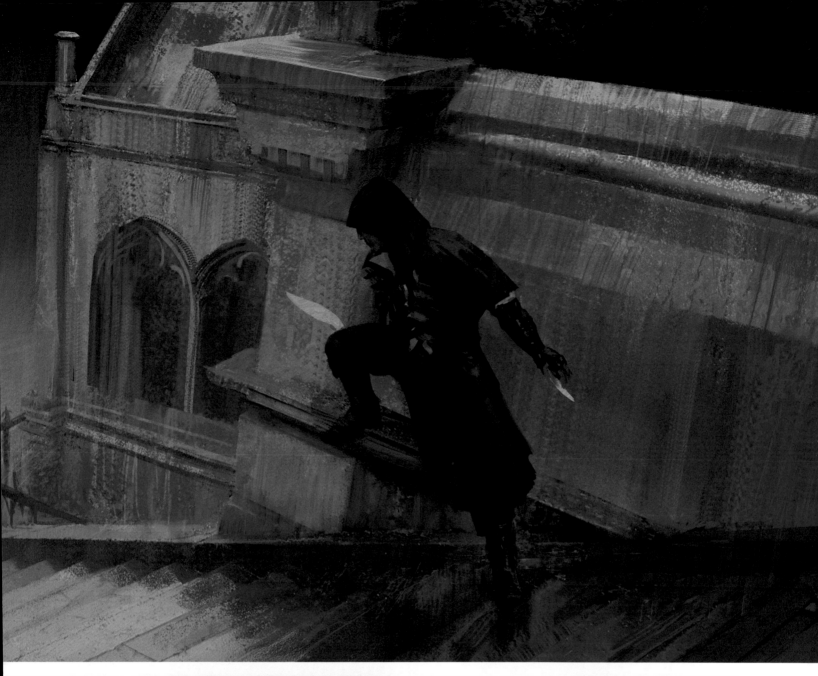

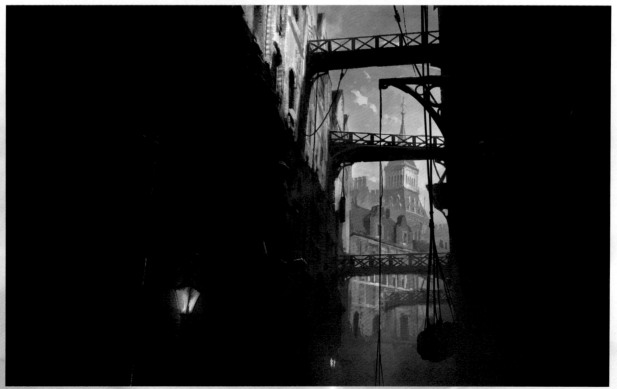

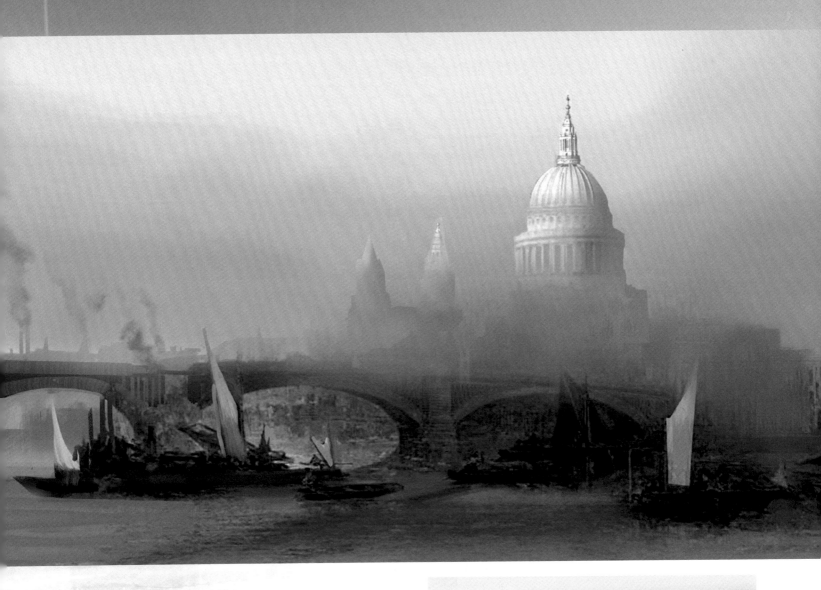

TIME OF DAY

ADVANCING TECHNOLOGY AVAILABLE TO the Ubisoft team has allowed subtlety of effect to become at least as expressive as things that break or explode. Primarily this means lighting and elements that distort visibility. "The time of day's color keys were very important for us because they show the atmosphere's cycle we wanted to repeat during the day," Hugo Puzzuoli explains. "The goal was to have diverse and rich atmospheres. We chose pink shades for morning and more orange afternoons, to really differentiate them. For twilight, I took inspiration from the green shades of the great British artist John Atkinson Grimshaw."

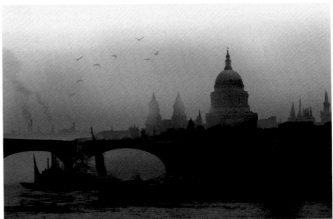

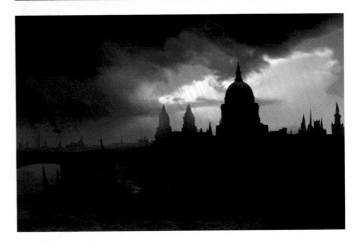

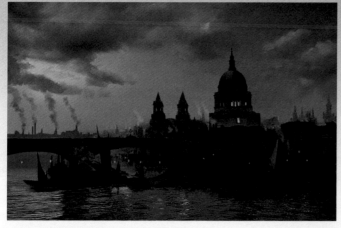

Night

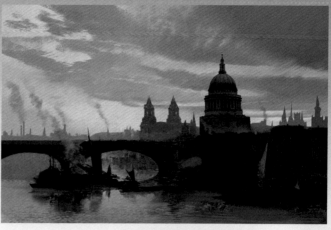

Early Morning

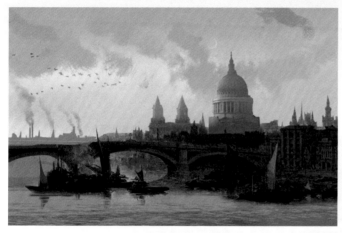

Morning

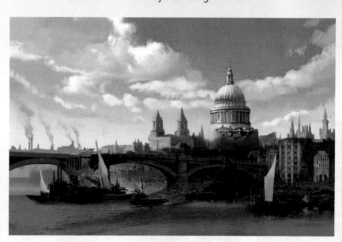

Noon

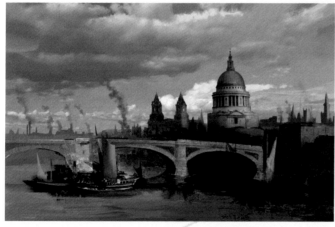

Noon

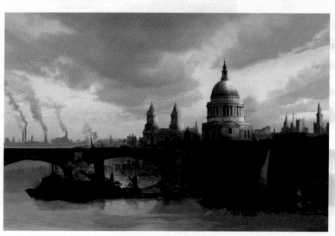

Late Afternoon

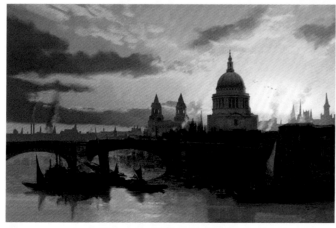

Sun Fall (Golden Hour)

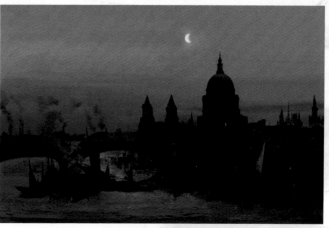

Twilight

BANK OF ENGLAND

THE HUSHED INTERIOR OF the Bank of England is conveyed here by artist Fernando Acosta, focusing on the Clerk Room, Library and Vault. It's a fairytale depiction of golden riches, with sunbeams that emphasize the polished floors, and darkened corners from where our Assassin may silently stalk the target. This is plainly somewhere the Assassin does not belong, forcing the eye of the player to search for stealthy routes among the columns and balanced on beams in the vaulted ceiling.

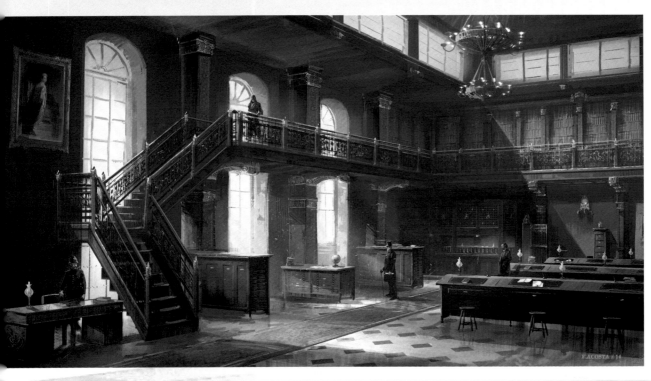

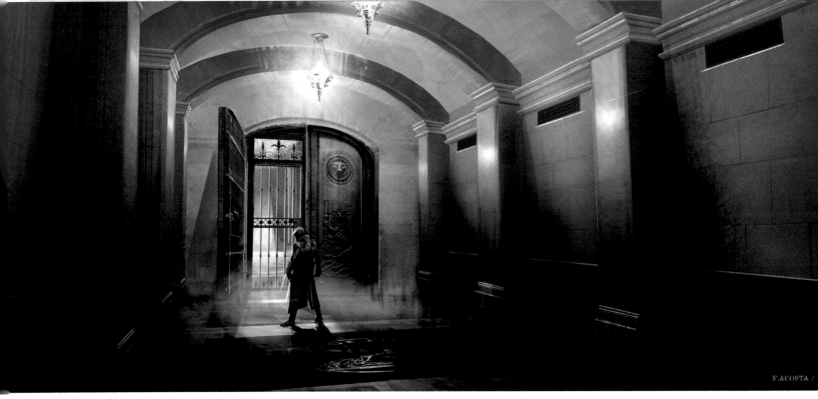

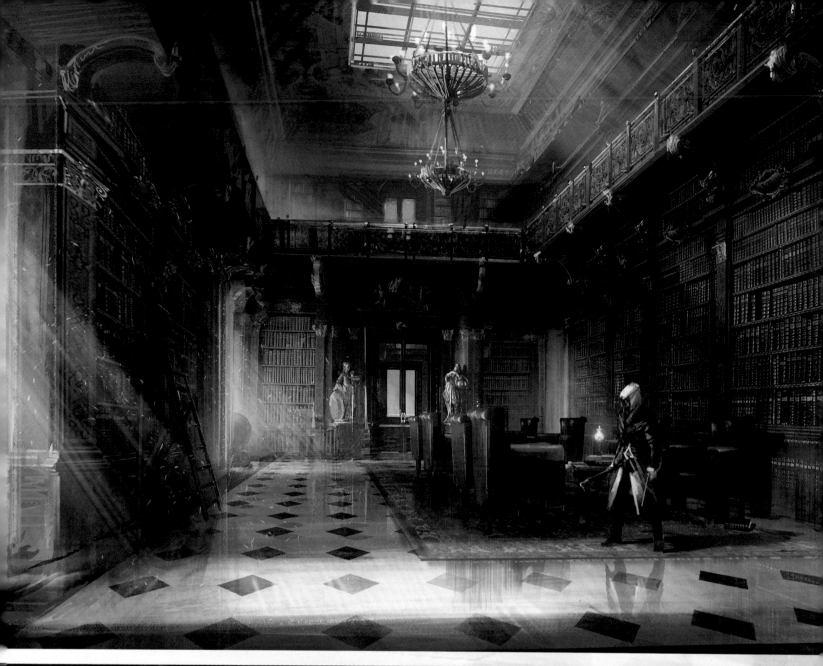

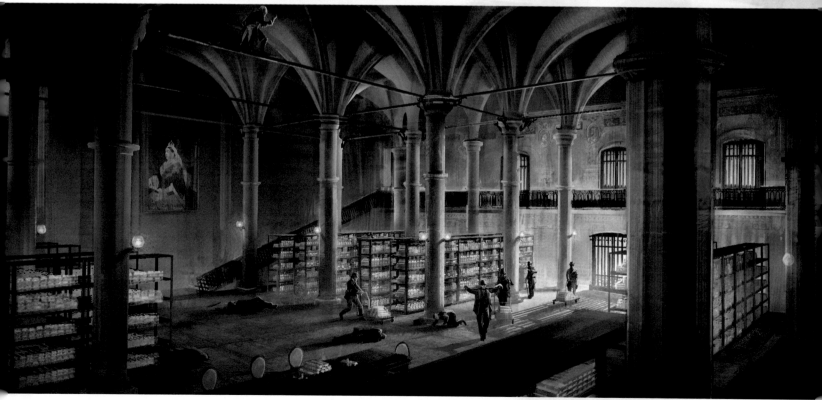

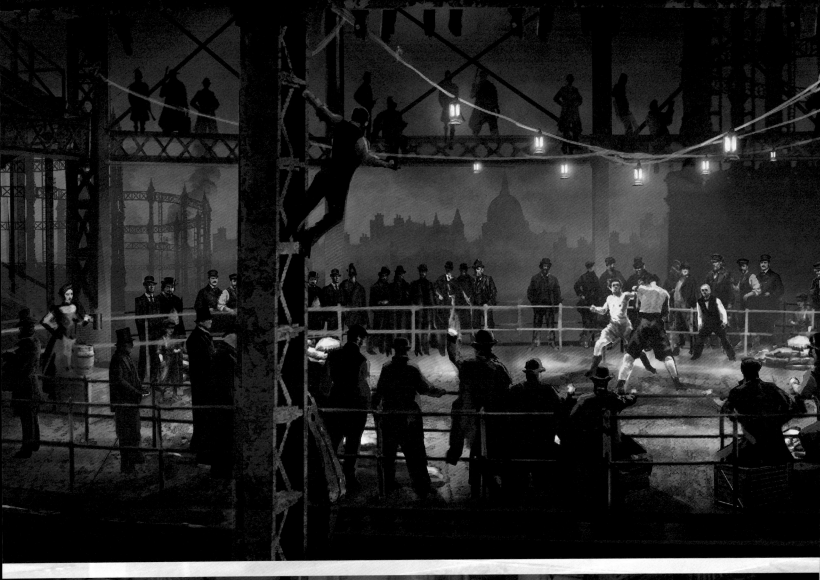

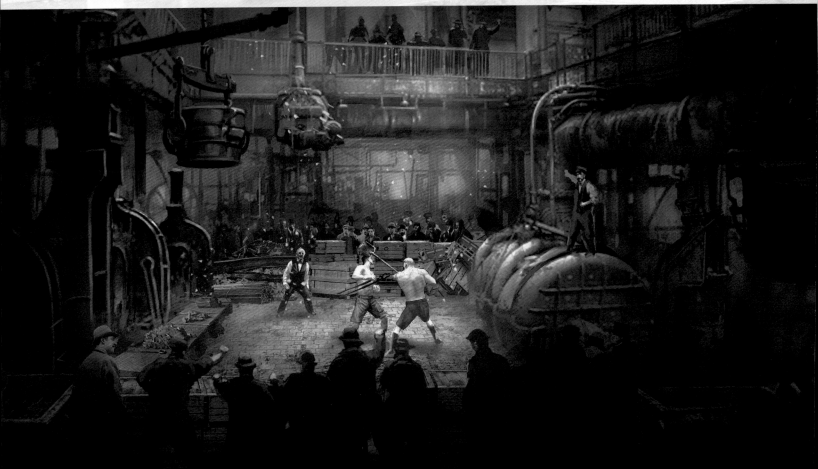

FIGHT CLUBS

EXPLICIT BRUTAL COMBAT IS a foundation for *Assassin's Creed Syndicate* gameplay, celebrated to excess in the Fight Club venues. Artists Caroline Soucy, Fernando Acosta and Gilles Beloeil all contributed at the concept stage.

After hours at the Iron Factory is one place where you might expect down-trodden men to vent frustrations in the hope of a windfall. Slightly surprising is the choice of Gasometer (top left), although as a theater in-the-round the audience gains a terrific view. Of the below fight club, Gilles Beloeil comments, "This fighting room needed to have a London high class feeling. It's cosy. It looks like a high-end gentleman club."

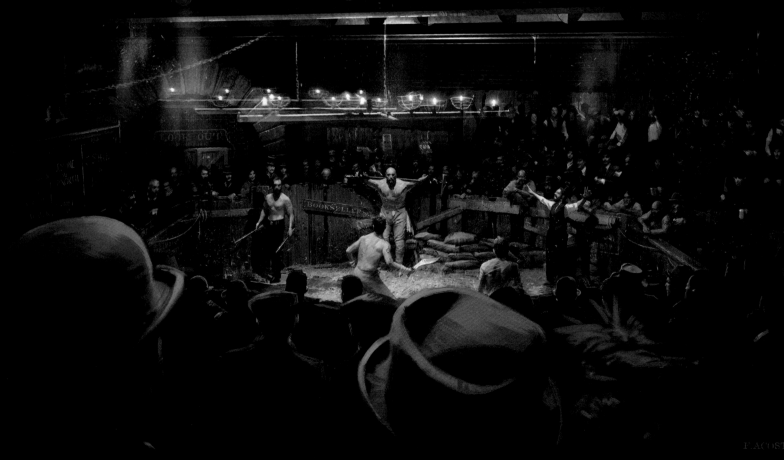

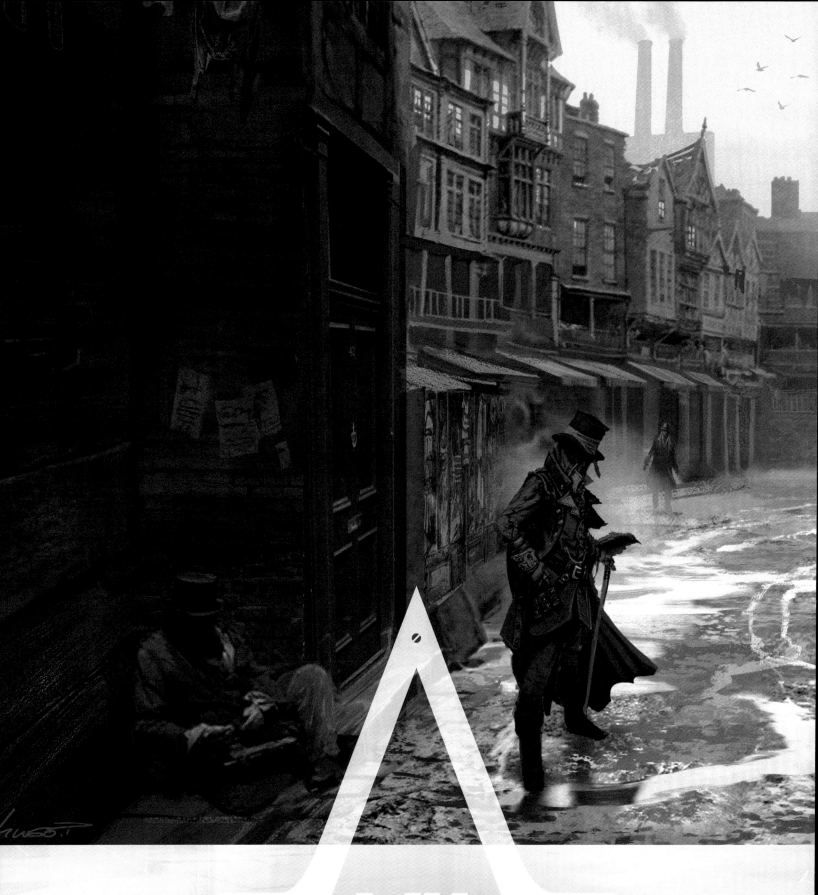

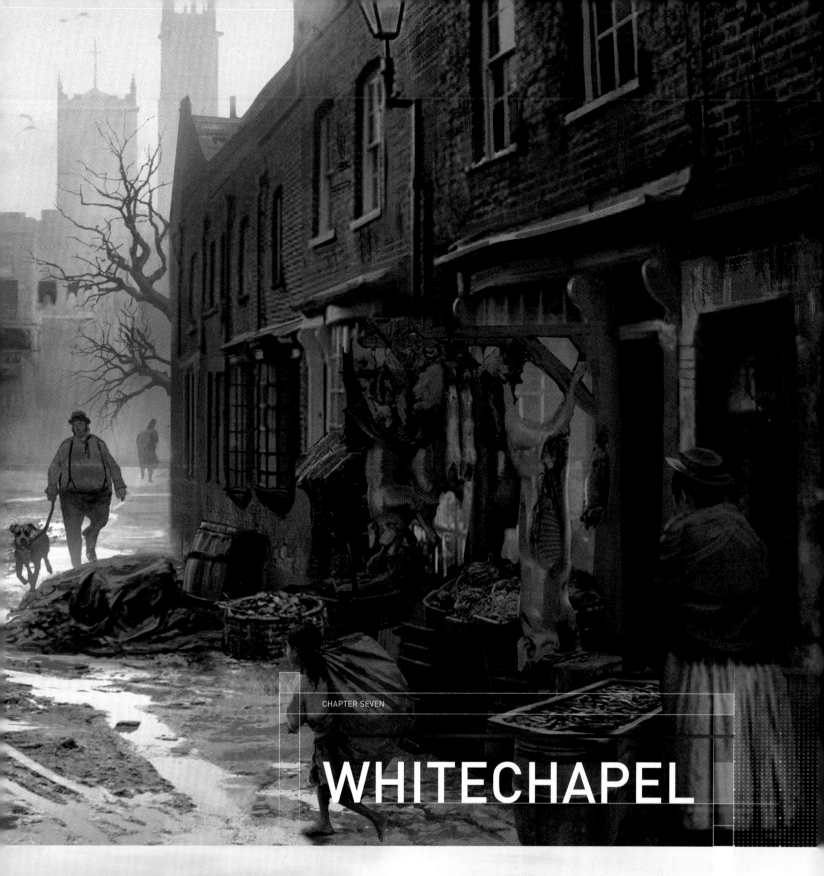

WHITECHAPEL

ONE OF THE GUIDELINES FOR THE CONCEPT TEAM WAS TO ENSURE THAT EVERY BOROUGH LOOKED UNIQUE AND REFLECTED ITS SOCIAL STATUS. RICH BOROUGHS HAVE LARGER STREETS, PARKS, CIVIC BUILDINGS AND PALACES, UPPER-CLASS CROWDS AND STORES. THE IMPOVERISHED BOROUGHS HAVE NARROWER STREETS, ALMOST NO VEGETATION, DECAYING ARCHITECTURE AND DAMAGED SIDEWALKS.

"London presents a dramatic and complex backdrop, defined by the contrasts between opulence and poverty. Industry is an ever-present aspect of daily life, and crime, disease, and pollution are rampant. The incongruity makes for an ideal game setting, filled with opportunities for artistic contrast. Whitechapel reveals the depth of poverty of the city's most afflicted citizens." Thierry Dansereau, art director.

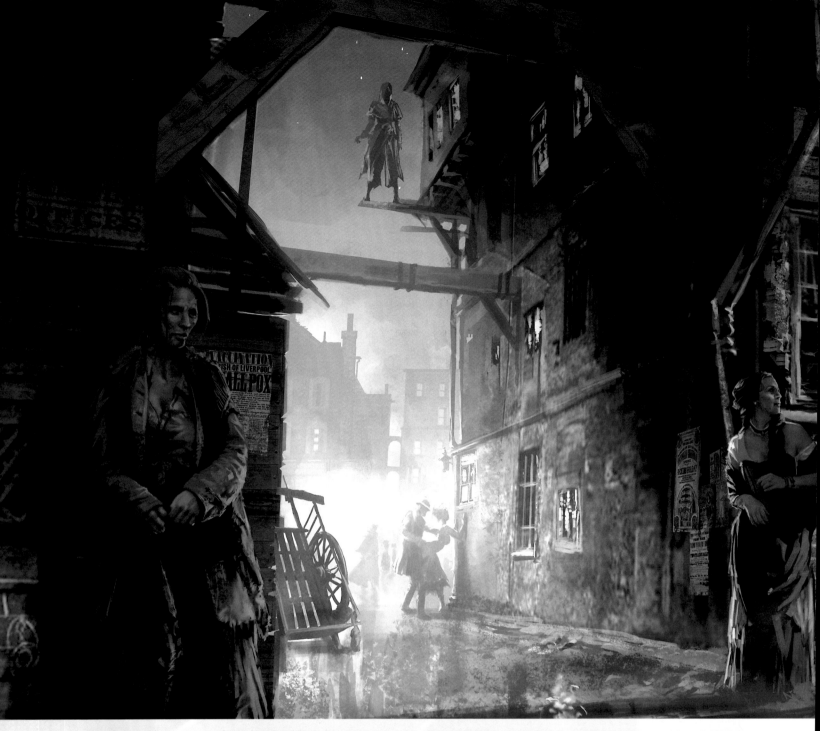

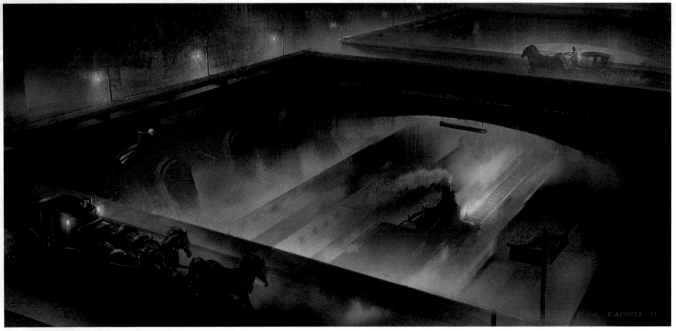

Assassin's Creed Syndicate

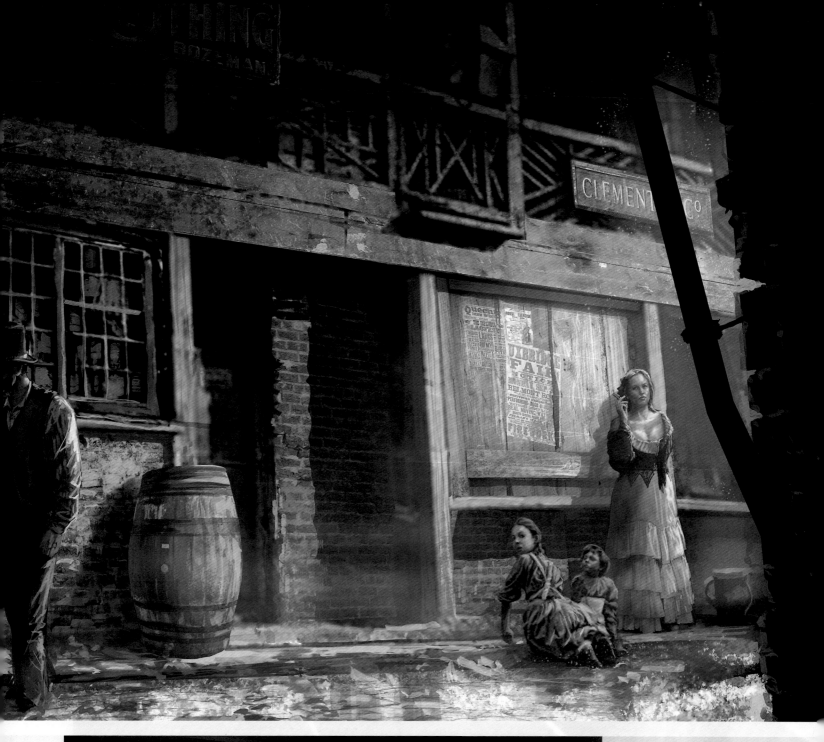

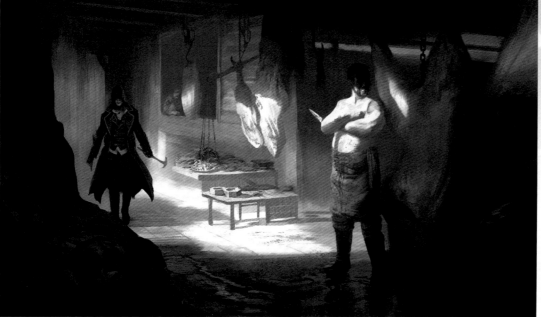

ABOVE: "Dark alley streets were a popular haunt for prostitutes and their clients to have a bit of privacy - if they even cared about that sort of thing." Grant Hillier, concept artist.

LEFT: "This route, lined with carcasses and blood streaming, would be a great place to explore. You could at least argue that the red brings color to the dull and sad streets." Hugo Puzzuoli, concept artist.

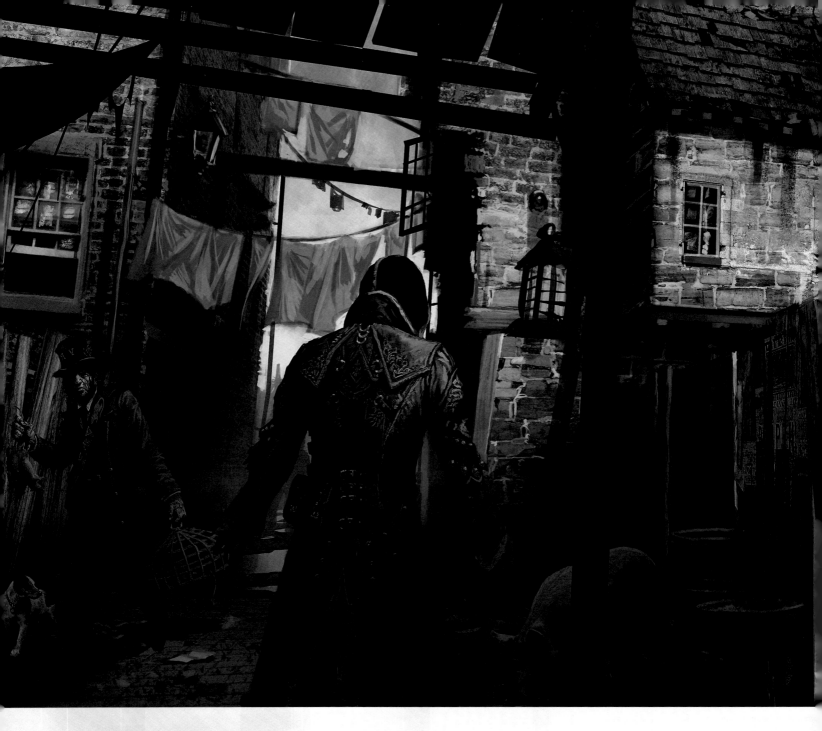

THE SLUMS

UNIMAGINABLE STENCH AND AN unerring sense of danger follow our heroes around London's most downtrodden district. Concept designer Grant Hillier's lively, texture-rich references do much to encourage exploration however. In creating the look of the area, Hillier says he mixed "old medieval wood and stone structures with more modern buildings, these back alleys were chaotic in form and overcrowded with poor and animals." Thierry Dansereau adds, "The lower class homes were ruins, tight buildings with no comfort, some even destroyed to build more factories and railways. They'd work fourteen hours a day for a very low wage in those same factories."

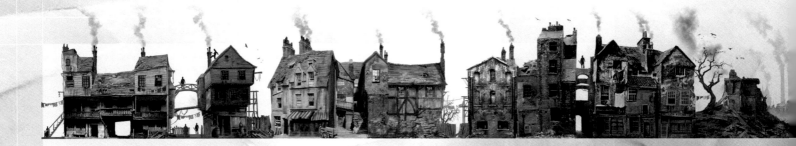

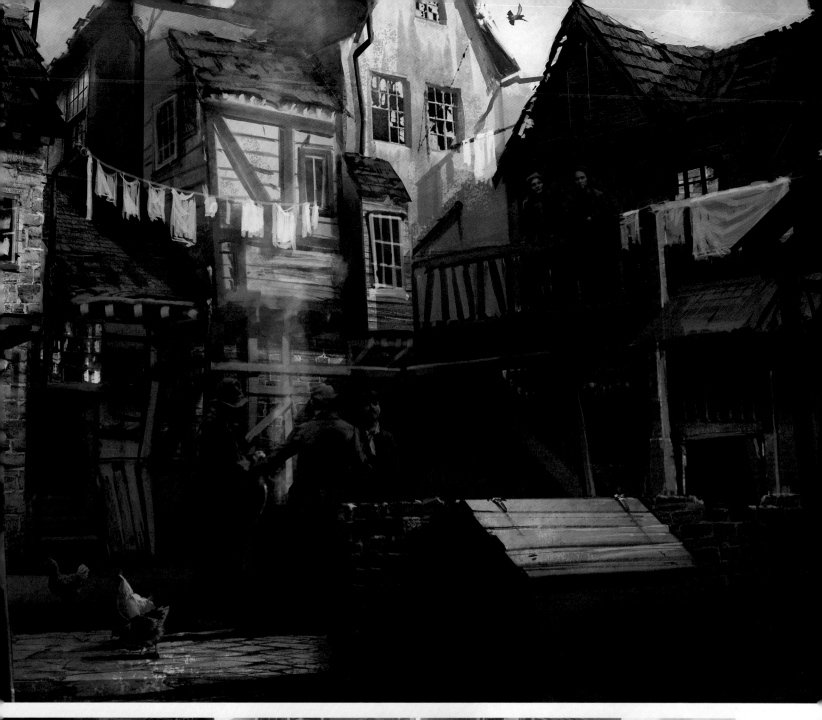

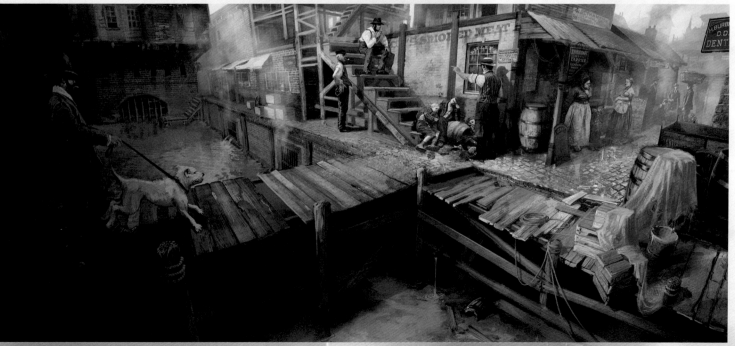

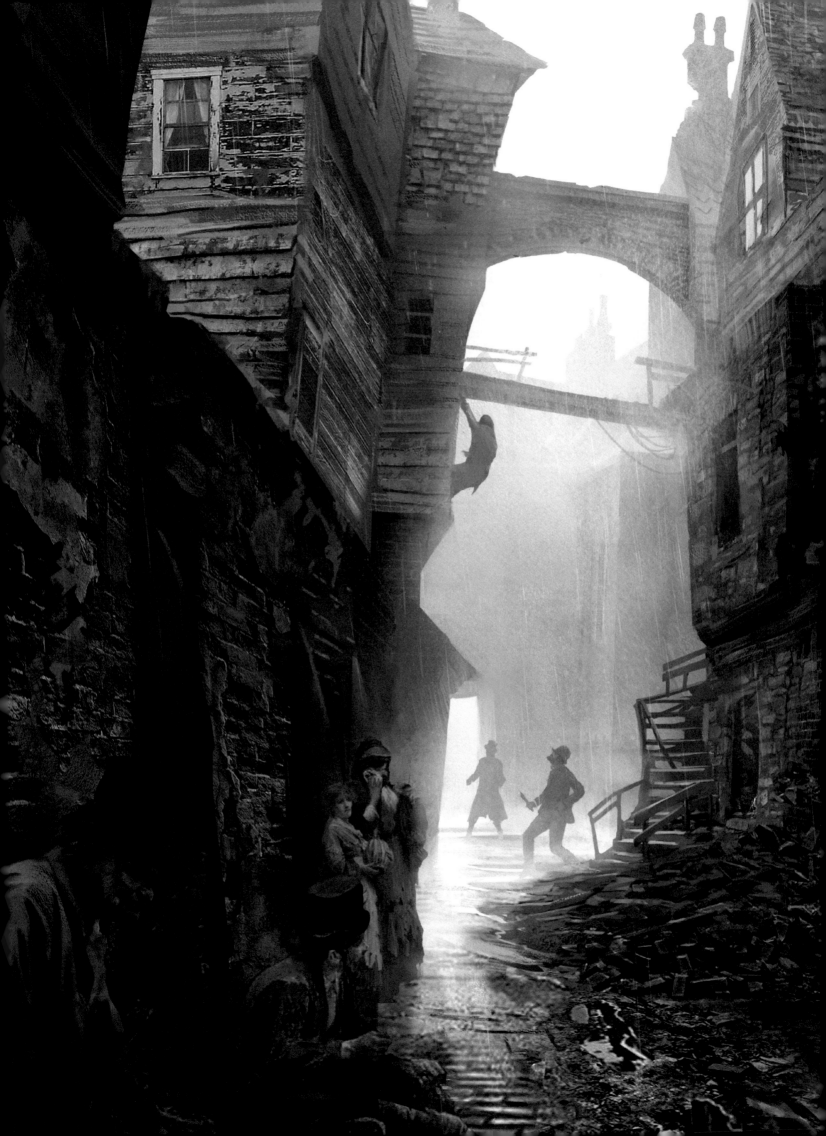

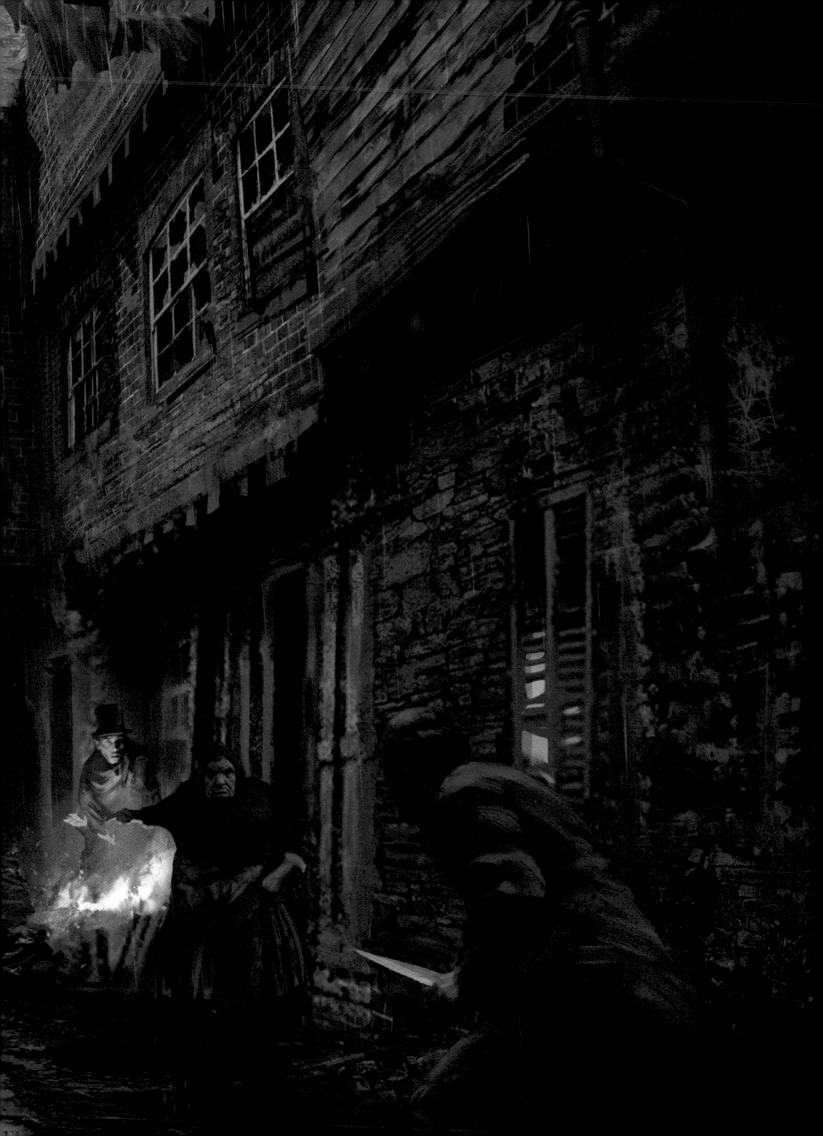

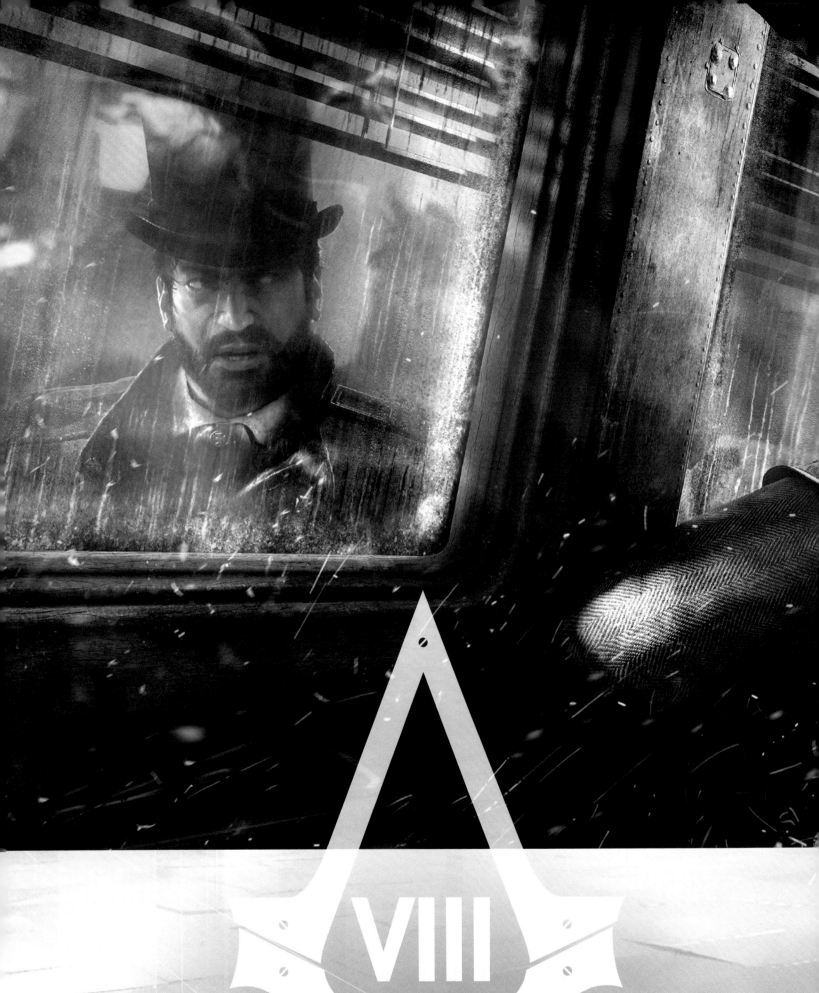

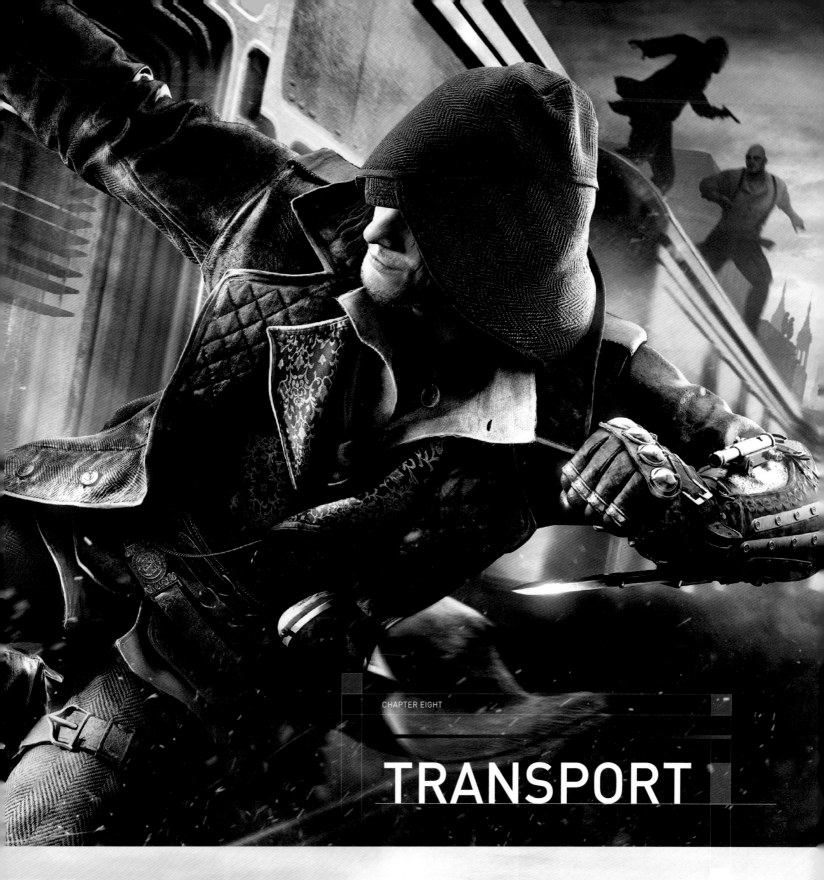

TRANSPORT

"BEING A TIME OF GREAT INNOVATION, WE HAVE THIS MOMENT WHERE WE SEE A MIX OF OLD AND NEW; RICKETY CARRIAGES, FANCY COACHES, LOCOMOTIVES AND STEAM BOATS. WE STARTED RESEARCH BY DIVING INTO ARCHIVES FULL OF DOCUMENATS AND IMAGERY. WE FAMILIARIZED OURSELVES WITH THE VARIETY OF VEHICLES. AFTER THAT, WE HAD OUR OWN LIBRARY TO SHARE."
JEAN-VINCENT ROY

Jacob, Evie, and newfound accomplice Henry Green would not gaze upon transportation in the same way as you or I. To them, carriages and fast moving trains are not so much promising the comfort of travel but vehicles by which to extend free-running assassination attempts. The concept work above shows Jacob ready to punch through the passenger window of a luxury coach. It offers little defense.

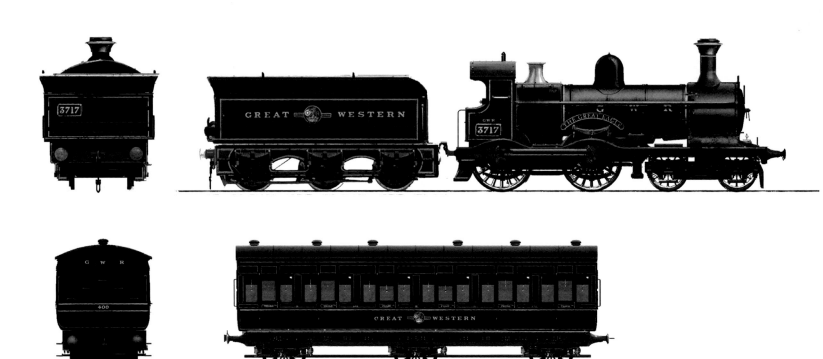

■ TRAINS

"STEAM LOCOMOTIVES ARE A great symbol of the era, metaphorically and thematically; signifying a new, faster paced city that is fuelled by coal. For Jacob and Evie, the train becomes home, their hideout; constantly in motion, adapting and evolving throughout the game, crossing the entirety of London. We took inspiration from three models of locomotives: Stirling's G Class '8-foot Single' 4-2-2, Stroudley's 'Terrier' 0-6-0T tank engine and the later GWR 3252 'Duke' Class 4-4-0.. We also recreated seven beautiful, iron and glass stations that connect to each other through rail lines."
Jean-Vincent Roy

BELOW: The Sterling 4-2-2, nicknamed "eight-footer" after its enormous driving wheels, was an express train capable of reaching 47 miles-per-hour. It was named after designer Patrick Sterling, intended for use as a high-speed workhorse, dragging as many as 26 passenger carriages between London and York. Its efficient design is considered a masterpiece.

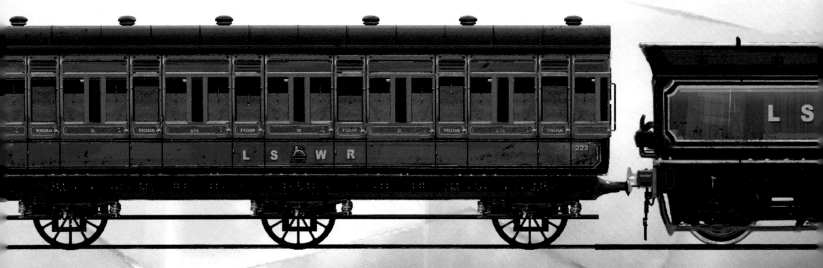

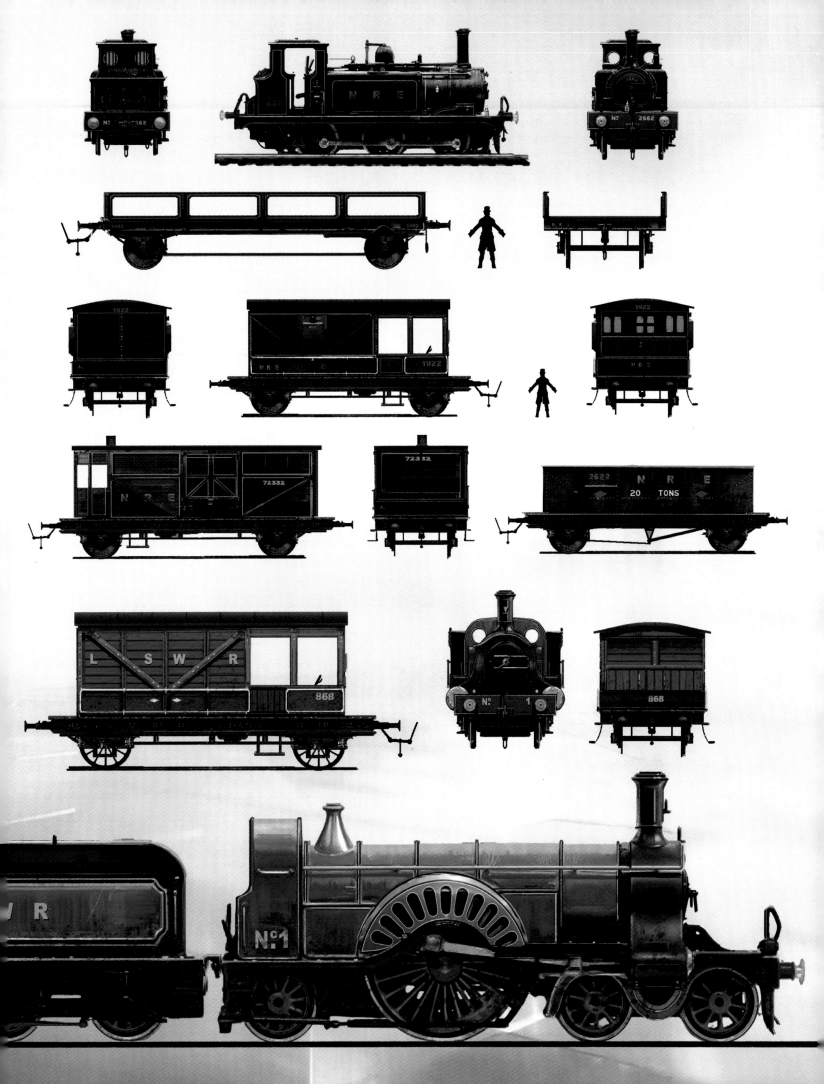

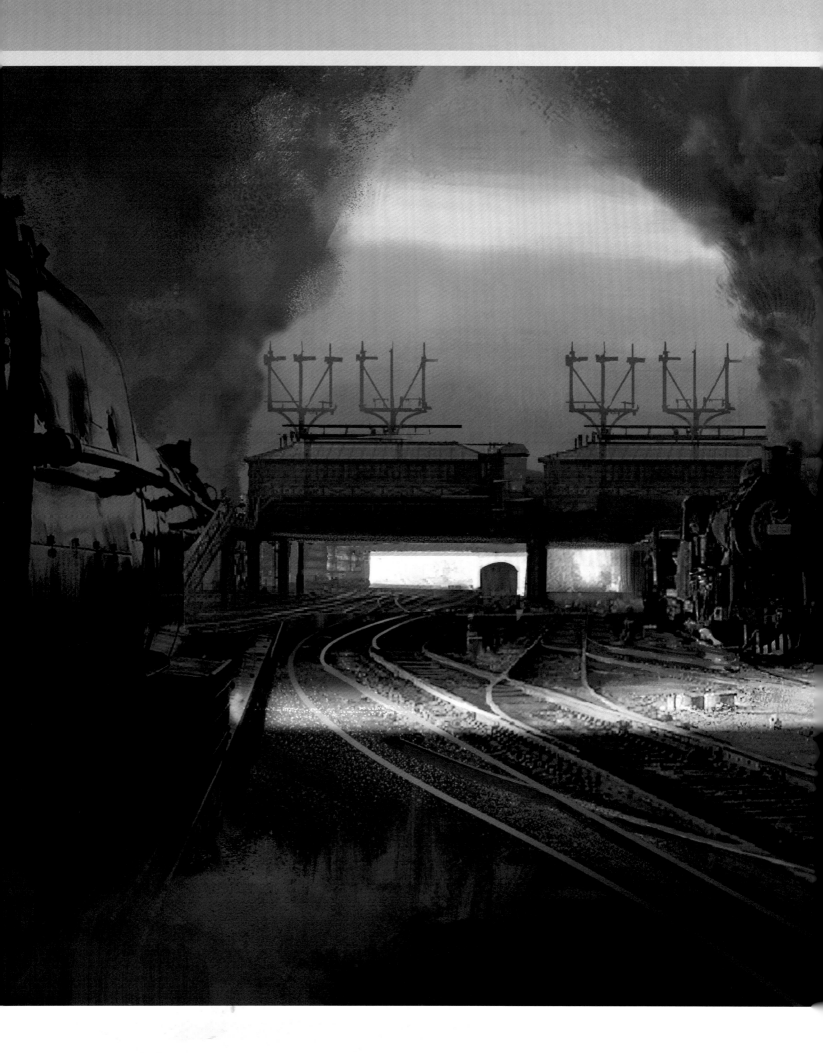

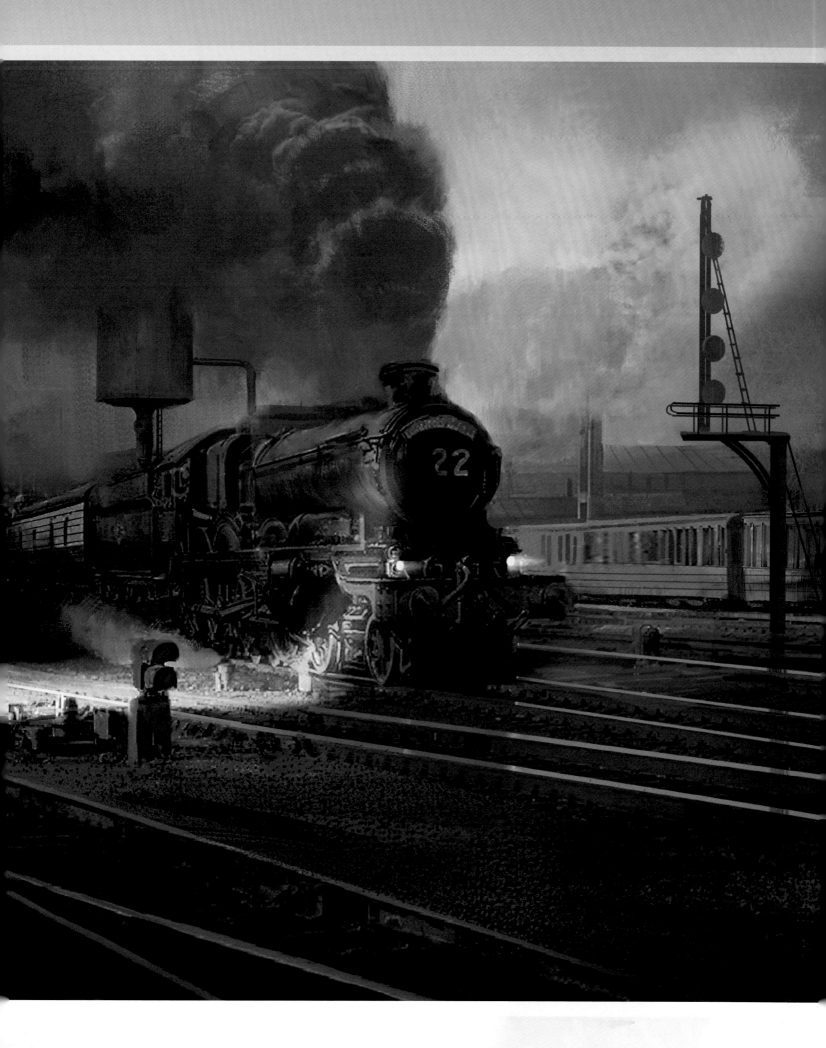

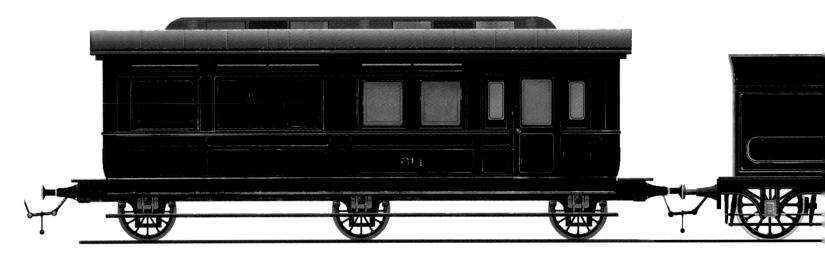

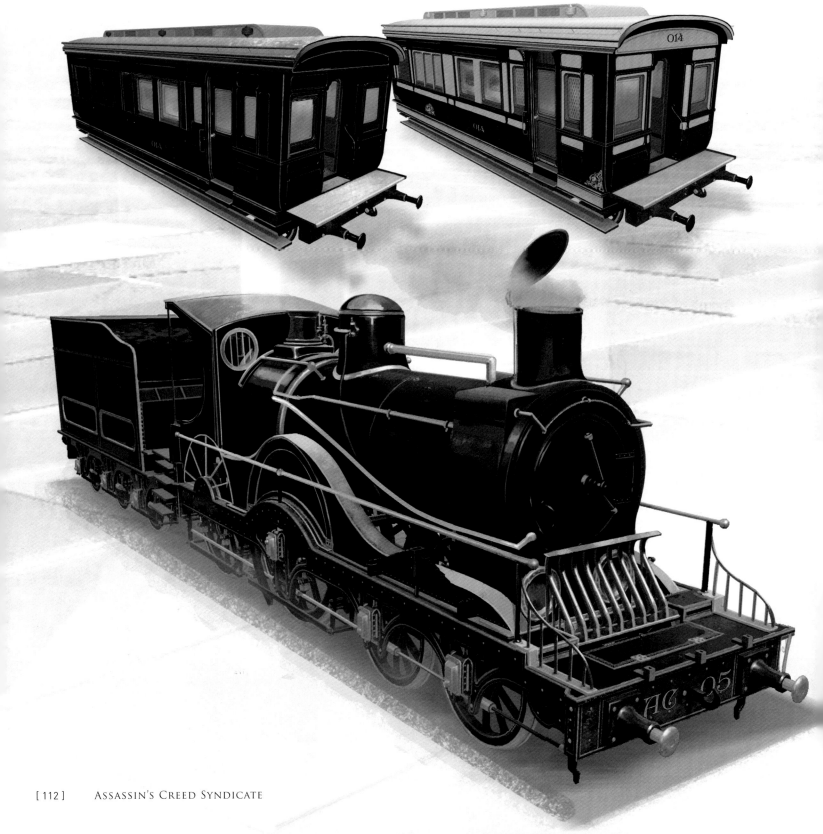

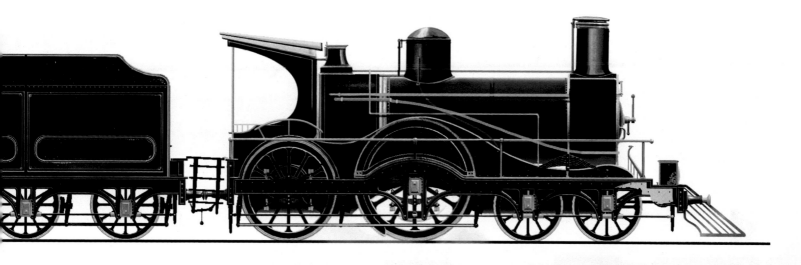

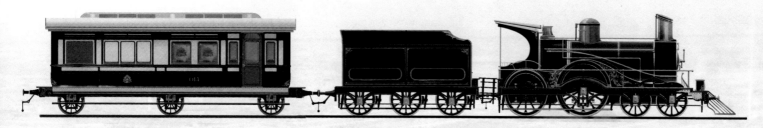

Artistic Director Yannick Corboz on artist David Alvarez's train concepts: "This is a custom arrangement of locomotives from those times. The fin and the wings add to the silhouette. The Assassin train design is inspired by the era (1870). It is a modern looking locomotive, its massive and stocky profile give it character and power. The red/silver color scheme of the ironwork and metal is the mark of the Assassins."

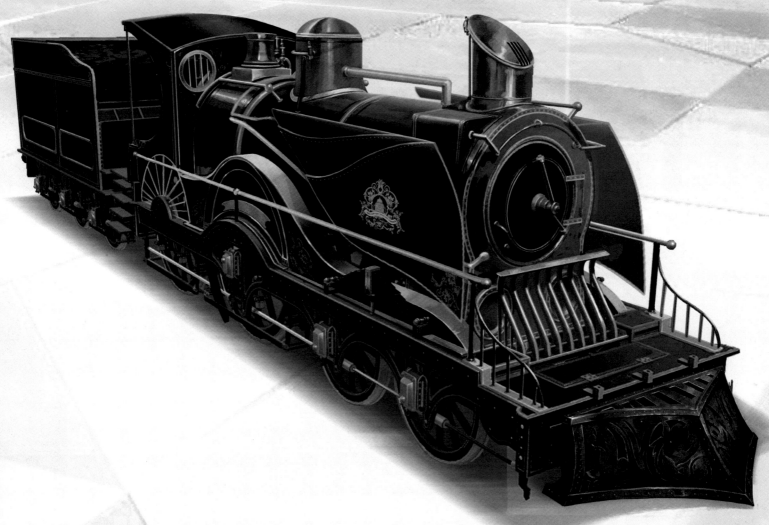

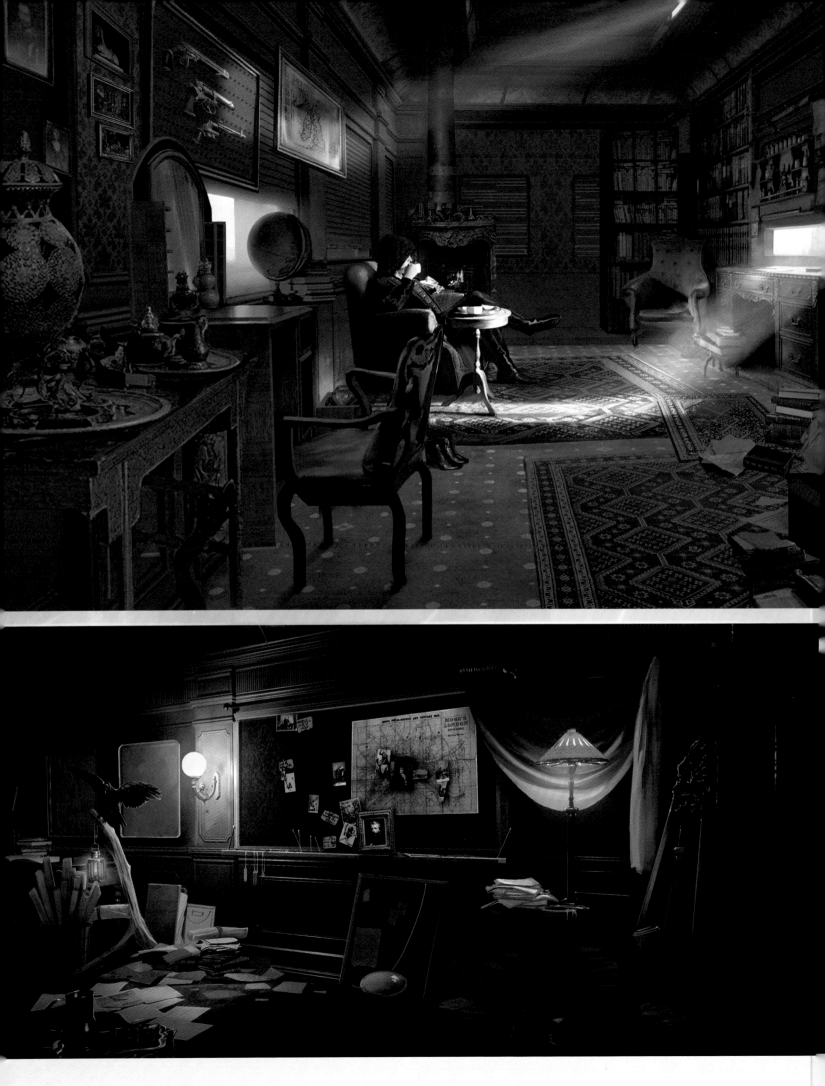

TRAIN HIDEOUT

QUARTERS WORTHY OF A successful Assassin partnership, aboard Jacob and Evie's fast-moving train HQ. The hideaway has its own workshop carriage in which to transform or create from scratch objects and weapons. There is also a 'recreation room' for The Rooks with a British pub atmosphere, although here is where Jacob exchanges information and decides group strategies. Jacob and Evie's private carriage (left) is where they may choose to take some rest while they're not formulating new plans. In another area the team has created a mural showing visual representations of assassination successes and those under investigation. Concepts are penned by senior artist David Alvarez.

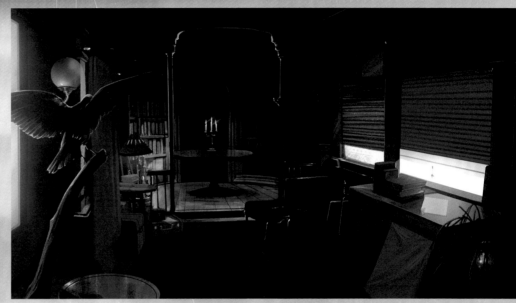

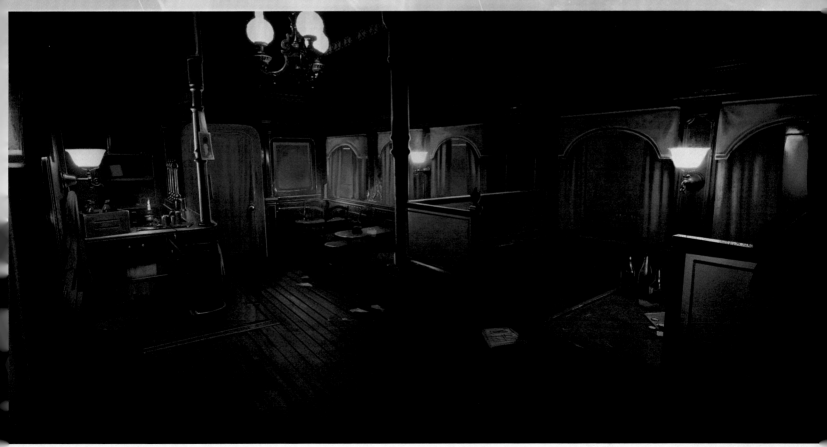

COACHES

EACH NEW CHAPTER IN the *Assassin's Creed* series introduces technical feats to surpass the last. *Syndicate* allows for the Assassin to leap seamlessly between fast-moving carriages before taking control if they wish. Jean-Vincent Roy: "Carriages are a part of the world system, ever present and always something we can interact with. In addition to speed of travel and stealth opportunities, there are activities; hijacking, racing and escorts, making for many engaging opportunities. There is always a chance that you will run into enemy gang members, or that you can get side swiped or rammed, forcing you to seek out a new carriage. The streets of London provide the space you need to chase down targets or escape from enemies. The police also have their own presence on carriages and will respond to you and other characters within the world."

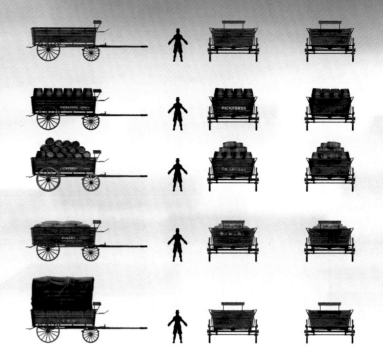

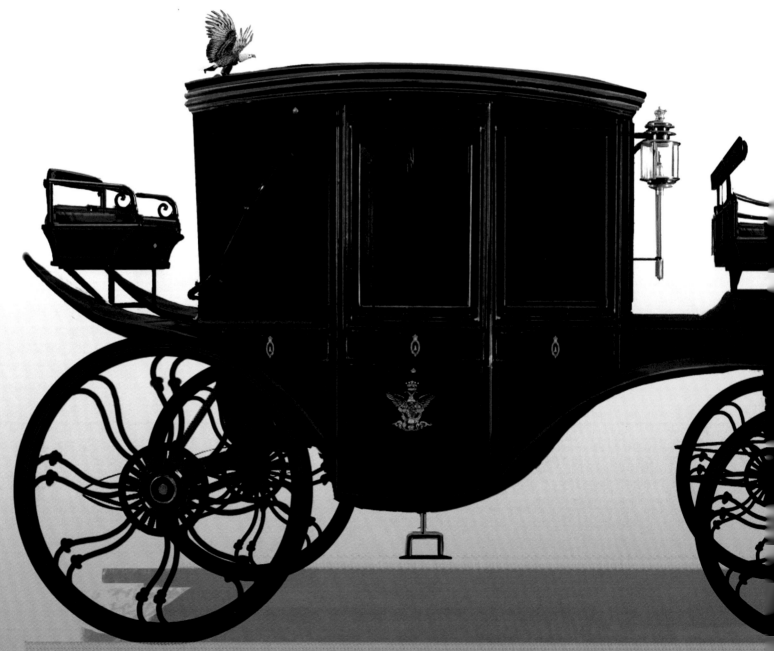

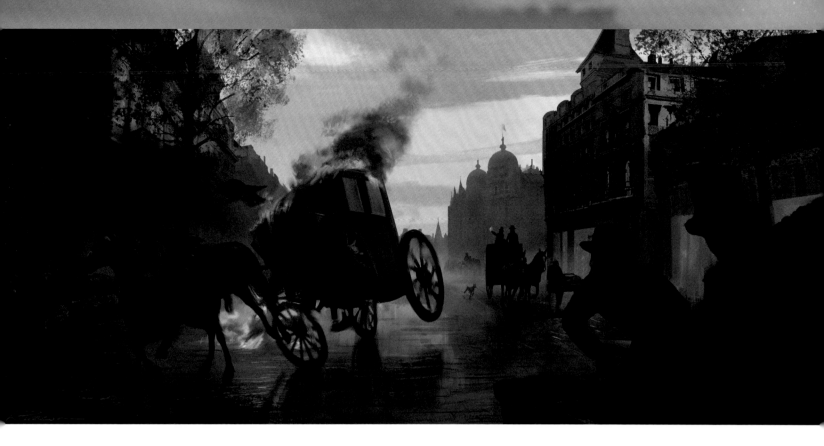

Hugo Puzzuoli's burning carriage that we dare say he had a fun time creating; firebombed out of action with its driver and occupants forced to abandon the ride. The man leaping to safety appears to be making a dive for the flower stall, hoping for a softer landing.

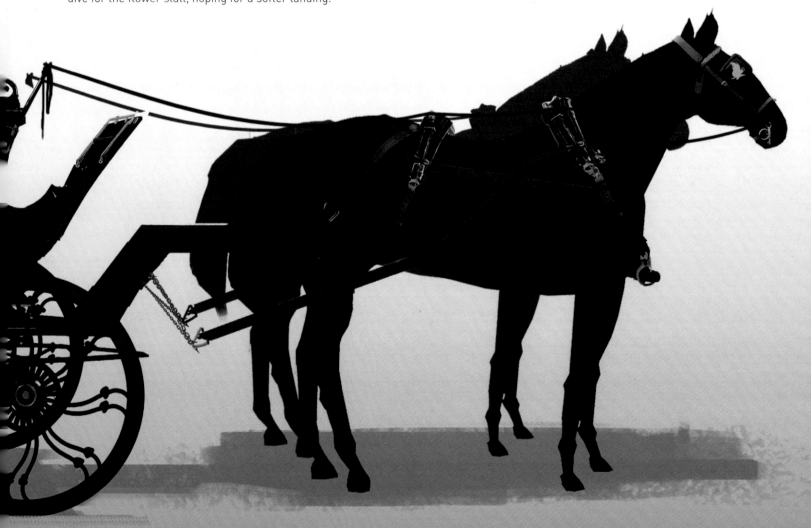

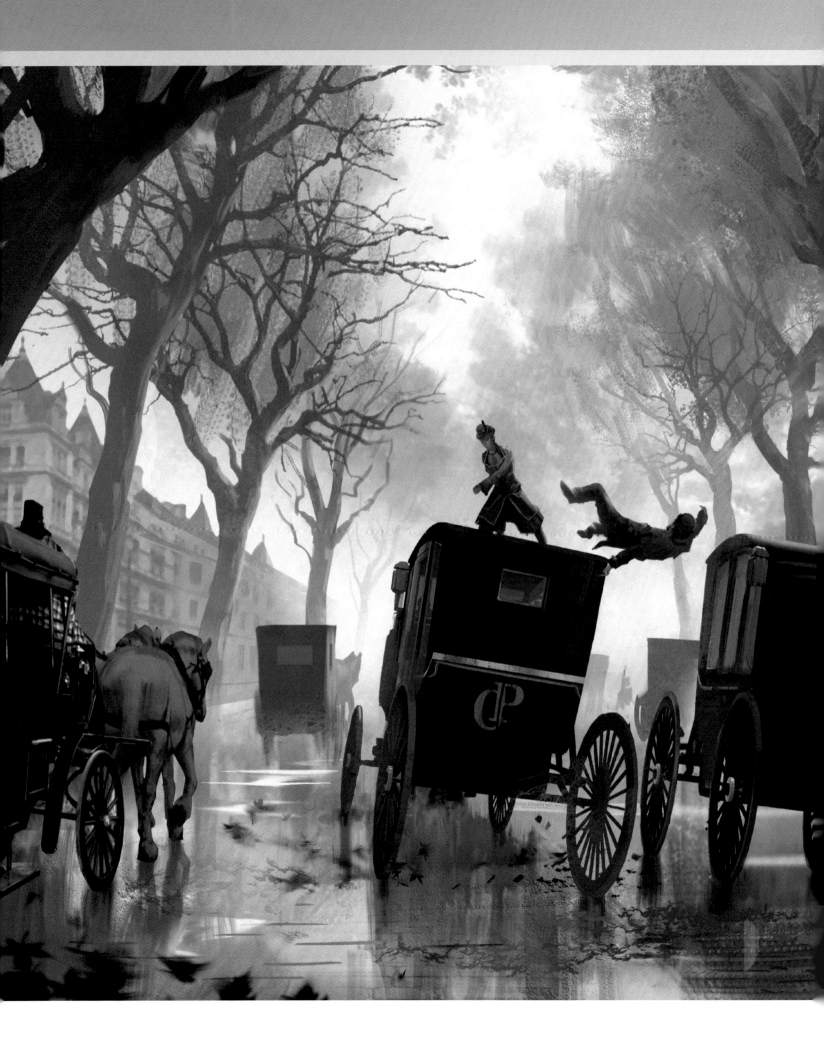

Assassin's Creed Syndicate

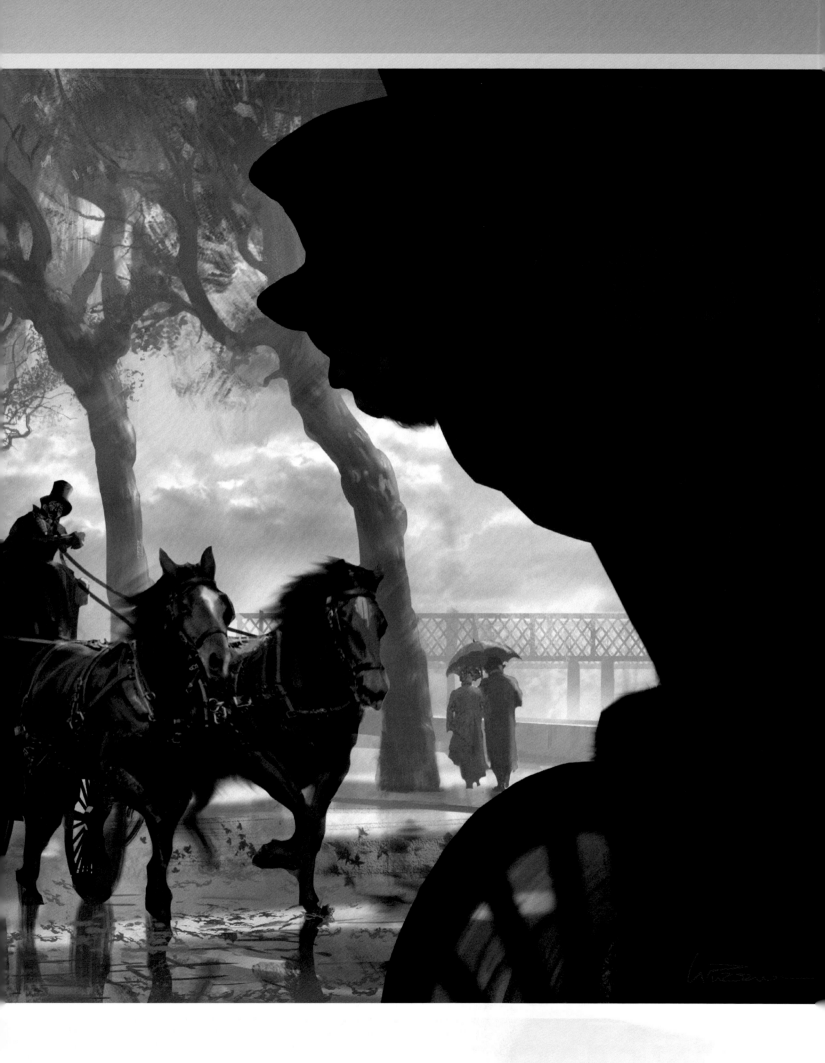

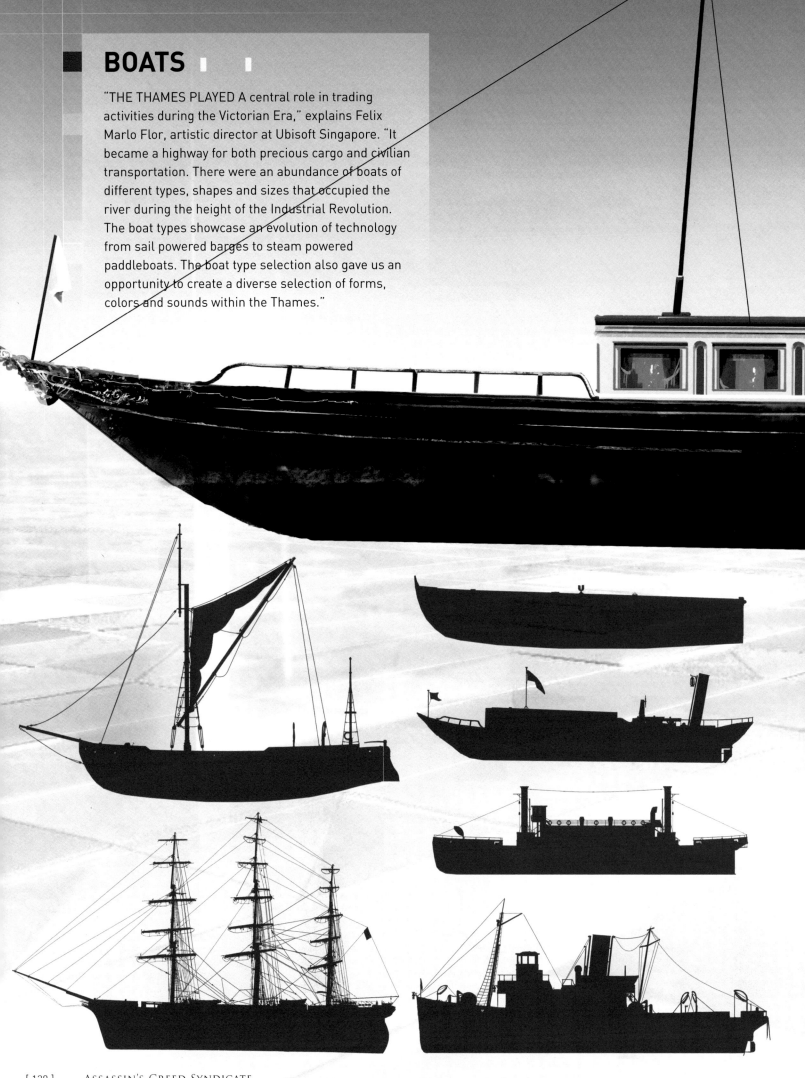

BOATS

"THE THAMES PLAYED A central role in trading activities during the Victorian Era," explains Felix Marlo Flor, artistic director at Ubisoft Singapore. "It became a highway for both precious cargo and civilian transportation. There were an abundance of boats of different types, shapes and sizes that occupied the river during the height of the Industrial Revolution. The boat types showcase an evolution of technology from sail powered barges to steam powered paddleboats. The boat type selection also gave us an opportunity to create a diverse selection of forms, colors and sounds within the Thames."

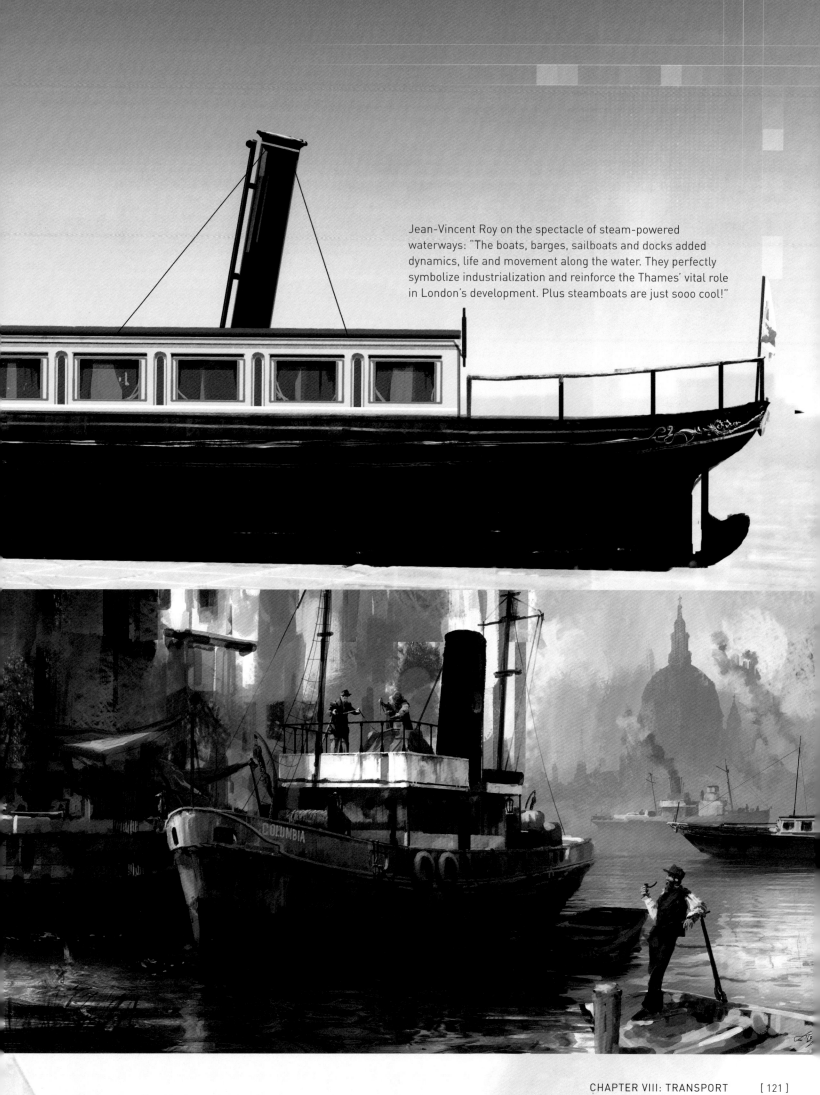

Jean-Vincent Roy on the spectacle of steam-powered waterways: "The boats, barges, sailboats and docks added dynamics, life and movement along the water. They perfectly symbolize industrialization and reinforce the Thames' vital role in London's development. Plus steamboats are just sooo cool!"

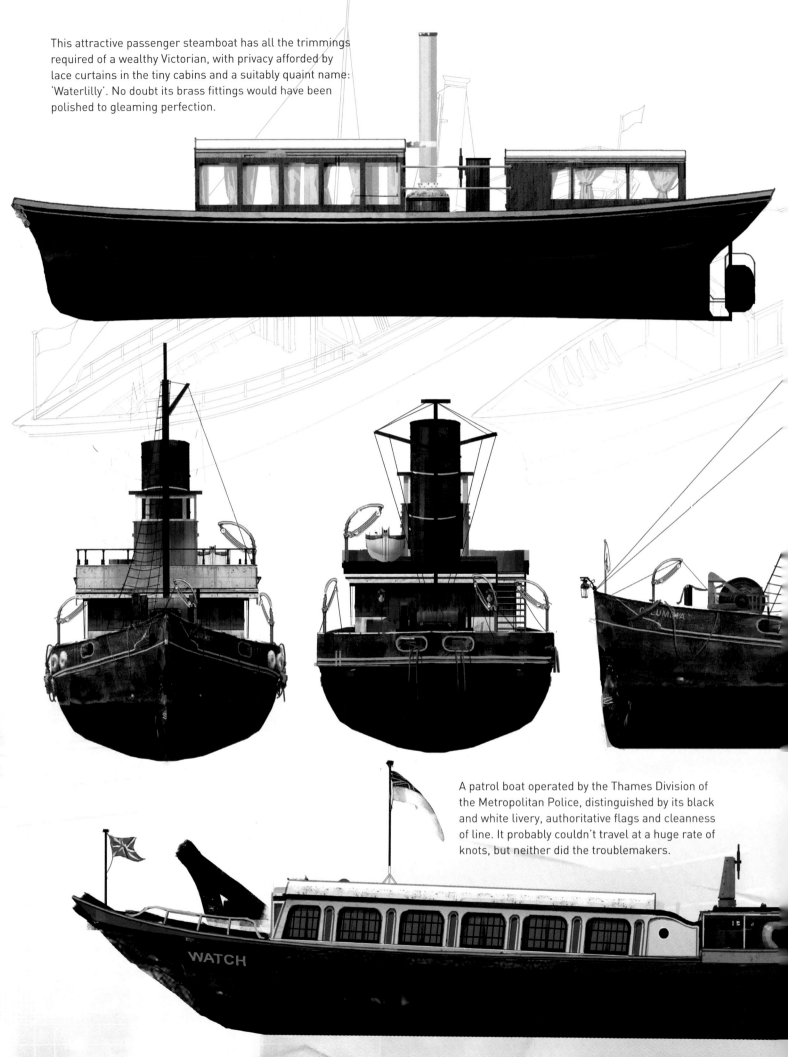

This attractive passenger steamboat has all the trimmings required of a wealthy Victorian, with privacy afforded by lace curtains in the tiny cabins and a suitably quaint name: 'Waterlilly'. No doubt its brass fittings would have been polished to gleaming perfection.

A patrol boat operated by the Thames Division of the Metropolitan Police, distinguished by its black and white livery, authoritative flags and cleanness of line. It probably couldn't travel at a huge rate of knots, but neither did the troublemakers.

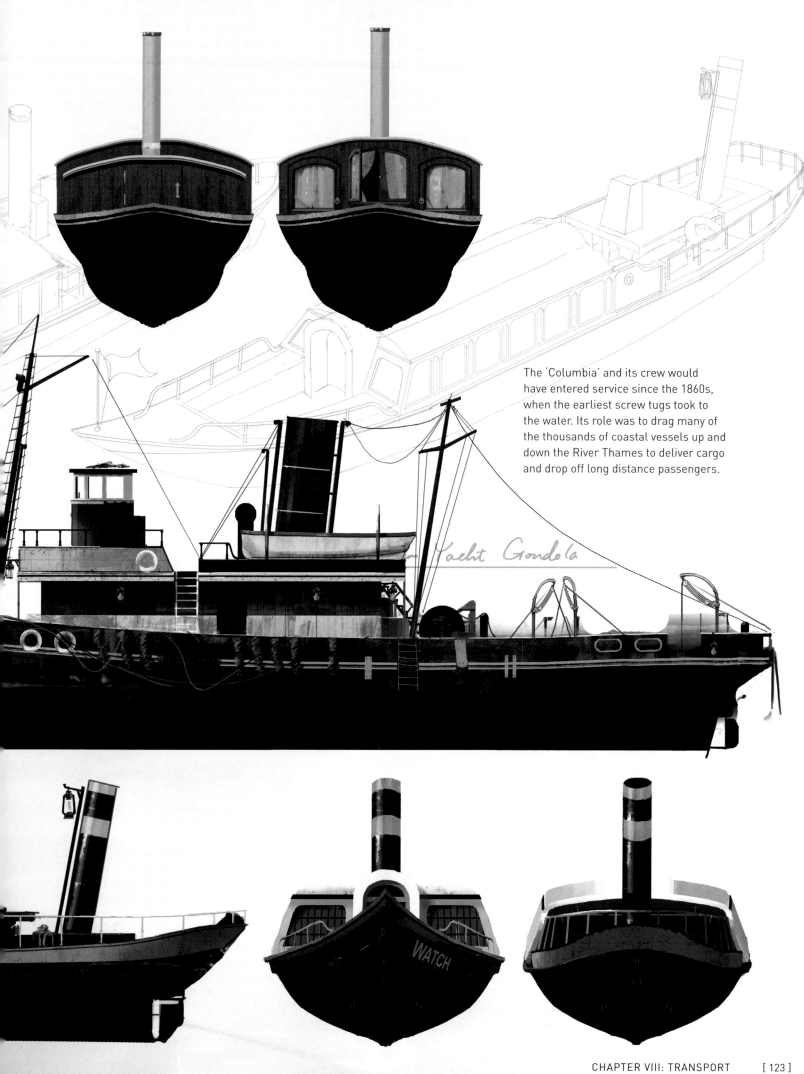

The 'Columbia' and its crew would have entered service since the 1860s, when the earliest screw tugs took to the water. Its role was to drag many of the thousands of coastal vessels up and down the River Thames to deliver cargo and drop off long distance passengers.

WATCH

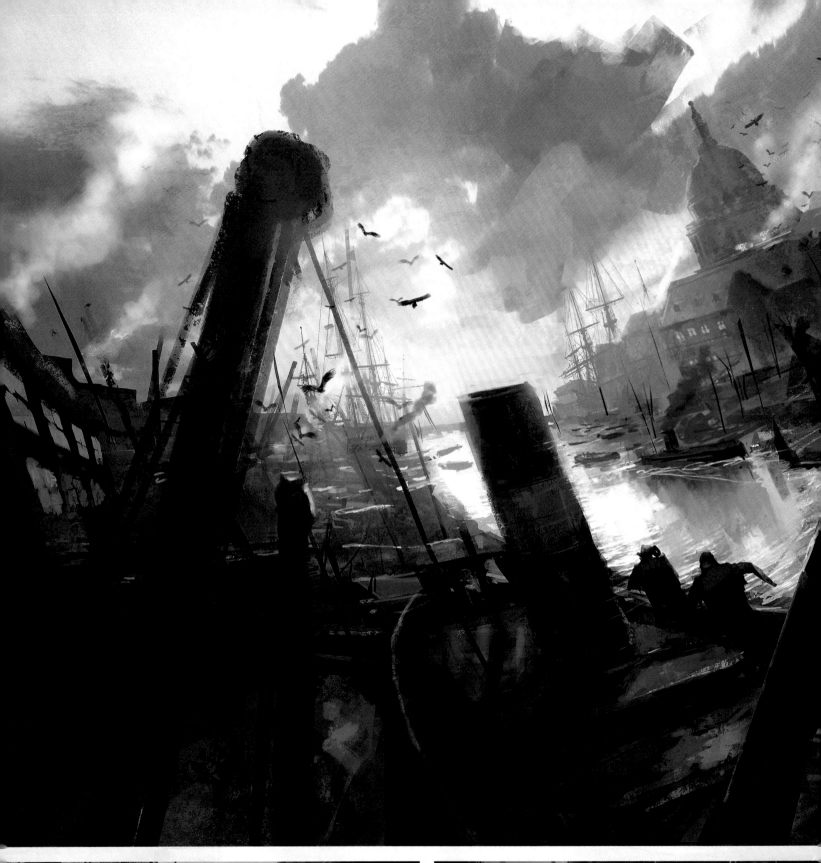

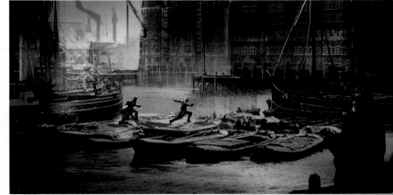

Assassin's Creed Syndicate

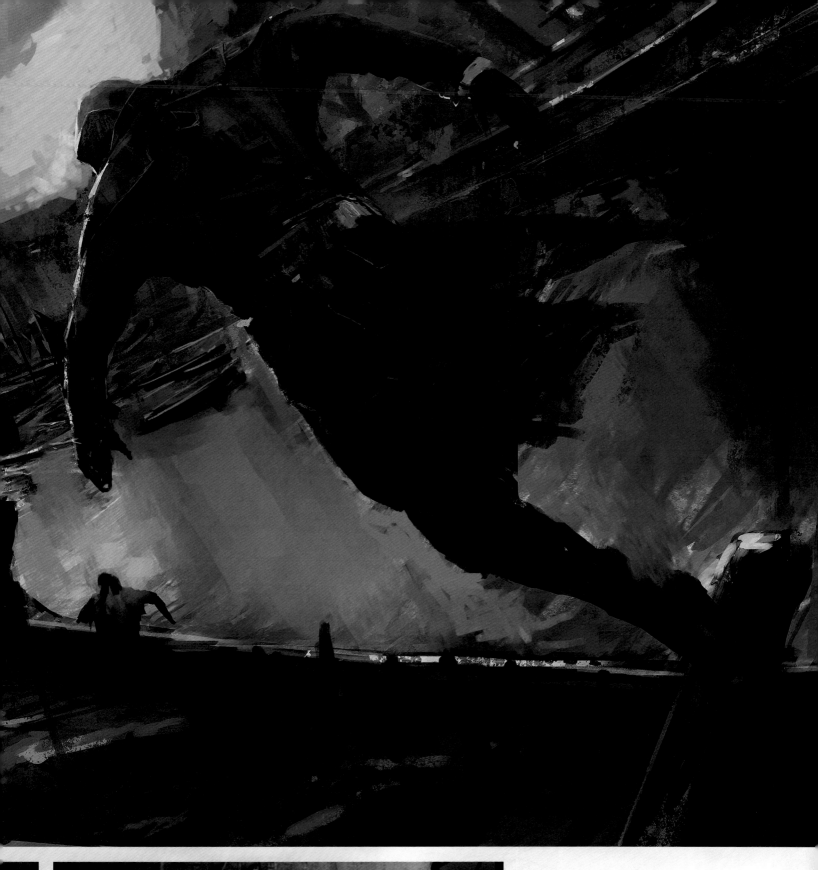

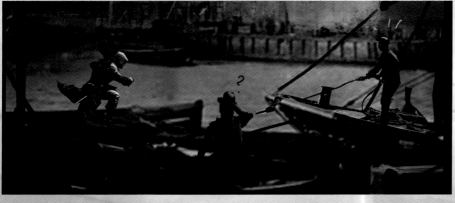

"The boats on the Thames helped give the river a different character. It enabled the possibility to create a dynamic, traversable land mass. This concept uses a very dynamic composition to support the idea of movement. To achieve this sense of movement, there are almost no lines in this piece that are axis-aligned."
Felix Marlo Flor.

ASSASSIN'S CREED SYNDICATE

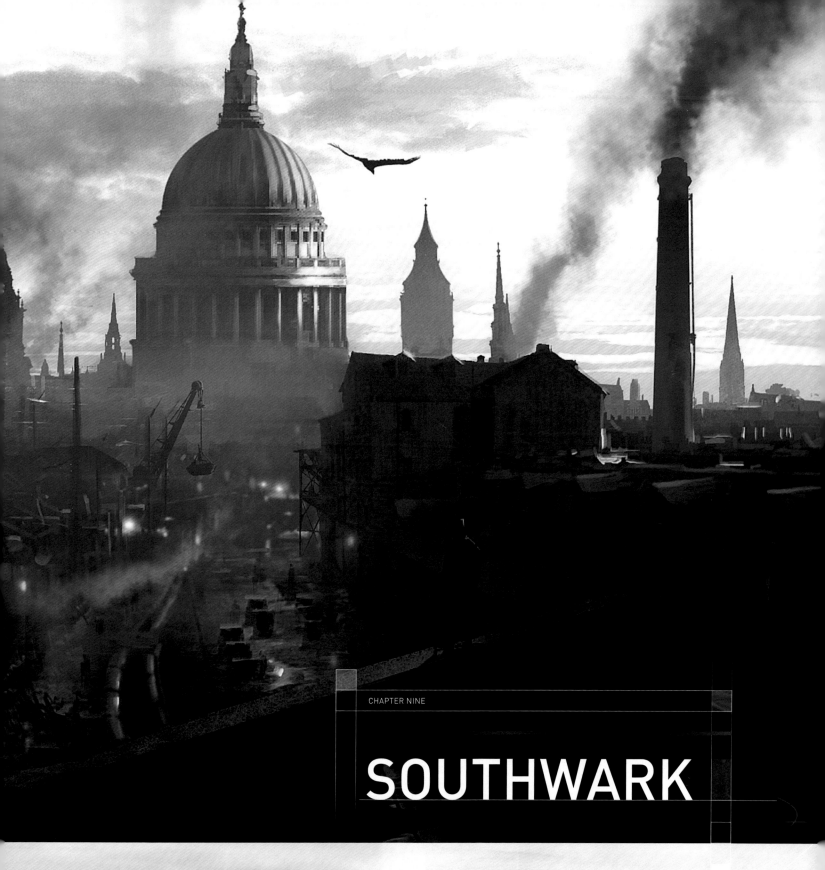

SOUTHWARK

ON THE POLISHED SURFACE, THE STEAM-PROPELLED INDUSTRIAL REVOLUTION GIFTED A BOON ACROSS ALL WALKS OF LIFE. BUT THE EXPRESS TRAIN PUFFING ROMANTICALLY THROUGH THE BRITISH COUNTRYSIDE WAS FAR FROM THE REALITIES OF DISEASE-RIDDEN SLUMS, POLLUTED RIVERS AND TREACHEROUS WORKING CONDITIONS WITHIN THE FACTORIES. COMMERCE WAS THRIVING, BUT PEOPLE WERE DYING.

Southwark became the epicenter of London's contribution to grand-scale manufacture, in stark contrast to districts such as Westminster. Says Jean-Vincent Roy: "Signature elements of the Industrial Revolution were factories, warehouses, trains and train stations, ever-expanding railway networks, slums, working-class lodgements and intense pollution, among other things, creating a unique visual signature for *Assassin's Creed Syndicate*."

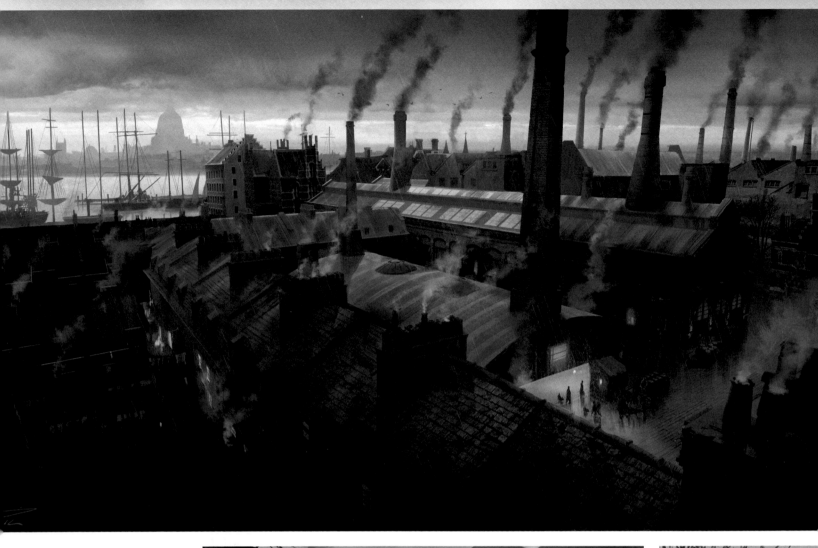

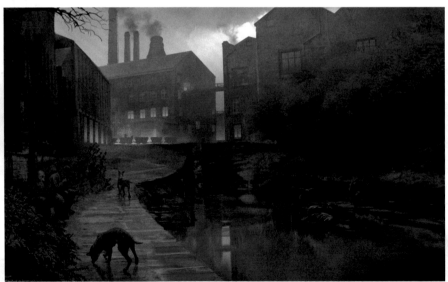

Overworked animals strain against their loads and chimneys choke the sky as workers pay no mind to the crack of dawn, St. Paul's and Big Ben are merely specters in the clouds. Astonishing feats of engineering also led to misery in the making.

"This era's brick factories are so iconic with their long smoking chimneys, their dirty walls and their thousands of workers toiling nights into days. To illustrate these industrial zones is like illustrating a world in itself, with the factory as the main character." Hugo Puzzuoli, concept artist.

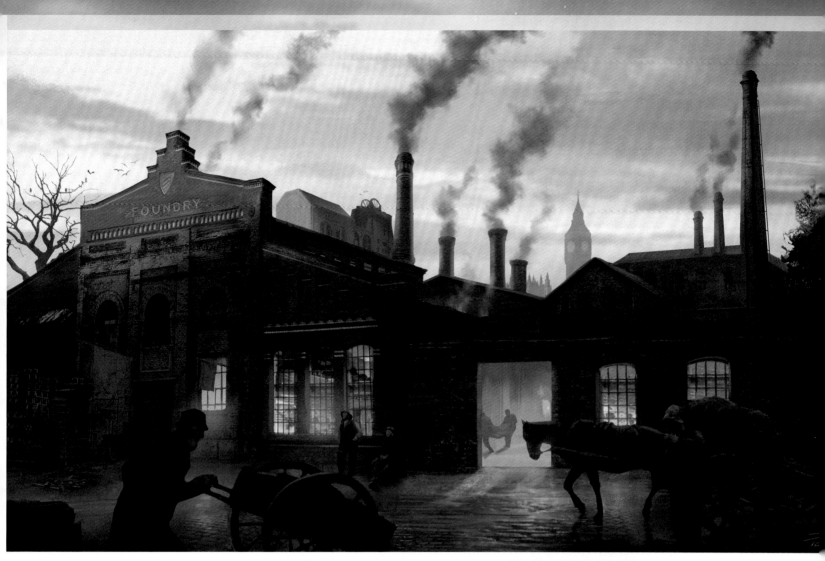

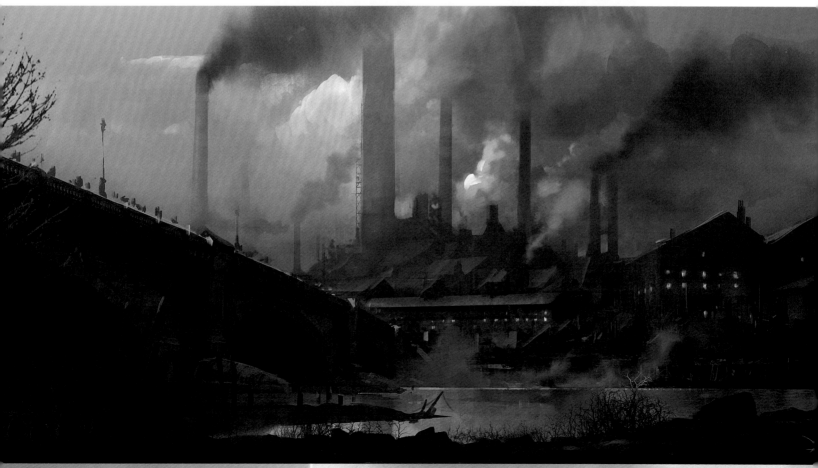

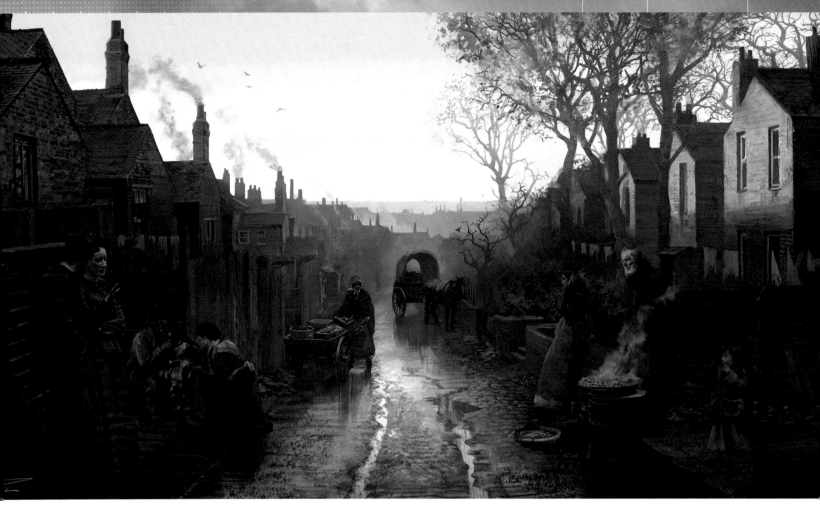

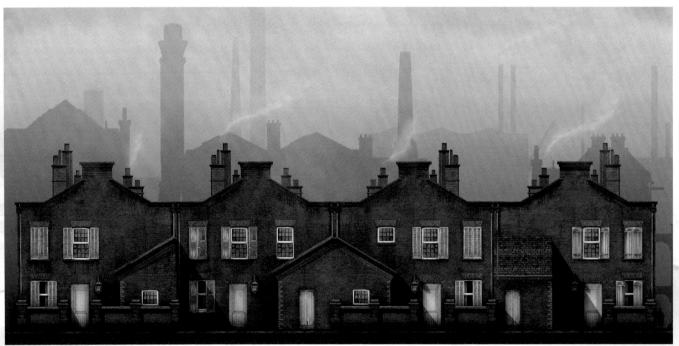

Housing built especially for factory workers was a smart move on the part of factory owners, but living conditions would have been miserable. Pollution made hygiene impossible, contaminated water often lead to diseases like cholera.

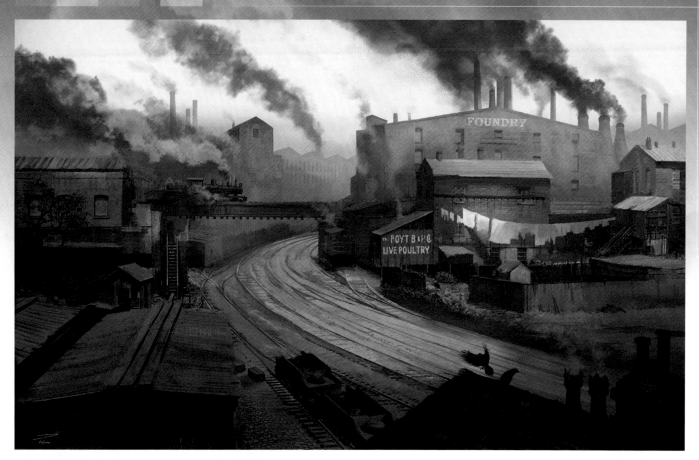

Ironically, the 'Live Poultry' in the area adjacent to the foundry would've enjoyed more personal freedom at this time than the humans they nourished. An incoming dock train trundles above a crude dirt track, absently highlighting the frantic approach of railway development. Industrial districts must have seemed like hell on earth, characterized by red brick and thick black smoke.

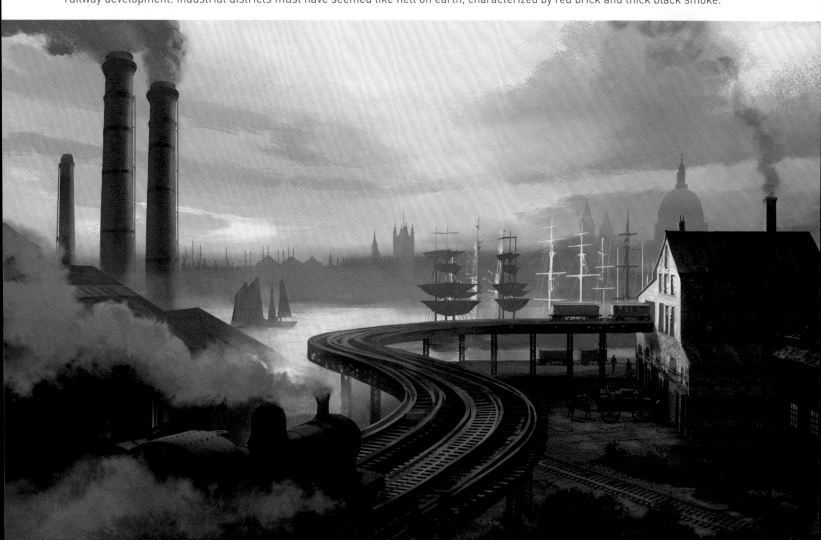

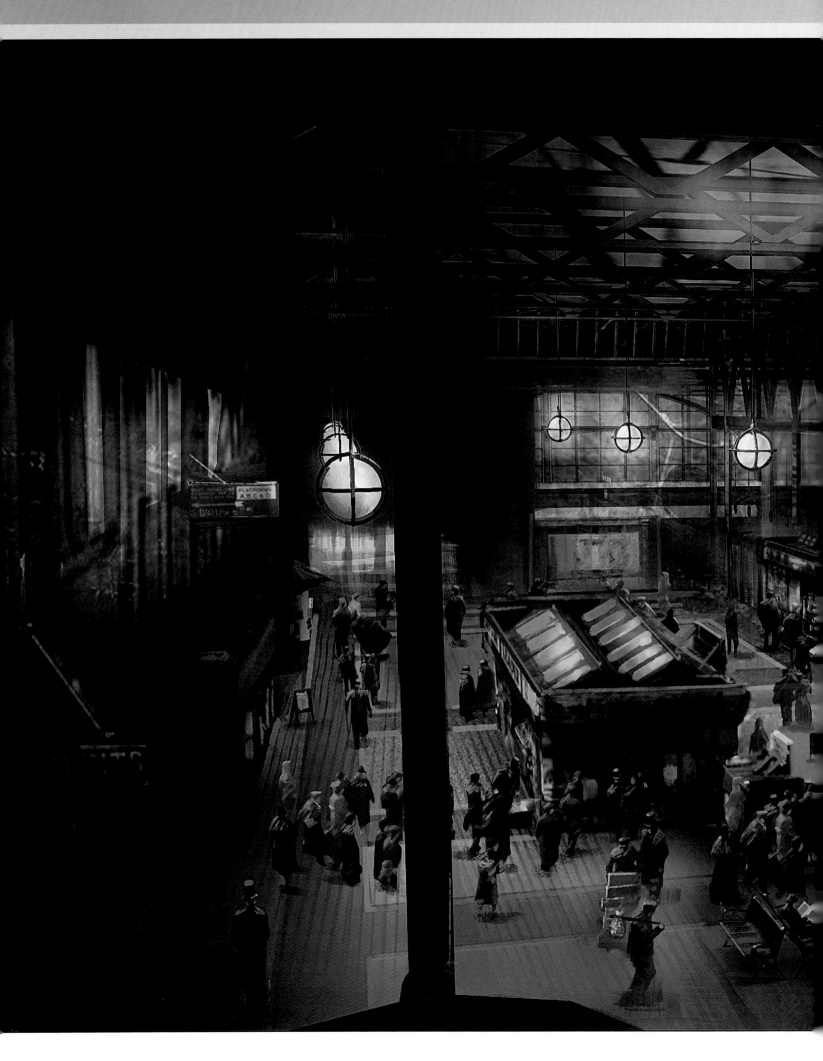

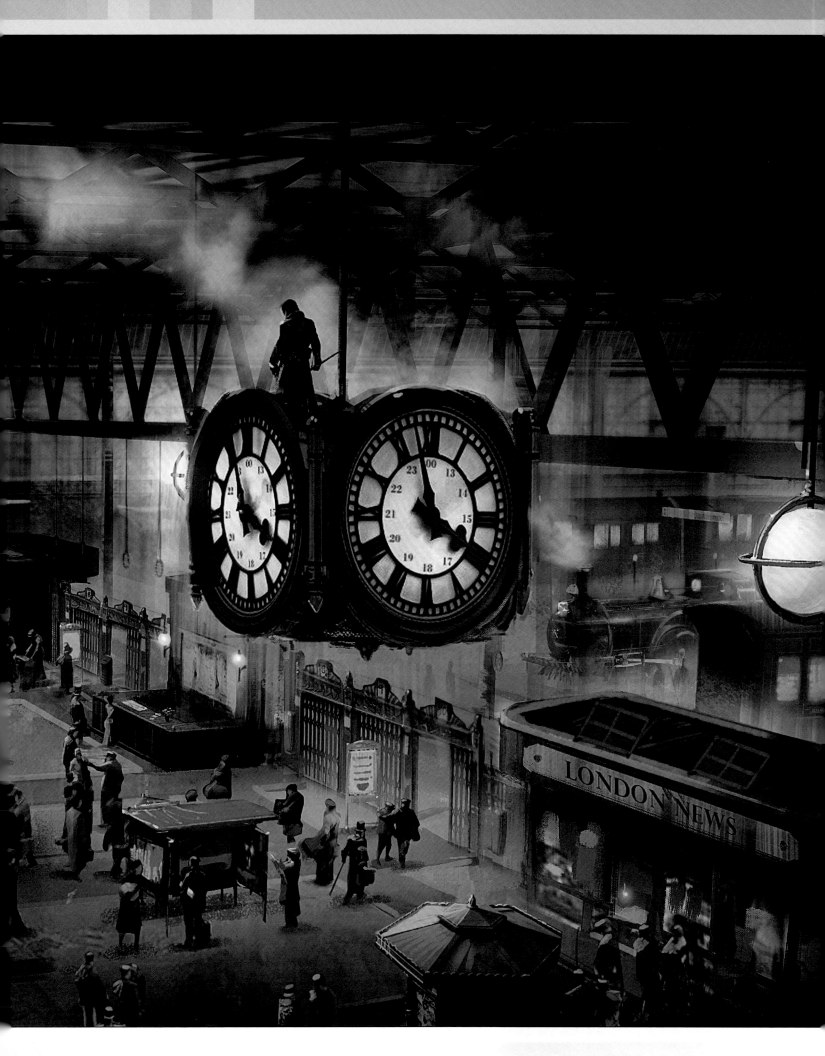

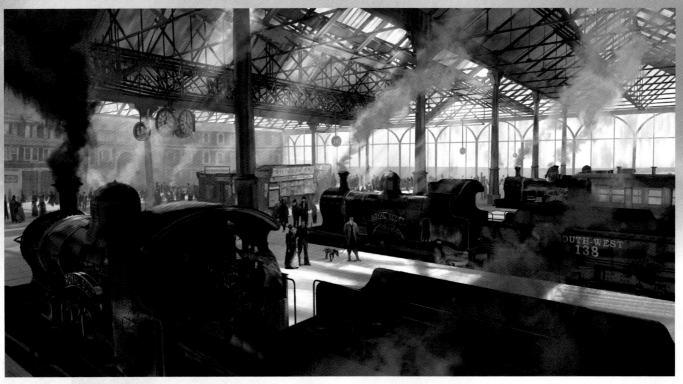

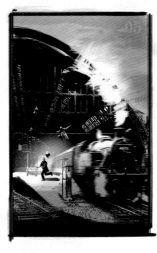

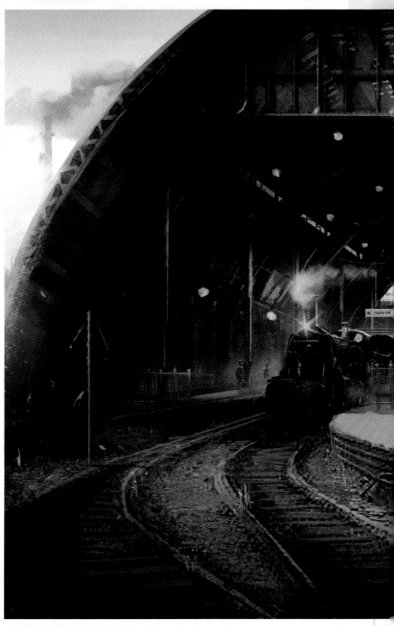

Waterloo train station is the setting for one of the finest sequences in *Assassin's Creed Syndicate*, during which our Assassin leaps heroically above moving trains to the platform. The drama is storyboarded above, a process undertaken for all set-piece events in the game. A feature-rich environment such as this, with so many moving components and atmospheric effects, takes months to plan and execute. But for just one heart-stopping moment such as this you have to say it's all worthwhile.

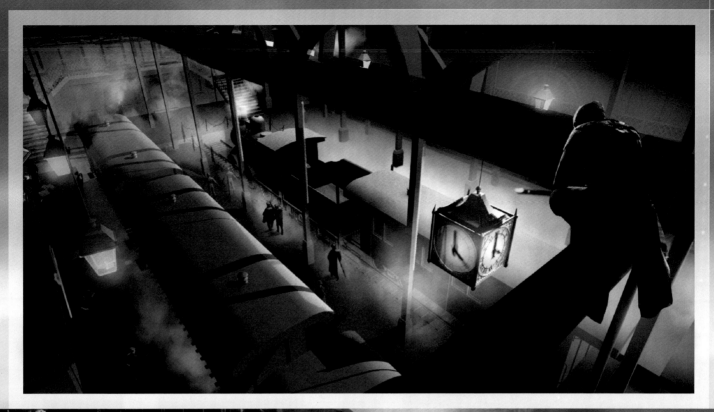

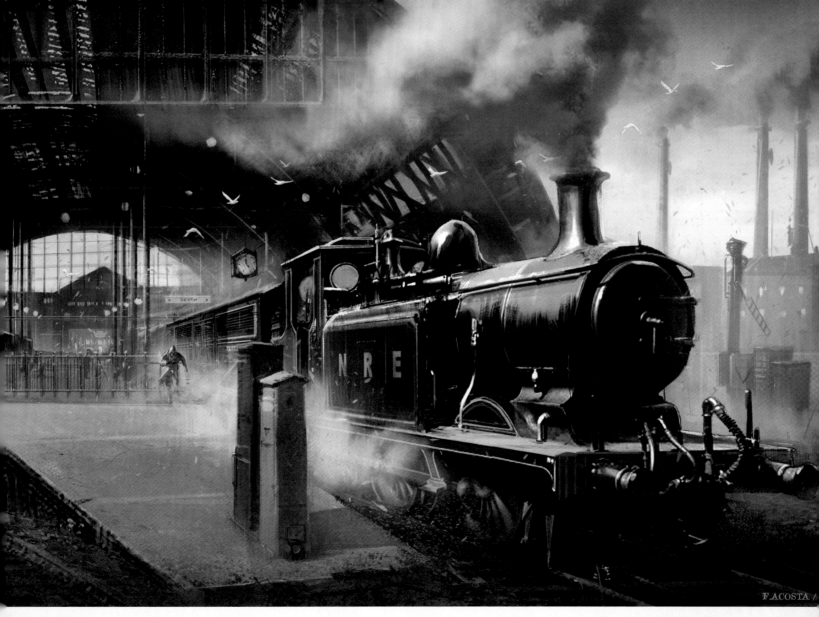

F.ACOSTA /

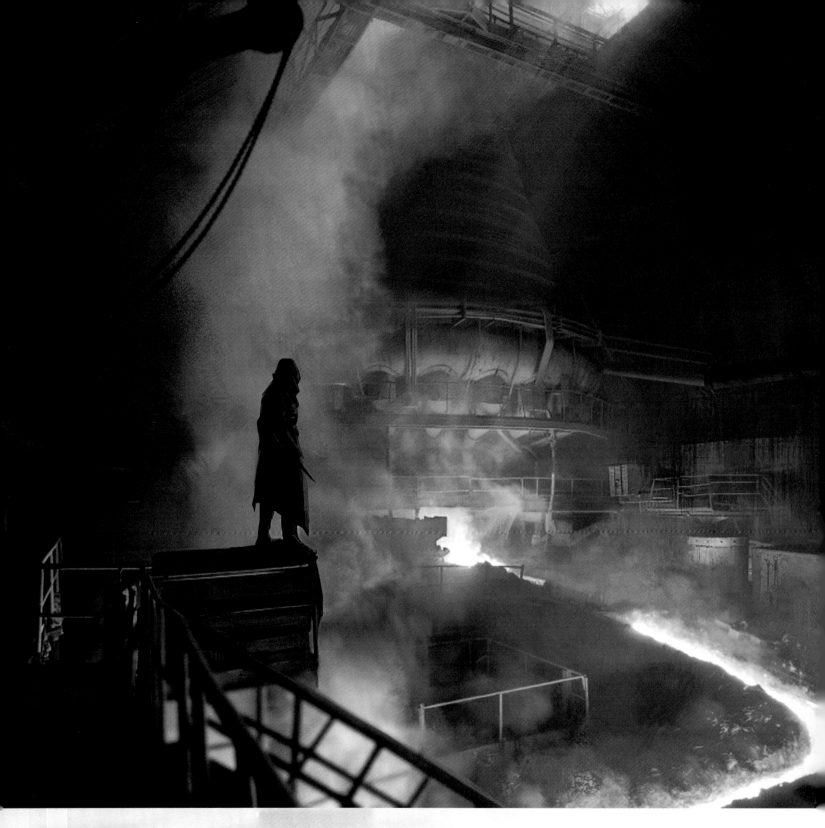

FOUNDRY

THE HEAT IS RAISED as our Assassin faces new obstacles in the foundry, where rivers of molten metal force hotfooted balancing acts. This infiltration mission plays upon the dark and smoky atmosphere of the cavernous rooms and ever present danger from the heat-distorted environment creating a constant sense of urgency. As a set-piece the foundry presents an audio-visual spectacle in the game, where the essence is the hellish glow illuminating from a suffocating oven that only a monstrous man could call his lair. As terrible as the ironworks may seem, such places were responsible for the raw materials that were used to build bridges, trains and the world's first iron warships. Necessary evil is the phrase that springs to mind.

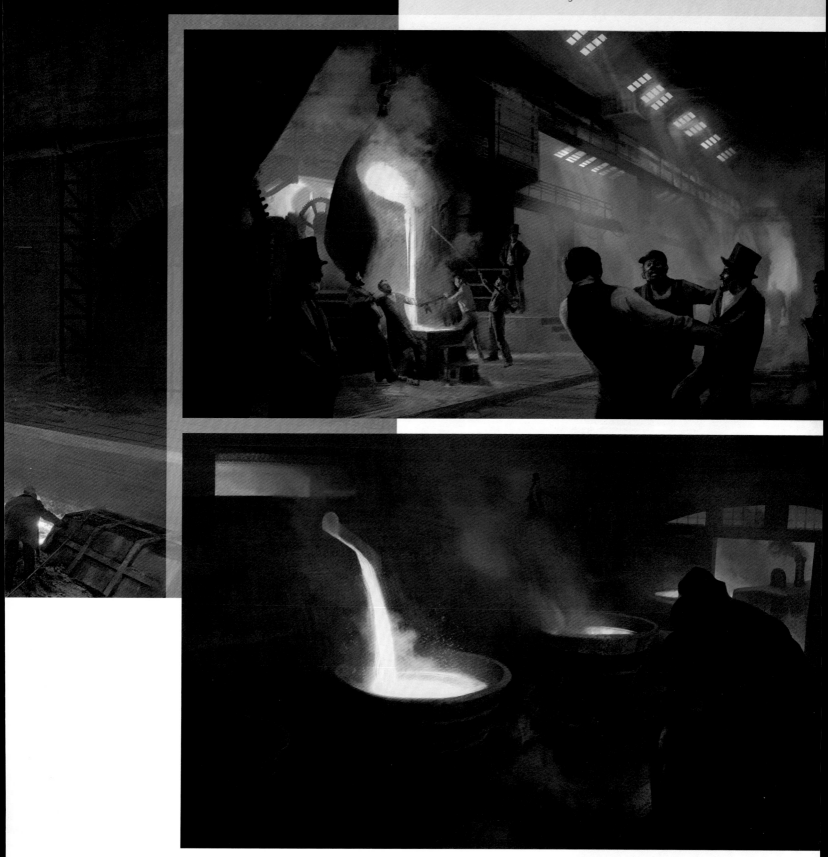

Perilous though fascinating, as Hugo Puzzuoli explains: "The foundries were the heart of the Industrial Revolution. I tried to represent them as mysterious places, dangerous, and above all, alive, vibrating and smoking. These are a universe in themselves, like huge monsters. I like the contrast with the small human silhouettes that gravitate around it."

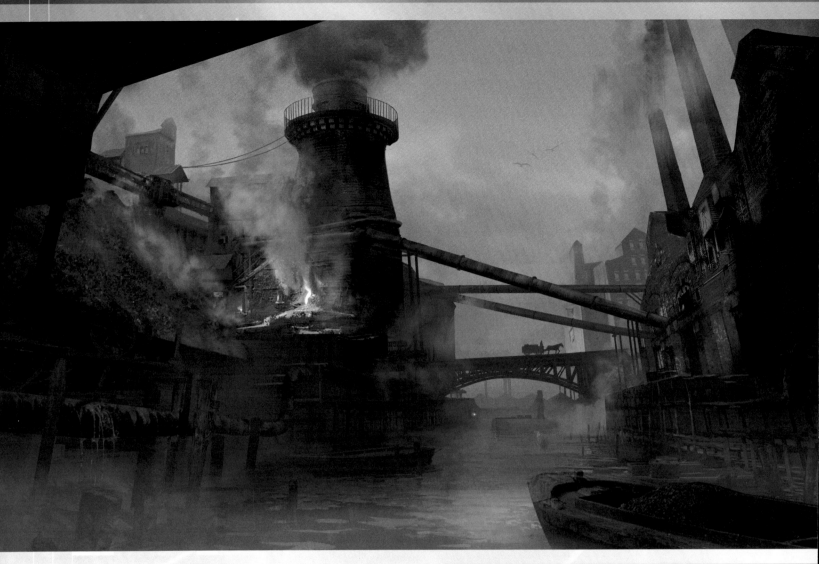

GAS WORKS AND BREWERY

MODERN LUXURY WAS FUELLED by manufactured gas in Victorian London, with the lighting, heating and cooking needs of 400,000 houses dependent on the resource. By 1868 there would have been 100s of gasworks serving the capital. Chemical byproducts such as ammonia were put to use in dyes and disinfectants, coal tar used to surface roads. While the gasworks earned a stinking reputation, their contribution to London life was enormous. Even so, the working force suffered horrendous conditions, feeding coal into containers called retorts which also required emptying by hand. It was hot, back-breaking work, at the end of which the workforce would be seeking liquid refreshment most likely of the alcoholic variety. A distillery with its peculiar apparatus lends itself perfectly as a backdrop to adventure. Hugo Puzzuoli: "The contrasts between water, metal, copper, wood and fire are the main ingredients of all these concepts. All these metal structures and huge silhouettes are really cool to stage. I was blown away by the black and white photos I drew inspiration from."

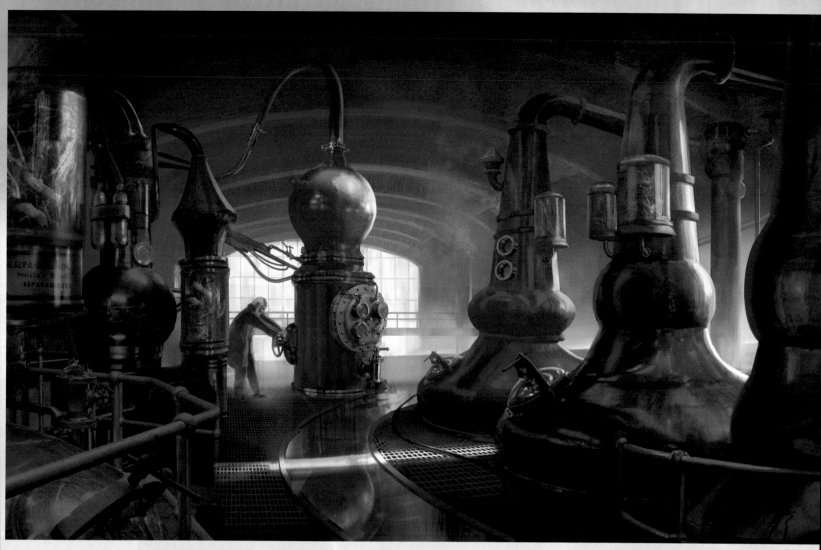

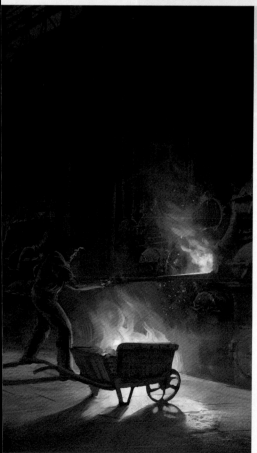

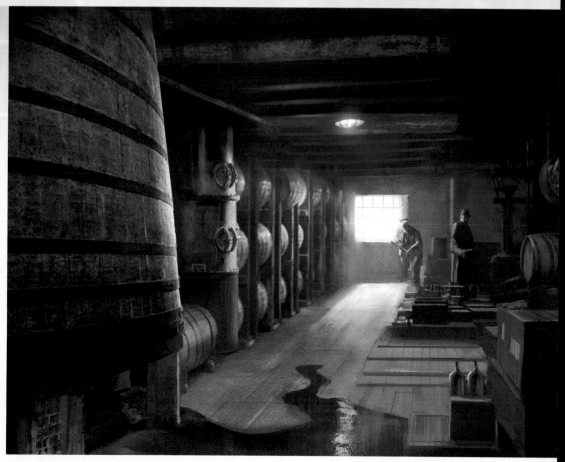

As with the Waterloo station set-piece shown earlier this chapter, the factory chase depicted here comprises many dramatic elements. One can imagine the cacophony and the chaos caused by a panicked individual crashing over levers to unbalance crucial equilibrium. Yet we see the Assassin as a wraith in the steam, calmly sizing up the situation as would any player planning their next move. Windowed ceilings and walls challenged the concept artists to create the desired lighting effects. Architecturally, the hurdles here were insane.

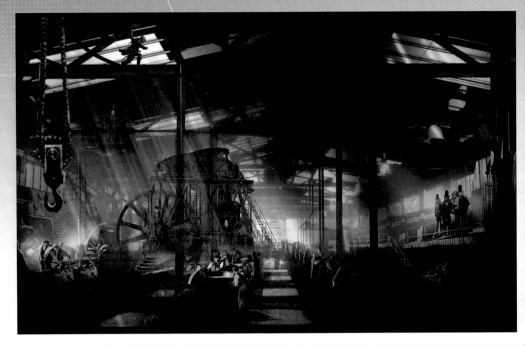

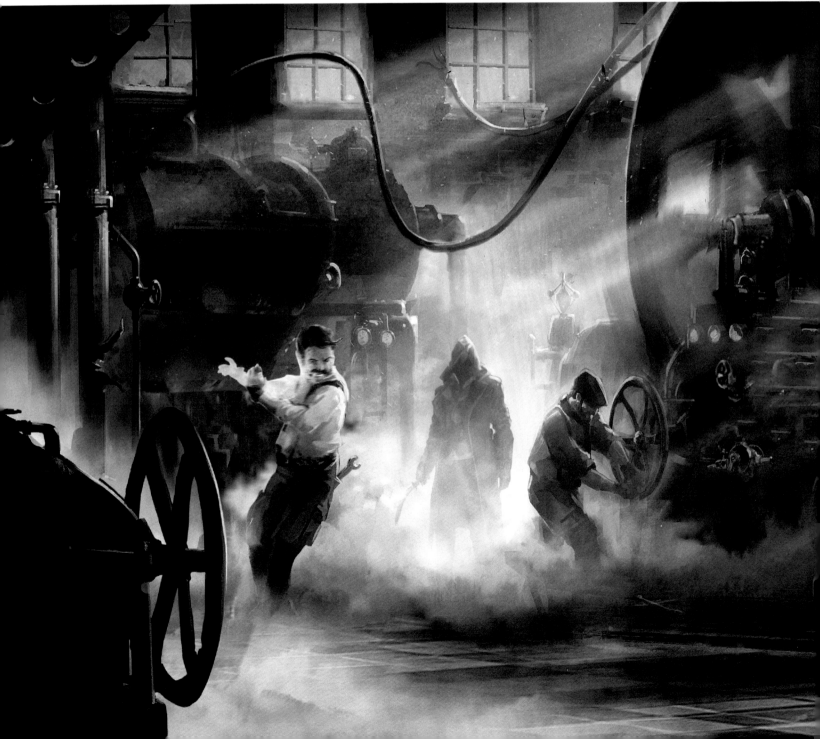

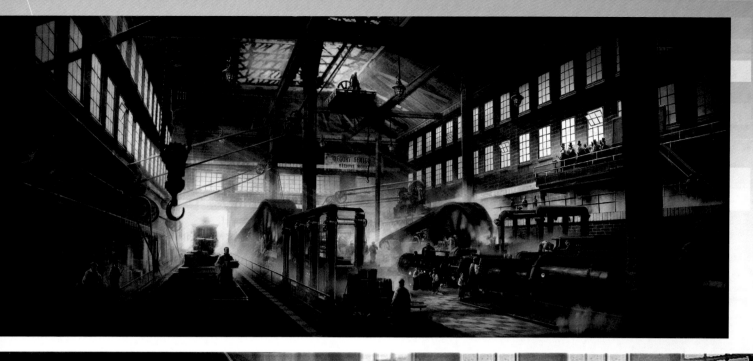

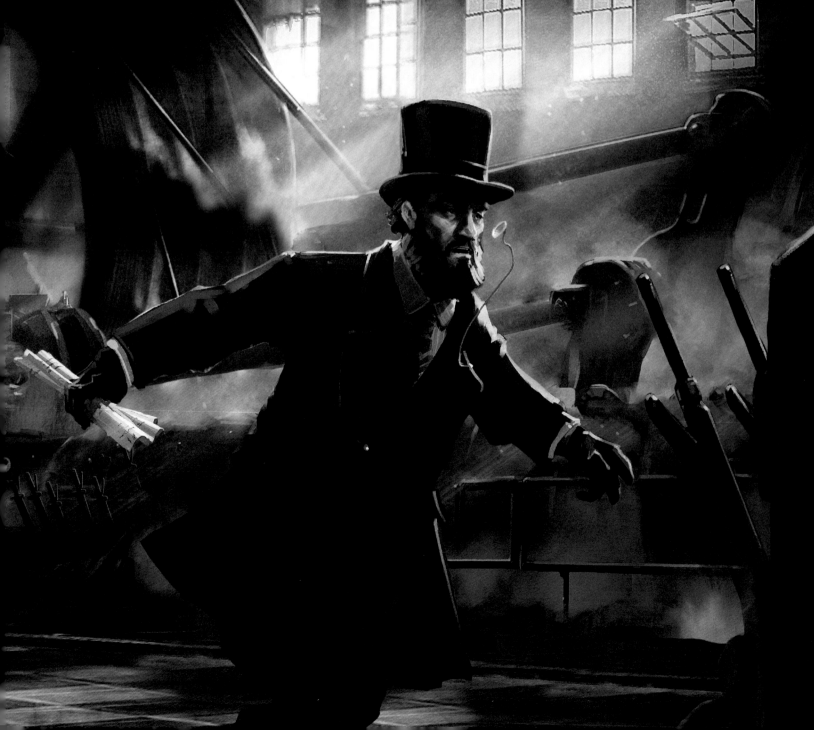

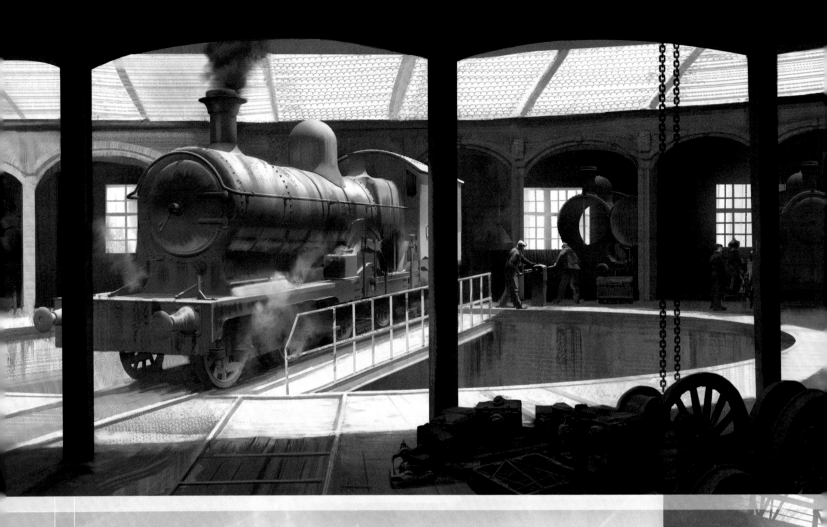

THE TRAINS

IF YOU HAVE EVER witnessed a steam locomotive in reality, even the lowliest examples can be arresting in motion: the noise, the smell, the subterranean rumble announcing arrival and departure. In the factory setting they are tamed but no less imposing and the environment itself is quite a monster. Hugo Puzzuoli: "The concept of the suspended locomotive with Jacob on top was done in the early stages. It's essentially 3D using SketchUp, I modeled the factory and the trains were created by our modeling team. It's the most efficient way to work as the architecture gets complex."

London's steam machine manufacturers were based in areas such as Neasden, Southwark and Rotherhithe, producing locomotives alongside cranes, dredgers, pile drivers and brick making equipment. The locomotive factory depicted in *Assassin's Creed Syndicate* is understandably the ideal presentation, inspired and informed by extensive historical research.

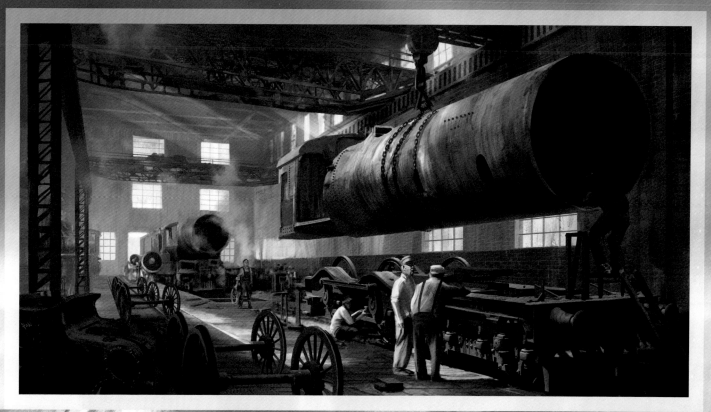

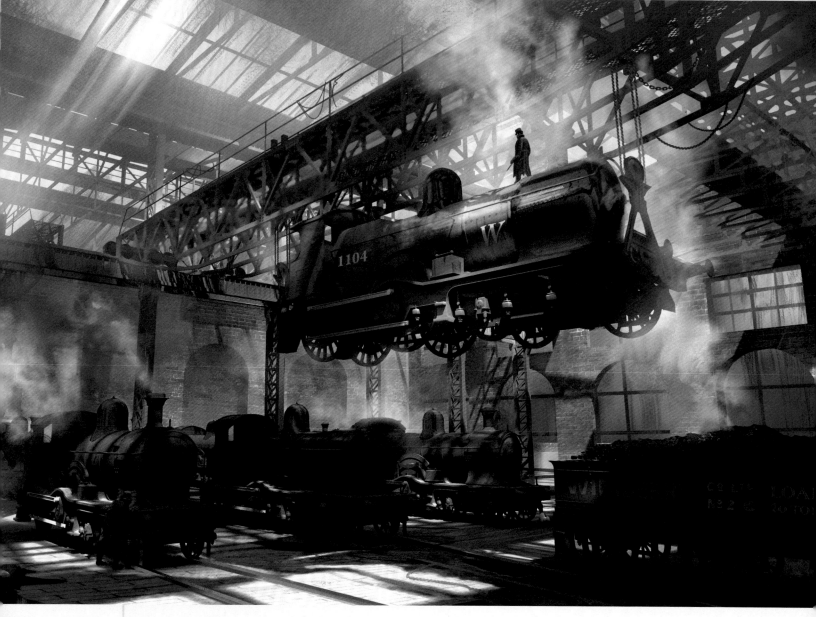

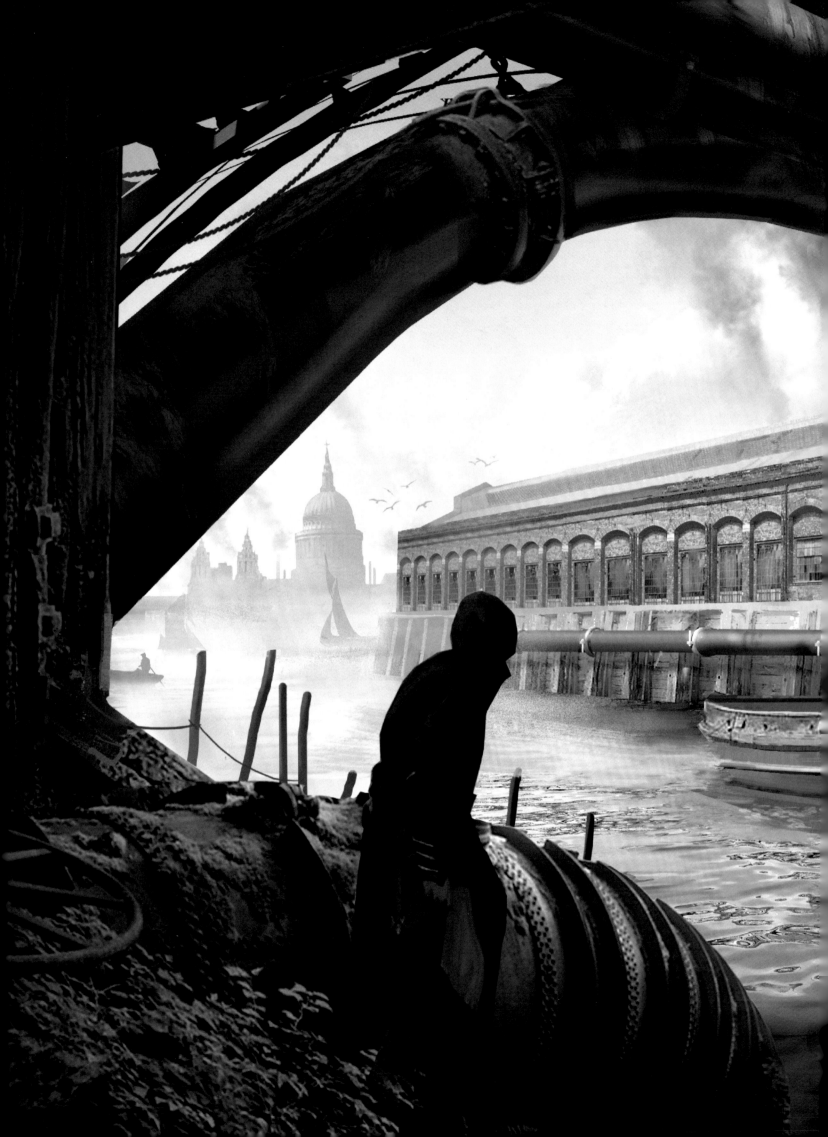

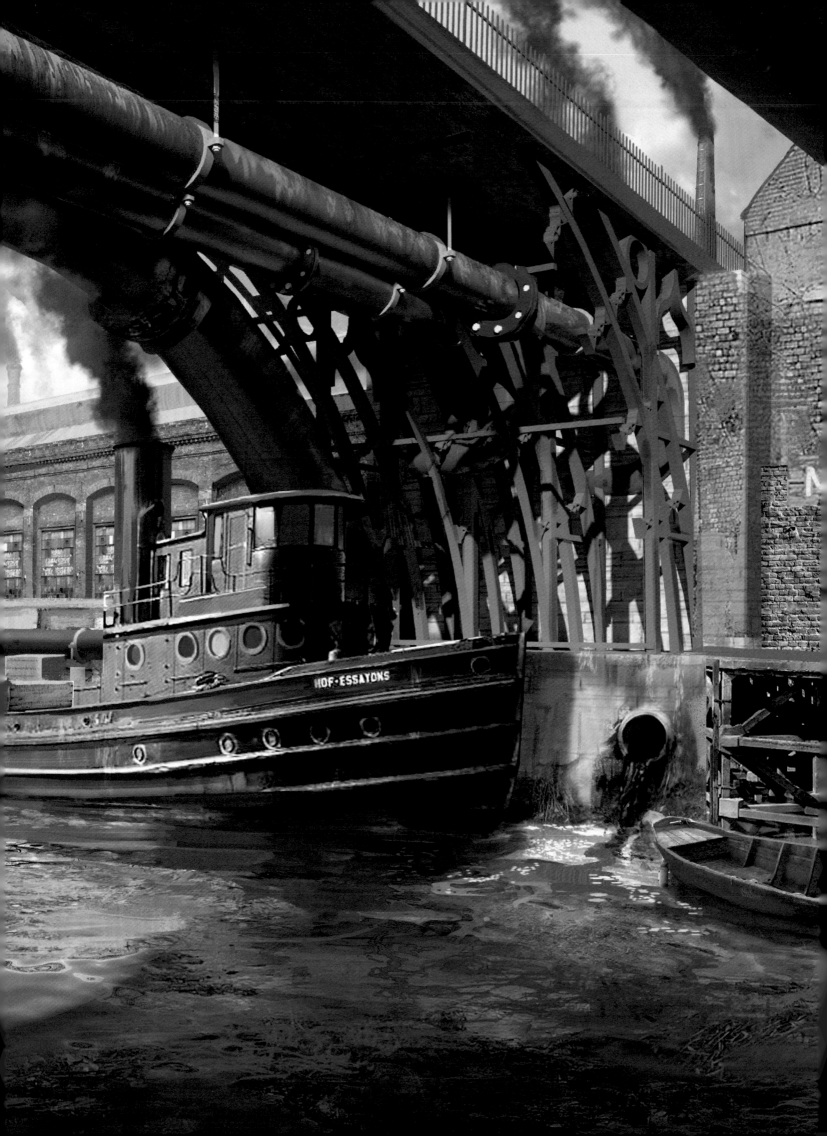

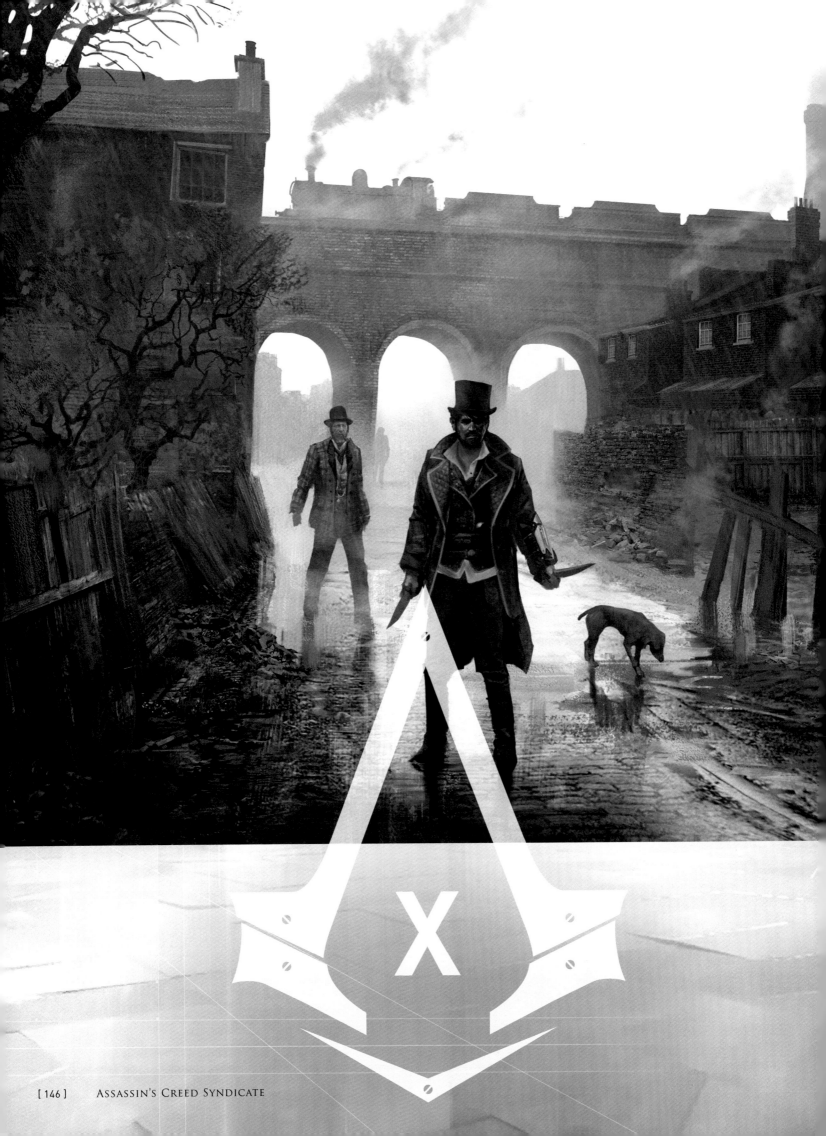

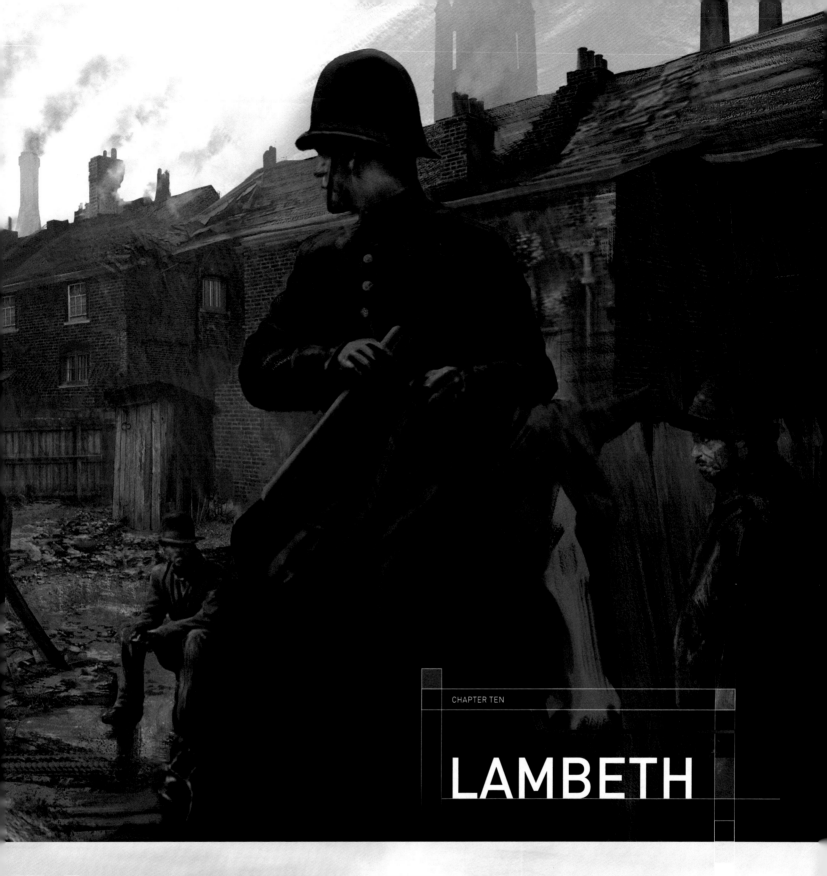

LAMBETH

DESCRIBED BRIEFLY AS "THE ROTTEN MARSH DISTRICT" IN UBISOFT'S DESIGN NOTES, LAMBETH SAW THE GREATEST CHANGE DURING THE INDUSTRIAL REVOLUTION, FROM MEDIEVAL HARBOR TO THE HOME OF UP AND COMING COMMUTERS LINKED TO THE CITY AND WEST END BY TRAIN. NOT EVERYONE WAS SO LUCKY, AS MEN, WOMEN AND CHILDREN WERE EXPLOITED IN THE NOTORIOUSLY DESPICABLE WORKHOUSE.

In *Assassin's Creed Syndicate*, Lambeth Marsh symbolizes the severest consequences of the Industrial Revolution: poverty leading to madness, the exploitation of the weak. It is home to the working class, also known as the dangerous class, whose women were described by journalist George Sala as "brazen, slovenly, disheveled, brawling, muddled with beer," where children are beaten and dogs kicked.

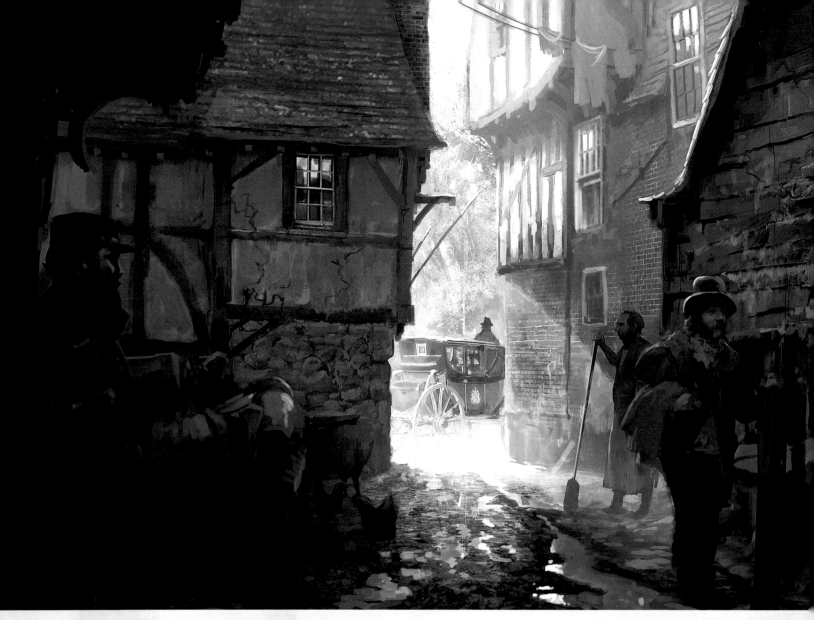

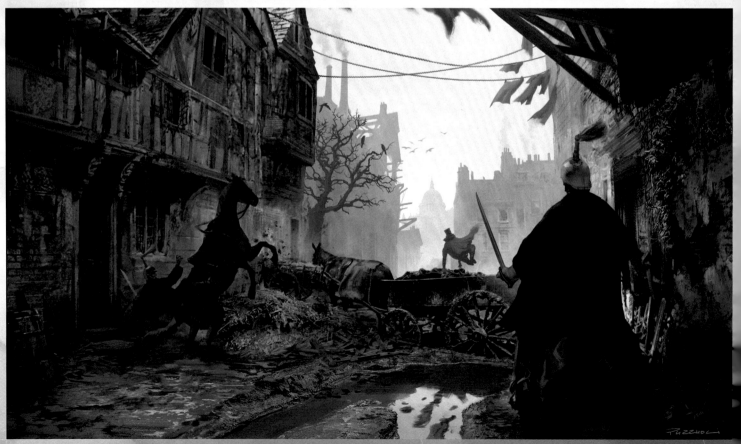

Assassin's Creed Syndicate

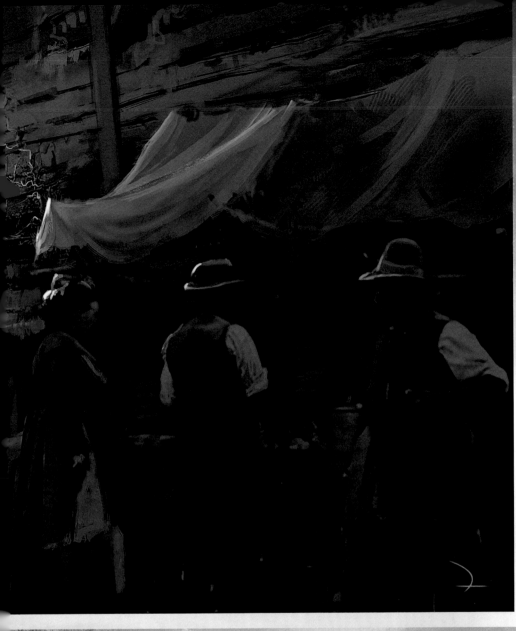

Writing in his 1859 book 'Twice Round the Clock: Twenty Four Hours in Victorian London' George Sala introduced readers to Lambeth Marsh thus: "It isn't picturesque, it isn't quaint, it isn't curious. It has not even the questionable merit of being old. It is simply Low. It is sordid, squalid, and the truth must out, disreputable." The conceptual works on these pages by Hugo Puzzuoli were made in 2013, exploring the main characteristics being: "working class, muddy and on the outskirts of town".

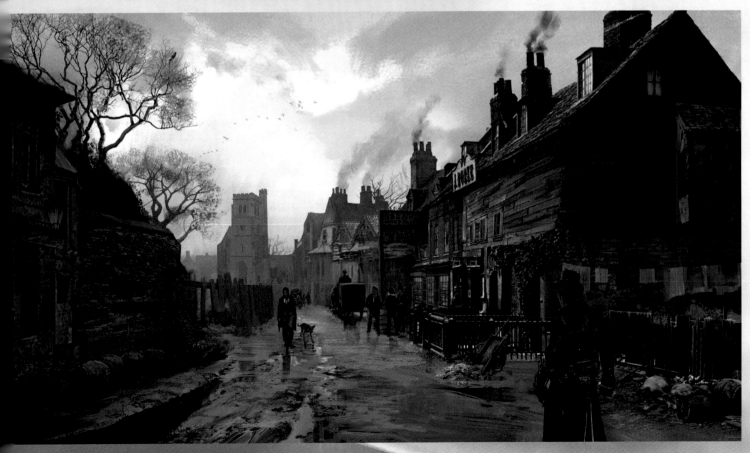

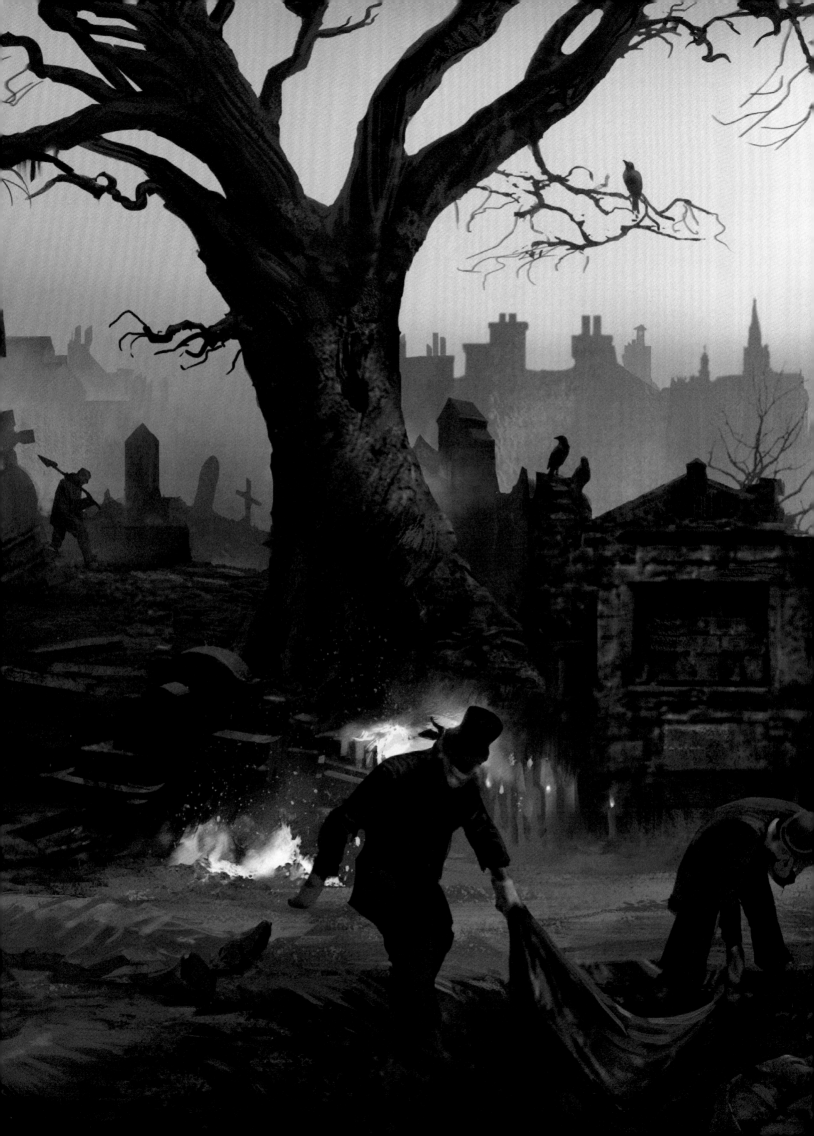

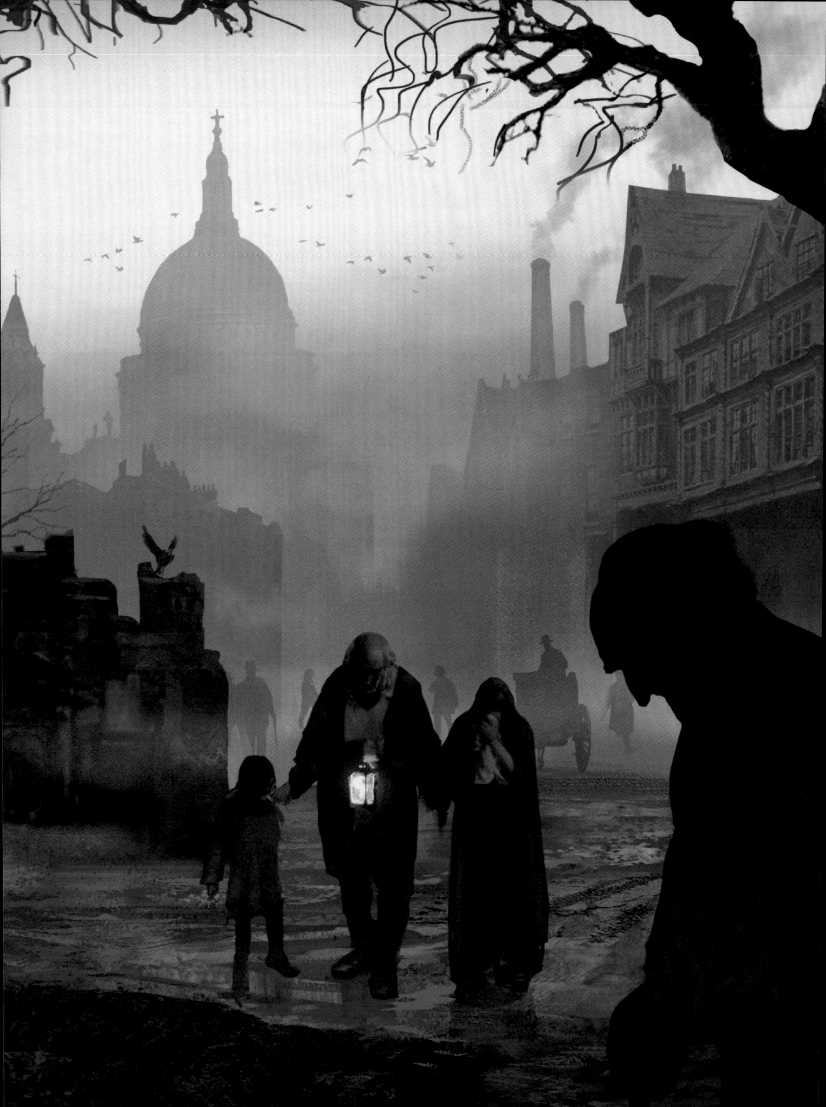

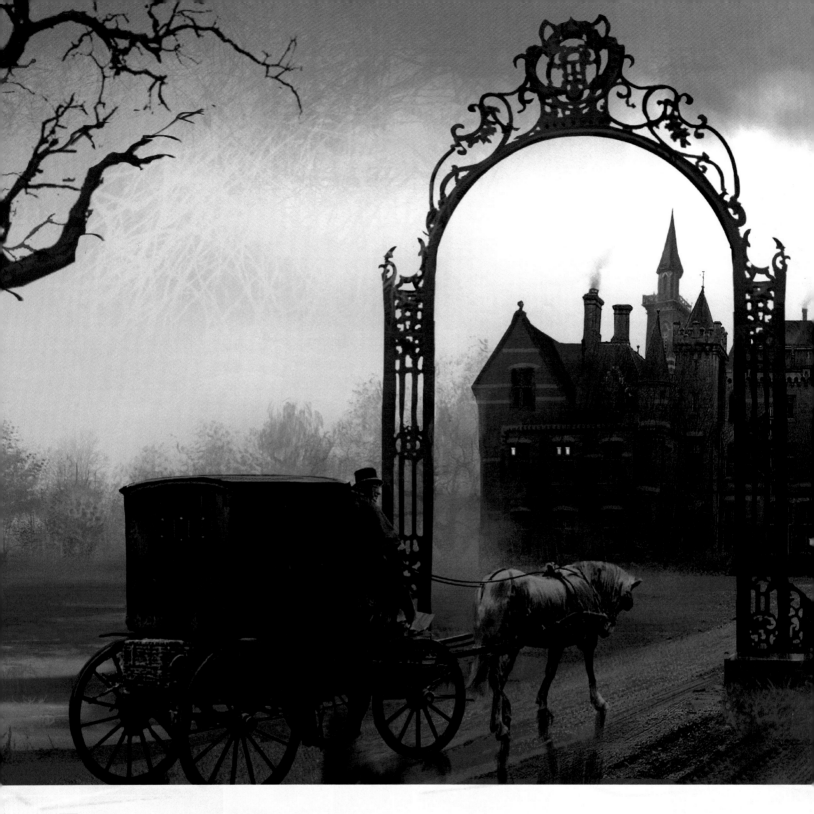

■ BEDLAM ASYLUM

NOW THE IMPERIAL WAR Museum, the original site of Bethlehem Hospital (*bedleem* in middle English, hence the nickname that became *bedlam*) earned its reputation from housing the criminally insane. The noun 'bedlam' is commonly used to suggest wild uproar and general chaos. Naturally, this is the association that caught the *Syndicate* team's attention when considering a London-based mission. There are suitably chilling narrative links involved and an investigation required that brings the Assassin to its doors. Upon navigating the asylum, their worst fears are confirmed.

While imagining 'bedlam', artist Hugo Puzzuoli sought to bring more color and texture variation to the experience: "When I started to work on the Bedlam asylum my goal was to bring an organic touch in our very urban game. I wanted to paint an asylum isolated and surrounded by trees, marshes and first and foremost far from prying eyes... to give it a dramatic and isolated feel."

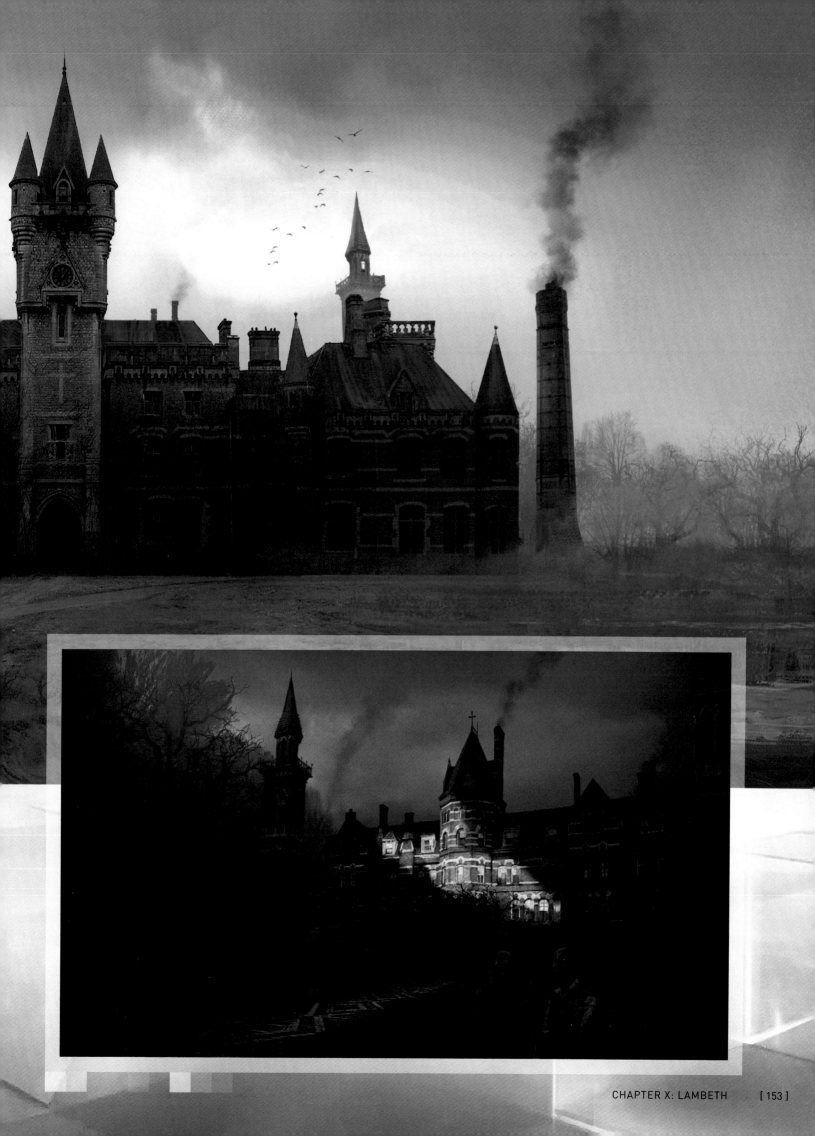

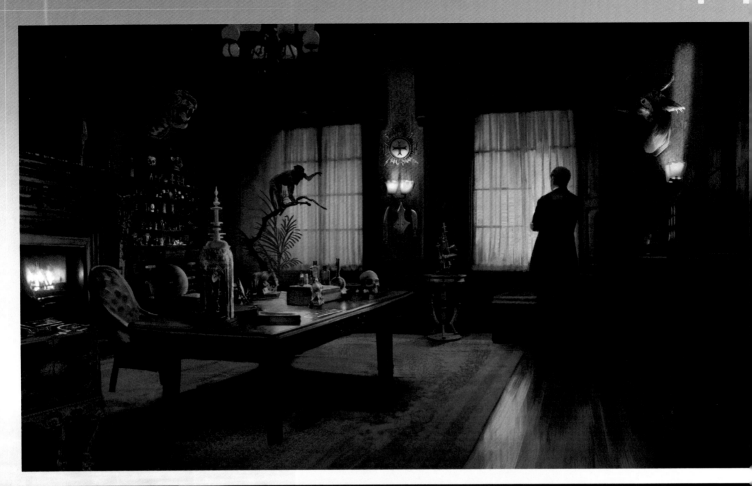

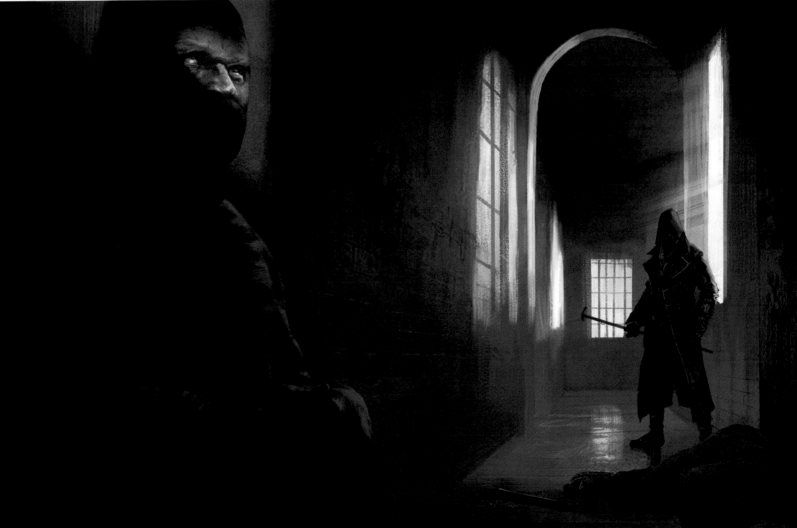

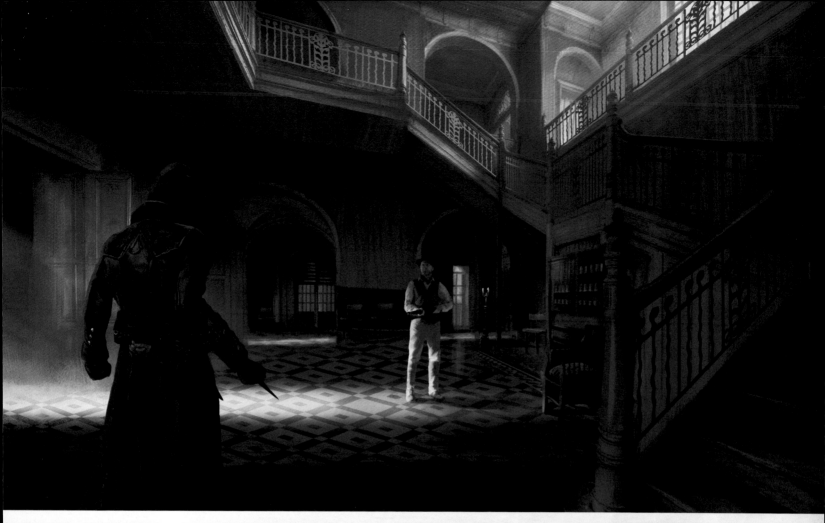

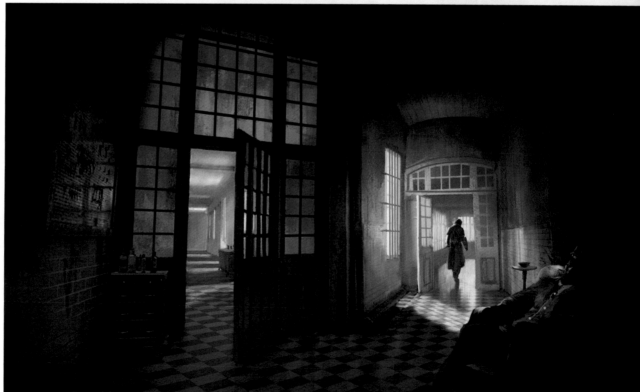

A hospital with dark and terrible secrets is what the Ubisoft team set out to establish, "always bearing in mind to credibly recreate a dramatic and scary tone to match the personality of the occupants of Bedlam," says Hugo Puzzuoli. The entrance gives the impression of a caring facility, pristine and smelling clinically clean. Out back is a different story, where inmates, not really patients at all, cower in filthy corners away from blood spattered walls. To them, the Assassin might appear a haunting figure.

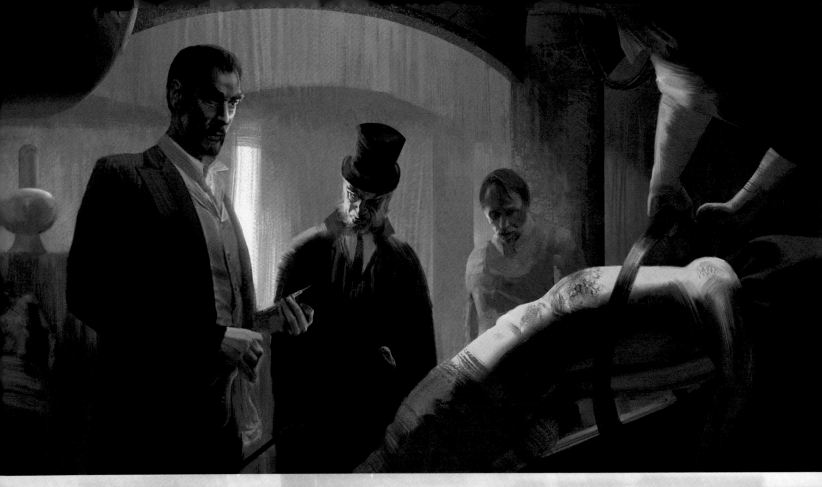

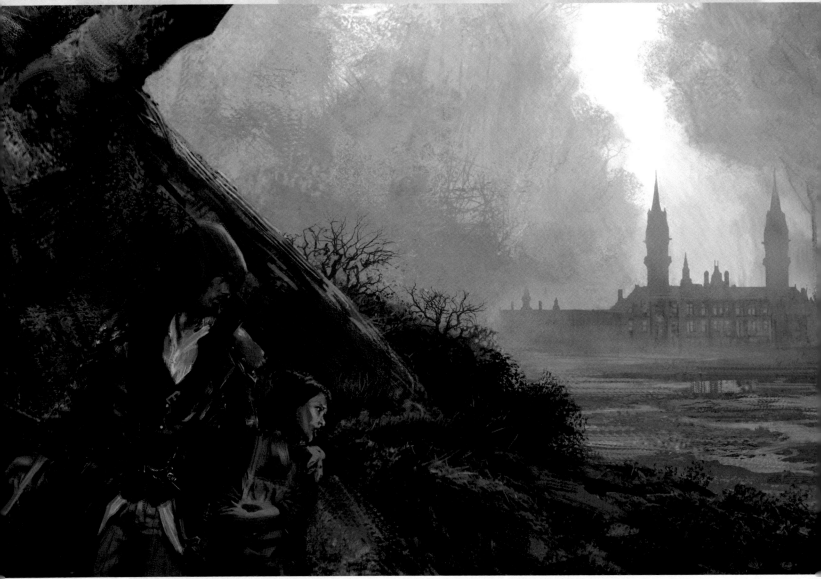

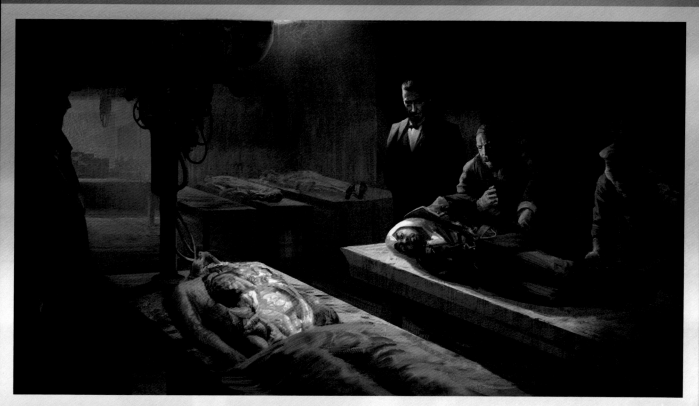

VICTORIAN MEDICINE

SEVERAL BREAKTHROUGHS IN VICTORIAN medicine transformed horrific practices into barely tolerable ones. Anesthetics and antiseptics began to save lives and limbs owing to historic figures that include James Young Simpson (chloroform), Louis Pasteur (pasteurization) and Joseph Lister (anesthetic). With man now apparently capable of playing God, this gave credence to horror stories such as Mary Shelley's *Frankenstein* and cast further suspicions on institutions such as Bedlam. It's a glorious platform upon which to build a compelling story, and a gripping location to explore. Meanwhile, to counter all the terror, Ubisoft also chose to include Florence Nightingale as a symbol of hospital reform. Clearly, Florence needed to be associated with the Assassins for this tale. She would have been appalled by the scenes pictured here.

"Here are some narrative proposals done in preproduction, following the idea of having a secret lab hidden in the Asylum. I thought it'd be fun to have Jacob in an out of character situation, at the mercy of the Templars, ready to be drugged or worse... dissected! The rise of Science in the 19th Century embodied by Templars: the Victorian gothic feel, dark and visceral, helped a lot!" Hugo Puzzuoli

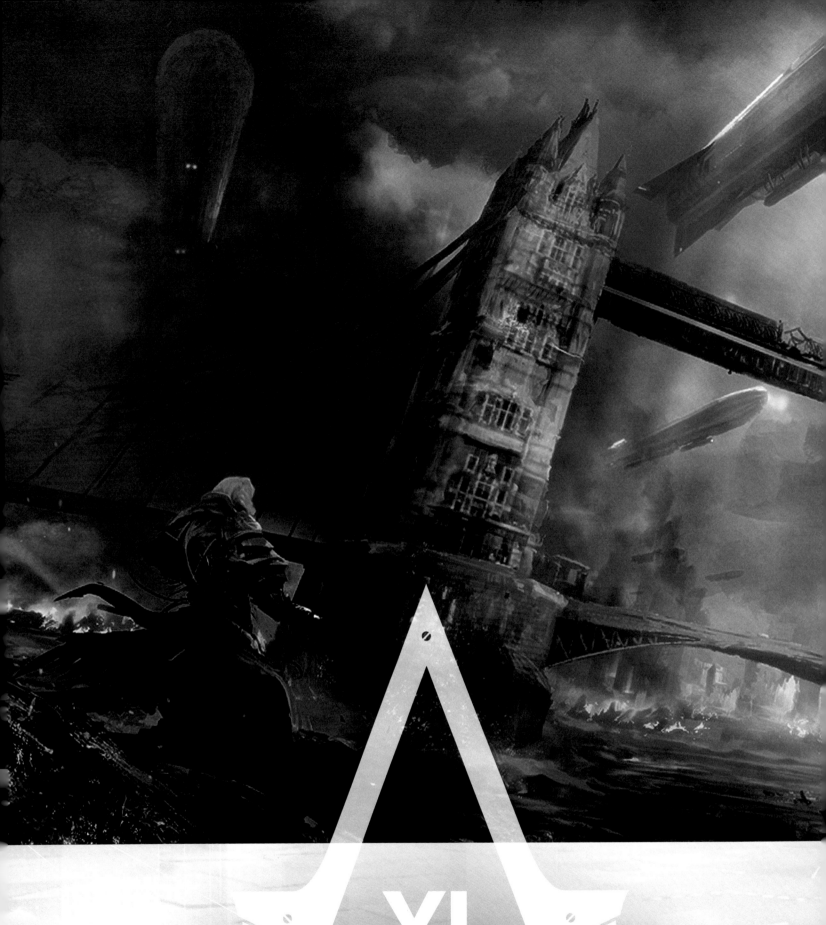

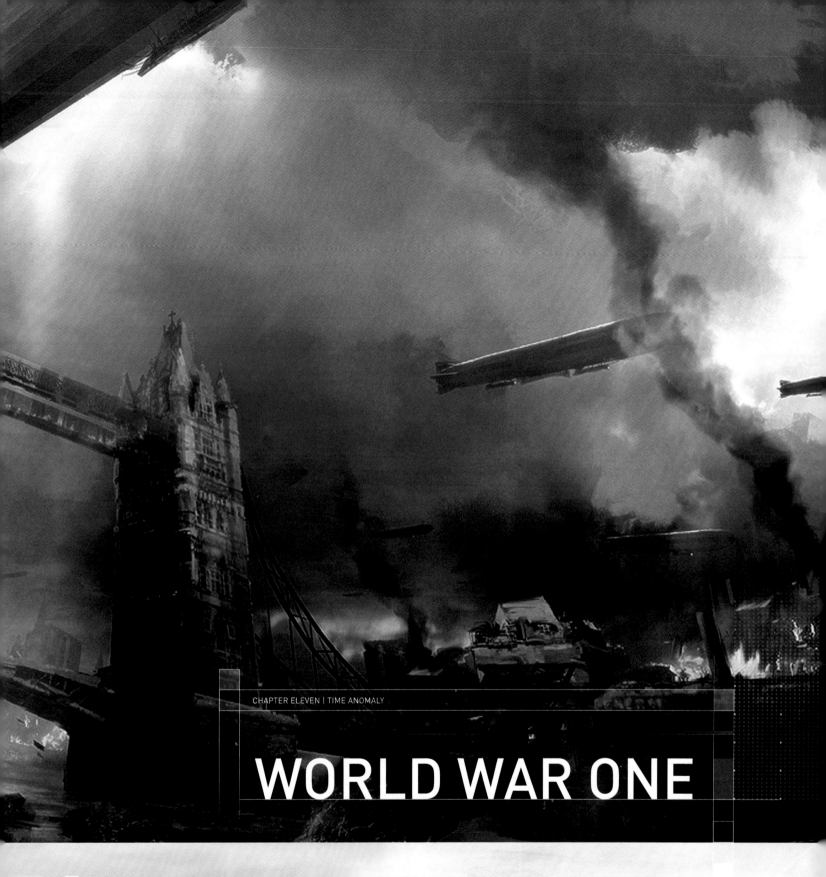

WORLD WAR ONE

"THIS TIME ANOMALY WAS A GREAT OPPORTUNITY FOR US TO TEACH HISTORY. ADVANCEMENT OF TECHNOLOGY IS THE MAIN ELEMENT USED TO ESTABLISH THE WWI ERA. THIS SCENARIO FEATURES MODERN VEHICLES, WIDESPREAD USE OF ELECTRICITY AND A COMPLETED VERSION OF TOWER BRIDGE. IT'S AN INTERESTING PLAYGROUND OWING TO THE VISUAL INGREDIENTS NOT FOUND IN OTHER DISTRICTS.

"The atmosphere of war is used to evoke different emotions to create a richer experience. We use a lot of thematic and visual contrasts to achieve this. The sky has a clear distinction between dark and light side to show hope and despair. The colors in the district are slightly more saturated but it is juxtaposed with hints of destruction and the looming threat of the zeppelin raid." Felix Marlo Flor, artistic director, Singapore.

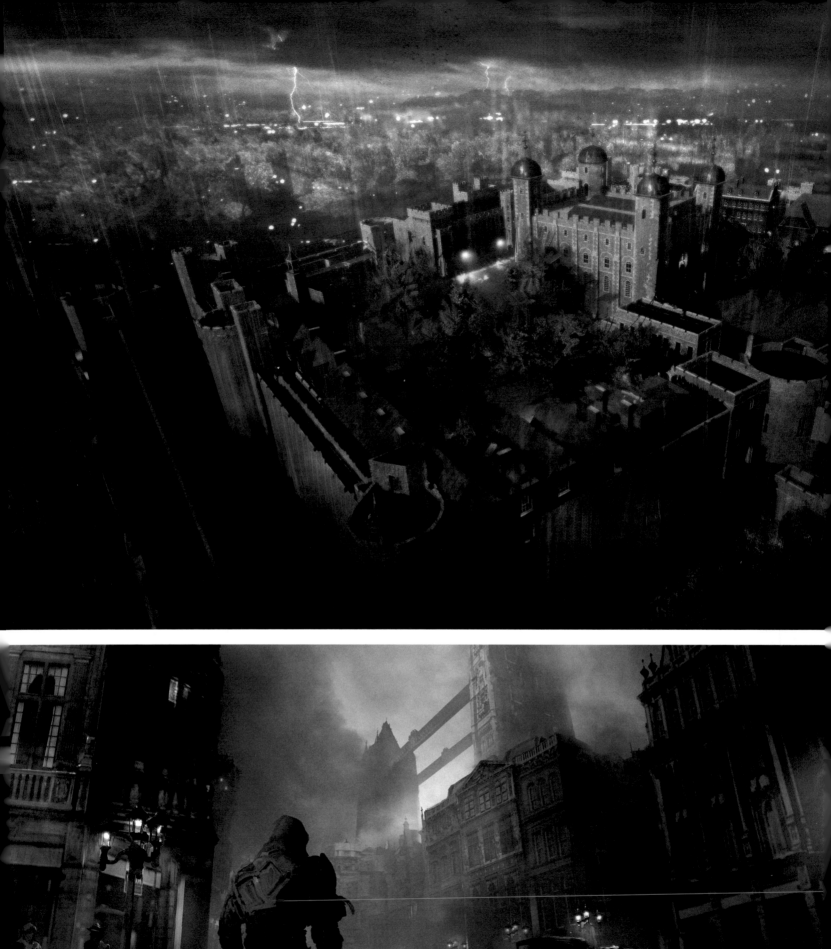

LEFT: "The Tower of London has a rich history, famous for executions and protecting the crown jewels, so we chose to focus on feeling intimidated. Visually, the Tower has very rigid lines and large, thick forms that create a sense of an impenetrable space. The White Tower, one of the main landmarks in the compound, has a very sturdy shape that further reinforces the character of the outer walls. To create the feeling of intimidation, we used numerous elements that have sharp tips like the metal gates for example." Felix Marlo Flor.

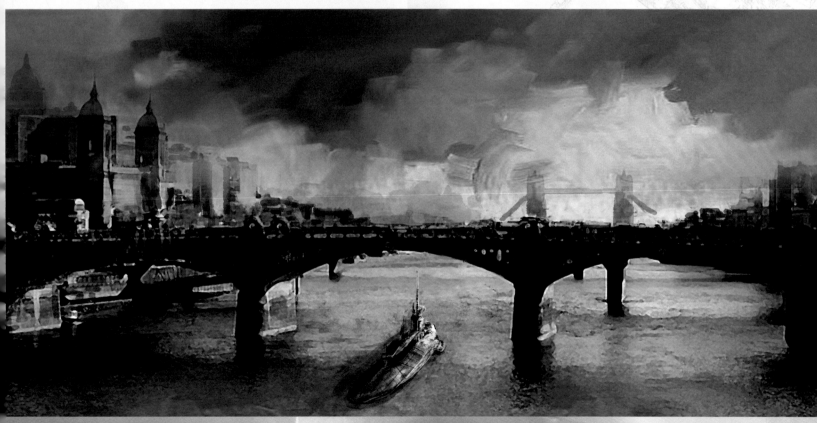

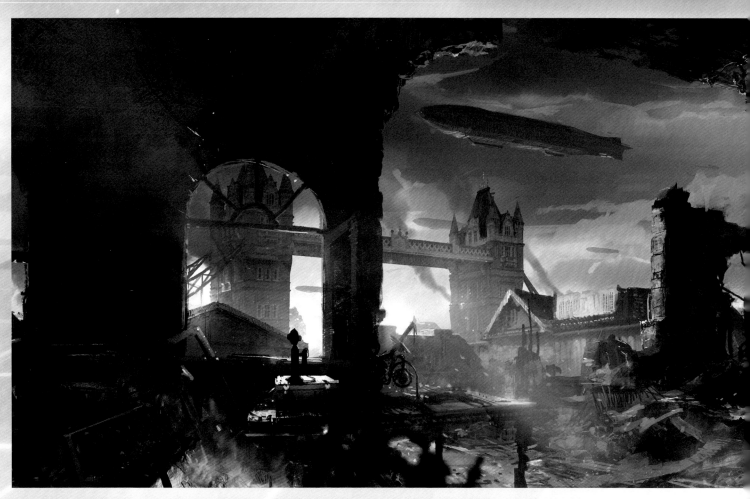

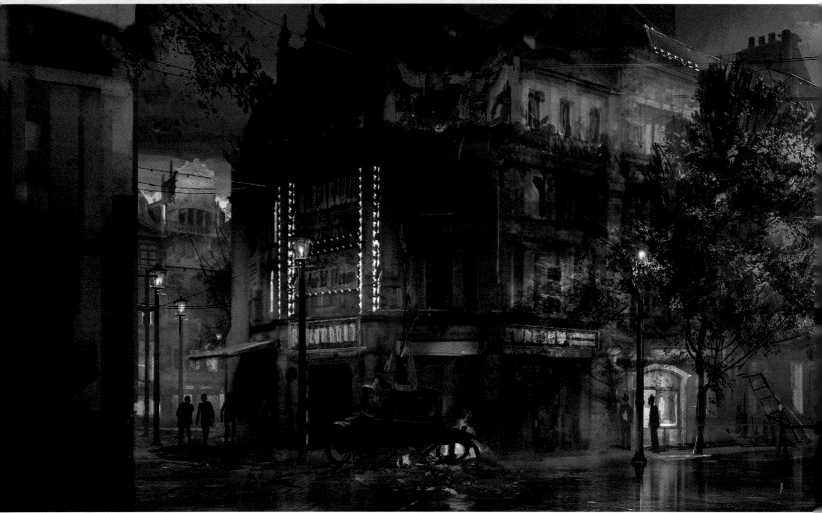

BOTTOM: "This mood piece is a great way to show the era and a lot of elements we wanted to use. There's the predominance of electric and telegraph cables, and posts that are unique to the district. Marching soldiers are seen in the distance and there is an absence of crowds on the streets." Felix Marlo Flor.

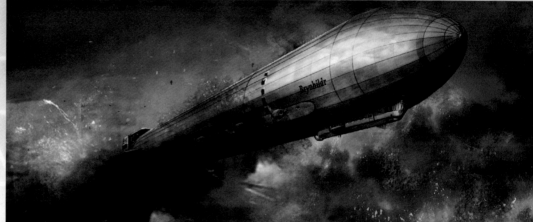

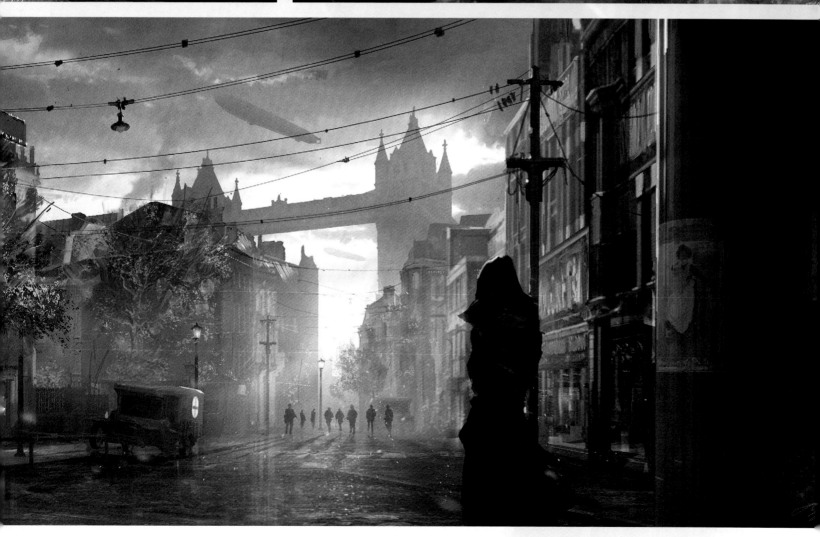

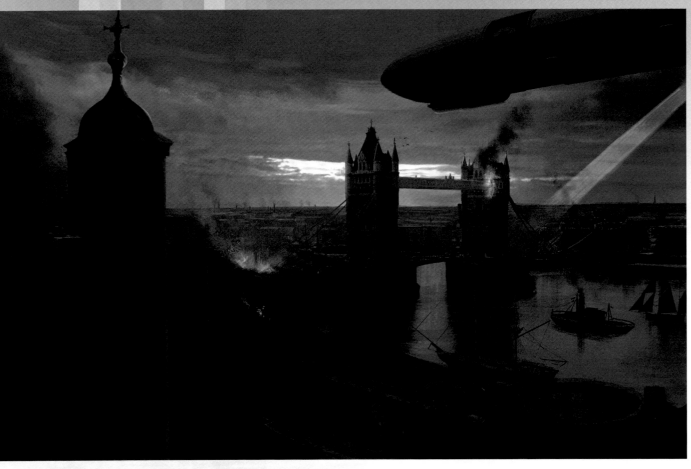

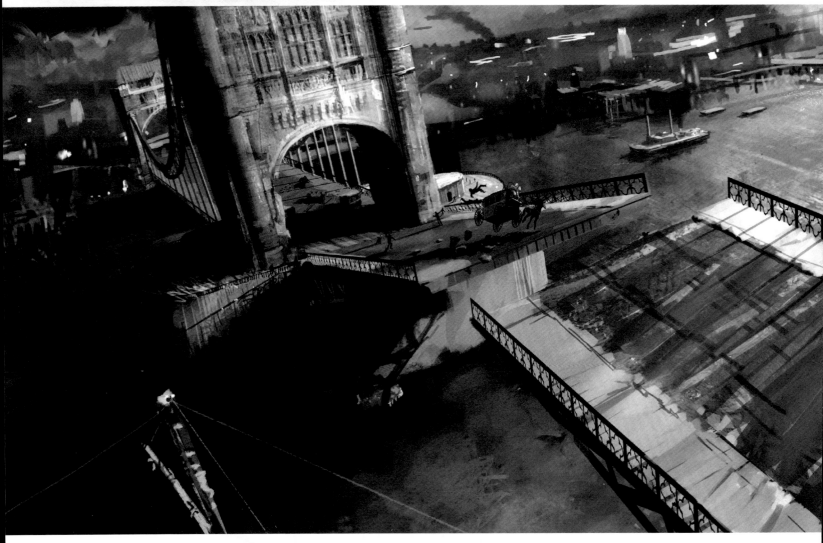

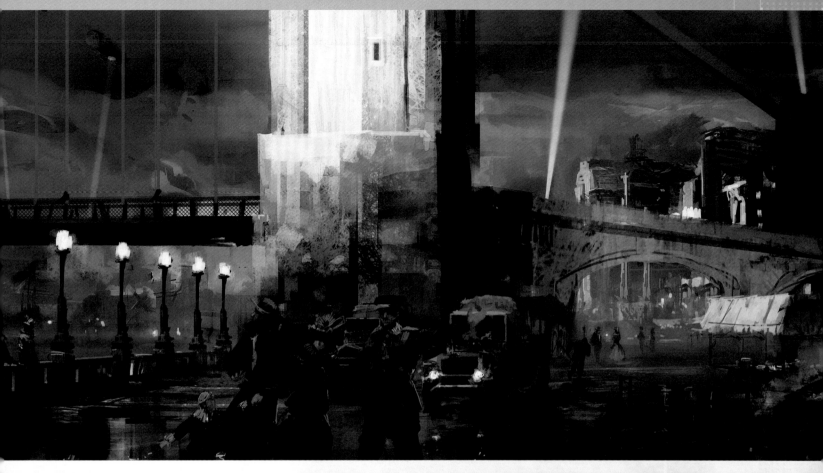

LEFT: "Concept art is always a great tool to flesh out the possibilities around your chosen playground and this piece is a good example of that. Jumping through the gap between the closing bridges was one of the ideas that we were playing with during the early stages of pre-production." Felix Marlo Flor.

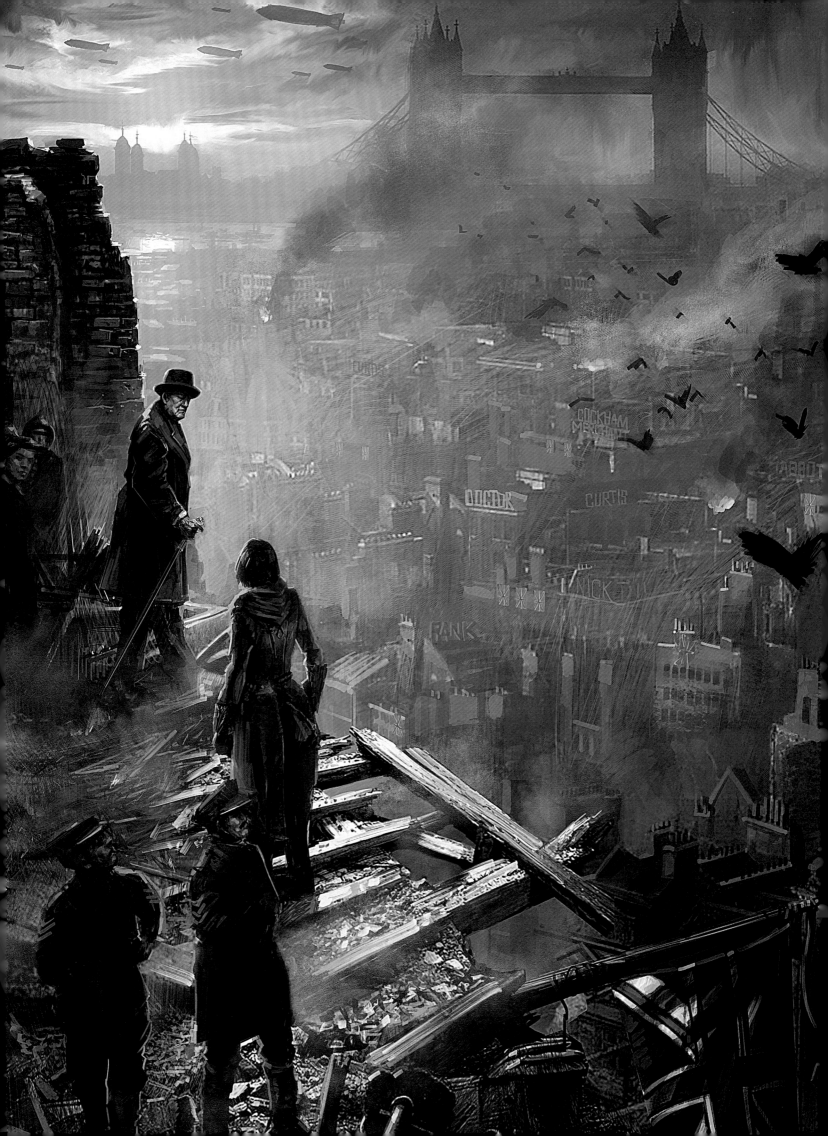

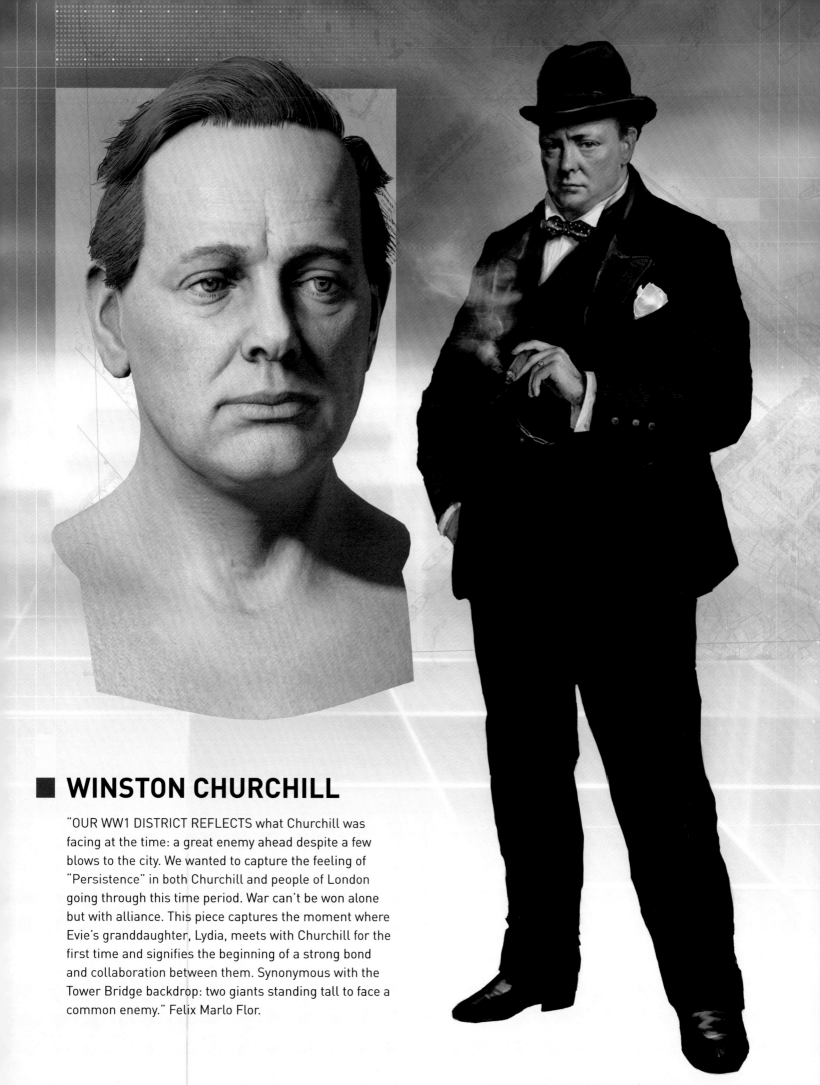

■ WINSTON CHURCHILL

"OUR WW1 DISTRICT REFLECTS what Churchill was facing at the time: a great enemy ahead despite a few blows to the city. We wanted to capture the feeling of "Persistence" in both Churchill and people of London going through this time period. War can't be won alone but with alliance. This piece captures the moment where Evie's granddaughter, Lydia, meets with Churchill for the first time and signifies the beginning of a strong bond and collaboration between them. Synonymous with the Tower Bridge backdrop: two giants standing tall to face a common enemy." Felix Marlo Flor.

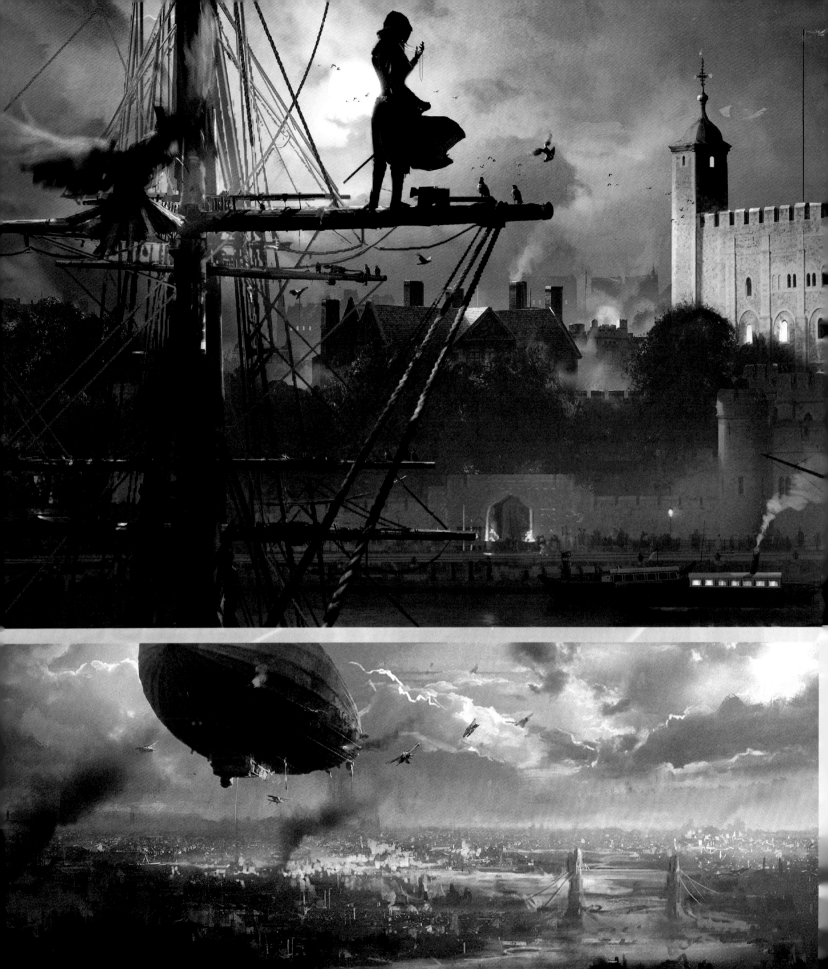

ASSASSIN'S CREED SYNDICATE

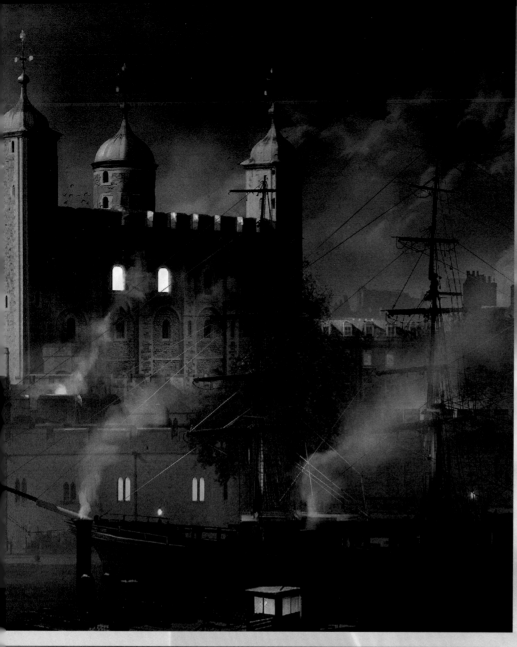

"The high level direction for our World War One district is to establish the era and the atmosphere of war. There are searchlights, huge, hovering zeppelins and planes that are great for showing the advancement of technology. Finally, there is opportunity to scale the famous Tower Bridge." Felix Marlo Flor.

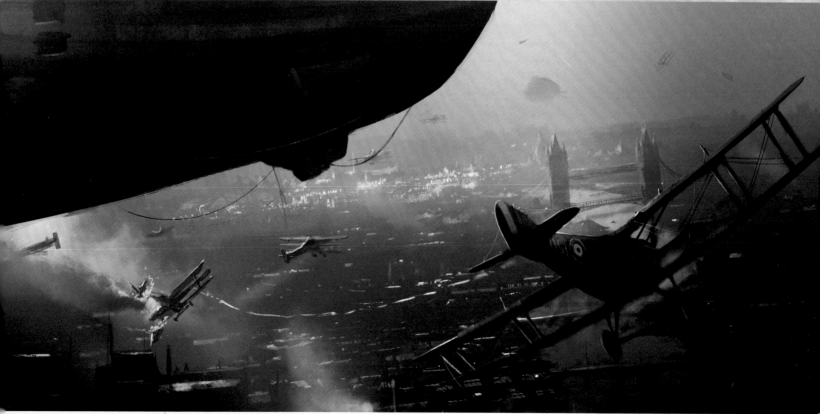

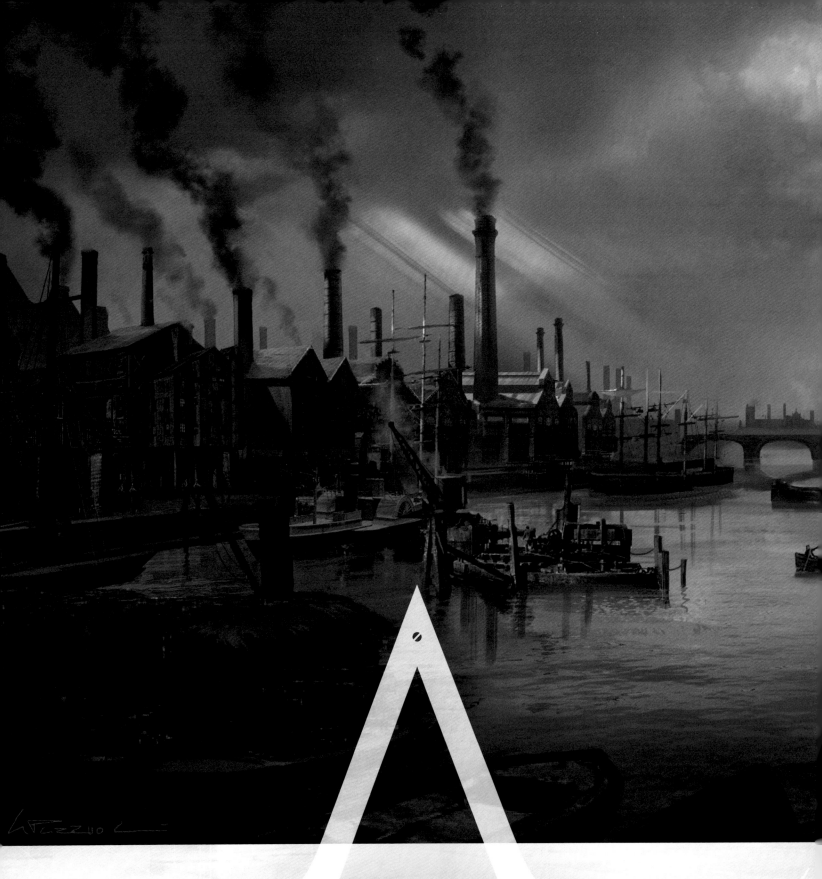

Assassin's Creed Syndicate

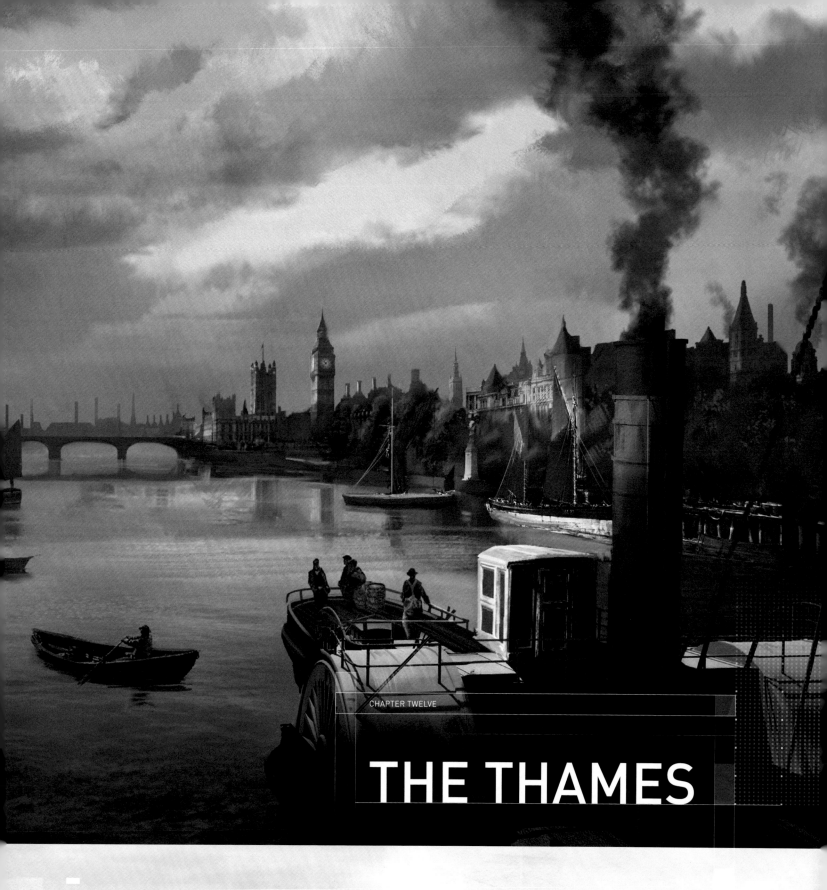

CHAPTER TWELVE

THE THAMES

"MOVEMENT IS AT THE HEART OF THE THAMES. THE MOTION IN THE DISTRICT OPENS UP AN ENDLESS STREAM OF POSSIBILITIES FOR THE PLAYERS TO EXPERIENCE. EACH DECISION THAT WAS MADE FOR THE CONCEPTION OF THIS DISTRICT HAD BOTH GAMEPLAY AND AESTHETICS IN MIND. FORM FOLLOWS FUNCTION. WE ALWAYS KEEP THIS IN MIND TO CREATE A BELIEVABLE SPACE THAT'S ALSO ENJOYABLE.

"The district shows dynamism through the boat traffic, cargo cranes and the river. These elements make the players experience a great sense of openness and freedom of movement that is key to the Thames. The district also exhibits thematic contrasts. Docks and boats were built for specific social stratifications and functions. It's new versus old, the opulent versus the oppressed." Felix Marlo Flor.

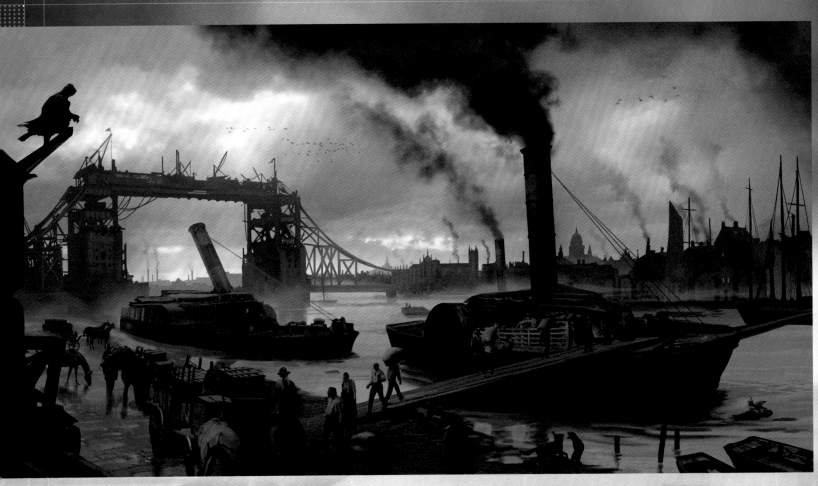
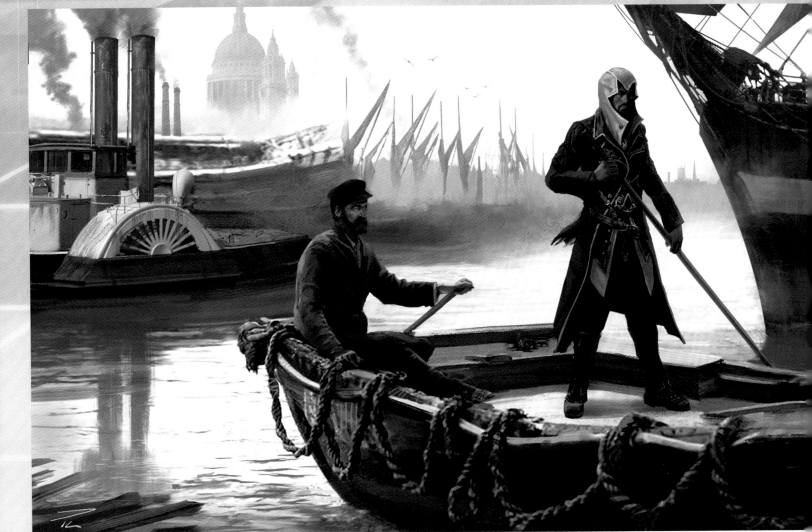

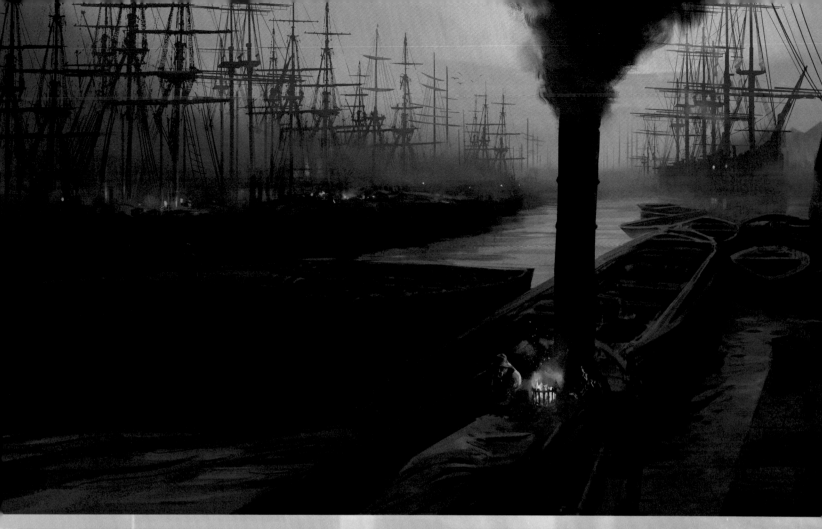

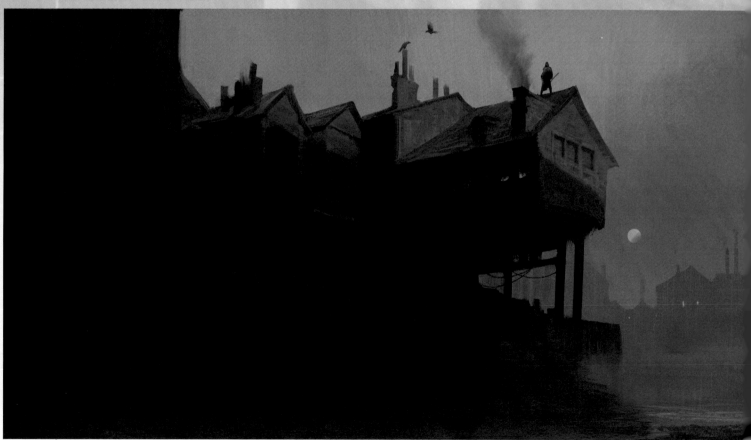

"The marine and port side of London was very interesting to paint. Countless sailing ships, barges and the first steamers, the factories in the background and the fog were the Thames' key visual elements that I used as patterns for these mood shots." Hugo Puzzuoli.

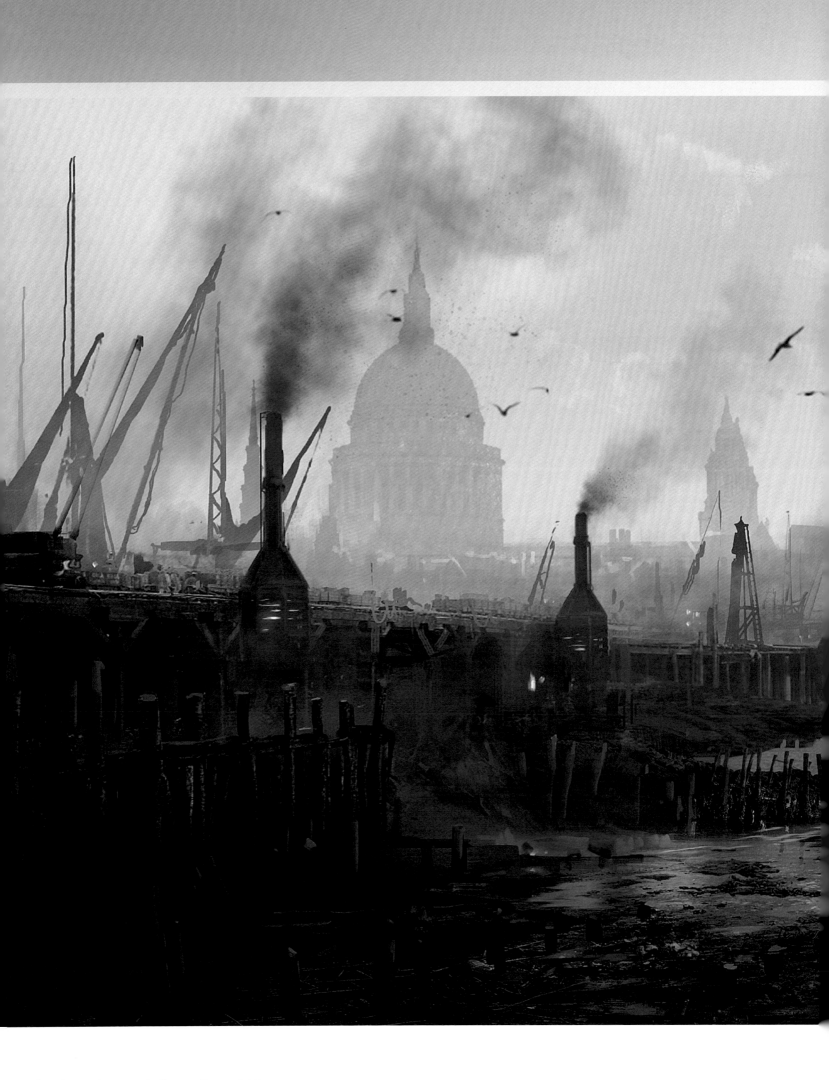

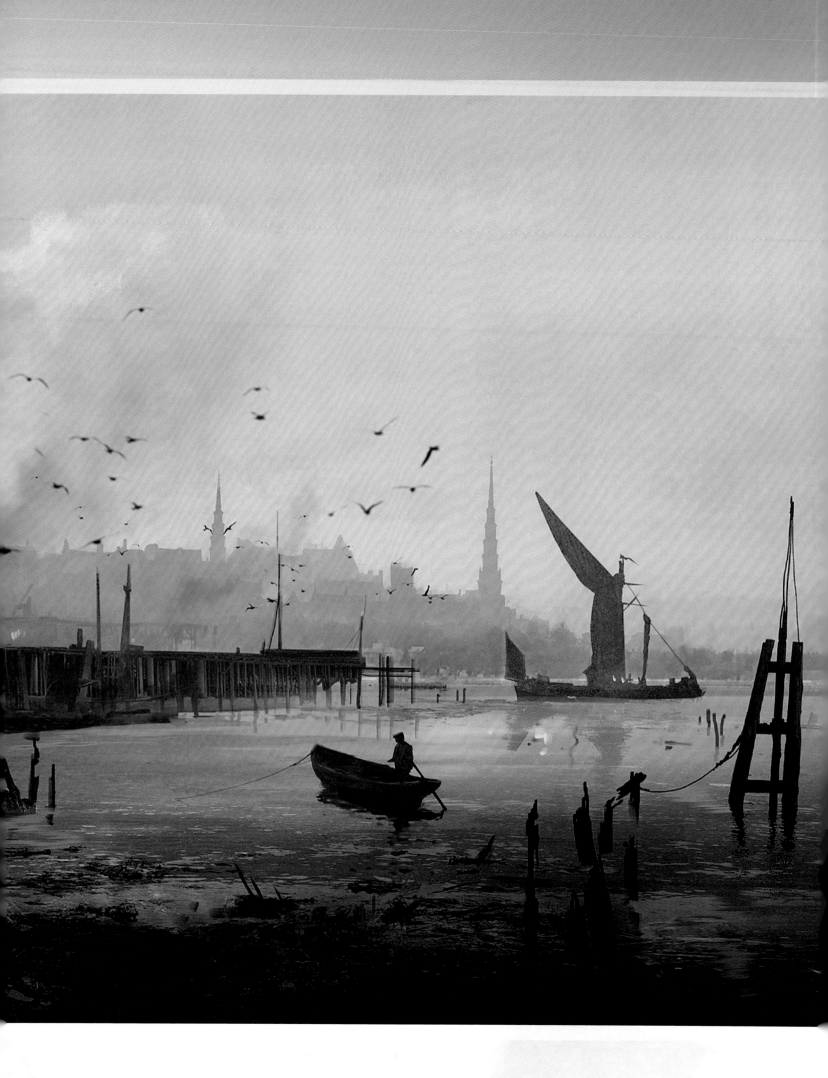

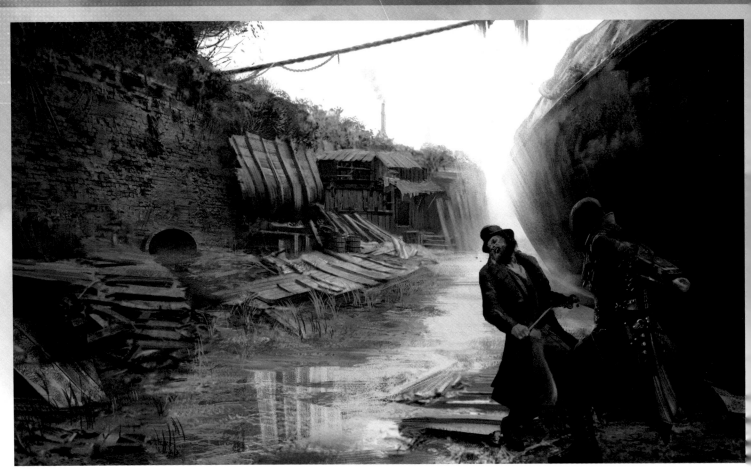

It appears quite impossible to distinguish friend from foe among the boats in this cluttered dock. Jacob knows who to look out for, however. Hugo Puzzuoli: "Painting the Thames' banks was fun. Dirty and damp dens... typical mafia and shady business places!"

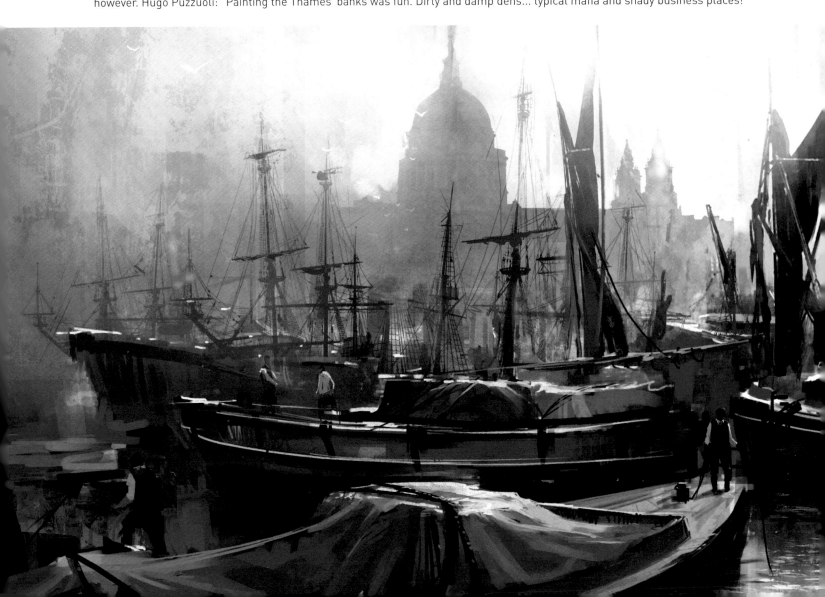

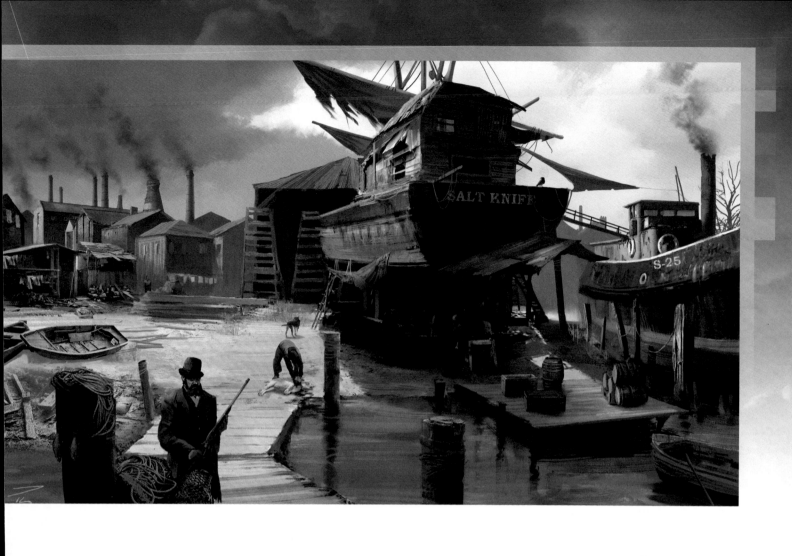
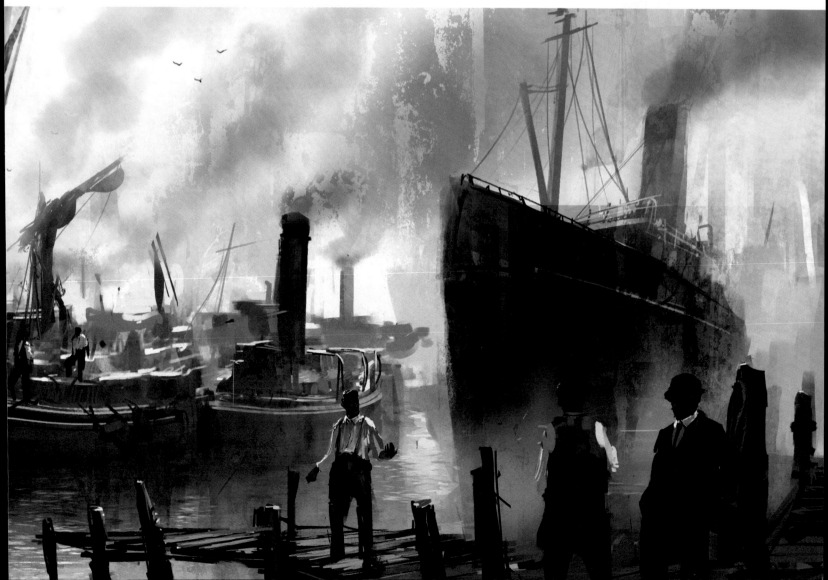

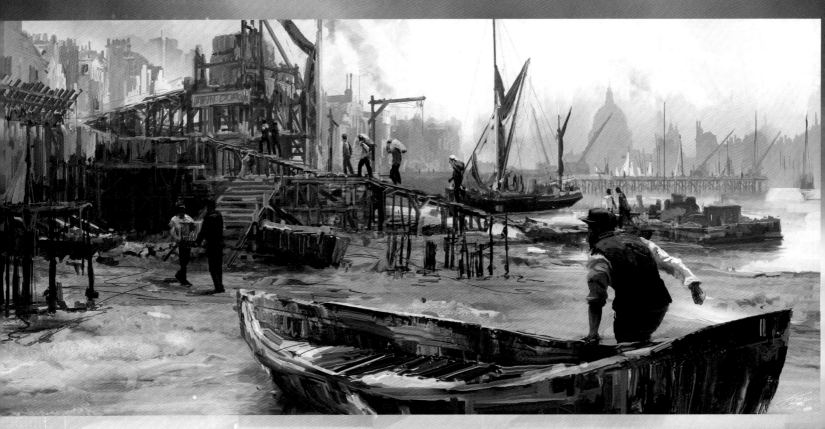

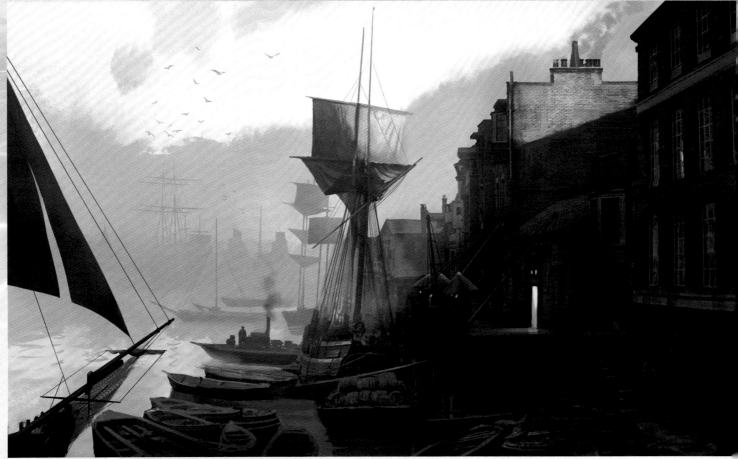

The presence of working class citizens about their business underpins the message of *Assassin's Creed Syndicate* wherever possible. These concepts capture the pride that beleaguered workers maintained in their work; silent boats aligned neatly on the shore. In the absence of fellow human beings we are made more keenly aware of the twilight hours, when Jacob and Evie might silently approach their next targets.

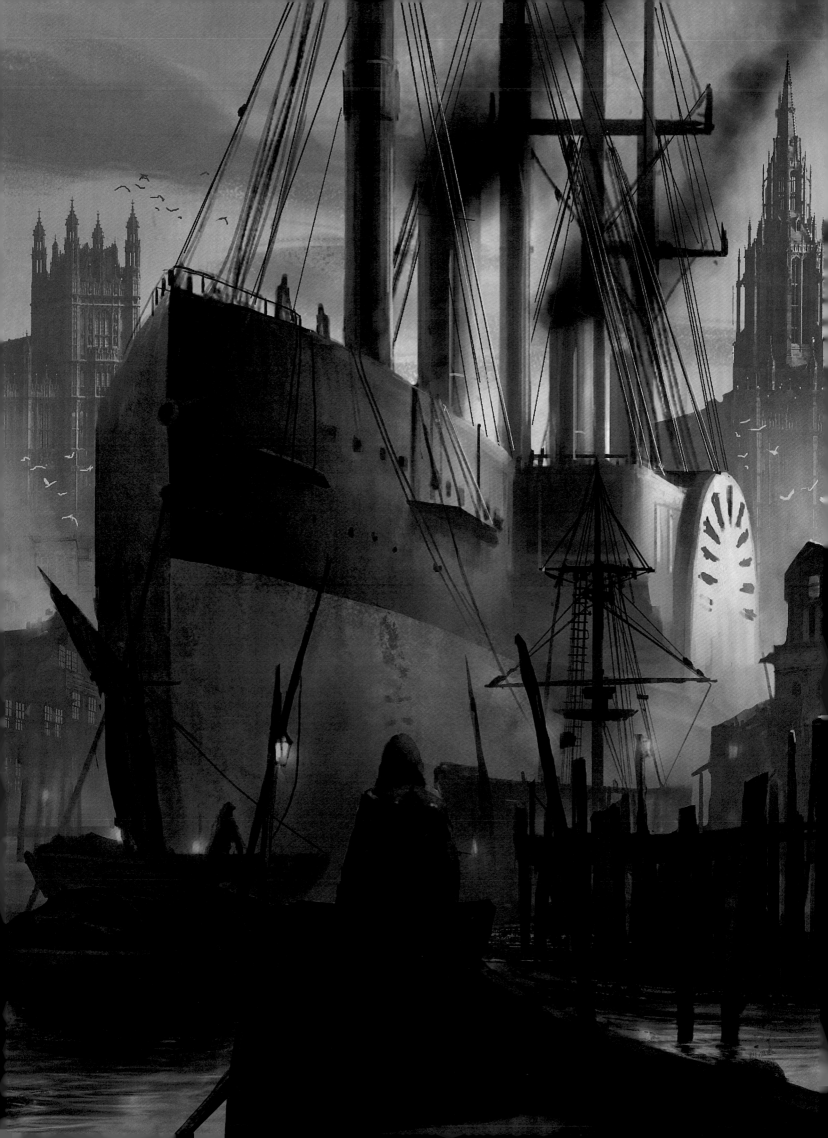

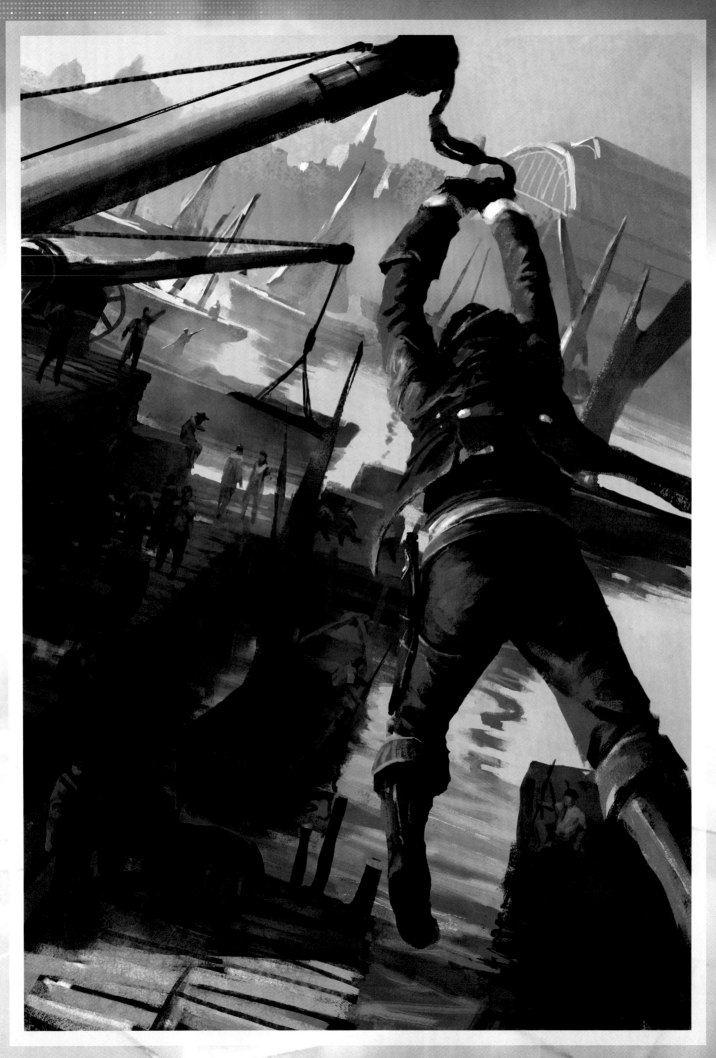

Assassin's Creed Syndicate

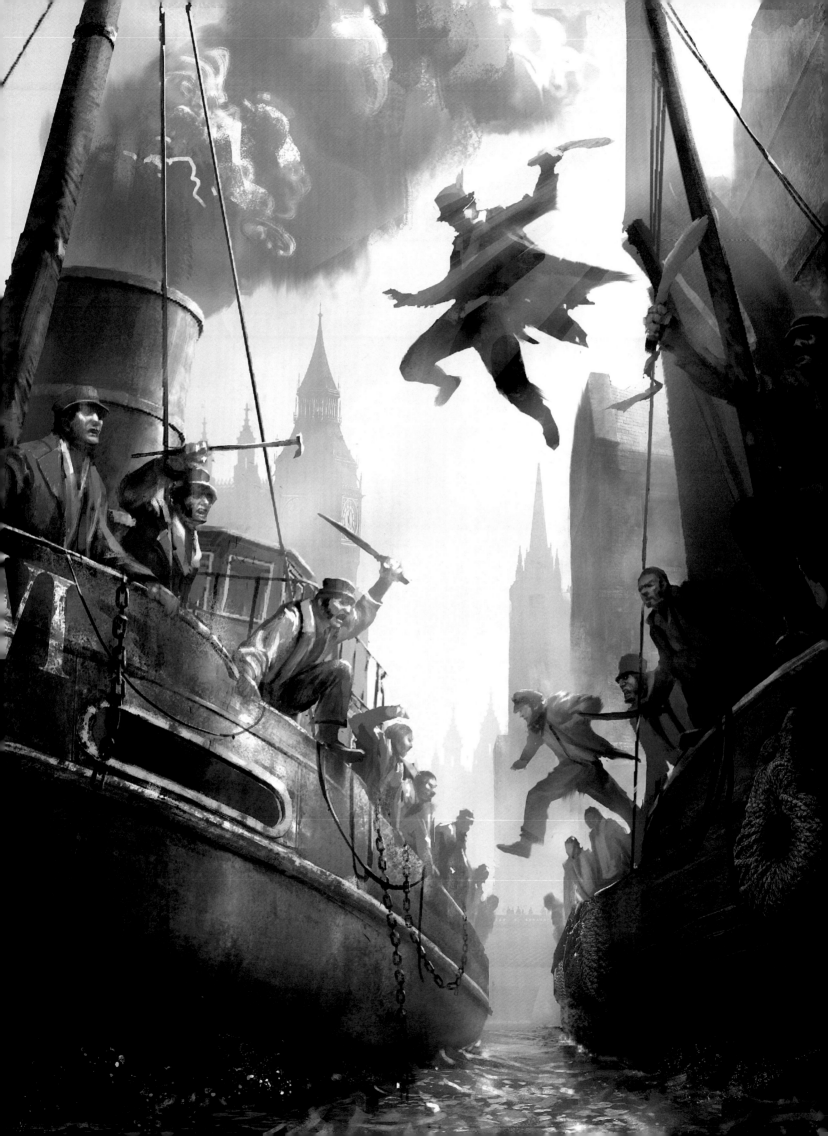

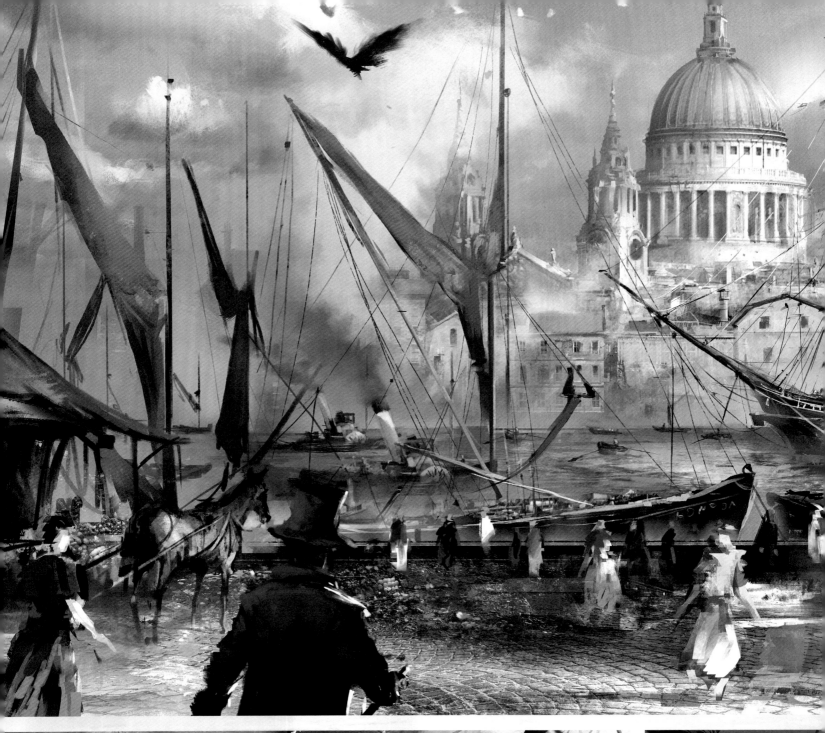

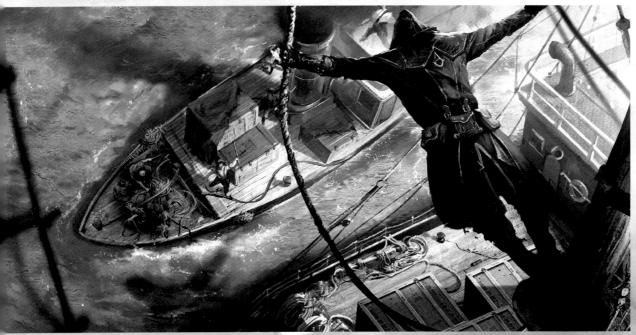

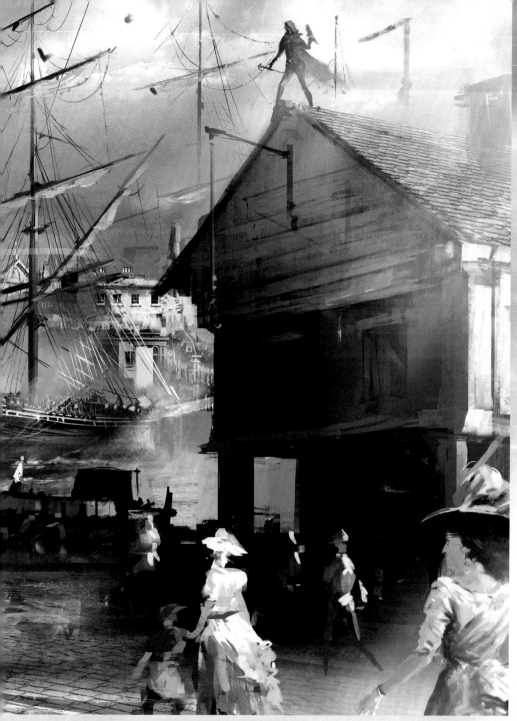

BOTTOM LEFT: "The boat raid is one of the activities that players can possibly encounter. This piece shows Jacob in a dominant position by approaching from the higher ground. In games, it is important to make the player feel powerful and able. The pose of Jacob in this piece shows full commitment to his action which creates a feeling of power and confidence." Felix Marlo Flor.

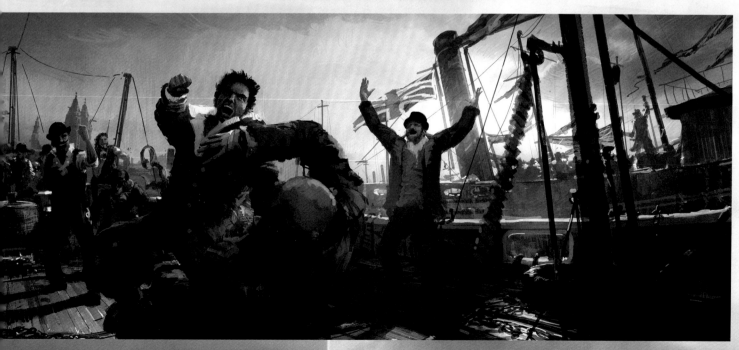

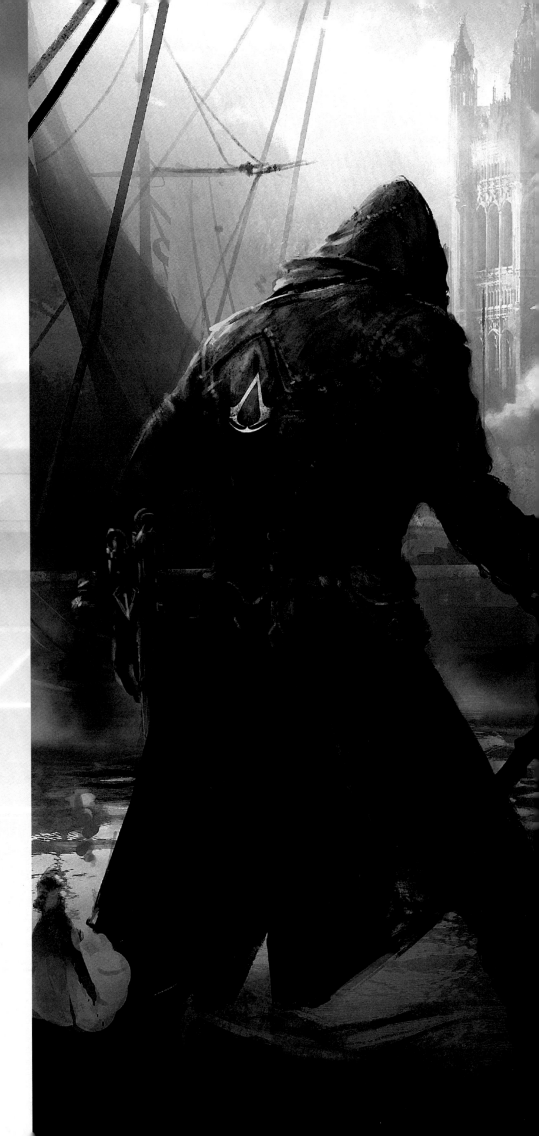

LONDON 1868

ONE OF THE HEROES of *Assassin's Creed Syndicate*, Jacob Frye, faces the River Thames beneath London's choked sky. The stench would be suffocating, the noise cacophonic, and yet the spectacle cannot fail to rouse the emotions. But is it pity, or admiration; sorrow or elation? Monuments to the capital's illustrious past vanish behind obnoxious smoke clouds of civilization's newest playthings. Carrion birds circle to feast on the flesh of those consumed by this frantic claim to power. Even were Jacob to succeed in capturing the hearts and minds of the people, could he guide them through the gates of the modern age?

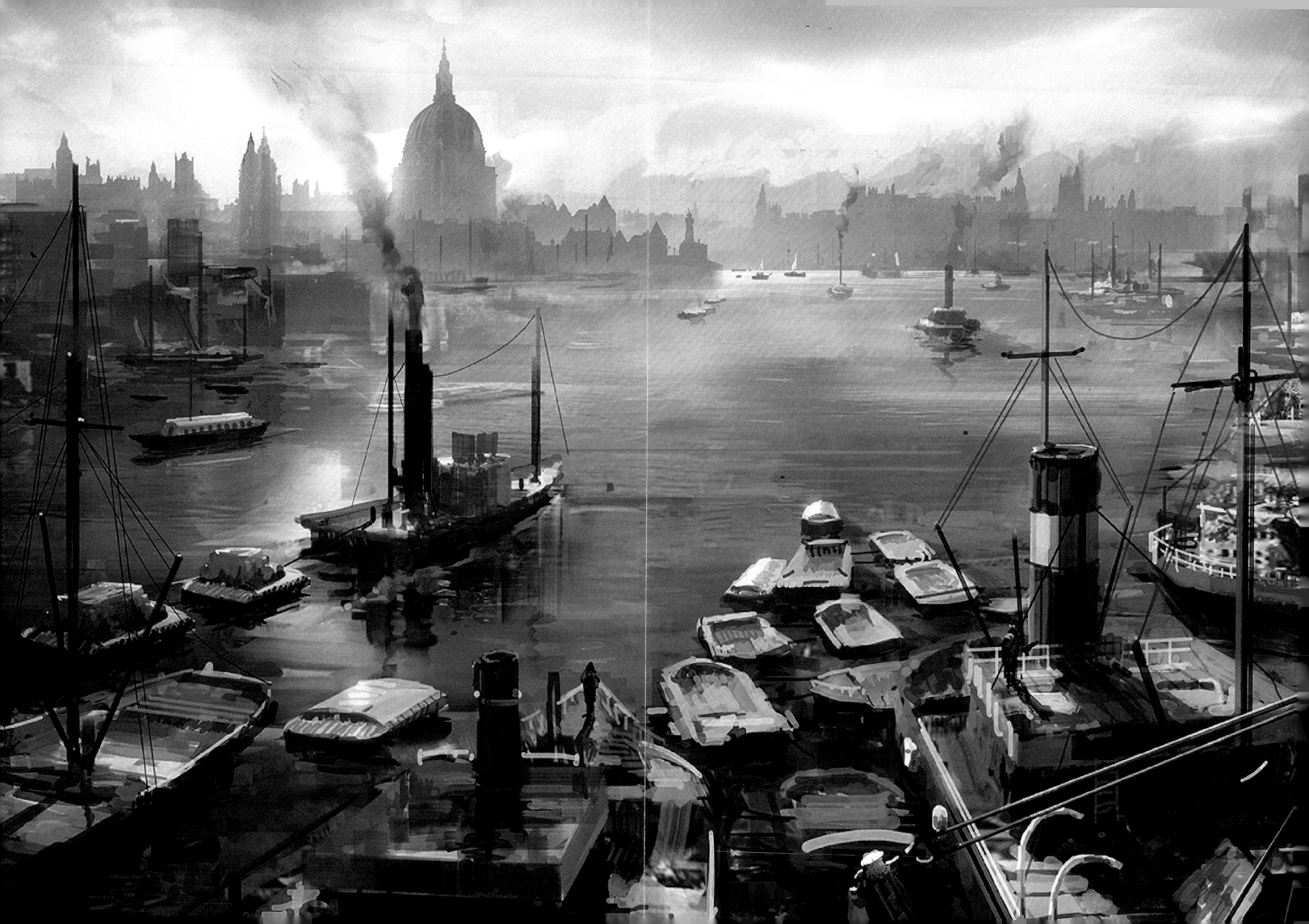

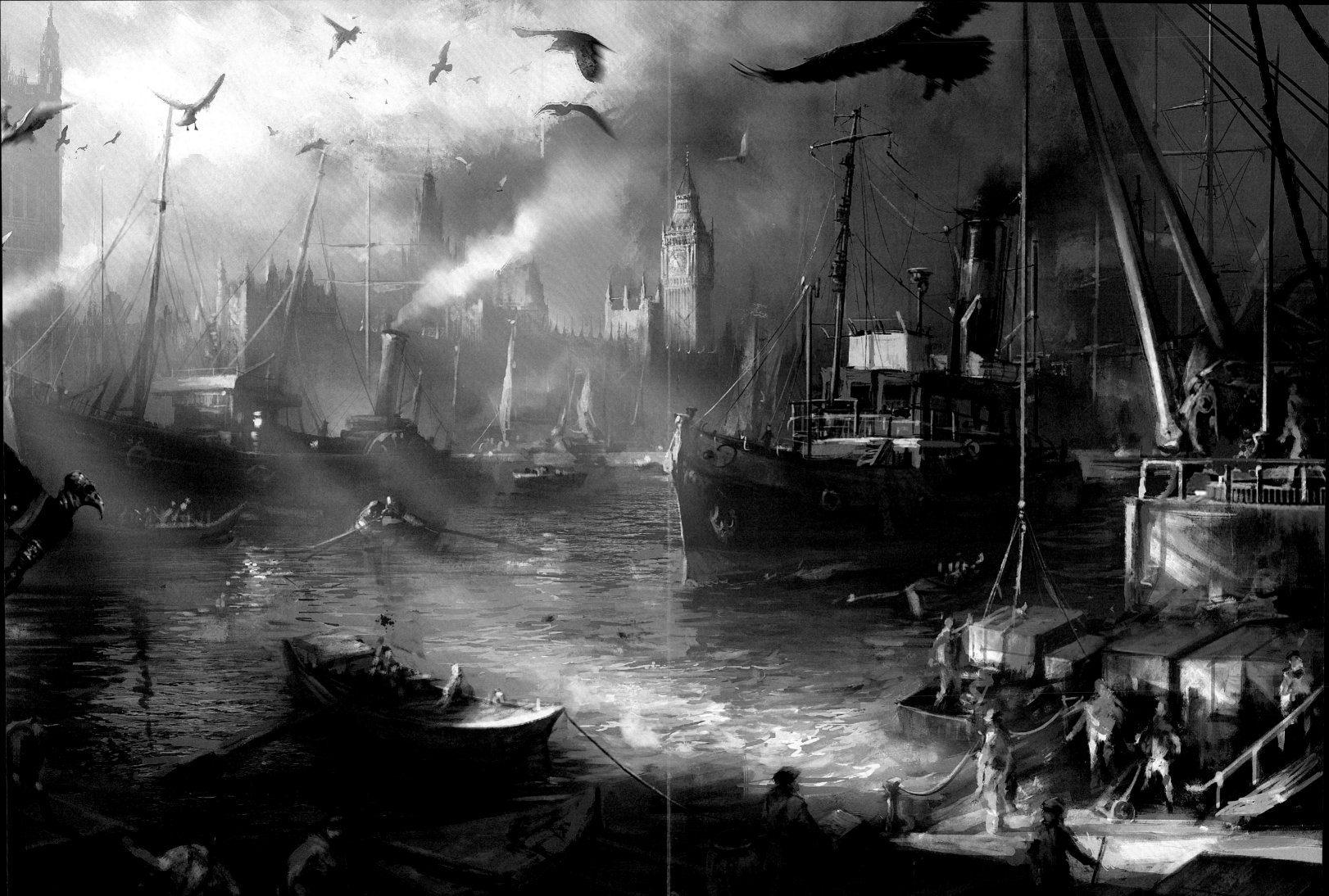

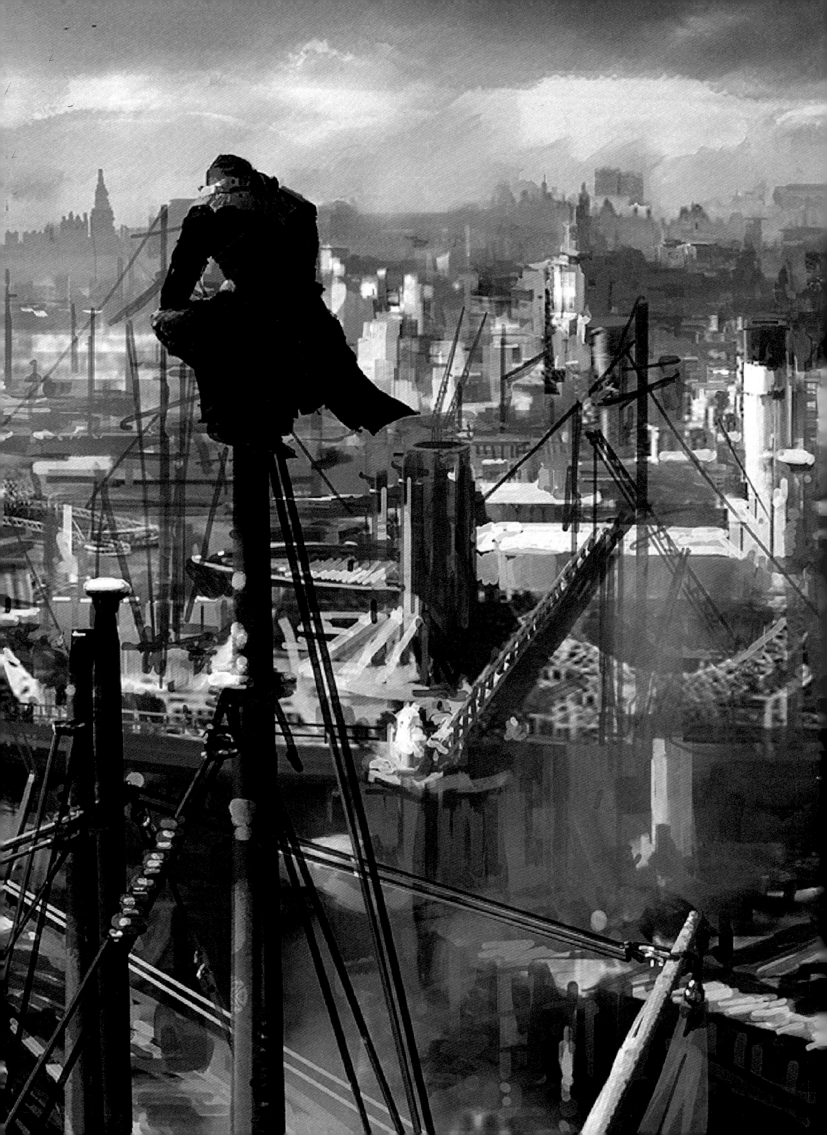

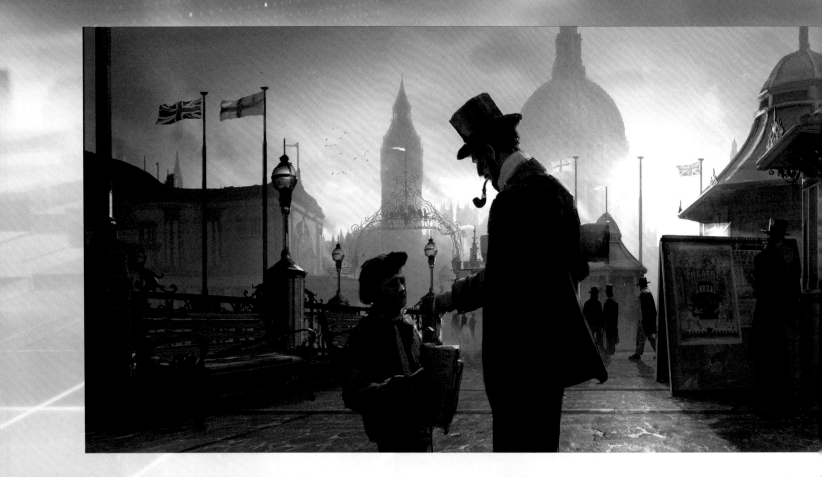

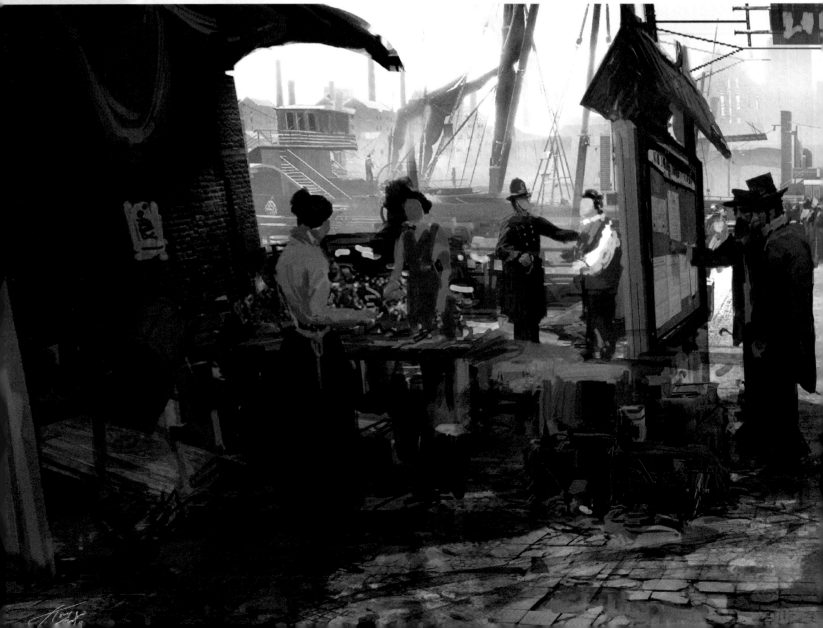

"To evoke different emotions as the player moves through the district, we created three different classifications of docks. Each type has a distinct style guide to create docks that are believable and create different moods using specific visual elements. The rich docks (left) use more elaborate shapes and materials with a lot of soft textures like vegetation. Middle class docks (below) on the other hand have more rigid lines and shapes with hard materials like stone and metal. Lastly, poor docks have a more organic layout and materials like wood and mud." Felix Marlo Flor.

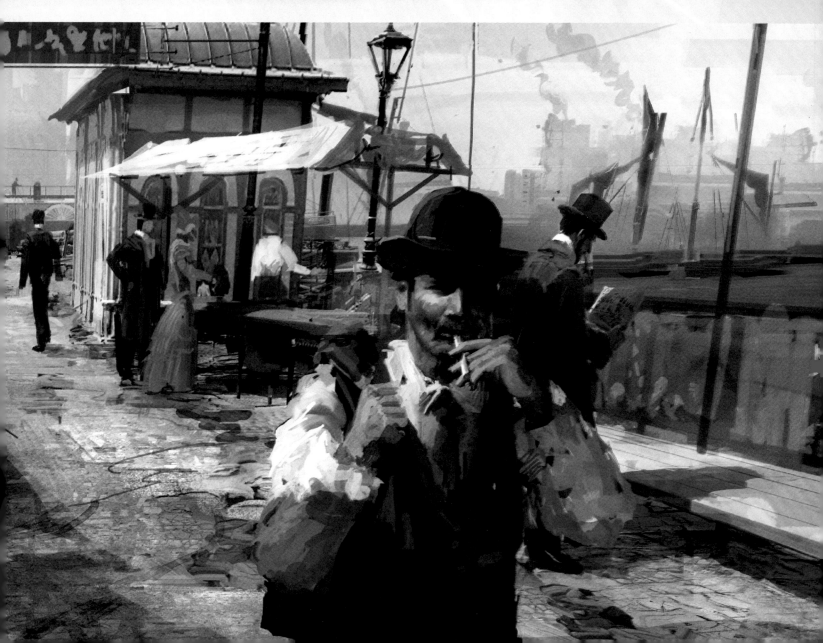

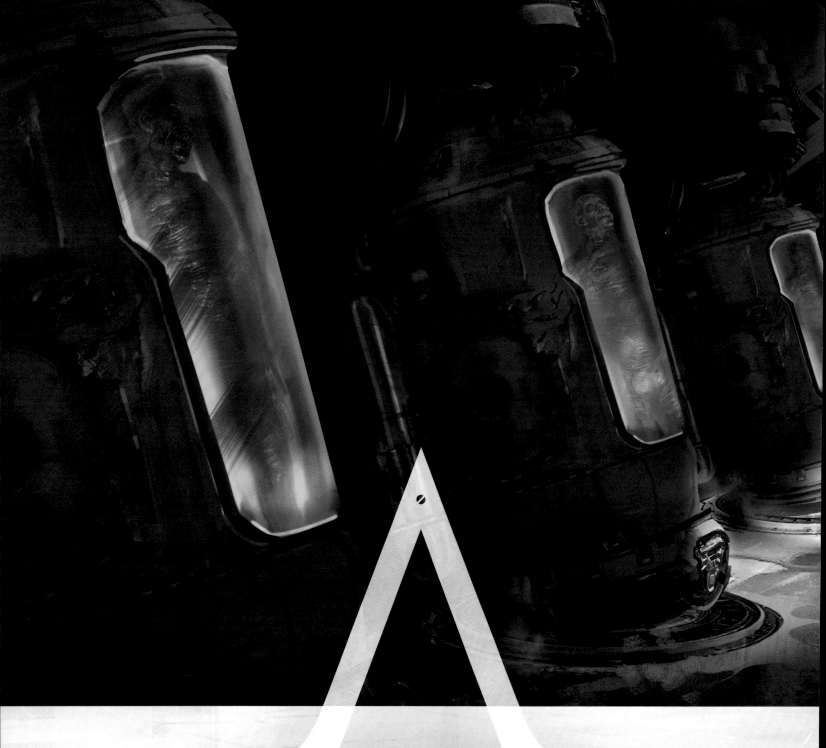

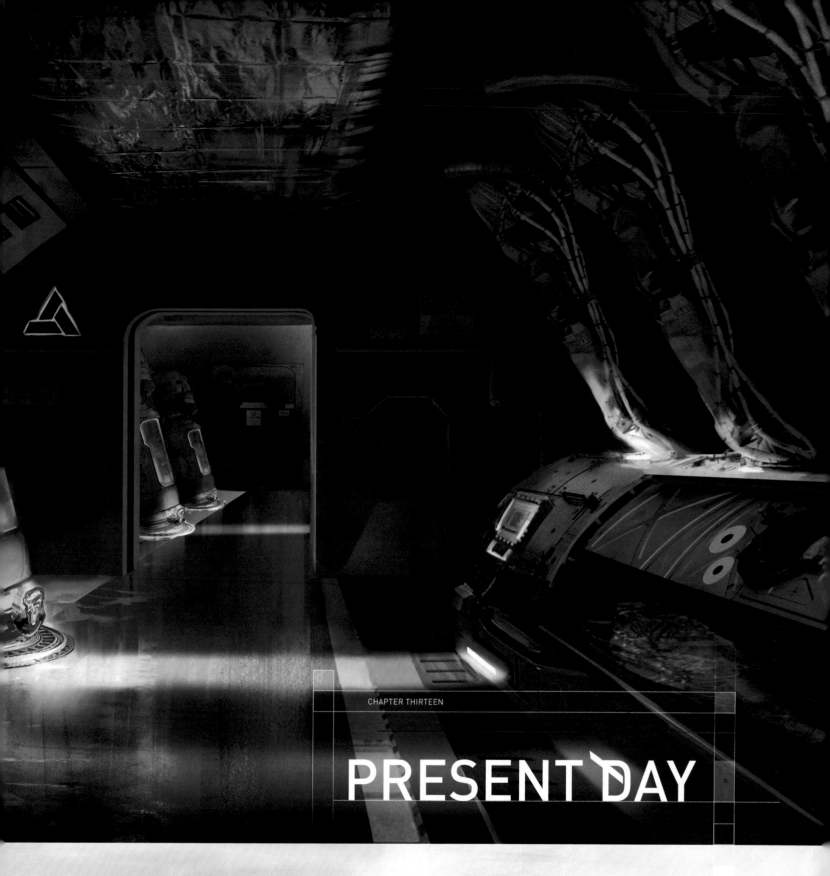

PRESENT DAY

THE GREATEST MYSTERY OF *ASSASSIN'S CREED SYNDICATE* SHALL REMAIN SO FOR THE PURPOSES OF THIS BOOK. YET WE DESIRE TO SHOW YOU A LITTLE BIT BEHIND THE CURTAIN, TO GAZE UPON THE HORROR OF MANKIND'S UNDOING; TO WHERE THIS HAS ALL LED AND TO WONDER IF THE HUMAN CONDITION MAKES SUCH STRIDES FORWARD WITHOUT EVER LOOKING BACK TO NOTICE LESSONS ALREADY LEARNED.

Issues tackled by *Assassin's Creed* often touch on the soul searching side. There are conundrums within conundrums that series fans collectively aim to solve. Yet all the while, without a sense of fun, even the most serious of subject matters could not be tackled well. "I made this secret lab as a mix between *Alien* and the ISS," says Hugo Puzzuoli. "I added floor lighting to create a scary mood!"

THE CLONES

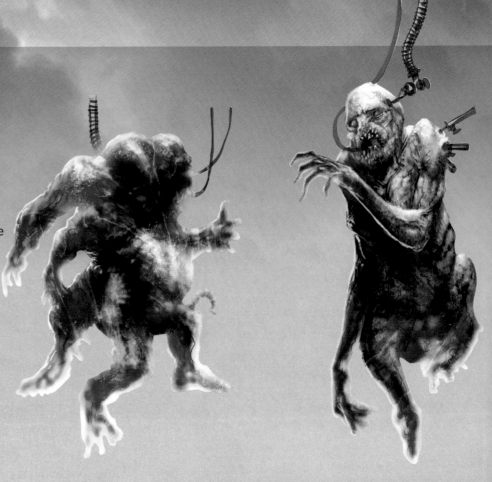

A POPULAR THEME THROUGHOUT science fiction, the likelihood of human cloning draws ever closer to reality. Since most of us are not very comfortable with the idea, our horror stories continue to invest in the fear of what might possibly go wrong. And as ghoulish as all the laboratory failures lined up here surely appear to the average eye, it is the perfect specimen that is the most frightening of all. Grant Hillier explains, "A series of failed clone attempts, each one a bit more successful than the former. In this case, Abstergo was trying to clone a Sage."

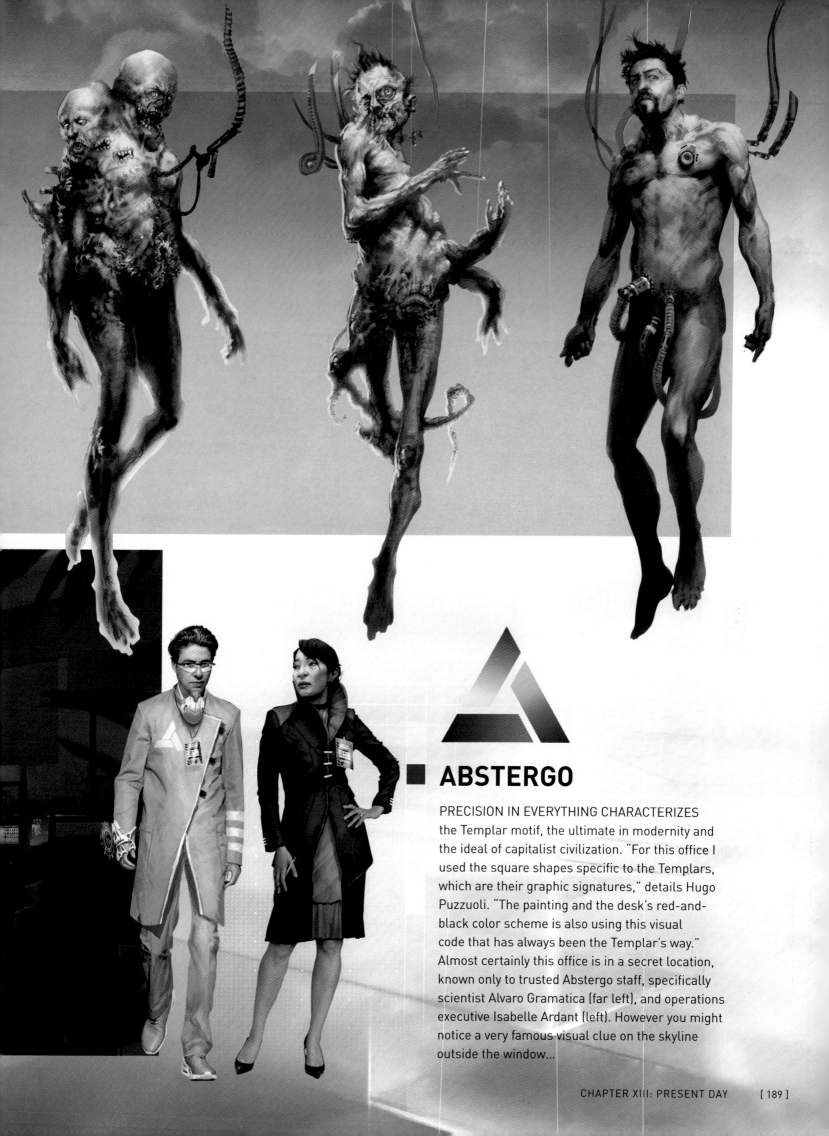

ABSTERGO

PRECISION IN EVERYTHING CHARACTERIZES the Templar motif, the ultimate in modernity and the ideal of capitalist civilization. "For this office I used the square shapes specific to the Templars, which are their graphic signatures," details Hugo Puzzuoli. "The painting and the desk's red-and-black color scheme is also using this visual code that has always been the Templar's way." Almost certainly this office is in a secret location, known only to trusted Abstergo staff, specifically scientist Alvaro Gramatica (far left), and operations executive Isabelle Ardant (left). However you might notice a very famous visual clue on the skyline outside the window...

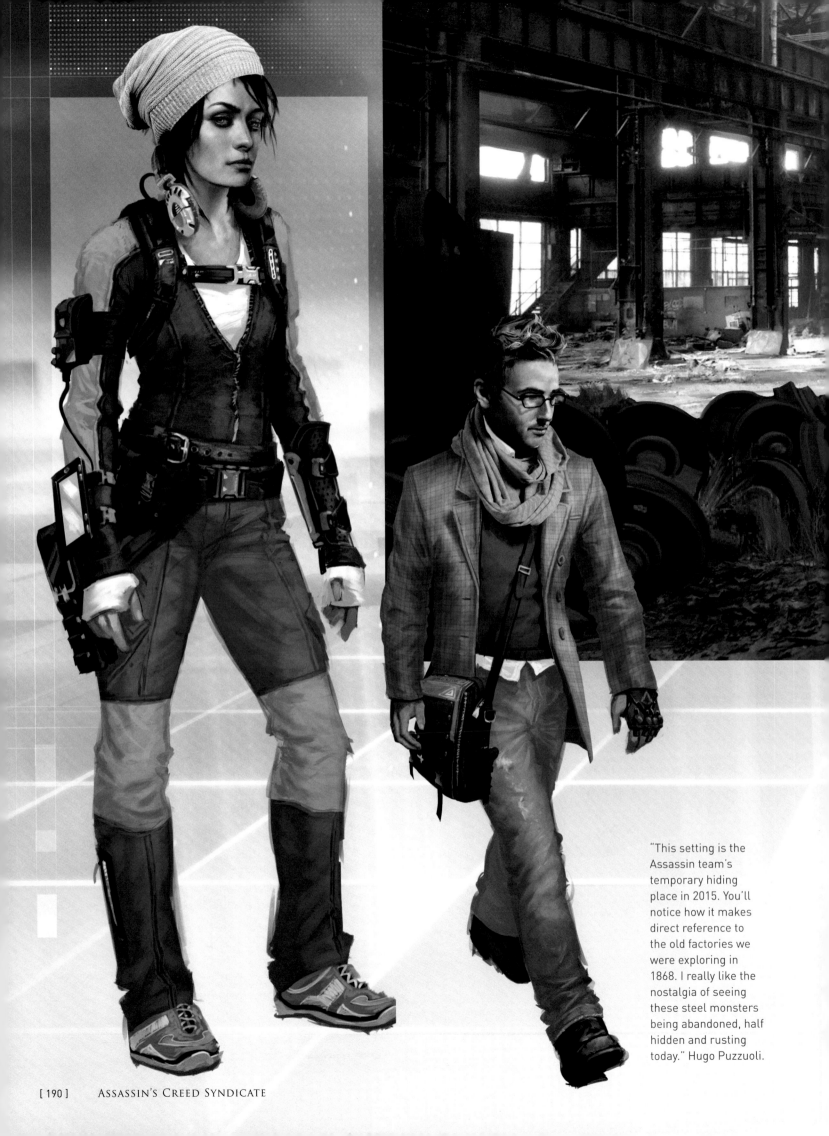

"This setting is the Assassin team's temporary hiding place in 2015. You'll notice how it makes direct reference to the old factories we were exploring in 1868. I really like the nostalgia of seeing these steel monsters being abandoned, half hidden and rusting today." Hugo Puzzuoli.

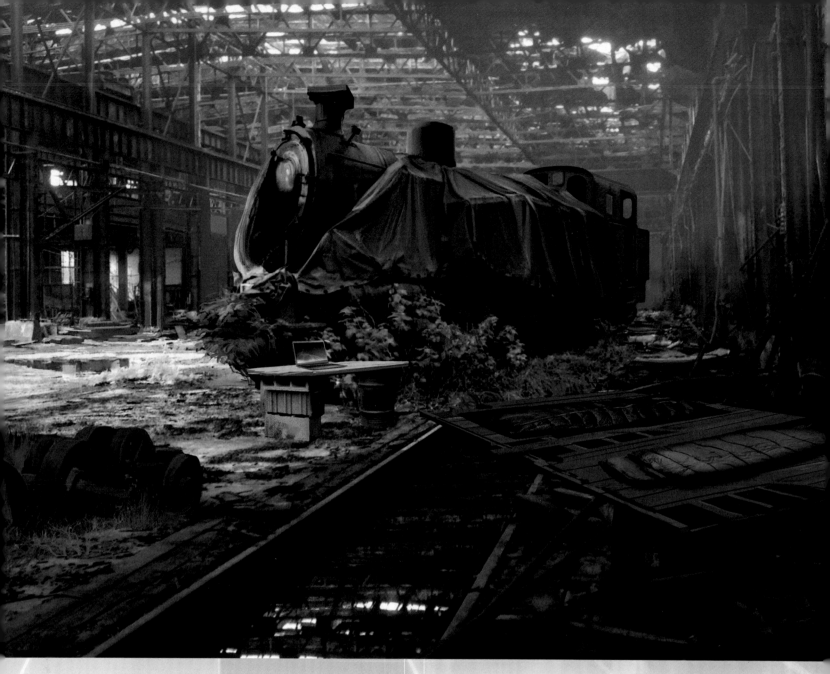

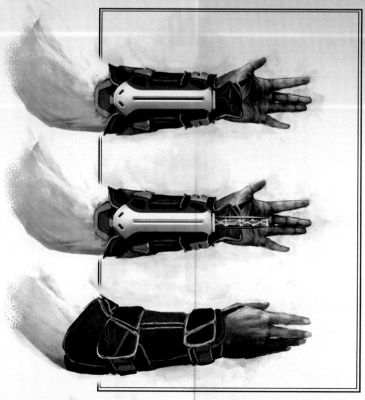

THE ASSASSINS

FEW SPOILERS HERE AS you may already recognize artist Grant Hillier's concepts of Rebecca Crane and Shaun Hastings, the present day Assassins' technical and tactical support team. They continue to observe the movements of Abstergo, aka the Templar Order, with Hastings providing mainly background information on persons of interest, present or in the past. Crane's specialty is decryption of coded communication, and acclimatizing new recruits to the uncanny effects of DNA-driven Animus virtual reality. Their roles within *Assassin's Creed Syndicate* must remain Top Secret, but we are showing the present day version of the Assassin's Hidden Blade to reassure you of great responsibility when the time comes. We shall leave you here in the 21st century. Stay your blade from the flesh of an innocent. Hide in plain sight. Never compromise the Brotherhood.

ACKNOWLEDGMENTS

UBISOFT - HQ
Yves Guillemot / CEO

UBISOFT – EMEA
Alain Corre / EMEA Executive Director
Geoffroy Sardin / EMEA Senior Vice President Sales & Marketing
Guillaume Carmona / EMEA Marketing Director
Clément Prevosto / EMEA Brand Group Manager
Romain Orsat / EMEA Brand Manager
Thomas Carpentier / EMEA Brand Manager Assistant
Clémence Deleuze / EMEA Publishing Executive
Chris Marcus / EMEA Publishing Manager
Alberto Coco / EMEA Head of Consumer Products

UBISOFT - NCSA
Laurent Detoc / NCSA Executive Director
Caroline Lamache / NCSA Licensing Manager

LEAD STUDIO - QUÉBEC
Thierry Dansereau | Art Director
Vincent Lamontagne | Assistant Art Director
Dan Vargas | Assistant Art Director
Caroline Soucy | Artist
Fernando Acosta | Artist
Frédéric Rambaud | Artist
Grant Hillier | Artist
Hugo Puzzuoli | Artist
Hughes Thibodeau|Character Artist
Mathieu Goulet| Character Artist
Alexis Belley-Dufault| Character Artist
Stéphanie Chafe| Character Artist
Pascal Beaulieu| Character Artist
Sabin Lalancette| Character Artist
Steve Beaudoin| Character Artist

STUDIO - MONTRÉAL
Patrick Limoges | Assistant Art Director
Gilles Beloeil | Artist
John Bigorgne | Artist
Martin Deschambault | Artist

STUDIO - SINGAPORE
Felix Marlo Flor | Art Director
Nick Tan Chee | Assistant Art Director
Guang Yu Tan | Artist
Tony Zhou Shuo | Artist
Darek Zabrocki | Artist
Kobe Sek | Artist
Frank Kitson | Artist
Darek Zabrocki | Artist

STUDIO - ANNECY
Yannick Corboz | Art Director
Alex Gingras | Graphic Team Lead
David Alvarez | Artist
Pierre Bertin | Artist

STUDIO - SHANGHAI
Alain Gurniki| Art Director
Yu Li Qing | Artist

STUDIO – BUCAREST
Giani Cojan | Artist

UBISOFT BRAND TEAM
Raphael Lacoste | Brand Art Director
Anouk Bachman | Brand Project Manager
Antoine Ceszynski | Brand Project Manager
Aymar Azaizia | Brand Content Director
Étienne Allonier | Brand Director
Jean Guesdon | Brand Creative Director
Martin Schelling | Brand Senior Producer

Special thanks to:
Beth Lewis and the whole team at Titan Books, Mohamed Gambouz, Virginie Cinq-Mars, Jean-Vincent Roy, Miguel Bouchard, Vincent Pamerleau, Adam Steeves, Thomas Giroux, Maria Loreto, Cyril Vergne and the Helix team, and finally to everyone who has worked on this wonderful project!

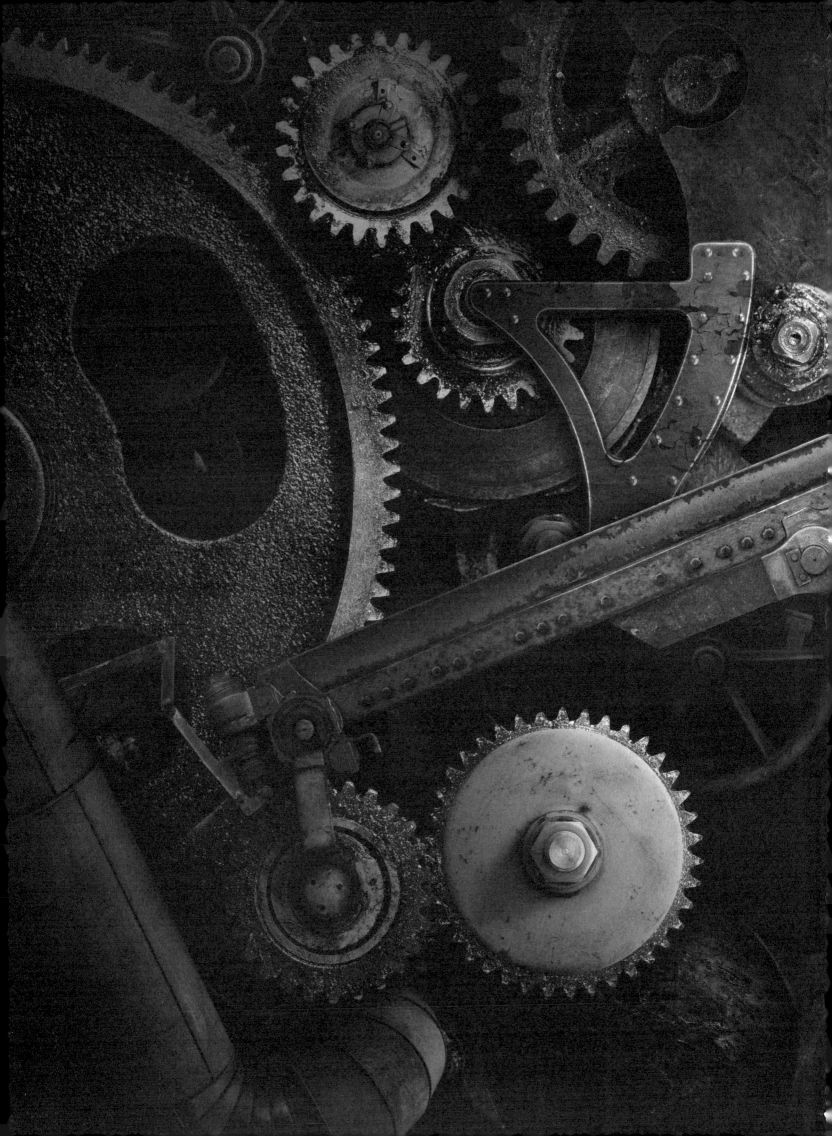